The Citi exhibition
Feminine power

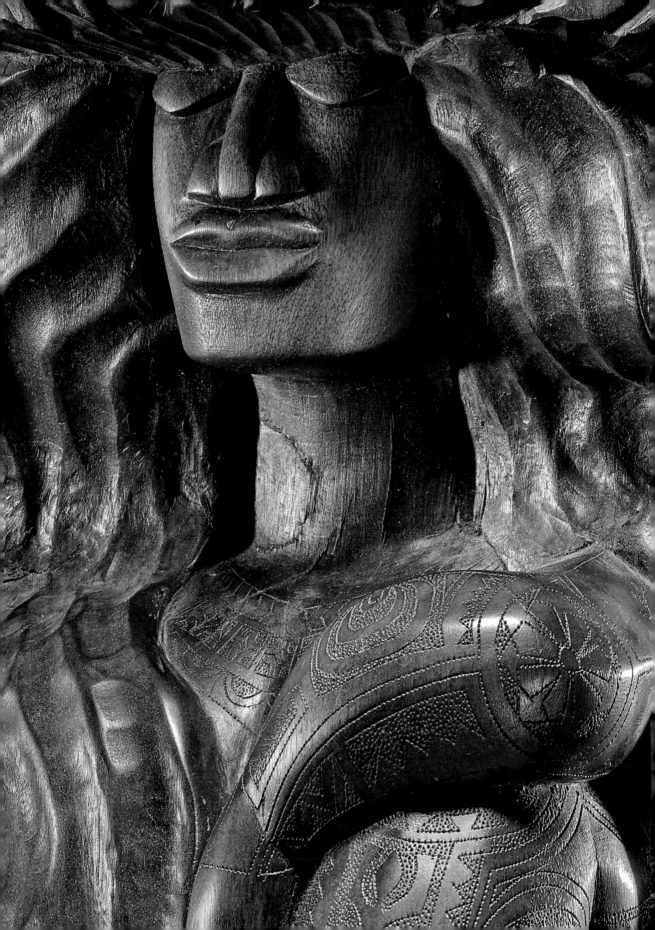

The Citi exhibition

Feminine power

the divine to the demonic

Belinda Crerar

Preface by
Mary Beard

The British Museum

Published to accompany the Citi exhibition
Feminine power: the divine to the demonic at the British
Museum from 19 May to 25 September 2022

Supported by Citi

This exhibition has been made possible as a
result of the Government Indemnity Scheme.
The British Museum would like to thank HM
Government for providing Government Indemnity,
and the Department for Digital, Culture, Media
and Sport and Arts Council England for arranging
the indemnity.

First published in the United Kingdom in 2022
by The British Museum Press

A division of The British Museum Company Ltd
The British Museum
Great Russell Street
London WC1B 3DG
britishmuseum.org/publishing

Reprinted 2023

Feminine power: the divine to the demonic
© 2023 The Trustees of the British Museum

ISBN 978 07141 5130 4

A catalogue record for this book is available from
the British Library.

Designed by Daniela Rocha
Colour reproduction by Altaimage, London
Printed in Poland by Drukarnia Dimograf

Images © 2022 The Trustees of the British
Museum, courtesy of the British Museum's
Department of Photography and Imaging, unless
otherwise stated on page 268.

Further information about the British Museum and
its collection can be found at britishmuseum.org.

The papers used in this book are natural, renewable
and recyclable products and the manufacturing
processes are expected to conform to the
environmental regulations of the country of origin.

Frontispiece
Tom Pico, *Tiare Wahine*, 2001. Hawai'i. 'Ohi'a
wood. 46.4 × 25.5 × 33 cm. British Museum,
London, 2014,2029.2. Donated by the American
Friends of the British Museum.

Front cover
Kiki Smith, *Lilith*, 1994. USA. Bronze
and coloured glass. 80 × 68.6 × 44.5 cm.
The Metropolitan Museum of Art, New York,
1996.27. Image © The Metropolitan Museum
of Art, New York / Photo: Hyla Skopitz.

Back cover
Thang-kha showing the 21 forms of Tara,
19th century. Tibet. Painting on cloth.
120 × 96.3 × 4.1 cm. British Museum, London,
1898,0622,0.22.

Note to the reader
1 Diacriticals are generally omitted from
transliterated languages, but have been retained
in titles of works and quotations.
2 Foreign terms are styled in italic except where
they are widely found in English-language
publications. Following the conventions of
different areas of scholarship, singular and plural
forms may be identical (e.g. *akua*: 'deity' or 'deities',
according to context) or may be differentiated by
the addition of English 's' for the plural form (e.g.
asura, sing.; *asura*s, plural); in the latter case the 's'
appears in roman type.
3 In quoted matter, editorial interventions may
appear in parentheses or in square brackets: in
every case the conventions used in the source from
which the quotation is taken have been followed.
4 In the captions to illustrations, dimensions are
given wherever possible; they should be regarded
as maxima where an object is of irregular shape.
5 The Select bibliography (p. 266) presents a
short list of the most comprehensive available
publications for each chapter. Full details of all
sources on which the text draws are provided in
the Notes (pp. 256–65).

Contents

6 Supporter's foreword

7 Director's foreword

8 Preface
Mary Beard

13 Introduction

24 1 CREATION & NATURE

70 2 PASSION & DESIRE

118 3 MAGIC & MALICE

162 4 JUSTICE & DEFENCE

206 5 COMPASSION & SALVATION

252 Grow the Tea, then Break the Cups
Wangechi Mutu in conversation with Lucy Dahlsen

256 Notes

266 Select bibliography

267 Acknowledgements

268 Picture credits

269 Index

Supporter's foreword

JAMES BARDRICK
Citi Country Officer
United Kingdom

We believe that by understanding the past, we all have the opportunity to define the future. No one brings the past to life like the British Museum, whose permanent collection is one of the finest in existence, spanning 2 million years of human history. In the Citi exhibition *Feminine power*, the Museum uses its collection, along with some spectacular loans, to create a thought-provoking look at the diversity of representations and complex meanings of the divine female over time.

As a global bank, our mission is to serve as a trusted partner to our clients by responsibly providing financial services that enable growth and economic progress. Success in our mission is only possible if we can continue to foster a culture of equality and inclusion that enables and encourages diversity of thinking. We are incredibly proud to partner with the British Museum and to support its role as a museum of the world, for the world. We value the fact that our support enables the Museum to continue with its ground-breaking exhibitions and renowned education programmes.

We hope that you have been able to attend the exhibition in person. If not, we hope that this book serves as testament to the Museum's mission to make its collection available to a global and increasingly diverse audience.

Director's foreword

HARTWIG FISCHER

Director, British Museum

From deep history to the present day, goddesses, spirits, demons, holy women and other manifestations of feminine authority have played a significant role in shaping historical and contemporary beliefs and cultures across the world. This exhibition brings together sacred and secular art and artefacts from six continents, displaying objects from as early as 6000 BCE and as recent as 2021 to explore the importance of female representation in global religion, spirituality and folklore.

Feminine power is organised around five themes: creation and nature; passion and desire; magic and malice; justice and defence; and compassion, wisdom and salvation. Together, they show how feminine influence has been conceived in a phenomenal range of human experiences. Petitioners dedicating curse tablets to Sulis–Minerva in early Roman Britain relied on the goddess to exact vengeance on wrongdoers. Masks created in South and South-East Asia for actors to embody demons such as Rangda and Taraka illustrate their importance in festivals and celebrations. Medals and coins reveal rulers appropriating aspects of deities to convey power and authority. Today, the presence of female figures of worship in contemporary art demonstrates the continual and growing desire to engage with them. We are thrilled to present a new work created specifically for this exhibition: a sculpture of the formidable goddess Kali by artist Kaushik Ghosh.

My sincere thanks go to the lenders to the exhibition: Gallery Oldham; Israel Museum, Jerusalem; The Metropolitan Museum of Art and Kiki Smith; National Museums Liverpool, World Museum; the Roman Baths, Bath & North East Somerset Council; the Syndics of Cambridge University Library; Tate; and Wangechi Mutu and Victoria Miro. The insights and absorbing narratives that have emerged during its creation would not have been possible without the generous input of many community groups, including the London Durgotsav Committee, led by Dr Ananda Gupta, Sunbir Sanyal and Anjali Sanyal; Nusrat Ahmed, Patricia Anyasodor, Robina Afzal and Abira Hussein; and members and supporters of the Children of Artemis – Jenny Cartledge, Olivia Ciaccia, Laura Daligan, Merlyn Hern, Raegan Shanti and Lucya Starza.

I am delighted that audiences in Australia and Spain will be able to engage with these objects when the exhibition tours to our partners, the National Museum of Australia, Canberra, and Fundación Bancaria La Caixa, from 2022 onwards. I am grateful to the guest speakers in our exhibition for their inspiring commentary on its themes, encouraging us to question our cultural biases and broaden our perspectives.

Without the kind support of our sponsor Citi, this project could not have been possible. I thank them for their continued generosity to the British Museum.

Preface

Mary Beard

On the ancient Acropolis in Athens, from the fifth century BCE onwards, there were two particularly distinctive images of the goddess Athena on display. Neither has survived, and we know them only from ancient replicas and descriptions. But, even so, they can tell us a lot about representing a deity. One, a masterpiece by the Greek sculptor Pheidias, was housed in the Parthenon, the famous temple completed in the 430s BCE (see p. 179). This Athena, built on a superhuman scale, was constructed around a wooden frame, cleverly covered in gold and ivory. The goddess stood more than 10 metres tall, dressed in a glittering helmet and long tunic, holding a spear and a shield. (A full-sized modern replica in Nashville, Tennessee is probably the best guide to her original appearance, fig. 1.) The other image was smaller and older, and had originally belonged to a temple destroyed in the war between the Greeks and Persians in the early fifth century BCE. It was preserved just next door to the Parthenon in a smaller shrine, known as the Erechtheion, where it was lovingly tended, adorned with jewels and dressed in a specially woven gown, but underneath it was nothing more than a plank of olive wood, which – so legend claimed – had miraculously fallen to earth from heaven. The central scene of the sculpted frieze of the Parthenon depicts the presentation of a new gown (or *peplos*) to clothe that bare, but very sacred, bit of wood (fig. 2).

The difference between these two images was not simply a matter of aesthetic styles or fashion, or of the distinction between the primitive plank and the more sophisticated construction in gold and ivory. What was at stake were two completely different ideas of how to represent the goddess and her divine power. The sculpture in the Parthenon was made by the ingenious hand of a great artist, at enormous expense and on a vast scale: a dazzling Athena, in the most precious materials, and in the form of a human female warrior, towering over the mortals who came to admire or worship her. The other image, by contrast, expressed sacredness by its very *refusal* to ape human form, or to depend on the skill of any human artist. The power of the plank resided not in its size or material preciousness, but in its origins in heaven itself.

This pair of 'statues' – if you can call a plank a statue – points to some of the key questions raised in this exhibition. What does the image of a goddess amount to? How have people through time, and across the world, imagined divine power, particularly *female* divine power? How have they represented it to themselves? How have they questioned, challenged, worshipped or rejected it? What stories have they told to explain it? Where have they drawn the boundary between feminine and masculine power, or between the power for good and the power for bad? The aim has not been to search out forgotten mother goddesses, or to uncover traces of a lost world in which, once upon a time, women ruled in heaven and on earth. The myth of matriarchy is exactly that: a myth. The aim is much more to show how questions of sex, gender and desire

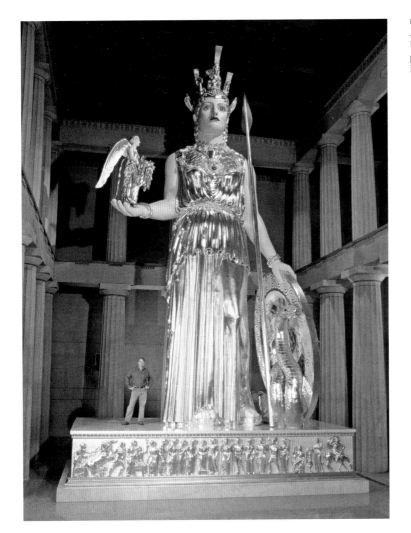

FIG. 1

Alan LeQuire, *Athena Parthenos*, 1990.
USA. H. 13 m. Gypsum, fibreglass,
plaster, steel, aluminium, gold leaf.
Nashville Centennial Park, USA.

have always been inseparable from ideas of divine power, and how
puzzling, unsettling and relevant those questions still are.

The exhibition and this book ask us to look hard at some of the
most arresting images ever made, and to reflect on their meanings
and ambiguities. There are no simple answers or straightforwardly
'right' interpretations. The paintings and sculptures of the
many-handed, blood-stained Hindu goddess, Kali, for example,
trampling on the body of her husband Shiva (see fig. 134) point, for
some observers, to a story of destruction and the dangerous power
of the woman, for others to a lesson in liberation and the goddess's
fearless transcendence of death. The figure of Eve in the Garden
of Eden, eating the apple and offering it to Adam (see fig. 66), is
regularly taken to signal 'woman as temptress', responsible for
the sins of mankind; but in some mystical traditions, she has been
presented as a seeker after 'Knowledge' (from whose tree the apple
was plucked). Or take the severed head of Medusa from Greek
and Roman art and myth, which destroyed anyone who looked

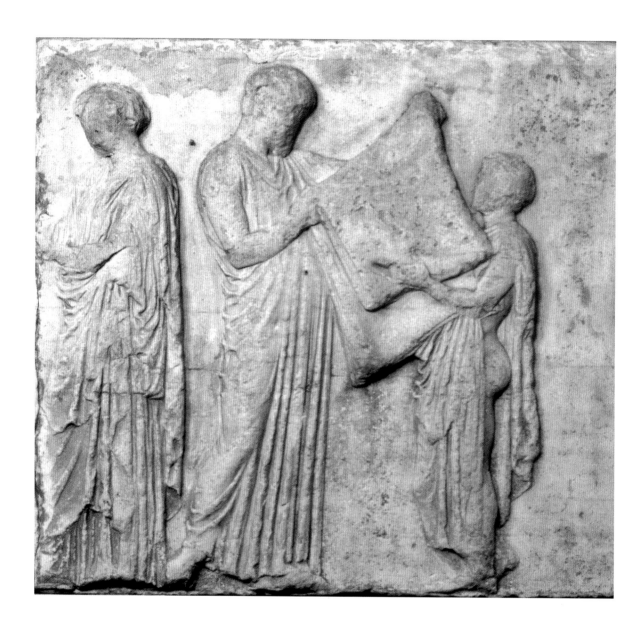

FIG. 2
Relief from Slab V from the East Frieze
of the Parthenon, 438–432 BCE. Athens,
Greece. Marble. L. 108 cm (approx.).
British Museum, London, 1816,0610.19.

A man and a child hold up the *peplos*
of Athena.

at it. How should she best be depicted? Usually, we see her as a
monstrous creature, with snakes for her hair and an over-sized
protruding tongue, as if her destructive power lay in her capacity
to shock and repel. But an alternative artistic tradition makes her a
beautiful young woman, as if that power lay instead in her capacity
to seduce (see figs 86–87). How far, to push that further, should we
see sexual desire as a superhuman force that risks destroying the
'civilised' order of the world?

At the same time the exhibition prompts us to look again at
some images that Western culture now takes too much for granted.
The naked image of the goddess Aphrodite or Venus – and there
are rows and rows of them in museums across the world – has
become so far removed from any idea of divine power that it can

seem almost banal in its apparently conservative classicism (see fig. 55). Here we get the chance to rediscover the danger in these images, and to see just how destabilising they were when they were first produced: not banal at all, but sensationally provocative. That is vividly captured in a chilling anecdote about the first ever full-sized ('human-sized', that is) statue of Aphrodite, made by the fourth-century BCE sculptor Praxiteles, and – though again the original does not survive – the ancestor of most of those we now see lining museum walls. Housed in a temple to the goddess in the city of Knidos, on what is now the Turkish coast, it had the capacity to turn men mad. On one occasion, it was said, a young man contrived to be locked up in the temple all night, made love to the statue (the traces of his ejaculation were supposed to have been still visible on its thigh centuries later) and the next morning threw himself off a cliff. Part of the moral here lies in the perils of confusing inanimate marble with flesh and blood. But the story underlines the destructive power of the 'goddess of love' (or perhaps we should better call her, in a less romantic way, the 'goddess of sex' or 'of desire'). Her statues are dangerous things.

The exhibition also shines a spotlight on the idea of the 'feminine' itself, as well as on the idea of 'power', raising in the process some sharp questions about gender boundaries. The case of Athena already headlines these issues. The goddess lay somewhere *between* female and male, for, though born a woman, she was – as Pheidias' statue demonstrates – equipped with martial attributes that fundamentally conflict with Greek concepts of female gender. Apart from the subversive, mythical Amazons, Greek women were not warriors. And Athena was not even brought into the world by a mother but directly from the head of her father, Zeus. This kind of fluidity of gender is a prominent feature throughout the exhibition, seen in ancient Mesopotamia, for example (where the goddess Inanna could be described as both a woman and a man), and most dramatically in the art of the nineteenth-century Luba kingdom, in the modern Democratic Republic of the Congo (see fig. 105). Here figures of secular and spiritual power can be represented with breasts *and* male genitalia, and sacred images may present a non-binary aspect. It is as if the divine sphere, and its representations, offer a space where binary gender norms of the human world can be debated and challenged. That could hardly be more topical.

Indeed, this *is* a very topical exhibition. Some of the works of art on display go back almost five millennia. But many of their themes are still part of our own cultural debate and artistic repertoire worldwide. I am thinking here of the performances of actor and singer Beyoncé Knowles, riffing on the famous statue of the Greek goddess of Victory in the Louvre (and at the same time challenging its 'whiteness' and its power) (fig. 3). And I'm thinking of the continued use of images of the severed head of Medusa to undermine women's prestige (some infamous

FIG. 3
Winged Victory of Samothrace,
c. 220–185 BCE. Greece. H. 3.3 m.
Marble. Musée du Louvre, Paris,
MA2369.

In the music video *APESHIT* by The
Carters (2018), Beyoncé performed in
front of this sculpture.

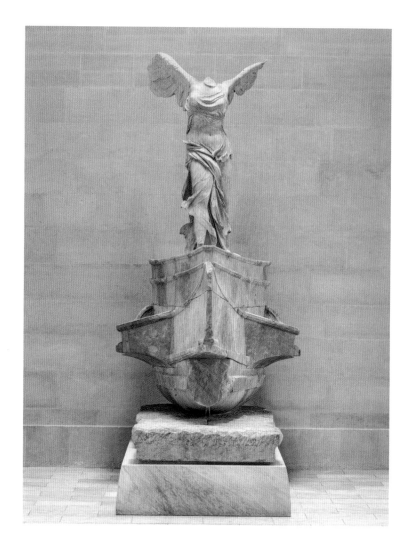

propaganda in the 2016 US election campaign featured Donald
Trump holding the dripping head of Hillary Clinton; p. 136).
But my own particular favourite is given pride of place on the
cover of this catalogue: it is Kiki Smith's *Lilith* – the ancient
demon, best known for destroying babies, who was said to be the
first wife of Adam and to have been expelled from the Garden of
Eden for disobedience. From the nineteenth century, she began
to be reclaimed as a symbol of female defiance. Smith's sculpture
of 1994 reclaims her better than any other. Lilith is naked, but not
displaying herself to us; she's fixing those who look at her with her
steely blue eyes; and she's a free spirit, upside down on the wall,
defying gravity. Feminine power undiluted.

Introduction

> Deluded, O Goddess, is this entire universe; you, when resorted to,
> are the cause of release right here on earth.
> All the various knowledges, O Goddess, are portions of you, as is
> each and every woman in the various worlds.
>
> *Devi Mahatmya*, 11.4–5[1]

Powerful goddesses, spirits, demons and saints live in the hearts
and minds of people around the globe. They may be perceived as
generous and comforting, or terrifying and aggressive, and their
celebration and veneration over thousands of years has produced
a wealth of art, poetry and prose. Their presence and influence
have been observed in all aspects of human life, from birth and
death, to war and peace, to natural phenomena like the abundance
of spring, the destruction of floods and searing drought. This
book is a thematic exploration of some of the diverse female
spiritual forces from ancient and modern world cultures, and
the significance that they hold in people's lives. In looking at the
contrasts and commonalities in ways of thinking about female
strength and authority, it also asks how these figures and forces
impact cultural understandings of feminine power.

Across world belief, there is much to inspire and affirm female
identity, particularly the widely held belief that divine power – and
in some traditions the supreme divine power – manifests in female
or bi-gendered form. Spiritual beings transcend corporeal form,
but humans often personify them in a gendered way or consider
them to have once had mortal form, adding a literal aspect to
how they are recognised. But for the most part their gendered
appearance relates to culturally specific ideas about femininity
and masculinity, which vary over time. The 'female' identity of
many of the beings explored here is drawn both from imagery
and gendered language commonly used to describe them, but
it may not be the only way they are seen. Concepts of gender
fluidity are found in many spiritual traditions: some distinct
forces are popularly recognised as female or male, but others are
held to transcend binary gender, being both female and male
interchangeably or concurrently, or being neither. In some cases,
a flexible or non-binary understanding of a being is intrinsic to
their power.

Collected here is a selection of objects and artworks from
traditions around the world that reflect on the subject of feminine
power and authority in favourable or enlightening ways. Drawn
from six continents and dating from around 6000 BCE to the
present, together these objects illuminate diverse perspectives
on femininity and interrogate the historical and contemporary
impact of spiritual figures on gender identity. For much of history,
spiritual belief has guided social, ethical and moral world-views,
shaping the lives of people around the globe. In most, if not

all, world cultures, particular roles have come to be associated with female and male gender identities, influencing understandings of the terms 'feminine' and 'masculine'. For some – predominantly Western – cultures the word 'feminine' can carry connotations of gentleness, modesty and physical weakness, while 'masculine' often implies assertiveness, aggression and physical strength. Although these adjectives may be applied to persons of any gender identity, they are loaded with societal expectations of female and male behaviour; expectations which can be influenced by spiritual ideas. In some faiths, spirits, saints or deities are perceived as a model for humankind to emulate (for example, the Virgin Mary); in others, the conduct of deities is not held to translate directly or literally to mortal behaviour (for example, Athena). As historians of religion have long noted, traditions that revere divine female power do not automatically result in greater socioeconomic or political authority, or higher social status, for women.[2] Such traditions might, however, hold a greater respect for, and broader understanding of, 'femininity', by contrast with those that have limited or predominantly negative female representation. The American academic Rita M. Gross writes:

> The use of feminine [religious] symbolism does not seem to guarantee anything about the role and status of *women*, though it does seem to correlate with a positive evaluation of whatever is deemed *feminine* in a given religious symbol system. This is an important distinction, for many people either automatically expect a Goddess to correlate with high status and autonomy for women or else fail to see that feminine qualities can be revered even if women lack autonomy.[3]

Much remains to be said on the role that spiritual belief has played in justifying gender-based oppression and discrimination around the globe. While this book touches on elements of this subject, its focus is the religious and spiritual beliefs that promote and revere feminine power, and that inspire us to reflect on definitions of femininity from different cultural and spiritual traditions.[4] In the popular imagination of many Abrahamic monotheistic cultures, discussion of the female divine seems radical, but globally people have venerated female beings for centuries. Many female deities are connected to physical strength, wisdom and leadership, even to violence and bloodlust (chapter 4), raising fundamental questions about our socially conditioned perceptions of 'feminine' behaviour. Other female forces, who are intimately connected to nurture, mercy and protection of the vulnerable (chapter 5), compel us to consider the value placed on these qualities as guiding principles for all people.

INTERPRETING THE PAST

The plurality of beliefs in every spiritual tradition has given rise to a wealth of contrasting views on the role of women and expressions of femininity. These views are often based on different interpretations of sacred texts or narratives, which gain varying prominence within popular knowledge and teaching. Across Eurasia and North America, religious discourse, along with spiritual leadership and instruction, has historically been dominated by men, and has occurred in religious and academic institutions from which women were largely excluded. This is not to say that all spiritual exegesis composed by men has been hostile or derogatory towards women or femininity, only that, for centuries, women themselves have had considerably less direct agency than men in the configuration and interpretation of authorised religious belief, and far less opportunity for education and public audience. There is little doubt that women have historically been actively involved in the religious guidance of families and communities, and every so often a rare insight into the female perspective has survived from the past – for example, the German abbess and mystic Hildegard of Bingen (chapter 5), the Greek poet Sappho (chapter 2), and a community of Buddhist nuns in India composing poetry around the turn of the first millennium (chapter 5). However, women's spiritual beliefs and scriptural interpretations – alongside those of other socially disadvantaged groups – have not been recorded for posterity to the same degree as those formally composed and disseminated by male scholars and faith leaders.

As global societies are changing, dominant male structures have been challenged or subverted, and feminist and LGBTQ+ movements in many parts of the world are demanding equality and insisting that their voices are heard. Revisionist theological readings of sacred texts and traditional spiritual practices have steadily been gaining prominence in different faith contexts and often contest prevailing androcentric or heteronormative readings of the foundational tenets of some faiths. This has opened doors to new ways of thinking about the major religions of today and their significance in the modern world, and created a dynamic conversation on the inclusivity of faith for all worshippers.

The diversification of academia and global theology in the twentieth century has not only impacted current conversations on 'living' faiths, but is also changing our understanding of past religions. Until the mid-twentieth century, the academic disciplines of history, archaeology and anthropology were dominated by male scholars – usually wealthy and European. Since other voices have entered these fields – largely from the 1960s onwards – historical scholarly biases have been highlighted and queried: a notable example is the common interpretation of goddesses of the ancient world as deities of 'fertility'. The term 'fertility' can be applied

to almost any goddess or god if one cares to find a way and is a pivotal concept in many spiritual traditions. Yet within Western scholarship, there has long been a propensity to apply this term far too readily to female deities of the ancient world and far too rarely to male deities. The result of this is put neatly by former Harvard professor of biblical Hebrew, Jo Ann Hackett:

> Choosing to put [female deities] into the category of fertility or mothering is a way of not dealing with them in their many-sided personalities. And, if all goddesses are at base fertility goddesses or mother goddesses, then they are all interchangeable, they all simply represent some cosmic 'feminine principle,' and they become even easier to deal with. At the same time, of course, such a misrepresentation conveniently reinforces the reduction of all women to the nature side of the nature/culture dichotomy. The fullness and breadth of power these goddesses represented in the ancient world is boiled down to one or two aspects, and they just happen to be the one or two aspects that the scholars doing the boiling are least likely to be threatened by.[5]

The corresponding reluctance to describe male deities as 'fertility gods' also excludes concepts of masculinity from these fundamental aspects of human life and experience.

Alongside a re-evaluation of ancient literary sources, the growing study of material culture, including symbolic iconography, the paraphernalia of worship and dedicatory inscriptions, is helping to enhance our understanding of ancient religion and ritual. This archaeological research, predominantly conducted since the twentieth century, is adding greater nuance to current perceptions of ancient goddesses, as well as the role played by women in their worship, and by extension, to our knowledge of the fabric and complexity of ancient societies more broadly.

INTERPRETING THE FEMALE IMAGE

Spiritual and cultural beliefs cannot easily be deduced from material remains alone. The study of past spirituality becomes more difficult the further back in time one goes, when surviving evidence for human behaviour becomes increasingly enigmatic. While it may be possible to identify, with a degree of confidence, archaeological objects and sites which were created to meet the psychological needs of an individual or community, the interpretation of such discoveries is often highly contested and may be influenced, consciously or unconsciously, by anachronistic assumptions.[6]

In Europe, the creation of figurative, decorative or symbolic imagery dates back approximately 40,000 years.[7] Around 160 small sculpted or modelled representations of women, created between

38,000 and 20,000 years ago, have been discovered from sites across Europe. These sculptures depict women of all ages and stages of life. Many are unclothed and some may have been worn as pendants.[8] By contrast, only about three figurative male sculptures from the same period and geographic region are currently known.[9] Produced as part of complex symbolic systems, which included animal representations, as well as non-figurative ornamentation, by people living across a huge area that stretched from France to Siberia, these early female images have attracted considerable debate and academic attention. While their significance for the people who made them may never be fully understood, the investment of labour required to produce these female sculptures, some of which show indications of pregnancy or childbirth, suggests an importance accorded to women's rites of passage, and it has been proposed that they may have been made by women to represent specific individuals.[10]

A predominance of female imagery over male in European material culture appears to have repeated, albeit in different ways, in later periods of deep history. The shift towards settled human society is believed to have occurred on different continents between 12,000 and 4,000 years ago. In Europe and Asia, this period brought significant changes to the social fabric of many cultures. People began to live in permanent settlements, which eventually expanded into urban areas supporting large populations sustained by agricultural production and animal husbandry, a pattern that may be seen in the early cultures of China, South Asia, the Middle East and the Mediterranean. Excavations of settlement sites have revealed material remains possibly reflecting spiritual practices, in some cases expressed through structural complexes with apparent ritual significance, notably Çatalhöyük in the Anatolian region of Turkey and the later megalithic temples of Malta. Several of these early cultures, including the Indus Valley Civilisation in modern Pakistan and north-western India, the Yarmukian culture of the Jordan Valley, and the Cycladic culture of Greece, produced carved or modelled anthropomorphic figures. The significant majority of those discovered to date are nude and distinctly female, sometimes showing pronounced hips and thighs, with breasts and detailed genitalia, and they are widely believed to have held spiritual meaning for the people who created them.

The manufacture and details of these figures differ from one geographical region to another, as does the evidence for their use and deposition. The Yarmukian culture, named after the Yarmuk river, which flows through the Jordan Valley, flourished in what is now southern Israel in the sixth millennium BCE. Several sites excavated since the 1930s have uncovered domestic and public buildings, graves, flint tools, ceramic pottery and luxury items made from obsidian and greenstone, alongside many figurative objects.[11] Among the last are approximately sixty female figures

found on separate sites within the region, the majority from Sha'ar HaGolan and Munhata. Most are made from clay and are sitting or squatting (fig. 4). Typically, the right arm lies along the right thigh, while the left is flexed across the chest. The heads are triangular with indications of hair or a headdress, distinctive elongated eyes and a large nose, but usually no mouth. Incised lines on the body may represent clothing or adornment and some of the figures are decorated with red paint. The seated posture has been variously interpreted as a birthing position, or as indicating that the figures were originally enthroned, although no ceramic seats have been found to accompany them.[12] Only two figural representations discovered from the region are definitively male.[13] The similarity of the figures discovered over a wide area suggests an organised and shared iconographic system, which has often been interpreted as relating to spiritual belief.[14] An abundance of female iconography, but in a distinctly contrasting style, is similarly observed from the archaeological imprint of the Cycladic cultures of Greece. Cycladic figures, produced around 5,200 to 4,000 years ago, were predominantly carved from the natural white marble found on the islands of the Aegean Sea, with minimalist and highly stylised rendering of anatomical details (figs 5–6). They have been discovered both buried in graves and on settlement sites. Since many are unable to stand unsupported, they may have had funerary associations and been designed to lie flat, but the possibility that they depict a deity cannot be ruled out: while most are small in scale, a few almost life-sized sculptures may have been the focus for worship.[15]

Since they began to be discovered in the mid- to late nineteenth century, these small female figures from deep history have given rise to some interpretations that reveal more about the social values and gender prejudices of the authors who published them than those of the cultures that created them. Often failing to take into account the inherent variety in the material, over the years scholars have used the figures to argue that women in early human societies were afforded heightened status and even worship, and also as evidence of male social dominance.[16] Some early interpretations of the oldest sculptures characterised them as 'immodest', and they are still often called 'Venus' figurines – a nomenclature that derives largely from late nineteenth-century comparisons of the voluptuousness of many of the sculptures to Saartjie Baartman, a Khoikhoi woman from southern Africa brought to England in 1810. Baartman's physique differed from the European ideal of female beauty at the time, which was based on the small hips and chest of Roman sculptures of the goddess Venus, and she was exhibited for six years to gawking London and Paris audiences under the deliberately pejorative name of the 'Hottentot Venus'.[17] Such assessments of the ancient sculptures, entwined with racist assumptions about the evolution of humankind, were followed

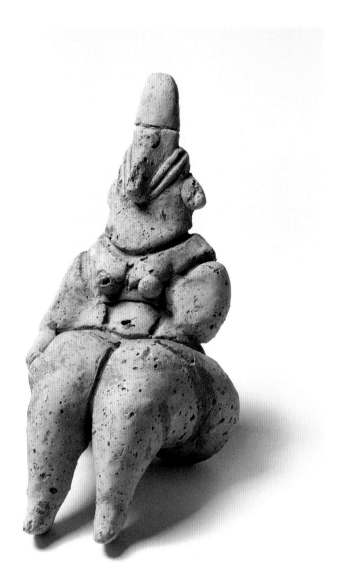

FIG. 4

Female figurine, *c.* 6,000 BCE.
Sha'ar HaGolan, modern Israel. Clay.
15.1 × 6.9 × 5.9 cm. The Israel Museum,
Jerusalem, IAA 2002-1187. Collection of
Israel Antiquities Authority.

from the 1920s by publications claiming that they were fashioned
by men to arouse or reflect erotic desires.[18] Following the discovery
in 2008 of the Woman of Hohle Fels – created around 35,000 years
ago and currently the oldest known female sculptural image in
the world – an article in the journal *Nature* noted that the large
breasts and prominent genitalia of this figure, which stands only
6 cm high, 'could be seen as bordering on pornographic',
indicating the negative and sexualised lens through which such
objects are still sometimes judged.[19]

At the other end of the spectrum, these same female images
have been taken by some as evidence that the earliest societies
of Europe were matriarchal and worshipped female divinities,
or a singular goddess who manifested in various guises.[20]

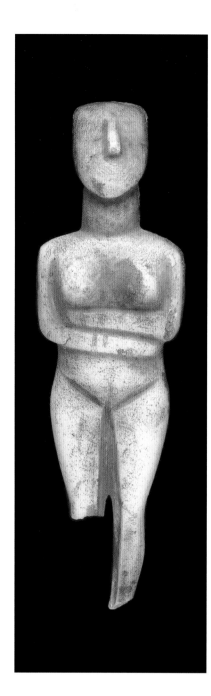

This theory gained wide public attention in the 1970s and 1980s, when it became intimately bound up with the social (and spiritual) agendas of second-wave feminism in North America and Europe. It was founded primarily on the work of the archaeologist Marija Gimbutas, a scholar of Indo-European culture and a professor at the University of California, Los Angeles, from the 1970s to the 1990s. Under the influence of Gimbutas's ideas, the female imagery from many European archaeological sites came to be seen collectively as representing a divine female principle widely venerated across 'Old Europe', which was said to have been suppressed and eradicated when patriarchal culture and religion came to dominate between 4,500 and 3,000 years ago (when evidence for metalworking can be found across Europe).[21] In archaeological and anthropological academia, the work of Gimbutas and her followers – often termed the Goddess Theory – has been heavily criticised for the assumptions inherent in the identification of all objects and symbols from this period as specifically religious (and even, in some cases, female), and their cultural significance as universal.[22] This theory, however, and the ancient depictions of women on which it was based, created a galvanising new mythology within second-wave feminism, according to which the struggle for female equality, or even ascendancy, in twentieth-century Western culture, together with the worship of female divinity, was merely a reclamation of a social and spiritual reality that had been lost – a reality that for some existed (like most matters of faith) beyond any need for empirical evidence.[23]

The use and meaning of sculptures and carvings created independently 40,000 to 4,000 years ago, in different times and places, remain obscure. However, the cultural currency of the Goddess Theory among some Western feminists, and its lasting legacy, are a reminder of how the creations of past human cultures continue to hold relevance and provoke debate in modern society. Ideas about the past also continue to inspire new spiritual and artistic expression. Memory, real or imagined, and the union of the past and the present are entwined in the work of the Jordanian artist Mona Saudi, whose smooth, curved stone sculptures 'simultaneously suggest the ageless and the modern'.[24] Exploring themes of creation and natural forms that she associates with the feminine and maternal, Saudi's 2010 sculpture *Mother Earth* quietly evokes a female body – an organic form emerging through geometrical shapes carved from rigid Jordanian marble (fig. 7). Saudi wrote that 'To be a sculptor, you have to fall in love with the Earth and all that it holds – to feel life pulsating around you … My imagination is full of sculptures yet to be born, as if stones are pregnant with forms waiting to be delivered.'[25] Her choice of stone for her works reflects a fascination with the ancient geology of the earth, while the abstracted, nascent female form is at once contemporary and redolent of the earliest figural art in human knowledge.

FIG. 5
Female figure, 2700–2500 BCE. Syros, Cyclades, Greece. Parian marble. 20 × 6.5 × 4 cm. British Museum, London, 1842,0728.616.

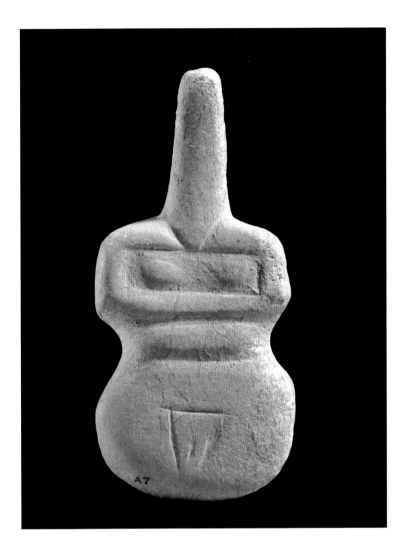

FIG. 6
Female figure, *c.* 2800 BCE. Amorgos,
Cyclades, Greece. Marble.
11.10 × 5.2 × 1.1 cm. British Museum,
London, 1889,0521.2.

INTERPRETING BELIEF

This book presents a selection of spiritual beliefs from different
cultures and periods of history through five themes. Chapter 1
reflects on narratives surrounding the creation of life and the
earth from cultures around the world, examining the relationship
between female and male creative agency alongside spirits and
deities, whose power in part reflects the benevolent and destructive
potential of the natural world. Divergent spiritual attitudes to sex
and human desire, variously perceived as emanating from divine
or demonic sources, are discussed in chapter 2. Chapter 3 brings
together some of the many malevolent female beings of global
belief to interrogate the fear of female agency, and the ambivalent
position of monsters and witches in social consciousness as harmful
or protective, terrifying or empowering. In chapter 4, the female
embodiment of physical and mental strength and resilience is
examined through warrior goddesses and cultural concepts that

FIG. 7

Mona Saudi, *Mother Earth*, 2010.
Beirut, Lebanon. Jordanian marble. 45
× 41 × 26 cm. British Museum, London,
2014,6015.1. Donated by Mona Saudi.

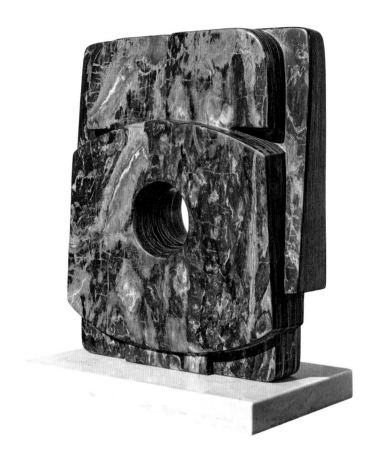

view active and secular power as expressions of femininity. Finally,
chapter 5 reflects on compassionate wisdom in both female and
male figures that combine protection of the vulnerable with
concepts of guidance and salvation.

All the deities, spirits and supernatural figures in the following
pages have individually been the subject of theological and
academic debate – many for hundreds of years. The coverage of
each one is necessarily condensed, though all have received, or
deserve, several books of their own (see p. 266 for a general reading
list). The wealth of literature that already exists illustrates that there
is no singular way to understand spiritual figures, their characters,
and their significance in the lives of the faithful. Most of the figures
discussed assume a broad significance in people's lives. Some, such
as the Hindu Great Goddess Mahadevi, hold all-encompassing
power that defies categorisation (as would the Abrahamic God).
Others possess powers that straddle multiple themes, such as Ishtar,
the Mesopotamian goddess of sex and war. The decision here to
include certain beings within one chapter or another reflects only
some aspects of their importance. Within every system of belief,
a vast range of perspectives and interpretations exists, precluding
a singular definition of what that faith is and what it stands for.

Personal approaches are multi-layered and deeply subjective: one individual may understand a deity, force or spiritual being very differently from another who worships them by the same name. Interpretations also change and evolve over time, so that the Egyptian goddess Sekhmet, whom ancient texts describe as the embodiment of war and annihilation, is today worshipped by some Modern Pagans in the USA as a benevolent maternal deity who grants children (see chapter 4). Similarly, in Europe and North America, magic and witchcraft were once widely feared as the devil's influence, but are now followed by many as a spiritual or religious path (see p. 157 for a discussion of Wicca). No one may claim ownership of another's spiritual experience, and this book presents a variety of past and current approaches drawn from literary scripture, oral traditions, sacred artworks and objects relating to ritual worship. Interpretations of contemporary faith are explored through communication with worshippers and commentators, and aspects of this project have been informed by interviews with members of different religious communities, academics, public speakers and contemporary artists, who have generously shared their personal views on the themes explored.

What does feminine power mean today? The objects, literature, history and contemporary accounts collected in the pages that follow reveal vastly different ways of answering this question, and encourage us to reflect on our own preconceived notions about femininity. Some of the figures show major social and cultural shifts in thinking: this is epitomised in the changing representations of Venus, who was once an icon of state harmony and military endeavour, but over time became an artistic shorthand for lust and desire and an object of the male gaze, and who was eventually reappropriated and reclaimed by feminist artists. Others demonstrate how the same concept can be perceived very differently depending on context: both Kali and Mary embody compassionate motherhood, and both Eve and Guanyin possess the power of feminine seductive persuasion (in Eve's case, towards sin, and in Guanyin's, towards salvation). While this book focuses predominantly on art and literature, celebrations of feminine power happen around the world in contemporary festivals and events, through music, dance and prayer – for example, the welcoming of Lakshmi into homes and businesses during Diwali (the Festival of Lights), or the Osogbo festival that celebrates Oshun (see p. 59). In exploring the myriad interpretations of feminine power, we can consider how it has impacted people's perceptions of gender and social and cultural norms in the past and today, and expand the ways in which these ideas are approached either as believers or as interested observers.

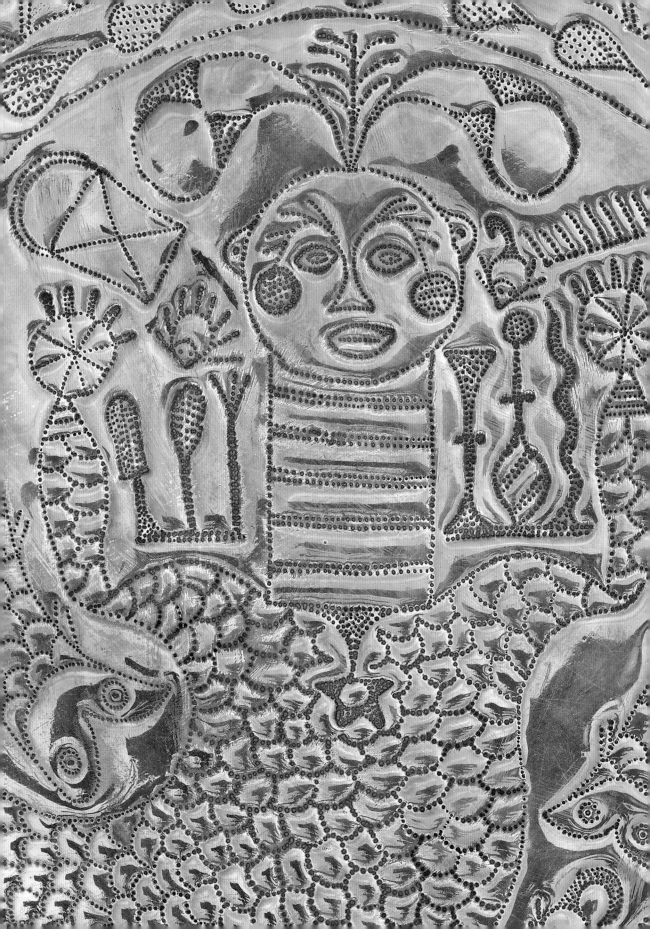

CREATION
& NATURE

She is the wisdom of the forest
She is the wisdom of the river.
Where the doctor failed
She cures with fresh water.
Where medicine is impotent
She cures with cool water.

Yoruba praise poem (*oriki*) in honour of Oshun[1]

A desire to understand our place within the cosmos, and to comprehend natural phenomena, over which we have little control, lies at the heart of much spiritual belief. Beginning with the origins of life and the earth, the creation narratives told by different cultures and faiths around the world are as varied as they are numerous. These stories, which may be interpreted literally or symbolically, represent not only beliefs about how existence began, but often also about how it was organised at the start of time, and how it influenced socio-cultural values concerning our relationships with nature and with one another. Certain faiths, such as Buddhism, Jainism and Taoism, eschew belief in a 'creation event', maintaining that the cosmos has always been and always will be. For others, the living world manifests through the will and actions of a primordial being or beings, variously perceived as feminine, masculine, both or neither, sometimes unfolding once or in several stages, each event being the responsibility of a different spiritual force. While some faiths have a single story of creation, others have several co-existing narratives, and these beliefs may be enshrined in sacred texts or passed down through the generations by oral tradition.

Our relationship with nature is key to our survival: humanity depends, as it always did, on the success of agriculture, farming and hunting, and is vulnerable to the danger of natural disasters such as earthquakes, storms, floods and volcanic eruptions, which can wipe out crops and whole populations. This fragile dependence on the benevolence and fertility of the natural world may account for the earth's personification as consciously or divinely maternal in most cultures throughout history – a concept that has become so ingrained that 'Mother Earth' exists widely in secular as well as spiritual thought. In many cultures, feminine and masculine deities and spirits are believed to inhabit and influence diverse aspects of

the natural landscape. These powers may assume vast significance in the lives of their worshippers, as they are the bringers of success and failure, or life and death. Embodying the elemental forces of nature, they are often perceived as both creative and destructive, and may be both loved and feared, worshipped to appease their anger and secure their good favour and, above all, respected as essential to life.

CREATION AND PROCREATION

Around the world, some perceptions of creative forces, in which the feminine and masculine act in union, have been rooted in beliefs about the origins of life. The metaphor of birth has, in many cultures, led to a spiritual association between women, life and generative potential. On a cosmic level, this power is often combined with masculine power, either in the form of a divine couple or united in a single bi-gendered being with the ability to conceive existence.

CREATOR COUPLES

In some spiritual world-views, creation is attributed to distinct feminine and masculine forces working in union as a celestial couple. The Japanese religion of Shinto ('the Way of the Spirits'), is closely linked to humankind's relationship with the natural world, which is believed to be inhabited by countless spirits known as *kami*.[2] Izanami-no-mikoto ('She who Beckoned') and Izanagi-no-mikoto ('He who Beckoned') are the creator *kami*, who gave birth to Japan and the majority of the other *kami*. The legend is told in the *Kojiki* ('An account of ancient matters'), an epic compendium of Japanese history and oral legends, completed in 712 CE and dedicated to the Empress Genmei ('Original Brilliance'), the forty-third sovereign of Japan.[3] It begins by relating how the heavens and earth, and various spirits, slowly emerged from the primordial ether. Izanami and Izanagi were among the first beings to emerge when the land was 'floating like tallow on water', and were charged by their companion spirits with the creation of solid earth. Standing on the Floating Bridge of Heaven (Ame no uki-hashi), they stirred the primordial ocean with a jewelled spear, and the drops of water that fell from it became the many different islands of Japan.[4]

This story, with an accompanying narrative, was captured by the renowned nineteenth-century print artist Utagawa Hiroshige as part of a series of works entitled *Illustrated Chronology of this Realm*. In a vibrant print, created around 1850, Izanami stands on the floating bridge next to Izanagi, who holds the jewelled spear (fig. 8). The moment chosen by Hiroshige occurred just after the creation of land, when the couple observed a wagtail on

FIG. 8
Utagawa Hiroshige, *Ame no uki-hashi* ('The Floating Bridge of Heaven'), 1847–51. Japan. Coloured woodblock print on paper. 45.6 × 60.3 × 2.7 cm (framed). British Museum, London, 1921,1115,0.2.

Izanami and Izanagi standing on the Floating Bridge of Heaven.

the rocks in front of them. From watching the bird's extended, bobbing tail they discovered the art of sex, and could then unite and create the other *kami*. However, Izanami was killed giving birth to the fire god Kagutsuchi and she descended to Yomi (the underworld). In desperation, Izanagi tried to rescue her, but disobeyed her instruction not to look at her and fled in horror at her decayed form.[5] Izanami then ruled Yomi as the *kami* of death, symbolically linking concepts of both life and death. In his grief, Izanagi created the *kami* of the sun, Amaterasu, to rule over the world of the living in her place. The most important Shinto *kami* today, Amaterasu is held to be the divine ancestor of the Japanese imperial family. Close to the shrine of Amaterasu at Ise, Izanami and her husband are remembered at the pilgrimage site of Meoto Iwa ('The married rocks') (fig. 9).[6] Two natural boulders that emerge from the sea, one large and one small, are said to represent (respectively) Izanagi and Izanami joined in marriage. The rocks are bound together with a *shimenawa*, a heavy straw rope, which traditionally demarcates sacred space in Shinto shrines, and which is ceremonially replaced three times a year.

While most *kami* are perceived as either female or male, the fundamental necessity of both for fertility may be reflected by Ugajin, *kami* of agriculture, wealth and fortune. In art, Ugajin

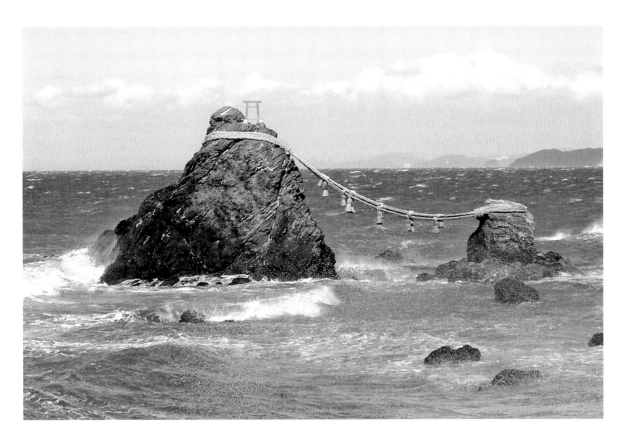

appears with the body of a coiled snake and usually the face of an elderly man, but sometimes with that of a woman (fig. 10).[7] A small representation of Ugajin, carved in the nineteenth century from a gourd, has a tapered base designed to resemble a lotus leaf, which symbolises enlightenment in Buddhist art. Ugajin is often associated with the prominent Japanese Buddhist deity Benzaiten (also known as Benten), herself connected to water, wisdom and abundance.[8]

A SINGLE CREATOR

Belief in a single bi-gendered source of creation is found within the spiritual world-view of the Mexica. The Mexica (popularly known today as the Aztecs) ruled central Mexico from the thirteenth century until the Spanish conquest in 1521.[9] Gender duality permeated religious belief, and deities were often perceived as female and male couples or counterparts. One creator deity was Ometeotl, meaning 'Two-God', a being combining the female Omecihuatl ('Two-Lady') and male Ometecuhtli ('Two-Lord') in one, who resided in the highest firmament, Omeyocan, the 'Place of Duality'.[10] Similarly, in the traditional[11] creation narratives of certain West African spiritual systems, the cosmos is sometimes

FIG. 9
Meoto Iwa ('The married rocks') in the sea off Futami, Japan. The rocks are joined by a *shimenawa* (a heavy rope of rice straw), which represents the union of Izanagi and Izanami.

FIG. 10

Figure of Ugajin, 19th century. Japan.
Carved gourd. 11 × 10.2 × 10.2 cm.
British Museum, London, 1926,0708.21.
Donated by Dr Walter Leo Hildburgh.

In this representation Ugajin, the spirit
of agriculture, takes the form of a man's
head emerging from a snake's body.

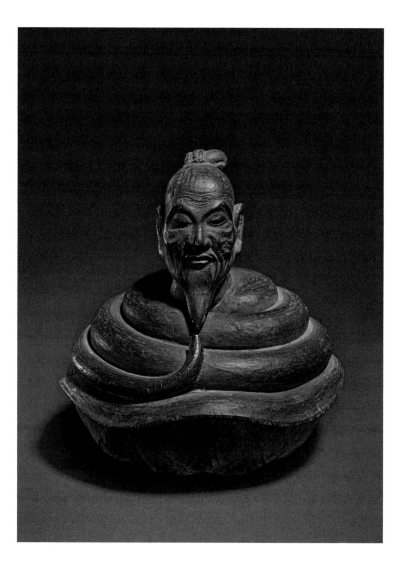

believed to have emanated from a single creator, who is perceived as
either genderless or as encompassing both feminine and masculine
aspects.[12] Among some of the Fon- and Ewe-speaking peoples
of Ghana, Togo and Benin, the supreme deity is sometimes
considered to be Nana Buluku. She may be perceived as an elderly
grandmother or a bi-gendered being, older than the universe and
reflecting the wisdom and respect that accrue with age. Nana
Buluku is believed to have given birth to the cosmos, along with a
daughter, Mawu (connected to the moon, coolness and gentleness),
and a son, Lisa (connected to the sun, strength and war), who
rule over the earth and creation, and in turn have assigned certain
tasks to their own children.[13] Alternatively Mawu and Lisa may be
approached as a single bi-gendered supreme creator – Mawu-Lisa
– or even as a whole pantheon of sky spirits.[14] Neither Nana Buluku
nor Mawu-Lisa is commonly depicted in figural form or worshipped

at shrines: they may be represented through symbols and associated artefacts, but are often considered to be knowable only through their creations.[15]

To followers of Judaism and Christianity around the world, the story of creation is found in the biblical book of Genesis, which describes how the heavens, the earth and all living things were created in six days by a singular deity. Throughout the written Hebrew scriptures, the God of creation is referred to with masculine pronouns, yet Genesis 1:27 describes the creation of both men and women 'in the image of God', implying that the *imago Dei* ('image of God') is reflected in all humankind.[16] Furthermore, belief in the transcendent nature of God, beyond binary comprehension, has permeated Judaeo-Christian theological discourse for centuries, with biblical scholars questioning the adequacy and validity of subjective language to describe a deity who is considered, in essence, unknowable.[17] Within Roman Catholicism, the limitations of human language to express the mystery of God are enshrined in the text of the Catechism – an authoritative exposition of the Church's teaching, used for formal instruction – along with the explicit denial of God's gender, and affirmation of combined maternal and paternal character: 'God transcends the human distinction between the sexes. He is neither man nor woman: he is God.'[18]

Despite this, the use of masculine language to express the inexpressible divine has dominated Judaeo-Christian teaching and literature. This normative perception of God as male has also long been reflected in Western Christian art, in which God has been habitually represented with male characteristics – specifically those of an elderly white man – as exemplified by Michelangelo's *Creation of Adam* (c. 1508–12), a fresco painting on the ceiling of the Sistine Chapel in the Apostolic Palace in the Vatican City, which captures the moment in the biblical creation narrative when God breathes life into the first human being.

During the twentieth and twenty-first centuries, questions surrounding the normative representation of God as male, and the impact of this in fostering patriarchal as well as Eurocentric narratives, particularly within Christian tradition, have been brought into sharp focus. Feminist theology, which has evolved since the 1960s, critiques normative religious teaching on the maleness of God, in part by promoting awareness of feminine and maternal language and allegory used to describe God's aspects and actions in Hebrew scriptures.[19] While masculine pronouns are used in written scripture to denote God, God's wisdom is grammatically feminine and is described in maternal terms in relation to the creation narrative;[20] the existence of divine wisdom before the beginning of time and its role in the creation of the cosmos are made explicit in Proverbs 3:18–20:

She is a tree of life to those who take hold of her;
those who hold her fast will be blessed.
By wisdom the Lord laid the earth's foundations,
by understanding he set the heavens in place.[21]

Many contemporary feminist theologians have chosen to speak of God in androgynous or non-gender-specific terms: American theologian Rosemary Radford Ruether has employed 'God/ess' to name the 'creator [and] source and ground of our being',[22] while the feminist philosopher Mary Daly has suggested that God is best expressed as an intransitive 'Verb in which we participate – live, move, and have our being.'[23]

At their core, debates on the gender of the Judaeo-Christian God often revolve around how far grammatical language in the Hebrew (and Greek) of the Bible should be understood as denoting literal gender, and how far it should be interpreted as generic and semantically inclusive, masculine terms predominating merely as the default, as is the case in most modern languages.[24] Efforts since the 1980s to produce inclusive-language translations of the Bible aimed at conveying the meaning behind, rather than the literal grammar of, the scriptures in English have been met with both praise and controversy, and the use of male normative language continues to predominate within Judaeo-Christian teaching the world over. While, in time, the long-standing philosophical discourse on the inherent ambiguity of the gender of the divine may enter popular religious discussion, some contemporary commentators, finding no room in the patriarchal symbolic language of Christianity, have approached feminist theology as partly a task in 'developing a transformative alternative'.[25]

A provocative example of this approach is found in the work of the American artist Judy Chicago. In the 1980s, Chicago, a prominent voice within second-wave feminism, was inspired to embark on *The Birth Project*, a community-driven artistic endeavour. It was generated by her interest in creation stories from around the world and by her conversations with a 'radical nun', with whom she produced a rewriting of the traditional Abrahamic creation narrative from an unapologetically feminist perspective.[26] Executed using needlework – an art form traditionally considered a woman's 'craft' – eighty-four large-scale representations of childbirth were created by a collective of 150 needleworkers across America. Chicago created designs and colour schemes which were sent to needleworkers for them to embellish in their own style. A vibrant screen print, based on one of the original designs (fig. 11), ties evolutionary theory to a female-gendered perception of the creation of the world, expressed through a female deity lying in a birthing position. Her face is entirely obscured and the primary focus is on the vulva, from which flows primordial life, evolving on the right-hand side of the scene into complex life forms and

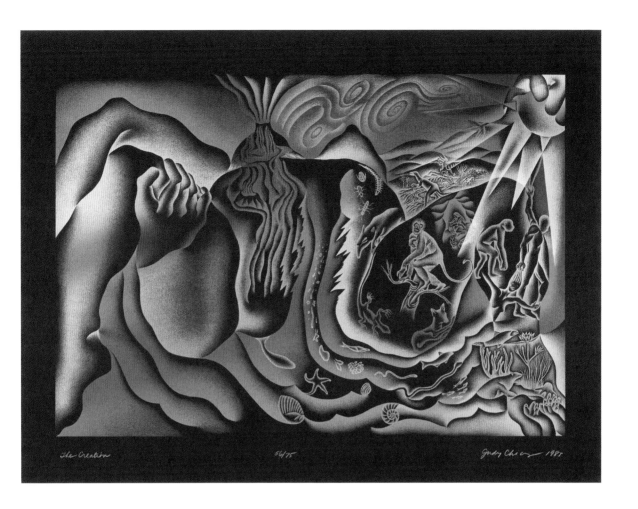

eventually human beings represented by a male figure aggressively dragging a female figure by the hair. In her right hand she grasps the sun and her left breast is an erupting volcano, perhaps symbolic of both the creation of the earth and the destruction of life. In 2019 Chicago stated that *The Birth Project* was her response to the 'fake news' of a male god creating the first man in Michelangelo's celebrated vision. Laughing, Chicago commented that her reinterpretation is 'a different kind of fake news but I like it!'[27]

The prominent vulvic imagery of Chicago's embroideries is reminiscent of Sheela-na-gig sculptures, crude carvings of women with prominent vulvas, often pulled open by the labia, which were mostly created between the twelfth and sixteenth centuries and adorned both secular buildings and churches in Ireland and England, with some further examples in Scotland, Wales and continental Europe.[28] One example, which entered the collection of the British Museum in 1865, was discovered in a field in Chloran, County Westmeath, in Ireland, and probably originally adorned a nearby building.[29] It is not known how it came to be in a field, but at various times from around the seventeenth century,

FIG. 11
Judy Chicago, 'The Creation', from the *Birth Project* series, 1985. USA. Coloured screenprint in 45 colours on black paper. 61 × 89 cm. British Museum, London, 1997,0928.69. Donated by Judy Chicago in honour of Edward Lucie-Smith.

Sheela-na-gig sculptures were ordered to be removed from churches on account of indecency, and many were defaced, destroyed or confined to museum collections rather than left on open public display.[30] Believed to have been carved in the twelfth century, the figure adopts the characteristic pose, with knees flexed outwards and fingers grasping both labia (fig. 12). Her unusually large head, almost the same size as her entire body, gives the figure an almost foetal aspect. It is not easy to gauge her age: her limbs are spindly and her breasts extremely small, which could imply an elderly figure. One unusual aspect is her prominently bared teeth; like so much about these figures, the significance of this feature is open to speculation, but it gives the head a skull-like appearance.

The name 'Sheela-na-gig' is of uncertain etymology but is generally interpreted as meaning something similar to 'old hag'.[31] More than a hundred Sheela-na-gigs have been identified in Ireland alone, but, despite much research on the subject, their intended significance remains elusive. From the early nineteenth century, they were habitually interpreted as 'apotropaic anasyrma' – devices designed to repel the Evil Eye by exposure to a woman's vulva – or as public warnings against lewdness and the sin of lust, particularly directed at women.[32] Such interpretations have continued up to today, but they co-exist with other theories that view Sheela-na-gigs as fertility symbols connected to a pre-Christian deity who combined the concepts of life, death and reproduction.[33] Proponents of this interpretation point to the prominence of their vulvas, and in some cases apparently pregnant lower bodies, suggestive of youth and birth, which contrast sharply with the aged and sometimes emaciated upper bodies of the women. It has also been proposed that these sculptures had a magico-religious function relating to childbirth, since a few examples show signs of wear from repeated touching of the vulvas – a belief that still attracts pilgrims today hoping for aid in conceiving and bearing a child.[34]

Like *The Birth Project*, the growing trend in spiritual and academic approaches to Sheela-na-gigs, which sees them as images of (re)birth rather than moral warnings against lust, seems to betray a growing desire to explore feminist interpretations of fundamental ontological questions in the context of Western spirituality. Since we know almost nothing of their original significance, all interpretations remain highly speculative, yet, as cultural attitudes change, Sheela-na-gigs are now often seen in popular culture as empowering images of female sexuality, reproduction and creative potential. They have inspired a number of artists and musicians, including Sarah Lucas, P.J. Harvey and the anonymous ceramicists who created Project Sheela (2020–present), a feminist street-art initiative that installs contemporary Sheela-na-gigs (fig. 13) at sites significant to women's resistance against social, political and environmental injustice across Dublin, including Donnybrook Magdalene Laundry and a mural of the environmental campaigner Greta Thunberg.[35]

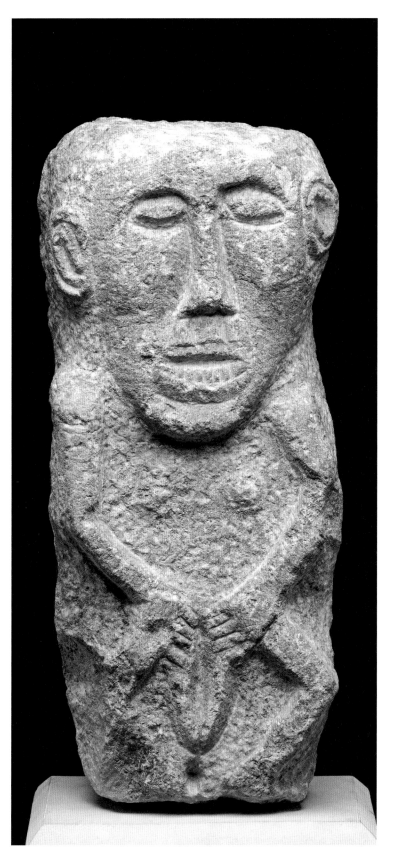

FIG. 13
Anonymous artists, Sheela-na-gig,
2021. Ireland. Clay, glaze, glass and
22k gold lustre. 18 × 14 × 3 cm. Project
Sheela, Dublin, Ireland.

Left

FIG. 12
Sheela-na-gig figure, 1100–1200.
Westmeath, Ireland. Stone.
58 × 26 × 18 cm. British Museum,
London, WITT.258. Donated by
Dr George Witt.

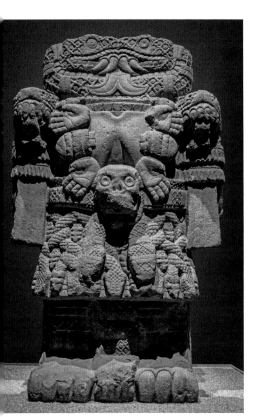

FIG. 14
Statue, usually identified as the
goddess Coatlicue, 15th century. Mexico.
Andesite. H. 2.5 m. National Museum of
Anthropology, Mexico City.

Opposite top

FIG. 15
Standing figure, before 1885. Easter
Island. Wood, bone and obsidian.
58 × 26 × 18 cm. British Museum,
London, Oc,+.2597. Donated by Sir
Augustus Wollaston Franks.

Opposite bottom

FIG. 16
Lintel, 1830s–40s. Aotearoa New
Zealand. Wood and haliotis shell.
43.5 × 131.5 × 5.5 cm. British Museum,
London, Oc1854,1229.90. Donated by
Sir George Grey.

This carved lintel depicts the Maori
creation narrative. Tane-nui-a-Rangi
and his brothers stand on their mother,
Papatuanuku (the earth). They have
forced their father, Ranginui (the sky),
up and out of the frame. Swirls of light
and life now fill the space that they have
opened up between their parents.

THE EARTH

The perception of the earth as a female entity is one of the most
striking consistencies in global and historical spiritual belief.
In traditional belief among some of the Akan of Ghana and
the Ivory Coast, the spirit of the earth is Asase Yaa, their most
important Great Spirit after the creator, Nyame. Also known as
Aberewa ('Old Woman'), the earth is honoured at the naming
ceremonies of children for granting life, and at funerals for the
protection of the dead. Asase Yaa is rarely depicted in art, nor
are altars commonly set up to her, since she is not a singular being
but exists in all places at all times.[36] To the Indigenous people of
the Andes, Pachamama – the Earth Mother – is the sustainer of
life. Worship of Pachamama is performed in acknowledgement of
humankind's dependence on nature; she is offered food and drink
all year round, but particularly in the cold month of August before
the sowing season begins, when subsistence is harder.[37] In Amaicha
del Valle, a town in the Calchaquí Valley region of north-western
Argentina, a three-day festival in honour of Pachamama takes
place each February, attracting hundreds of national and
international spectators. The celebration has become intimately
connected with the expression of Indigenous identity and involves
the election of a 'Pachamama Queen', the oldest woman in the
community, who is honoured as a symbol of wisdom, life and
fertility. She takes centre stage in a grand procession at the finale
of the festival, carrying the produce of the harvest in a chariot
escorted by mounted riders.[38]

Among cultures that honour spiritual forces through imagery,
perhaps the most formidable visual depiction of the earth in
female form was created by the Mexica. In 1790 a colossal statue
of a goddess was excavated in the Plaza de la Constitución
(Zócalo) in Mexico City, the former centre of the Mexica city
of Tenochtitlan. She stands at almost 3 metres tall and from her
headless neck emerge two serpents, confronting one another so
that their profiles give the impression of a unified face (fig. 14).
Overlying her breasts are severed hands and hearts, and around
her waist is a skirt of snakes fastened front and back with human
skulls. Following its discovery the statue was initially placed on
open display in the city's university, where it began to attract
considerable interest, and Indigenous visitors left offerings to
the goddess; as a result, it was promptly reburied by Catholic
authorities, who were concerned that it was a corrupting
influence.[39] The statue is now on display in the National Museum
of Anthropology in Mexico City. Many scholars believe her to be
Coatlicue, the earth goddess and mother of the cosmos, who gave
birth to Huitzilopochtli, the god of the sun and war. According to
the Mexica calendar, Coatlicue died, or sacrificed herself, so that
this age could come into being.[40]

Of similarly colossal scale are the moai, megalithic figures that define the landscape of Rapa Nui (Easter Island). Created between the thirteenth and fifteenth centuries, they are believed to be *aringa ora* – living spiritual ancestors.[41] Many of these sculptures were buried up to their waists or shoulders and were long assumed to all be male on account of the lack of distinguishing anatomical details on their upper bodies and heads. However, excavations of the buried portions of at least two moai, undertaken in the 1950s, revealed distinctly female anatomy.[42] An alternative art form of smaller moai, carved from wood, has been expertly practised on Rapa Nui for hundreds of years and survives up to the present day. These spiritual figures, which mirror the larger stone moai through their flattened bodies and fully rounded heads, sometimes reveal an ambiguous expression of gender: among those created with female genitals and breasts, their bald heads and prominent brow lines might easily be understood as male, and some also have beards or goatees, which have been interpreted as signifying status, as they do for their anatomically male counterparts (fig. 15).[43] These female figures are known as *moai papa*, which may allude to the personification of the earth – known as 'Papa' in many Polynesian cultures.[44] In 2014 the filmmaker Leonardo Pakarati of the Rapa Nui described these figures as being related to fertility, the hand on the belly indicating pregnancy and the hand on the vulva relating to impregnation and birth.[45]

In the traditions of the Maori, the Indigenous people of Aotearoa New Zealand, the *atua* ('deity') of the earth is Papatuanuku and her husband is Ranginui, the sky. Many variant oral traditions describe how Papatuanuku and Ranginui were locked together in a loving embrace, from which the other gods and all living things were born (fig. 16). However, they clung to one another so tightly that light could not get between them,

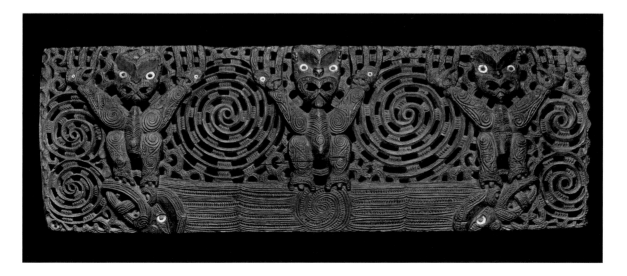

FIG. 17
Cloak (*kaitaka*), before 1887. Aotearoa
New Zealand. Flax and wool. 133.5 ×
213 × 2 cm. British Museum, London,
Oc1938,1001.79. From Sir Augustus
Wollaston Franks.

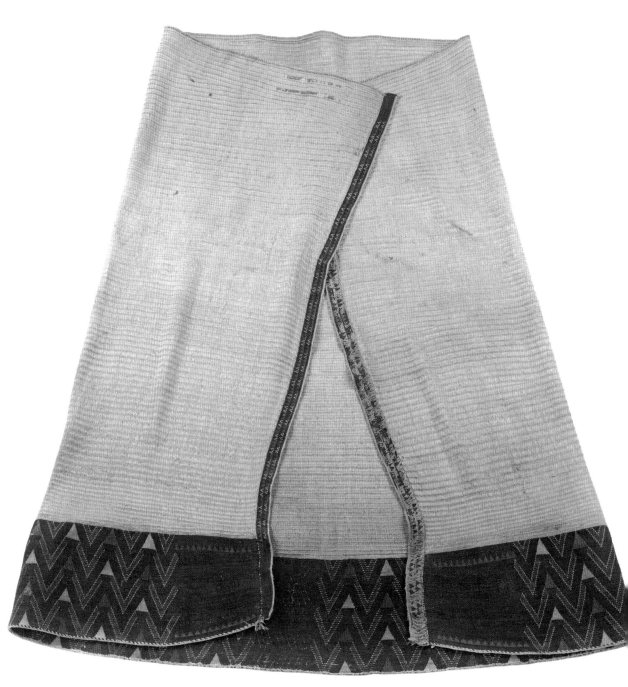

forcing their children to live in darkness. Tiring of the gloom, their son Tane-nui-a-Rangi, the *atua* of forests, forced his father upwards, allowing light to enter the world and life to begin. According to some traditions, Tane-nui-a-Rangi went on to beget a daughter, Hine-te-iwaiwa, the *atua* who presides over weaving and childbirth.[46]

Finely woven cloaks are among the most highly prized Maori arts. Their creation, known as *whatu kakahu*, is intrinsically connected to beliefs about the natural world, conjoined with women's skill, agency and status. Traditionally woven from *harakeke* (New Zealand flax), the staple of Maori fibre arts, they are created without a loom, using a time-consuming technique in which the fibres are hung from a frame and dextrously hand woven.[47] The knowledge of cultivating and selecting the flax, extracting and preparing the inner fibres, and the weaving techniques have been handed down by generations of women. The first piece of work completed by a new weaver is typically gifted to a family elder or buried as an offering to Papatuanuku.[48] A complete cloak may take more than a year to produce. One style of cloak, which gained prominence in the early nineteenth century, was the *kaitaka* (fig. 17).[49] These large cloaks were worn by both men and women. They were adorned with decorative *taniko* borders along the sides and bottom, created from black, brown and red fibres stained with natural dyes, but the main body of the cloak was left undecorated, emphasising the natural golden colour of the flax fibres and showing the skill of the weaving.[50]

Historically Maori cloaks have been exchanged as high-status gifts and they are worn today at many ceremonial occasions, including weddings, funerals and graduations, as well as diplomatic events. The annexation of Aotearoa New Zealand into the British Empire in the mid-nineteenth century substantially disrupted traditional Maori social structures through cultural imperialism and the work of Christian missionaries, which particularly affected women's social and spiritual status.[51] Furthermore, European colonisers tended to focus on male achievements and leadership in their historical accounts of the Maori, neglecting to record women's participation. Since the 1960s, Maori cultural crafts have seen a resurgence, partly in response to the growing movement called *mana wahine*, often loosely translated into English as 'female power' but connoting an intersection between temporal, spatial and spiritual power and the experience of being a Maori woman.[52] The philosophy of *mana wahine* aims to expand awareness of Maori women's pre-colonial knowledge and re-emphasise their contribution to their people's history and living culture, in part by promoting women's own creative agency and reasserting the prominence of female *atua*s and the feminine within Maori spirituality.[53]

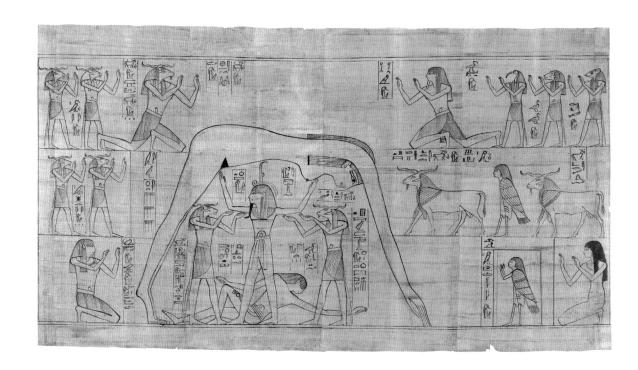

The identification of the earth as a female and maternal
power in many modern cultures is also found within some
ancient religious thought. To the ancient Greeks, the earth was
Gaia, who emerged first from chaos and created Ouranos, the
sky, to be her husband.[54] However, in the ancient Egyptian city
of Heliopolis (now part of Cairo) the earth was personified as
the god Geb, while the sky was formed from the body of the
goddess Nut, his sister and wife. As the mother of the heavenly
bodies, Nut was said to give birth to the sun (the god Ra) every
morning and consume him every night in a never-ending cycle
of creation and destruction.[55] As the earth, Geb brought forth
water and the harvest, while his laughter brought earthquakes
and his anger drought.[56] Geb and Nut were venerated as part of
the Great Ennead – nine deities who collectively brought about
creation and maintained existence. They were the children of
Shu and Tefnut, air and moisture, and grandchildren of the
creator Atum.

Nut appears in Egyptian art more frequently than her husband.
She was not commonly venerated in temples, but her intimate
connection with the concept of rebirth made her supremely
important in Egyptian funerary traditions. Her image was often
painted or carved on the inside of sarcophagi or tombs, where
she appears either as a woman with large outspread wings or with
her body stretched across the heavens and covered in stars.[57] The
Greenfield Papyrus is one of the longest manuscripts of the Book
of the Dead, an ancient Egyptian funerary text, to have survived.

It was made as part of the funerary preparations for a woman named Nestanebetisheru, who is depicted as a worshipper at the creation of the world by the Heliopolitan gods (fig. 18). Nut is the largest figure arching over her husband/brother Geb, who is stretched out on the ground. They are kept apart by their father, Shu, god of the air, according to some traditions because of Geb's anger with Nut for consuming their children, the constellations.[58] Nestanebetisheru herself can be seen kneeling in the lower right corner, raising her hands in adoration, along with other gods who surround the central scene.

MOUNTAINS AND VOLCANOES

Humankind's broad perception of the earth as a living, often feminine deity manifests in some cultures through the belief that specific aspects of the landscape, particularly imposing natural features such as mountains and volcanoes, are imbued with spiritual power. A relatively new conception of this link is found in Venezuela, where the growing worship of María Lionza blends Indigenous spirituality with West African, Norse and Catholic beliefs. A goddess of harmony and nature, María Lionza's sacred site is Sorte Mountain in Yaracuy state, where she is worshipped in an annual October festival. According to one tradition, María Lionza was a chief's daughter, who, when an anaconda attacked her, prayed to the mountain for help and found its spirit fused with her own. Sometimes also called Yara, she may appear in different forms: one is fair-skinned, often depicted crowned, and closely equated with the Virgin Mary, but in her dual aspect she appears as an Indigenous woman. This latter form was memorialised in 1951 by the Venezuelan artist Alejandro Colina in a monumental statue showing María Lionza as a naked woman with an athletic frame, riding on a tapir and thrusting a pelvic bone into the air (fig. 19).[59] The popularity of María Lionza's worship is intimately connected with Indigenous agency and Venezuelan national identity, and has grown rapidly since the 1920s in both rural and urban areas; recent estimates of participation in her worship are put at between 30 and 60 per cent of the Venezuelan population.[60] The most sacred day for the worship of María Lionza is 12 October, the Venezuelan 'Day of Indigenous Resistance'. Thousands of devotees travel to Sorte Mountain in hope of protection and guidance; there they commune with spirits of the dead through mediums and possession rituals, amid an atmosphere of incense, cigar smoke and the accompaniment of drumming.[61]

In Hawai'i, *akua* ('deities') exist throughout the natural world, embodied in plants, animals and geographic features. Each *akua* may manifest in multiple forms called *kinolau*. Pele is the *akua* of volcanoes, and forms of lava and various plants are among her *kinolau*. Embodying both destructive and creative power, Pele is

FIG. 19
María Lionza riding a tapir, 2004, replica cast by Silvestre Chacón of Alejandro Colina, *María Lionza*, 1951. Faux stone. 5.9 × 1.2 × 3.7 m. Central University of Venezuela, Caracas.

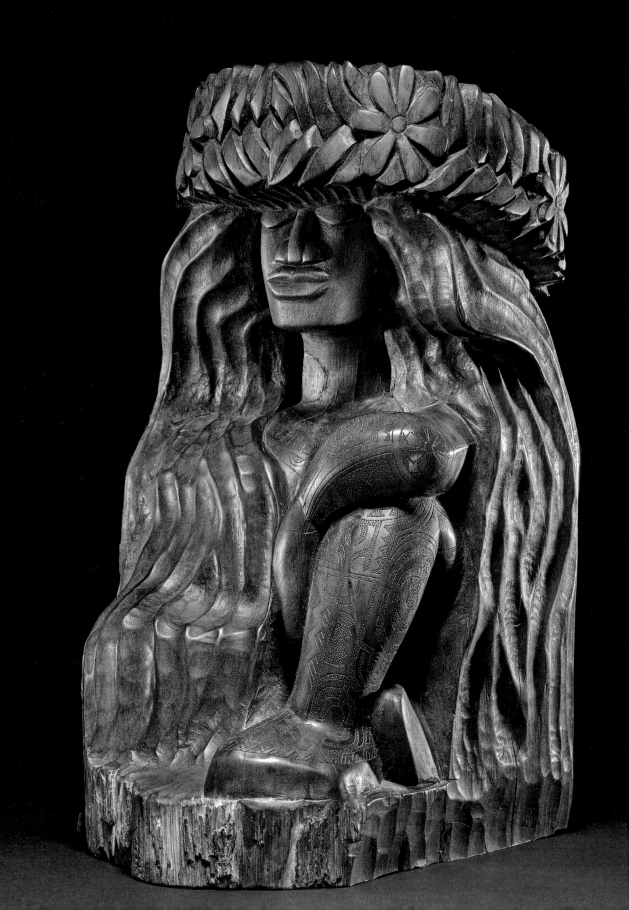

sometimes called 'Eater of the Land', and she continues to be honoured by Indigenous Hawaiians today. A sculpture of 2001 called *Tiare Wahine* ('The flowered woman') by the Hawaiian artist Tom Pico is carved from the wood of the 'ohi'a tree, which has a natural reddish hue that evokes the fire of the volcanoes and Pele's flaming red hair (fig. 20).[62] Pico depicts the *akua* wearing a *lei* crown of Tahitian flowers (including *tiare*, the Tahitian gardenia), offered to visitors when they arrive in Hawai'i, and her tattoos, of a style known from the southern regions of Polynesia, declare that she arrived from overseas. Speaking about his work in 2011, the artist said:

> I have never named a piece 'Pele' as [there is] an ancient custom of not saying her name for fear that she would respond and come to you ... she is feared here as we see her destructiveness ... other islands see her as a beautiful woman ... none of them have experienced lava flows historically ... Comfortably we say the 'woman of the pit' or Ka Wahine – The Woman.[63]

Many people view volcanic eruptions as demonstrations of Pele's power and presence, and Mount Kilauea on Hawai'i Island is considered to be her home. One of the most active volcanoes in the world, Mount Kilauea has been erupting almost continuously since 1983, and during the eruption in 2018, residents left *ho'okupu* ('offerings') in the path of the lava flow to honour Pele (fig. 21).

FIG. 21
Offerings of Hawaiian *ti* leaves, rocks and cans to the goddess Pele lie in the street as lava burns across a road in the Leilani Estates near Pahoa, Hawaii in May 2018.

Opposite

FIG. 20
Tom Pico, *Tiare Wahine*, 2001. Hawai'i. 'Ohi'a wood. 46.4 × 25.5 × 33 cm. British Museum, London, 2014,2029.2. Donated by the American Friends of the British Museum.

CREATION & NATURE

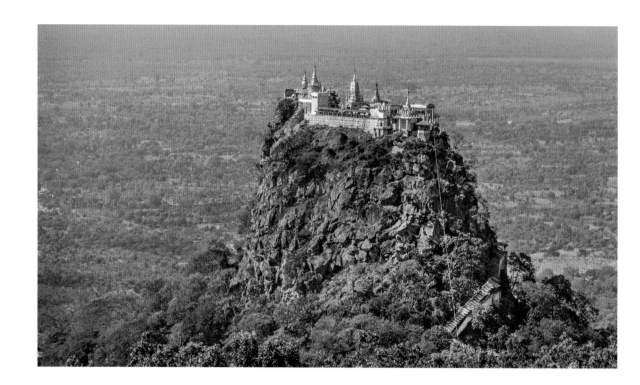

Across the world in Myanmar, Indigenous spirituality honours *nat*s – countless spirits who inhabit all aspects of the natural and built landscape, and are believed to influence people's lives in either benevolent or disruptive ways. The veneration of *nat* spirits is widespread throughout Myanmar. These animist beliefs have evolved alongside, and become syncretised with, Buddhist philosophies. Rituals are performed at shrines and at festivals, and offerings and other signs of respect are continually made to *nat* spirits both in the home and across the landscape to maintain their co-operation and amiability in daily life.[64]

Nat spirits may be named or unnamed, and are sometimes considered to have once been people who suffered unfair, painful or violent deaths, and remain in the spirit world. The *nat* Popa Medaw ('Queen [or Lady] of Popa') is believed to reside on Mount Popa, an extinct volcano that lies south-east of Bagan and is a sacred centre for her and other *nat* worship (fig. 22). According to legend, Anawrahta, the eleventh-century king of Bagan, would send his loyal follower, Byatta, to collect flowers daily from Mount Popa for his court. During one of his expeditions, Byatta met a flower-eating ogress named Mei Wunna ('Miss Gold') and they fell in love and had two sons. Wanting to spend time with his wife and family, Byatta persistently delayed returning to the palace. This angered King Anawrahta, who ordered him to be killed and later also had their sons seized. Mei Wunna died of grief, and after her death she became Popa Medaw.[65]

Today Popa Medaw is honoured by pilgrims who leave offerings throughout the year at Mount Popa. A painting on glass, purchased

ပုပ္ပါးမယ်တော်ကြီး

တောင်ပြိုးကိုယ်တော်ကြီး တောင်ပြိုးကိုယ်တော်လေး

FIG. 23
Popa Medaw with her two sons,
the Taungbyon brothers, 2000–04.
Bago, Myanmar. Reverse glass print and
paint. 33.5 × 23.5 cm. British Museum,
London, 2004,0618,0.6. Donated by
T. Richard Blurton.

at a bazaar near the Shwemawdaw temple at Bago in 2004, shows
Popa Medaw standing between her two sons, known as the Taungbyon
brothers after the town that honours them. Each brother sits on
the back of a tiger and they are important *nat*s in their own right
(fig. 23). Popa Medaw is dressed in a traditional Myanmar *htamein*
(tube-skirt) and holds peacock feathers, which are symbolic of the sun
and of the Konbaung dynasty, the last imperial dynasty of Myanmar
before the annexation of the country by the British in 1885. Her
headdress bears the face of an ogress, reflecting her former identity.

Communication with *nat*s is performed at private and public
ceremonies, as well as at raucous festivals, by a *nat kadaw* ('consort')
– a shaman or medium who can channel the spirit world to
seek insights into the future on behalf of a paying client. The
role of *nat kadaw* has long been, and is still today, predominantly

performed by women, but since the 1980s has been fulfilled by an increasing number of transgender and gay men – the subject of a documentary in 2001 made by the British filmmaker Lindsey Merrison, *Friends in High Places: The Art of Survival in Modern Day Burma*.[66] The practice is met with a high degree of political and social tolerance, allowing an assertion of social, spiritual and economic independence for persons otherwise marginalised by traditional patriarchal cultural expectations.

AGRICULTURE

Traditionally, spring and the harvest have been times for great annual festivals, invoking the blessing of the spiritual world on the sowing of crops and rearing of livestock, and offering thanks for agricultural plenty and the means to survive the coming year. Goddesses worshipped for the provision of food are also linked to broader concepts of abundance and prosperity, and are often characterised as generous beings, who endow worshippers with happiness and success. However, their bounty may be revoked, leaving the fields and earth barren; so their power over life and good fortune is countered by their ability to bring starvation, failure and death.

SHRI-LAKSHMI

Hinduism is the oldest religion in the world that is still practised today. The term 'Hinduism' refers to the numerous interconnected spiritual beliefs of the Indian subcontinent and has its roots in 'Hind', the Persian name for the Indus Valley region (and later the whole subcontinent), derived from *sindhu*, the Sanskrit word for 'river'. It was first coined by non-Hindus to distinguish local Indian spiritual beliefs from those of Islam, Christianity and Buddhism, although there is considerable intersection with the latter.[67] Hinduism and Buddhism share common sacred texts and largely overlapping concepts of divine forces, but vary in their interpretations of them.

The oldest Hindu texts, the Vedas, date to approximately 1500–500 BCE and comprise hymns and ritual instructions believed to have been divinely revealed to Brahmin sages, members of the highest caste within the traditional Indian social hierarchy. These texts are dominated by male gods, but aspects of nature, earth and fertility are noticeably feminine. The connection between vegetation, agriculture, the earth and female power is found in the *Rig Veda*, a sacred text composed around 1500 BCE, which contains hymns sung to Prithvi, the goddess of the earth, the creator of the world, and the source of nourishment to all living things alongside her husband Dyaus, the sky.[68] The veneration of rivers and waterways is also

FIG. 24
Gaja-Lakshmi seated on a lotus flanked
by elephants, c. 1780. India. Gouache on
paper. 22.9 × 27.7 cm. British Museum,
London, 1956,0714,0.32.

strongly associated with feminine creative forces in the Vedas: today,
the popular goddess Saraswati is honoured as the source of music,
wisdom, eloquence and inspiration, yet she originated in Hindu
thought as the personification of the (now lost) Saraswati river,
whose flowing waters were believed to emanate from the celestial
realm and to bring fertility, life, purification and destruction.[69]

The Vedic goddess Shri is described as the embodiment of
prosperity, royal power and beauty. In the *Shri-sukta*, a hymn that
forms an appendix to the *Rig Veda*, Shri is said to reside in the
moistness of cow dung, integral to the nourishment of soil and
the increased abundance of the earth.[70] In modern Hinduism,
Shri is generally known as Lakshmi and primarily worshipped in
connection with wealth, success and good fortune. However, her
established connection to fertilisation is expressed in one of her
most iconic representations in art, the Gaja-Lakshmi, in which the
goddess appears showered with water by two elephants (fig. 24).[71]
Captured in vibrant colours in a late eighteenth-century gouache

painting from the Bundi district of Rajasthan, the goddess levitates on a pink lotus in the centre of the scene. Dressed in silks and pearls, in two of her hands she holds an elephant goad and a lotus, and with her other two she wrings out her hair, as two elephants, which hover in the air on tiny wings that emerge from the tops of their legs, lustrate her from above with golden vessels. This imagery references a long-standing tradition that the first elephants, in the form of clouds, dowsed the earth with water, but they were stripped of their wings by an angry sage when they disturbed his meditations by landing in a tree above his head. The iconographic connection between Lakshmi and elephants in Gaja-Lakshmi imagery connects her not only with fertilising rains but also with prosperous rule through the close association of elephants with royal status and military power in India.[72]

Gaja-Lakshmi iconography is directly related to a popular narrative known as the *Samudra Manthana* ('Churning of the ocean of milk'). In the version recorded in the *Vishnu Purana*, composed around 500 CE, Shri-Lakshmi departs from the world after being insulted by the god Indra, after which 'the three worlds … lost their vigour, and all vegetable products, plants, and herbs were withered and died'.[73] The *deva*s ('gods') lose their power and are overthrown by the *asura*s ('demonic forces'). Tricking the *asura*s with the promise of immortality, the *deva*s persuade their rivals to aid them in churning the primordial oceans, with the objective of flushing the goddess Shri-Lakshmi and other auspicious boons out from the depths of the ocean to help them regain their authority. Once she is restored by these means, Shri-Lakshmi rises from the water seated on a lotus; upon her appearance, Indra, the cause of her departure, signals her power to bring about the return of prosperity:

> From thy propitious gaze, oh mighty goddess, men obtain wives, children, dwellings, friends, harvests, wealth. Health and strength, power, victory, happiness, are easy of attainment to those upon whom thou smilest. Thou art the mother of all beings, as the god of gods, Hari, is their father; and this world, whether animate or inanimate, is pervaded by thee and Vishńu.[74]

All the *deva*s are enamoured of Shri-Lakshmi's beauty, but she chooses Vishnu to be her partner.

As in Mexica religious thought, gender duality and the combined power of feminine and masculine forces is central to much of modern Hinduism. Among his many roles, Vishnu is the maintainer of *dharma* – the Hindu principle of proper cosmic order. As his companion, Lakshmi may be seen as the good fortune that accompanies observance of dharmic principles. In devotional art, she is usually shown as smaller than her husband, representing the traditional dharmic hierarchy of the sexes.[75] However, this is not a reflection of lesser importance and the pair are viewed as

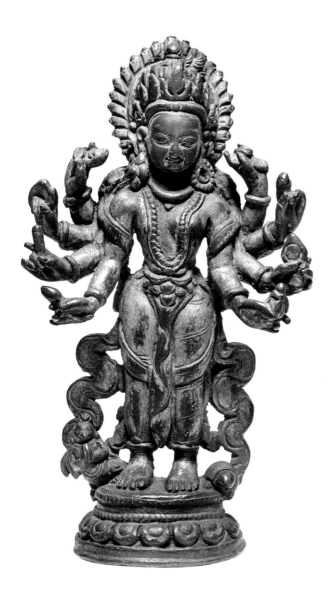

FIG. 25
Vishnu–Lakshmi figure, 16th century.
Nepal. Copper and gold. H. 13.3 cm.
British Museum, London, 1958,1215.2.
Donated by P.T. Brooke Sewell, Esq.

inseparable. In an image that is popular in Nepal but is rarely seen elsewhere, Lakshmi and Vishnu are sometimes depicted as a single androgynous being, the physical manifestation of their intrinsic unity, which stresses the benevolent grace associated with both deities and the inseparability of feminine and masculine agency.[76] The differences between the female and male sides of the deity are indicated on a sixteenth-century gilt-copper figurine by different earrings on either side of the face, and the single female breast on the figure's left side, emphasised by the fall of the neck ornament (fig. 25). The indispensability of Lakshmi to Vishnu's representation of power is articulated in the *Vishnu Purana*, which is central to Vaishnavism, the branch of Hinduism that venerates Vishnu as the supreme expression of the divine: 'Lakshmi is the light: and Hari (Vishnu), who is all, and lord of all, the lamp … oh lord of all, protect us with thy great power, in union with the goddess who is thy strength.'[77]

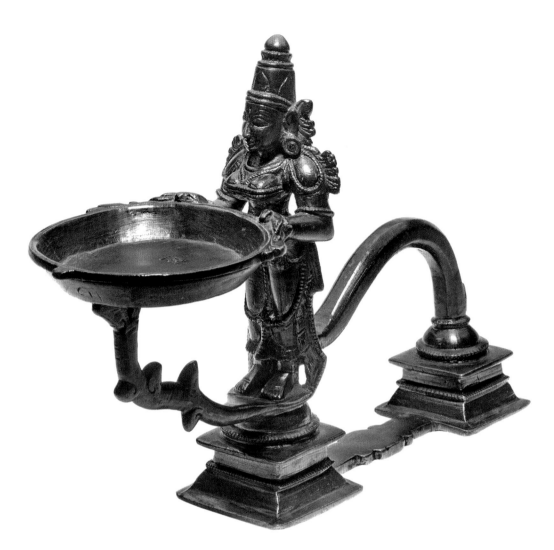

FIG. 26
Lamp supported by a figure of
Lakshmi, 18th century. Maharashtra,
India. Bronze. 12.5 × 6.4 × 19.3 cm.
British Museum, London, 1940,0716.128.
Donated by Mrs A.G. Moor.

FIG. 27
Rangoli, an artwork made from coloured
powder, and an oil lamp at Diwali
celebrations in Mumbai, India, 2013.
During Diwali, rangoli and lamps
welcome Lakshmi into people's homes
and businesses.

Today, images of Lakshmi can be found in almost all Hindu temples to ensure good fortune. As the world has modernised, the definition of prosperity has changed. Lakshmi's connections to the earth have become less prominent, and her image is now often found inside shops and office buildings in India as a symbol of prayer for financial success. She is also one of the principal deities worshipped during Diwali (the Festival of Lights), which takes place each autumn to coincide with the traditional harvest. One of the most important festivals in the Hindu calendar, Diwali is now celebrated by Hindu communities around the world. In Western India, lamps are lit and noise is made to drive away Alakshmi (literally: 'Not Lakshmi') the goddess of misfortune (figs 26–27). Gifts are exchanged among family and friends, and are offered to Lakshmi herself as a way of welcoming the goddess into people's homes to bless them with good fortune and prosperity for the following year.

DEMETER AND PERSEPHONE

The breakdown of celestial, social and natural order that follows the disappearance of Shri-Lakshmi from the world in the *Vishnu Purana* is echoed in many other religious traditions; notable parallels include the descent of Inanna to the underworld in ancient Mesopotamian belief (see chapter 2) and the Greek myth of Demeter and Persephone. Demeter was one of the twelve principal deities of ancient Greece. She was the goddess of agriculture and abundance, but more broadly, her powers were connected to concepts of life, death and regeneration. The *Hymn to Demeter*, composed by an unknown poet around 600 BCE, narrates how the cycles of the seasons – the fertility of spring and the sterility of the winter – were caused by Demeter's joy and grief at the loss of her daughter, Persephone, who was abducted by the god of the underworld, Hades. In the *Hymn*, when Demeter learned what had happened, her sorrow and anger were so great that she refused to allow any life to flourish on earth, and the whole world succumbed to famine.[78] So relentless was her despair that the other gods became alarmed and insisted that Hades return his stolen bride for part of the year. During this period, Demeter's happiness at her reunion with her child fills the world with abundance and life, but on Persephone's return to the underworld, the earth once again becomes barren.

Demeter's desperate search for her child is captured in a marble statue from the second century CE (fig. 28), which portrays the goddess as a characteristically matronly woman in heavy robes; with her right hand she pulls a cloak tightly over her head, and with her left she holds a large burning torch to guide her as she fruitlessly hunts for her lost daughter.[79] The story of Persephone's return, heralding the change of the seasons, is depicted on an Athenian wine amphora, created around 500 BCE (fig. 29).

Overleaf left

FIG. 28
Statue of Demeter, 2nd century CE. Rome, Italy. Parian marble. 95 × 31 × 24 cm. British Museum, London, 1836,1008.2. Donated by J.S. Gaskoin.

Overleaf right

FIG. 29
Black-figured neck amphora, 510–500 BCE. Greece. Painted pottery. 44.5 × 30 × 30 cm. British Museum, London, 1848,0619.3.

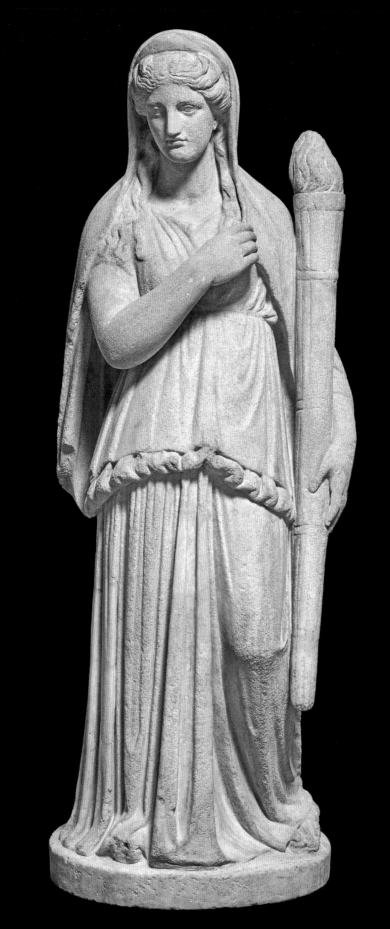

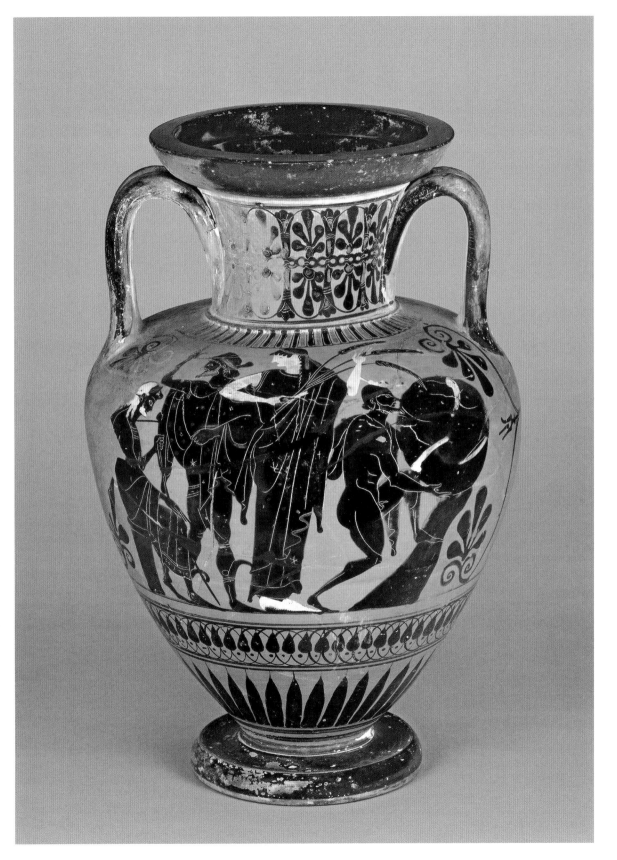

FIG. 30
Grave stele of Choirine, 370–360 BCE.
Greece. Marble. 50 × 26.5 × 7 cm.
British Museum, London, 2007,5001.1.
Purchased with contributions from Art
Fund and British Museum Friends.

Painted in the 'black-figure' technique in which details of the
design are etched into the body of the vessel, Persephone appears
at the centre of the scene holding stalks of wheat that symbolise
the return of fertility to the earth. The elderly, white-haired Hades
sits hunched to the left, and between them stands Hermes, the
messenger god, tasked with escorting Persephone back to her
mother. The figure on the right is the mythical king Sisyphus,
doomed perpetually to push a boulder up a mountain, only to have
it roll down again: his presence situates the scene in the underworld.

In worship, the return of Persephone was celebrated in one
of the most famous festivals of ancient Greece – the Eleusinian
Mysteries. Held at the Panhellenic sanctuary of Demeter and
Persephone at Eleusis in Attica, the festival was observed from
around 600 BCE and took place annually, with a larger celebration
every four years. Attendance was open only to initiates, to preserve
the secret of the rituals from outsiders. Consequently, details are
scarce in ancient sources, though it is known that the festival was
attended by both men and women and the deities were served by
both priestesses and priests.[80] A funerary relief dating to the fourth
century BCE and discovered close to the sanctuary site is believed to
show one such priestess involved in the Mysteries. Unpretentious
in its design, but originally enlivened with paint, the central panel
shows a heavily robed woman with a simple hairstyle facing to the
right. Named Choirine in an inscription above, she holds a large
key, signifying her sacred office, and her connection to the worship
of Demeter is implied by her name, which is related to the ancient
Greek word for piglet (*choiros*), a favoured sacrifice offered to the
goddess during the festival (fig. 30).[81]

Although perhaps not the post held by Choirine herself, the role
of priestess of Demeter and Kore (Persephone) was one of the
most prestigious public offices in Athens, and was also financially
well compensated.[82] This priestess played an important part in
facilitating many festivals in honour of Demeter and her daughter,
including the Thesmophoria. Unlike the Eleusinian Mysteries,
the Thesmophoria was strictly only for women and took place
in autumn. Like the larger festival, details about the rituals of
the Thesmophoria are few, and information about the activities
of participants does not come from the women themselves,
though it may reflect the atmosphere of the celebration. In
his fifth-century BCE comedy *Thesmophoriazusae* ('Women at the
Thesmophoria') the Athenian playwright Aristophanes paints
a picture of the festival as a riotous affair, during which women
entertain each other with bawdy humour, insults and obscene
language. Such a view may result from male speculation about what
occurred at such an unusual event from which men were excluded.
A vase showing a woman sowing seeds that sprout into penises may
have been intended as a similarly humorous reference to this fertility
festival by a (probably) male artist (fig. 31). A more sober source, the

fourth-century Athenian orator Isaeus, records the additional detail that the obligation to fund the festival fell upon wealthy men on behalf of their wives and the other women attending.[83]

The Thesmophoria, and the similar Roman republican worship of the goddess Bona Dea ('Benevolent Goddess'), who was also connected with agricultural and human fertility, offered women living within these cultures the opportunity not only to fulfil sacred duties but also to transcend social and political obligations. Married women, particularly those from wealthy classes, enjoyed temporary licence to shed domestic responsibilities and engage in drinking, dancing, socialising and knowledge sharing – behaviours that were otherwise discouraged or proscribed. This aspect of the festival has been interpreted as a deliberate inversion of social norms, in which women were free to honour goddesses of nature through the temporary triumph of wildness over social regulation.[84]

FIG. 31
Red-figured pelike, 440–430 BCE.
Greece. Painted pottery. 19 × 12 × 12 cm.
British Museum, London, 1865,1118.49.
Donated by Dr George Witt.

WATER

An essential ingredient for life, water features prominently in the spiritual beliefs of many cultures around the globe. Some societies view oceans and lakes as sacred and make them a focus for devotion and prayers, and rivers may be considered sentient beings. The power of water to sustain and destroy is acknowledged everywhere and its role in bringing nourishment through rains and springs, or destruction through floods, is often attributed to the action of spiritual beings or divine hands. In many belief systems, these forces assume wide cultural significance and may be perceived as both generous and capricious beings, who through their actions ensure prosperity or inflict chaos and suffering.

SEDNA

For the Inuit of the Arctic and sub-Arctic, the ocean offers bountiful food and materials to those who know how to take care of Sedna, the Mistress of the Sea. Known by many names, including Taluliyuk in Canada and Takanaluk Arnaluk in Greenland, Sedna holds power over life and death, providing food from the ocean and, according to some traditions, receiving the souls of those who die of sickness.[85] Although details of the story vary, oral traditions record that she was once a beautiful girl who was seduced by a bird spirit, disguised as a handsome man, and taken away from her home. She was eventually rescued by her father, but the bird spirit pursued them across the sea and whipped up a storm that threatened to capsize their boat. Terrified, the father threw his daughter overboard, but she clung for her life onto the side of the kayak, whereupon her father took his knife and cut off her fingers. As she sank to the seabed her severed fingers became seals, whales and walruses.[86]

A soapstone carving attributed to Inuit artist Lucassie Kenuajuak shows Sedna as part-woman, part-seal (fig. 32).[87] Unusually for depictions of the goddess, her fingers are shown intact, as she holds a fish head and raises either an oyster or a mussel to her mouth. Her hair is conspicuously sleek as if either she or a shaman has groomed it, indicating her contentment with the community.[88] As the mother of all sea creatures, Sedna's goodwill is vital to success in hunting. She gets angry and withholds her animals when transgressions, which can involve disrespectful behaviour or the breaking of taboos, are committed by community members. Songs, offerings and shamanic rituals are performed to ensure her favour before a hunt because, if she is displeased, she will keep the animals entangled in her hair and the hunt will fail. If this occurs, she must be soothed by a visit from a shaman, who combs her hair and conveys her grievances to the people, which may be rectified by public confessions.[89]

Opposite

FIG. 32
Lucassie Kenuajuak, figure of Sedna, 1987. Puvirnituq, Nunavik, Canada. Soapstone. 37.2 × 25.1 × 23.8 cm. British Museum, London, Am1987,08.4.

YAWKYAWK

Australian Aboriginal spiritual and cultural beliefs are often referred to in English as 'the Dreaming', but in the Kuninjku language of Western Arnhem Land they are known as *djang* – a word that conveys an eternal, life-giving transformative power that accounts for every aspect of existence, as well as the land itself and the art and songs created to represent that being. Bodies of water are sites where Ancestral Beings live and ceremonial exchanges with them can take place.[90] In Western Arnhem Land, Yawkyawk are young female Ancestral Beings with mermaid-like bodies, who live in waterholes (billabongs). They are sometimes described as shy and will flee at the approach of humans, who see them only as fleeting shadows.[91] Yawkyawk are closely related to the powerful Rainbow Serpent, which also lives in waterholes and has powers associated with rain and water.[92] The artist Owen Yalandja is a senior member of the Dangkorlo clan of the Maningrida region in Australia's Northern Territory. He is a custodian of the Mirrayar billabong, an important Yawkyawk Dreaming site, and has, since the 1990s, created sculptures of the spirits. Carved in his own innovative style, one of his pieces (fig. 33) is made from the wood of the kurrajong tree and is intricately painted with natural earth pigments to re-create the slender, sinuous and scaly appearance of the spirit.[93]

OSHUN

The Yoruba are one of the largest cultural groups in Africa, constituting approximately 42 million people and living predominantly within Nigeria, Ghana, Togo, Ivory Coast, Niger, Burkina Faso, Equatorial Guinea, Liberia, Gambia and Sierra Leone. Ifa is the name given to the traditional Yoruba way of life, which incorporates spiritual belief, ethics and moral behaviour. Within Ifa philosophy, an intrinsic connection between water, creation and female power is exemplified by the Yoruba *orisha* Oshun. *Orisha* are spirits who govern all aspects of the natural world and human experience.[94] Oshun (whose name means 'Source') is the essential origin of life – the waters of the earth and the womb – and is the most highly venerated female *orisha* among the Yoruba. She is typically viewed as the embodiment of female sensuality – joyful, generous and beautiful, but also capricious and fierce if she wishes – and she is particularly worshipped by those seeking love, happiness and children.[95] This Ifa divination verse celebrates Oshun's creator role:

> When they [the *orisha*] were coming from heaven,
> God chose all good things;
> He also chose their keeper,
> And this was a woman.[96]

Several creation narratives co-exist within Yoruba belief. In one, the supreme creator – an androgynous primal force known by many names, but most commonly Olorun ('Owner of Heaven') or Olodumare ('Almighty') – delegated the completion of the earth and life to seventeen *orisha*. Oshun was the only female *orisha* among the group. The male *orisha* enthusiastically set about the task, but they excluded Oshun because they viewed her gifts as unimportant, so Oshun quietly withdrew and watched. Time and again the efforts of the male *orisha* failed and the earth slipped into chaos. Confused and exhausted, they returned to Olorun/Olodumare, who, seeing that Oshun was not among their group, chastised them and informed them that all good things flow from her. Returning to the earth, the sixteen *orisha* prayed to Oshun to appease her indignation and she eventually agreed to help them by using her *ase* ('vital sacred power') to create life.[97] This creation narrative has profound resonance in Yoruba cultures as expressing the calamity that awaits if women are not consulted or involved in decisions and endeavours.[98] This precept extends to political security: although political power rests primarily with men, the office of the Oba, the political and spiritual ruler of the Yoruba, is not gender specific, and it is customary to address the Oba as 'Father–Mother'.[99]

In Yoruba tradition, Oshun is honoured as the 'pre-eminent hair-plaiter with the coral-beaded comb', a reference to the spiritual significance of plaiting the hair, which beautifies both the outer head and the 'inner head', the centre of divinity, insight and destiny.[100] She is connected not only with the life-giving necessity of water, but also with its coolness, which quenches the heat and fire of some male *orisha*, particularly Ogun, the *orisha* of iron and blacksmithing, and Sango, the *orisha* of storms, subduing their warrior tendencies so that they become beneficial to humankind.[101] Yet she may also be viewed as a warrior herself through her power to destroy life, when angered, by causing floods or drought.[102]

Orisha are often considered to be universal forces as opposed to anthropomorphic beings, and are honoured through dance, poetry and music. Shrines and altars to them are adorned with objects believed to represent or transmit their power. In the case of Oshun, these often include bronze jewellery, representing wealth and beauty, and fans, which are symbolic of her cooling power.[103] The most important festival in honour of Oshun is held annually in a sacred grove in Osun state, Nigeria, outside the city of Osogbo, and is celebrated over fourteen days every August. Now a UNESCO World Heritage site, the grove is situated along the Osun river and features contemporary carvings of Oshun alongside other *orisha* (fig. 34). The festival itself reaffirms the bond between the *orisha* Oshun and the community, attracting thousands of worshippers and tourists alike, who make offerings, prayers and sacrifices to invoke health and good fortune. Central to the festival is the role of the Arugba, a young girl who is

Opposite

FIG. 33
Owen Yalandja, *Yawkyawk*, 2011. Maningrida, Australia. Kurrajong wood, ochre, metal and paint. 107 × 11.5 × 8 cm. British Museum, London, 2012,2013.1.

FIG. 34
Sculpture and trees in the Osun river
at the sacred grove in Osogbo, Nigeria,
dedicated to Oshun, 2013.

identified through divination and tasked with carrying the sacred
paraphernalia of Oshun to the river. As the Arugba processes
through the crowd, worshippers shout their prayers for the future
(and sometimes curses on others) towards her, in the belief that she
will carry these messages directly to Oshun.[104] Modern Osogbo
is a multi-faith city, in which Yoruba religion co-exists with Islam
(the dominant religion of the region) and Christianity. To the more
militant factions on all sides, the Oshun festival can be a source
of friction and a venue for confrontation, but to most it is viewed
as an expression of Yoruba cultural heritage and an occasion for
unity, with many participants holding beliefs that integrate aspects
of different faiths.[105] A song from the festival, recorded in 1998,
expresses this plurality in no uncertain terms:

> We shall practice both together
> It is not wrong
> To perform ablution (a Muslim ritual)
> And to go to Òsun River to seek for children
> We shall do both.[106]

Ifa is now practised around the world, particularly in the
Americas as a result of the enslavement and forced migration

of millions of predominantly West African people by European enslavers, most aggressively during the eighteenth and nineteenth centuries. Those who survived the inhumane treatment they suffered on the perilous journey across the Atlantic carried their culture and beliefs with them, retaining and adapting many of their traditions and philosophies despite attempts by enslavers to impose their own faith and customs upon them. Devotion to *orisha* and their own religious traditions provided unity, pride and spiritual protection, and functioned as a form of resistance to the prolonged violence, oppression and injustice of slavery.[107] Over time, aspects of Catholicism became synchronised with the worship of *orisha*, giving rise to a diverse range of Yoruba-based religions across South and Central America, most prominently Brazilian Candomblé and Cuban Santería.

Within both Candomblé and Santería, Oshun (also spelt Ochun or Oxum) has gained a multiplicity of meanings. As well as being viewed as a mother and a warrior, she is to some a seductive and dangerous flirt and to others an expression of female strength and sexual liberation.[108] Embodying the mutability of water, she is approached as both ancient and modern, gentle and fierce, creative and destructive:

> Ochún is always the same and always different. One cannot step into the same river twice.[109]

In Santería, *orisha* (or *oricha*) are viewed as both individual beings and multitudinous at the same time, being described as *caminos* (pathways) in acknowledgement of their changeability and adaptability. Oshun is recognised as having many 'pathways', often expressing her youthful and exuberant joy, and her importance to sex, marriage and conception, but occasionally appearing as an elderly woman, residing in the depth of rivers and holding great riches.[110] She is often syncretised with the Virgin Mary as Our Lady of Charity, but also holds erotic power, controlling the highs and lows of desire and female seductive persuasion. She is described in this way in one *pataki* (myth), in which Ogun, the *orisha* of blacksmithing and industry, had turned his back on humankind and retreated to the forest. With no tools, society began to collapse and no amount of supplication could persuade him to return, until Oshun entered the forest. Without entreating Ogun directly, she began to dance, sing and feed him honey, until he was so enamoured that he followed her, adoringly, back to society, whereupon he was captured by the people. In another *pataki*, Oshun is even said to enchant death.[111]

Originating in the north-eastern state of Bahia, Candomblé has rapidly spread throughout Brazil, particularly among urban populations, and is now intimately woven into the cultural fabric of the country. Within Candomblé, spiritual influences from

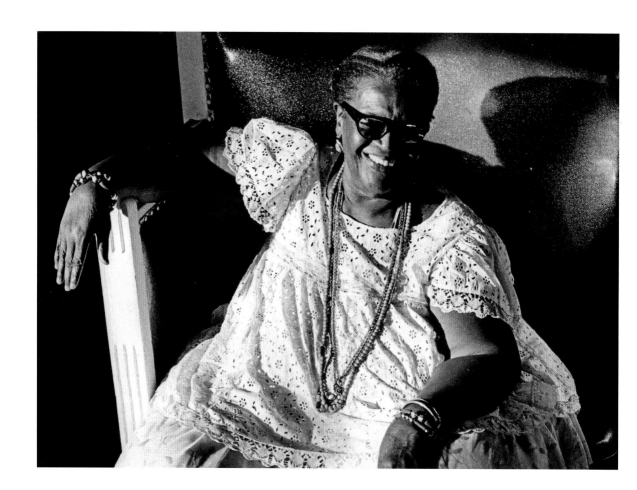

Brazilian spiritual leader Mother
Menininha do Gantois, head of the
Terreiro do Gantois temple for 64 years.

across various African cultures are synchronised with Catholic
beliefs, but the veneration of Yoruba *orisha* is particularly
prominent, as is female spiritual leadership.[112] One of the
most famous and important spiritual leaders in the history of
Candomblé is Mother Menininha do Gantois (1894–1986) (fig. 35).
Born Maria Escolástica de Conceição Nazaré and of Nigerian
descent, she became a senior priestess (*iyalorixá*) of Oshun at
the age of twenty-eight. She was instrumental in promoting
Candomblé in Brazil, fighting racial prejudice towards this and
other African-based religions, and gaining legal recognition
for Candomblé as a religion distinct from Catholicism. She
was considered by many during her lifetime to be the living
manifestation of Oshun.[113]

In both Cuba and Brazil, Oshun is celebrated in dance and
music, particularly by women who dress in yellow (her sacred
colour) and adorn themselves with golden ornaments, reflecting
her love of finery, wealth and generosity. Long worshipped for
her spiritual power on both sides of the Atlantic, in more recent
times Oshun has become a cultural icon of female sexuality
and empowerment. Figural depictions of Oshun have become

more common in popular art of the twentieth and twenty-first centuries, and, while there is no single way of representing her, she is typically depicted as an exceptionally beautiful woman with dark skin, dressed in yellow or gold. It is this image of Oshun that the singer Beyoncé is widely acknowledged to have channelled in her performance at the 2017 Grammys, where she appeared while heavily pregnant in a gold-beaded bikini, flowing yellow cape and nimbus headdress. Such pop-culture representations occasionally sit uncomfortably with Oshun's spiritual devotees, who fear a 'carnivalisation' of her sanctity, but they have also brought awareness of the *orisha* and the concepts she expresses to a global audience.[114]

MAMI WATA

Oshun is one of many water deities venerated across West Africa and the Americas, each of whom embody the power of water as the fundamental source of life and success. Another, not always identified as distinct from Oshun, is Mami Wata, who is approached by worshippers as a spirit of the sea, oceans, rivers and waterways. She is the bringer of happiness, wealth and good fortune, but may also be considered a dangerous presence, capable of withdrawing these gifts if offended. Worship of Mami Wata is practised mainly in Nigeria, the Republic of Benin and Togo, where the belief system is referred to as Vodun, but it has spread across continental Africa and to both North and South America, transcending traditional cultural and religious boundaries. Defined by her plurality, she appears in many forms and is known by many names. Mami Wata may be a single female spirit, or the name can refer to a host of water spirits, who may include male manifestations. But the essential, defining aspects of Mami Wata are that she is independent, confident and irresistibly attractive.[115]

Believed to be able to change her shape, Mami Wata is often depicted in art as a mermaid-like being with the upper body of a beautiful woman and the tail of a fish. However, some depictions show her as fully human, such as that created by the Californian sculptor Alison Saar. In her work *La Pitonisa* (1987), Mami Wata appears entwined with a snake, wearing only a pair of red high-heeled shoes (fig. 36).[116] The title of the work was explained by the artist as evoking a 'pythoness' dancing with snakes. Inspired by ideas of transformation, Saar's work is made from found metals forged together through fire and heat to form the vibrant new image of the spirit who embodies the cooling and cleansing power of water.

Although Mami Wata's home is in rivers or the sea, she travels – sometimes, it is said, by car – to meet worshippers at shrines dedicated in her honour, and communicates with her followers through visions, dreams and possession, speaking usually through

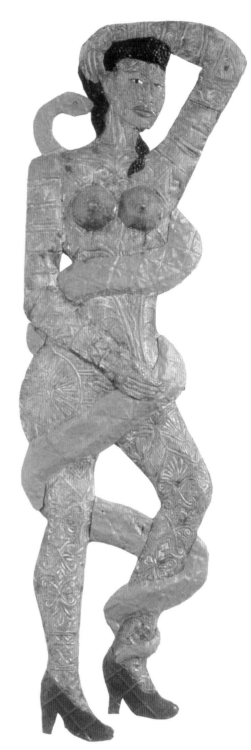

FIG. 36
Alison Saar, *La Pitonisa*, 1987. Wood, copper, tin. H. 167.6 cm. Collection of Justine I. Linforth, L2000.25.1.

a priestess who invites the spirit to enter her body.[117] In Nigeria, altars and shrines to Mami Wata may be adorned with mirrors, through which devotees believe she can be contacted, and offerings of flowers, food, cosmetics and perfume.

Depictions of Mami Wata often combine local aesthetics with imported artistic influences, particularly from European and Hindu art. The historical origins of her worship are obscure but she probably evolved from widespread pre-colonial veneration of water spirits in West Africa, in particular the Yoruba *orisha* Yemoja, a powerful maternal spirit, who, like Oshun, is said to reside in rivers and waterways, and is particularly revered for the protection of women.[118] From the fifteenth century, the kingdoms of West Africa traded extensively with Europe, and images of mermaids as figureheads on European ships are believed to have become associated with long-standing beliefs in female water spirits, resulting in the striking iconography of a beautiful woman who emerges from the sea, bringing material riches.[119]

FIG. 37
Dish with a mythical being (possibly Mami Wata), late 19th to early 20th century. Probably UK and Nigeria. Brass. Diam. 47.5 cm. British Museum, London, Af1952,20.1. Donated by the Menendez family.

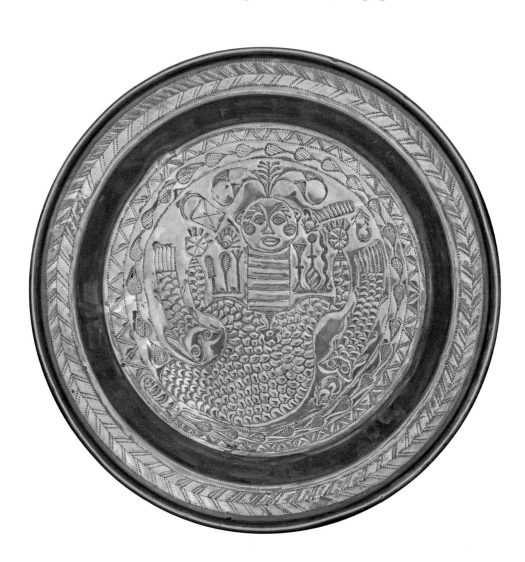

Brass was one of the most desirable goods traded by Europeans into West Africa, where it was associated with wealth and royal status. Mermaid-like figures, who may have been intended as representations of Mami Wata or similar spiritual beings, can be seen in the intricate brass work of the Efik people, who live near the mouth of the Cross River in south-eastern Nigeria (fig. 37). Throughout the nineteenth century, foundries in Birmingham, UK, mass-produced different types of brass goods by the ton to supply demand from African markets. The dish shown here was almost certainly made in Birmingham, but the decoration was probably added at some time in the late nineteenth or early twentieth century by Efik women in Old Calabar, who were renowned for the art.[120] Small metal tools with shaped ends were used meticulously to hammer out different patterns, producing, in this case, the image of a mermaid-like spirit in an aquatic scene surrounded by fish. In her left hand the figure holds a comb, a characteristic attribute of Mami Wata and mermaids more broadly, and in her right a purse. By her head are other objects related to wealth and female beauty, including what appear to be perfume bottles and mirrors. She wears what may be a feather in her coiffed hair, and her body is covered in scales from the neck down, ending in a tail that spirals around the edge of the recess. Decorative dishes such as this served a number of ritual and domestic functions. They were offered as expensive gifts or at weddings, or were sometimes sold back to missionaries and traders, particularly from England, with the result that a number are now in British collections.[121]

Today a common defining feature of Mami Wata's iconography is a serpent entwined around her shoulders or her raised arms. This aspect of her imagery was inspired in part by the popularity of a German chromolithograph, made in the 1880s, showing the upper body of a well-known nineteenth-century snake charmer, whose stage name was Maladamatjaute, holding a large snake above her head, with a second winding around her hips and chest (fig. 38).[122] The image circulated widely throughout western, central and southern Africa in the early twentieth century, and was interpreted by many as an image of Mami Wata herself, correlating with a long-held belief in the divinity and royal status of pythons in Nigeria and Benin. Copies of the image often adorn altars to Mami Wata and the influence of the iconography can be seen in many depictions, including a twentieth-century carved wooden headpiece for a masquerade costume made by the Annang Ibibio of south-eastern Nigeria (fig. 39). Masquerade performances have been an integral part of religious celebration throughout Africa for centuries, and elaborate costumes and masks allow dancers to channel and embody different spiritual entities. Created in a regionally popular style, Mami Wata is presented in human form in modern dress with an elaborate hairstyle, painted red nails,

FIG. 38
Poster interpreted as Mami Wata, based on a German chromolithograph originally by the Adolph Friedländer Company, *Der Schlangenbandiger* ('The snake charmer'), 1880s.

Opposite

FIG. 39
Mami Wata headpiece, early 1900s.
Nigeria. Painted wood and metal.
61 × 37.5 × 34.8 cm. British Museum,
London, Af1993,10.7.

heavy golden jewellery and a short blue dress. Her arms are raised in the manner seen in the chromolithograph, while a large python coils around her shoulders. Representations of Mami Wata depict her with a range of different skin tones: lighter skin, as seen here, may reflect a perception of her as a spirit originating from overseas, or express the widespread association between the colour white and divinity.[123] Beside her stand two female acolytes, their skin painted red and yellow respectively, although the significance of this has unfortunately been lost. It is likely that the carving would originally have been mounted on a large helmet mask that completely covered the performer's head.[124]

Masks used in masquerades are often not merely representations of spiritual beings but may be considered to be powerful spirits in their own right. By putting on the mask and accompanying costume, which transform or obscure the human form beneath, the performer is transfigured into the spiritual being and may undergo possession. Whether embodying male, female or animal spirits, the majority of performers are traditionally men, but an exception exists in the Agot tradition of the Bakor-Ejagham people, also within the Cross River region of Nigeria, in which all performers are women – a deliberate reversal of cultural norms, intended to promote awareness of women's social issues.[125] In 2004, the documentary photographer Phyllis Galembo captured a series of images of Agot performers in Egbung Village, including two women wearing masks of Mami Wata and the crucifixion of Christ, demonstrating not only the elaborate and colourful dress of the performers but also the religious fusion that permeates contemporary culture in this part of the country.[126]

Veneration of Mami Wata remains prominent within the Cross River region today, and expanded considerably during the twentieth century to encompass an array of local beliefs in female water spirits across Nigeria and West Africa.[127] This has been interpreted as partly due to increased large-scale city living: Mami Wata's independent and multicultural persona, together with her ability to bestow wealth or ruin, makes her 'as unpredictable and aggressive as city life'.[128] Along with certain other aspects of West African religions, the worship of Mami Wata was carried to the Americas as a result of the transatlantic slave trade and has evolved alongside other cultural traditions. Her status as a protective spirit of the sea brought her particularly close to people's lives, and her veneration has flourished across Latin America and the Caribbean. In Haitian Vodou, she is known as La Sirène. Within Candomblé and Santería she is closely identified with the Yoruba *orisha* Yemanja (also known as Yemoja) as well as the Virgin Mary, and is worshipped as the goddess of the sea and the patron of sailors; she is also adored as the embodiment of fertility, maternity and protection.[129] Her primary festivals are held on 2 February and 8 December, consciously integrated with feast

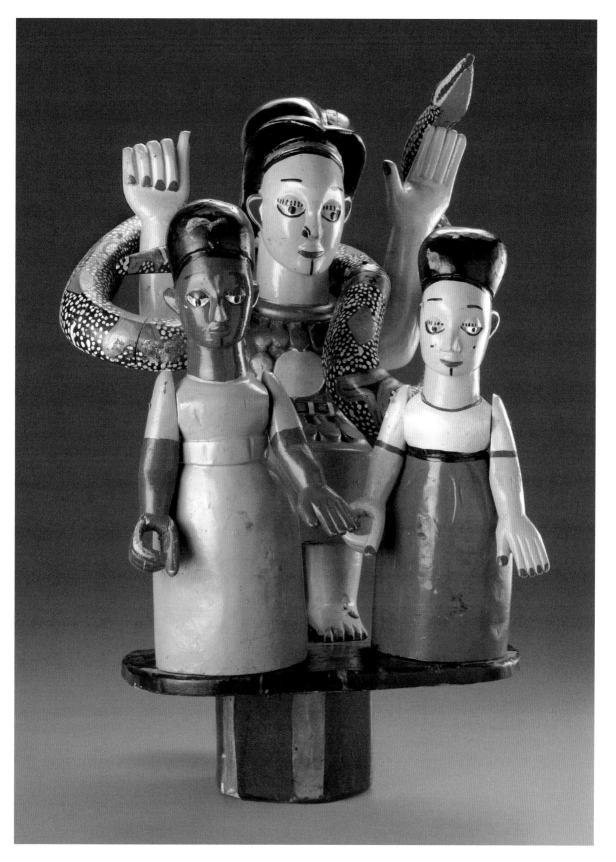

FIG. 40
Candomblé supporters and worshippers greet the Yemanja orisha during a festival on the Rio Vermelho neighbourhood beach in Salvador, Brazil, 2 February 2015.

days of the Virgin Mary (respectively the feasts of the Purification and the Immaculate Conception). Celebrations may consist of closed sacred ceremonies alongside a huge public festival, in which thousands of worshippers gather on beaches to make offerings to the goddess amid a carnival atmosphere of music, dance and parades (fig. 40). Participants traditionally dress in white and blue, the colours of Yemanja, and wear clear crystal beads, which evoke her watery home; some enter trances, during which they are believed to communicate directly with the goddess, allowing her to speak and act through them.[130]

As for Oshun, the beauty and seductive allure of Mami Wata have led to her being viewed as dangerous within some cultures on both sides of the Atlantic. In Ghana and the Democratic Republic of the Congo, it is sometimes believed that when she appears to men, she offers riches and success but demands their sexual fidelity in return, requiring the man to remain unmarried and childless. If this promise is broken, she will take back everything she has given and more, bringing death, disease and ruin on the individual and his loved ones.[131] However, most worshippers view her as a generous and benevolent figure, and by some she is likened to a saint, bringing spiritual healing to those who honour her and appearing in art alongside Jesus and the Virgin Mary.[132] For example, when

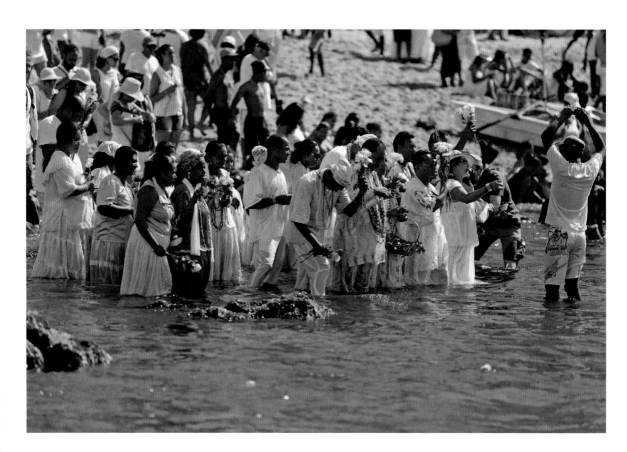

interviewed in the 1990s about his faith, the Edo Christian missionary and Mami Wata devotee Anthony Omorefe Bob-Eghaghe (known colloquially as 'Uncle Bob') spoke about his visions of Mami Wata, who appeared to him as a beautiful woman, and how he could seek guidance on behalf of his congregation either from her or from Christ.[133]

~

Beliefs that connect feminine power to creation, nature and the fertility of the earth are widespread around the world, and have existed in human thought for thousands of years. Intimately associated with the topography and natural environment of the places where they are worshipped, these spiritual beings are observed and venerated in the landscape itself, in the fields, mountains, rivers and oceans, as well as in urban centres. Their generosity is held to determine the very survival of humanity, and the intrinsic role that many of these spiritual forces play in defining and shaping human existence positions them as forces not only of nature but also of culture. Several, including Shri-Lakshmi and Mami Wata, today carry broad significance in the lives of worshippers, from the bounty and generosity of nature to commercial success and material wealth, conveying prosperity and abundance in all their forms.

While rural living, both in the past and today, gives rise to an acute awareness of humankind's precarious position in nature, as the climate crisis advances, human dependence on the natural world is once again coming into sharp focus. In South America, Indigenous cultural and spiritual beliefs honouring the centrality of nature to our existence are gaining political attention in response to environmental and ecofeminist activism.[134] In some cases this has resulted in 'Mother Earth' being afforded legal status and protection: the Ecuadorian constitutional chapter 'Rights of Nature' of 2008, which establishes Pachamama as a legal entity, and the Bolivian legislation 'Ley de Derechos de la Madre Tierra' ('Law of the rights of Mother Earth') of 2010 both exemplify this development.[135] In part concerned with the preservation of long-standing traditions within Andean culture, this legislative trend, which may in time spread to other parts of the world, can be seen as the secular, judicial expression of spiritual perspectives that have long viewed the natural world not as a resource but as a powerful and living presence.

PASSION
& DESIRE

[S]he is immortal life, she is raving madness, she is unmixed desire, she is lamentation; in her is all activity, all tranquillity, all that leads to violence. For she sinks into the vitals of all that have life; who is not greedy for that goddess?

Sophocles, Fragment 941, lines 1–8[1]

Love, lust and desire are powerful forces in human life. They may be harmonising or destabilising, bringing joy and unity or suffering and conflict. Such ambiguity is reflected in the myriad ways that sex and passion have been perceived within the religious traditions of both the ancient and the modern worlds – from a blessing that elevates the mind and draws one closer to the divine to a dangerous and demonic distraction to be resisted at all costs. According to the teaching of certain faiths, physical desire (whether viewed in a positive or a negative light) has long been conceptually tied to the erotic allure of women, arguably reflecting a cultural dominance of male heterosexual desire and contributing to a visual association in sacred art between passion and the naked female body. In the religions of Eurasia, this correlation stretches back around 5,000 years to the ancient goddesses Inanna and Aphrodite (and their later counterparts Ishtar and Venus). Central to the religious life of the Middle Eastern and Mediterranean worlds, they are often described in popular commentaries as goddesses of 'love', but this romanticism severely underplays the extent of their ancient significance. Intoxicating, unpredictable and inescapable, they embodied passion in all its forms, from ecstasy to rage, heavenly rapture to carnal lust, so that not only marital but also political harmony depended on their favour. Embodying the emotional drive of the heart over the logic of the mind, they brought joy or despair, peace or war to individuals, empires and other deities alike.

The antiquity of these goddesses and their prominence within their respective religions acknowledge the fundamental power of desire to guide human behaviour. While hymns or praises to these goddesses resonate with both love and fear, there is no doubt that their influence was viewed as divine. Yet, from

the first millennium BCE, a growing tendency emerged in the theology and philosophy of the Mediterranean and Middle East to view the body and the spirit as separate and opposed, and carnal urges as tethering the spirit to profane concerns. With the elevation of Christianity to the official religion of the Roman Empire in the fourth century CE, a radically different attitude towards sex swept across the religious landscape of Europe and the Near East. No longer attributed to divine will, the turbulence of bodily desire was taught to be a dangerous antithesis to spiritual faith that must be suppressed and eradicated through denial and chastity. It was, however, no less associated with feminine influence, the biblical Eve epitomising the disaster that accompanied women's seductive persuasion.

Almost simultaneously, however, the worship of sexual power was expanding within the religions of South Asia, through the growing veneration of goddesses whose union with male gods was central to theological comprehension of creation and existence. Like predominant Western philosophies, from the classical world to the Enlightenment, Hindu theology distinguishes the sensory visible world (connected with the feminine) from invisible consciousness (connected with the masculine). But in much of the long history of the faith, and in most branches of Hinduism today, both are viewed as positive and essential components of a whole, and the union of mind and matter is celebrated in artworks and scripture through the metaphor of sexual intercourse.

GODDESSES OF ORDER AND CHAOS

INANNA

> Indeed I am the lady who is surpassing in the land …
> Indeed I am the emanating light …
> Verily I am the heart of battle, the arm of heroism …
> When I sit in the ale-house
> I am a woman, (but) verily I am an exuberant man …
> The gods are (mere) birds, (but) I am a falcon …[2]

Inanna, the 'Lady of Heaven', was the most prominent female deity of the many gods and goddesses venerated across ancient Mesopotamia (the fertile region between the Tigris and Euphrates rivers in modern Iraq). Both a warrior and the embodiment of sexual desire, she is one of the oldest named goddesses in world history and was worshipped from at least the end of the fourth millennium BCE by the Sumerians and Akkadians, and later by the Babylonians and Assyrians as Ishtar. The long history of her cult is known through literary myths, hymns and prayers recorded on inscribed clay tablets, along with depictions in art in which she

is often shown standing on a lion with an arsenal of weapons on her back.

It is difficult to summarise Inanna/Ishtar in a holistic and all-encompassing way. A complex and ambiguous deity, she is represented in Mesopotamian literature in various guises ranging from regal and stately ('princely Inanna') to capricious and dangerous. An early celebratory hymn is attributed to the priestess Enheduanna, daughter of Sargon, King of Akkad, who lived around 2300 BCE. It is known as the 'Exultation of Inanna' and conveys the goddess's terrifying destructive potential:

> At your battle-cry, my lady, the foreign lands bow low. When humanity comes before you in awed silence at the terrifying radiance and tempest, you grasp the most terrible of all the divine powers. Because of you, the threshold of tears is opened, and people walk along the path of the house of great lamentations. In the van of battle, all is struck down before you. With your strength, my lady, teeth can crush flint.[3]

The sexual aspects of Inanna's power position her as a liminal and sometimes paradoxical being: in art and literature, she was depicted and addressed as female, yet also described in masculine terms as both beautiful and virile.[4] While almost all Mesopotamian deities were viewed as sexual beings, explicitly erotic language is most common in prayers and songs to Inanna, and her influence was associated with a broad spectrum of sexual activity, from marital love to heterosexual and same-sex desire, prostitution and adultery.[5] Offerings at her temples included votive models of amorous couples, perhaps representing the goddess and a lover, or the worshippers themselves seeking her aid or thanking her for renewed sexual potency (fig. 41). She was also said to have the power to turn a man into a woman and a woman into a man, which has been interpreted as indicating her ability to assign gender identity and/or sexual preference to individuals, and suggesting that these identities were recognised as having been divinely ordained.[6] It may also indicate that she could instil traditionally masculine qualities into women, in keeping with her own aggressive, martial nature, and feminine qualities into men, as implied by certain male priesthoods in her service during the second millennium BCE, who were said to blur gender norms – for example, by dressing in both men's and women's clothes – as an aspect of their devotion.[7]

Often approached as a volatile force, Inanna was nonetheless central to social and political life: while her anger was said to bring destruction, her favour ensured harmony and reconciliation in both the home and the city. Sometimes considered to be the world's oldest urban centre, the Sumerian city of Uruk was founded in the fourth millennium BCE on the banks of the

Euphrates in what is now southern Iraq, and was the site of Eanna, Inanna's oldest temple and cult centre. Inanna was the tutelary deity of the city, alongside her father, An, the god of the sky. By the end of the third millennium, Inanna had become central to the civic affairs of Uruk, as is made evident by the rebuilding and upkeep of her temple and by dedications left at the site by royalty, including an inscribed peg figure commemorating the temple's restoration by King Ur-Nammu (r. *c.* 2112–2095 BCE) (fig. 42). Moulded in the form of a man carrying a basket on his head, it shows the king himself bringing soil for brickmaking, emphasising his personal responsibility

FIG. 41
Votive model of a nude couple on a bed, *c.* 1800 BCE. Iraq. Clay. 11.7 × 7.1 × 4.8 cm. British Museum, London, 1923,0106.1. Donated by Scott Bell & Co.

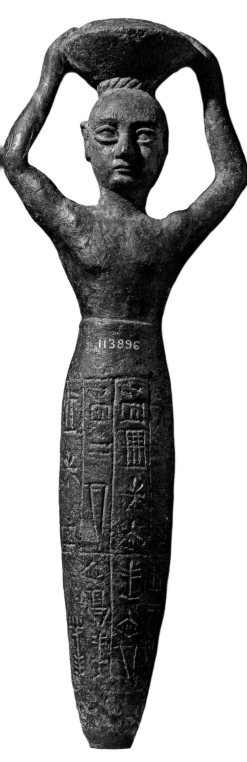

FIG. 42
Male peg figure carrying a basket on his head,
c. 2112–2095 BCE. Iraq. Copper alloy. H. 27.3 cm.
British Museum, London, 1919,0712.645.

The inscription commemorates the restoration
of the temple Eanna by King Ur-Nammu.

for maintaining the goddess's sacred sites and ensuring her
divine favour.

Inanna's importance to the royal authority of Sumerian, and
later Akkadian, kings seems to have been expressed through
symbolic sexual congress between the goddess and the ruler, which
bestowed legitimacy on a king's reign by indicating her divine
favour and protection. Texts describing this union, which has
become popularly known as 'sacred marriage', describe how
offerings and sacrifices made outside her temple served to endear
the goddess to the king before he entered the sacred inner space to
be united with her. The harmony of this conjugal relationship
ensured his success in battle and prosperity for his reign, and was
sometimes recorded through erotic poetry – for example, a hymn
composed for the Neo-Sumerian king Shulgi (r. *c.* 2094–2047 BCE),
which imagines Inanna's pleasure at his devotions and the rewards
she would bestow on him following their intercourse:[8]

> When he lays his hands on my holy genitals …
> When he treats me tenderly on the bed, then I too will treat my lord
> tenderly …
> I will decree a good fate for him! I will treat Shulgi, the good shepherd,
> tenderly …
> In battle I will be the one who goes before you.
> In combat I will carry your weapon like a personal attendant.
> In the assembly I will be your advocate.
> On campaign I will be your encouragement.[9]

Yet Inanna was temperamental and her favour precarious.
Bad fortune experienced by a ruler, such as famine or defeat in
war, could be attributed to the goddess's displeasure. Another
hymn dedicated to Inanna by the early second millennium king
Ishme-Dagan demonstrates the fragility of this dependency, as the
king implores Inanna to forgive him for an undisclosed offence
and make him her husband once again (fig. 43). Addressing the
goddess as 'Taboo woman, quaking the heavens, shaking the
earth …', Ishme-Dagan's personal god pleads for mercy on
the king's behalf, relaying how he 'writhes in distress[,] …
lamenting[,] … his frightened heart … sobbing, bitter tears'.
Eventually, Inanna is placated: 'lifting her hand from him', she
becomes 'full of kindness', and as their relationship is restored,
so is Ishme-Dagan's legitimacy as king. The goddess grants him a
wife and heir, underscoring the dependence of political power on
Inanna's divine favour.[10] The prayer ends with praise of Inanna's
all-encompassing power: 'Who lets people live, lets them give
birth, and remits the offence in the way that you do?'

In later Babylonian and Assyrian cultures, Inanna was honoured as Ishtar. One of the most enigmatic images of Babylonian art is known today as the 'Queen of the Night' (fig. 44), a moulded clay relief created around 1750 BCE and probably originally set up within a shrine or temple.[11] It is widely considered to show Ishtar, yet unusually for depictions of the goddess, she is unclothed except for a large neck ornament and bracelets on each arm. Her winged body was originally coloured with red ochre, and she stands on the back of her characteristic lion mount. Her conjoined eyebrows, once painted black, were a sign of great beauty within Babylonian art, and she stares confidently and confrontationally at the viewer, with both arms raised. In each hand she holds a rod-and-ring, an emblem of justice and royalty, and on her head she wears the horned crown commonly worn by all major Mesopotamian deities.[12] While Ishtar remains the most likely identification of the figure, certain elements of the composition – in particular, her taloned feet and the two owls by her side – are unparalleled, prompting some to propose that the relief instead represents Ereshkigal, Ishtar's sister and the goddess of the underworld.[13]

Otherwise unknown in Mesopotamian figural art, Ereshkigal is connected to Ishtar in an important myth known from several surviving cuneiform tablets, in which Ishtar descends to the underworld to challenge her sister's power (fig. 45). In each account of this myth, Ishtar prepares for the journey by dressing herself in emblems of power, including the crown and rod-and-ring seen on the relief; yet as she passes through the seven gates of the underworld, these items are stripped from her one by one until she arrives naked before her enraged sister, who instantly kills her and hangs her body on a hook to rot. After several other deities refuse to intervene on Ishtar's behalf, blaming her predicament on her own greed, she is eventually restored to life through the aid of the god of wisdom, Enki, on condition that she sends someone else to take her place. According to some versions, while Ishtar is trapped in the underworld, all sexual activity on earth ceases, indicating the importance of her presence to life in the upper world.[14] Eventually returning to the earth, Ishtar despairs at the task of condemning another being to death, until she spies her lover, Dumuzi, seemingly unconcerned by her long absence, dressed in finery and feasting, and calls on Ereshkigal's demons to drag him away.[15]

The common narrative of this myth suggests a more negative portrayal of Ishtar's power: she is described as pushing 'aggressively' at the door of the underworld, and as abandoning her temple Eanna in her ambition to expand her realm.[16] A similarly ambivalent characterisation of Ishtar, linked explicitly to her sexual nature, is found in the *Epic of Gilgamesh*, which follows

FIG. 43
Tablet inscribed in cuneiform with a hymn to Inanna, 1800 BCE. Iraq. Fired clay. 13.7 × 4.9 × 1.6 cm. British Museum, London, 1898,0215.202.

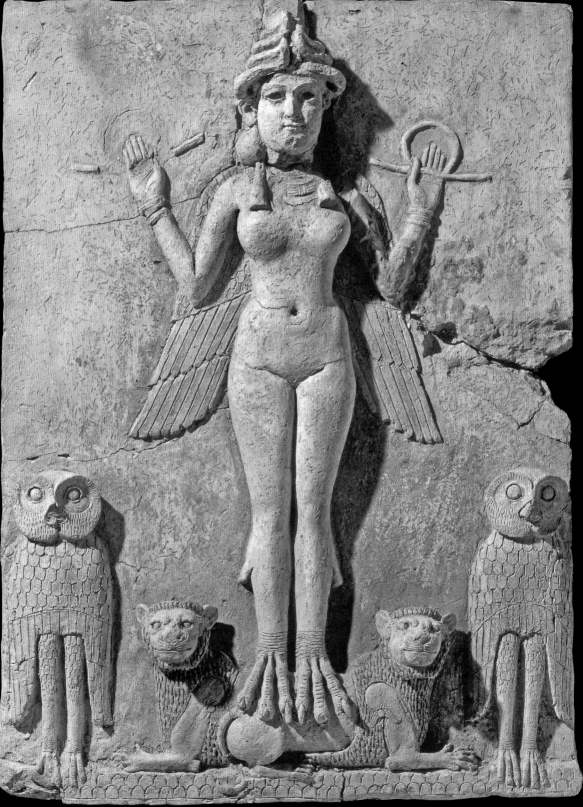

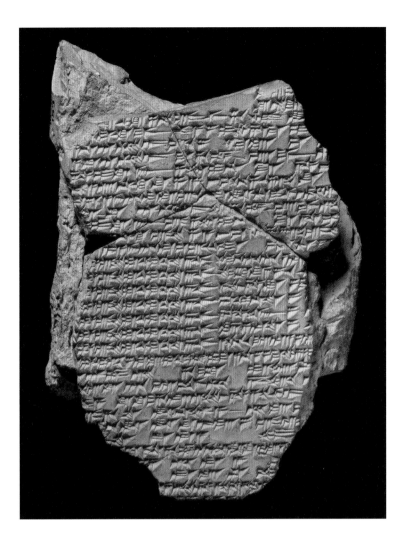

FIG. 45
Fragment of a tablet from the Library
of Ashurbanipal inscribed in cuneiform
with the myth of Ishtar's descent to the
underworld, 7th century BCE. Iraq.
Clay. 16.8 × 8.6 × 2.9 cm. British
Museum, London, K.7600.

the quest of Gilgamesh, the legendary king of Uruk, to uncover
the secret of eternal life. The most complete version of the text
dates to approximately 1200 BCE, and it is considered to be one of
the oldest epic poems in world literature. A notable scene early in
the narrative concerns the young king's encounter with Ishtar. After
witnessing Gilgamesh's strength and prowess as a warrior, Ishtar
appears to him and proposes marriage, in return promising him
luxury, power and increased fertility for his realm. Rather than go
willingly into the goddess's bed, as one might expect a Sumerian
king to do, Gilgamesh rudely rejects her, recounting her previous
lovers (including Dumuzi, who died at her hands), and claiming,
perhaps not unreasonably, that she would kill him too. After he
heaps insults upon her – calling her 'a door that lets in the draught'
and 'a slipper that trips the wearer' – Ishtar becomes furious. She
calls on her father, Anu (An), to unleash the monstrous Bull of
Heaven to destroy Gilgamesh, along with the entire city of Uruk,
threatening to open the gates of the underworld and let the dead

Opposite

FIG. 44
'Queen of the Night' relief, *c.* 1750 BCE.
Iraq. Painted clay. 49.5 × 37 × 4.8 cm.
British Museum, London, 2003,0718.1.

overrun the living if she is refused.[17] The ensuing scene is captured in tiny detail on a light blue chalcedony seal stone, engraved between 800 and 700 BCE (fig. 46). Gilgamesh, dressed in fine robes, and his friend Enkidu, naked from the waist up, furiously wrestle with a winged bull, while Ishtar, bow and arrows in hand, stands watching to the side. To Ishtar's dismay, in the narrative the two men overpower the bull, and Enkidu goes so far as to throw one of its legs at the goddess – an act of extreme hubris that ultimately condemns him to death.

The scene reflects Ishtar's irrepressible temper and volatility, emphasising the destructive side of her character, but it is unlikely that it was intended to show the disproportionate response of a scorned woman. It may be read as reflecting a conviction that the sexual powers encapsulated by Ishtar, however turbulent, defined human culture, and that attempts to avoid or deny them could result in chaos – a concept emphasised at the beginning of the poem, when Enkidu, a man living with animals in the wilderness, is tamed and seduced into human society by the allure of a prostitute.[18] Gilgamesh's attempt to preserve his own life and his belief that he can avoid the inevitability of death lead him to reject union with Ishtar and the gifts she offers for his kingdom. This brings destruction to his city, resulting in the deaths of hundreds of citizens, including his closest friend. Viewed in this way, the episode frames Gilgamesh as a brave yet self-interested and impetuous ruler, and marks a crucial stage in his transformation into, by the end of the poem, a wise and distinguished king.[19]

Worship of Inanna/Ishtar spanned more than 3,000 years and over the course of her long-lasting cult, the powers she encompassed appear to have been both celebrated and maligned. In early Sumerian texts, Inanna's intense sexuality is integral to harmonious civic culture, and though some later Babylonian and Assyrian literature depicts her in more negative, though not less powerful, terms, her importance to royal power remained unchanged. Whether resisted or embraced, the goddess's essence as a volatile deity of sex and war endured, combining stability and disorder in a single being.[20]

This correlation between sex and war, embodied in the female form, was to persist for centuries in the religious consciousness of the Mediterranean and Middle East. To the Phoenicians, a seafaring people living in what is now the Central Levant, she was Astarte. Almost certainly influenced by worship of Ishtar, Astarte was similarly a warrior goddess connected to passion and desire, yet her iconography evolved in a different direction. Numerous figurines discovered in Syria and Cyprus, dating to around 2000–500 BCE, have been identified as representing Astarte. They typically show the goddess unclothed and unarmed, placing visual emphasis on the sexual rather than martial aspects of her power, and this remained a defining element of her iconography

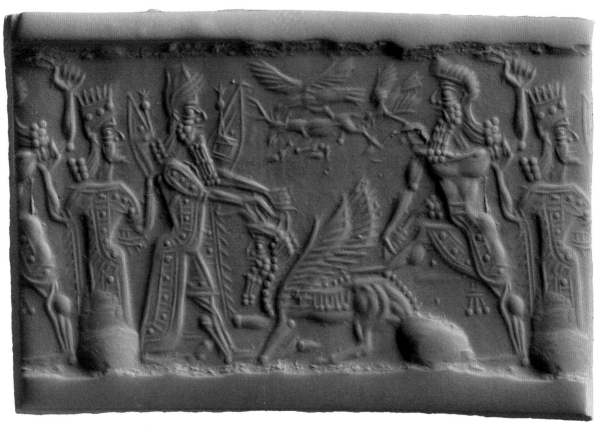

FIG. 46
Cylinder seal, 800–700 BCE. Late
Babylonian. Chalcedony. H. 2.9 cm.
British Museum, London, 1853,0822.6.

The seal (*left*) shows the goddess Ishtar
watching as Gilgamesh and Enkidu
battle the Bull of Heaven, the scene in
the impression of the seal (*above*).

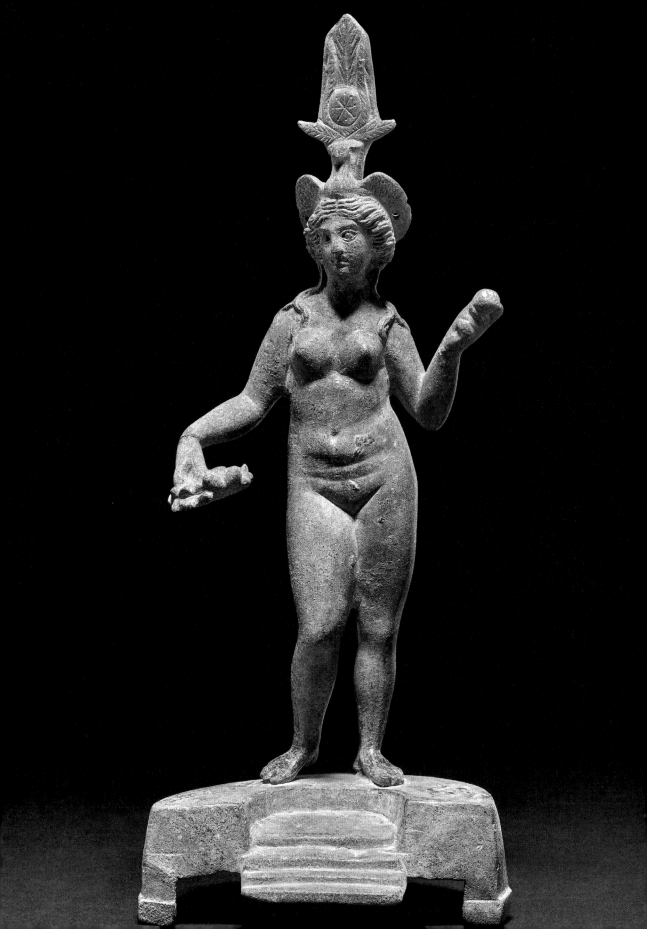

until the early first millennium CE (fig. 47). From around 1000 BCE onwards, the extensive trading of the Phoenicians spread the worship of Astarte around the Mediterranean, and is believed to have influenced the worship, and imagery, of the Greek goddess Aphrodite.[21]

APHRODITE

Aphrodite, known to the Romans as Venus, is one of the most familiar ancient goddesses in the modern Western world. Today, her name is synonymous with seduction and female physical beauty, and her naked image has lingered in art and Western popular imagination much longer than her religious worship.

According to early Greek authors, Aphrodite was closely connected to Cyprus – a centre of trade between Greece, the Near East and Egypt, making the island a hotspot for cultural and religious exchange and associating it, in Greek thought, with luxury and exotic decadence.[22] Aphrodite is sometimes simply called 'The Cyprian' in literature, and her connection with the island is recorded in the most famous narrative of her birth by the seventh-century BCE Boeotian poet Hesiod, in his epic cosmological poem the *Theogony*. As Hesiod tells the story, at the beginning of time, Gaia, the earth, created Ouranos, the sky, and together they had many monstrous children whom Ouranos despised, fearing that one of them would usurp his power. Wanting to save her children and be rid of her violent husband, Gaia gave her son Kronos (time) a flint sickle, which he used to castrate his father, flinging the severed genitals into the Mediterranean Sea, from where:

> [A] white foam rose up around them from the immortal flesh; and inside this grew a maiden. First she approached holy Cythera, and from there she went on to sea-girt Cyprus. She came forth, a reverend, beautiful goddess and grass grew up around her beneath her slender feet.[23]

This popular story of Aphrodite's birth from the sea was captured in Greek and Roman art through imagery of the naked goddess holding a seashell on which she was brought ashore (fig. 48). It also conveys the complexity of Aphrodite's significance in spiritual thought: embodying grace, beauty and fecundity that accompany her every step, the goddess is nevertheless born from conflict, violence and castration. Greek poetry and drama delighted in stories of Aphrodite's many lovers, extramarital affairs and jealous fits, painting a picture of a frivolous temptress, physically irresistible but, just like many other classical deities, self-interested and spiteful, who more often than not used her

Opposite

FIG. 47
Statuette of Astarte, 2nd century CE. Lebanon. Copper alloy. 22 × 8.5 cm. British Museum, London, 1966,1010.1.

This figurine shows Astarte wearing an elaborate headdress supported by a dove, reflecting Egyptian headdresses with feathers, horns and a sun disc. In her hands she holds a garland and a piece of fruit. The pose of the goddess echoes Roman depictions of Venus.

Opposite

FIG. 48
Statuette of Aphrodite, 1st–2nd century CE.
Cyprus. Bronze. H. 9.7 cm. British Museum,
London, 1872,0816.87.

power over sexual desire to punish and humiliate gods and mortals alike. Yet the dominance of these literary narratives in studies of ancient Greek religion has obscured other evidence for her worship across the Mediterranean, uncovered – largely only since the last century – through archaeological and epigraphic research into the goddess's cult sites and ritual worship. This evidence reveals a far more nuanced deity, with far-reaching significance across the Greek and Roman worlds, who commanded, like Inanna/Ishtar, martial and civic authority. Her importance to warfare, almost entirely absent in literary myths, is evident at the Athenian fortress at Rhamnous, north-east of the city, where Aphrodite was honoured as Hegemone ('Leader'), along with Nemesis, the goddess of divine retribution. Beyond Athens, she was a prominent goddess in the highly militarised city-state of Sparta, in which temples were dedicated to Aphrodite Areia ('Warlike' Aphrodite) and Aphrodite Poliouchos (Aphrodite 'Protector of the City').[24] In Corinth, the Greek philosopher Plutarch records that during the Persian wars the women of the city prayed to Aphrodite to inflame a passion for battle in their men, and figurines from Sparta and Corinth showing a goddess carrying weapons have sometimes been identified as Aphrodite, while several inscriptions refer to her with military epithets, designating her protector of the army.[25] As well as being worshipped in times of conflict, she was also a goddess of peace and resolution. Her civic role in Athens reflected her powers of harmony and persuasion, and her sanctuary on the Athenian Acropolis honoured her as Aphrodite Pandemos (Aphrodite 'of All People' or 'who Brings People Together').[26] She was also closely linked to seafaring and the protection of sailors – possibly through the myth of her birth from the sea, but perhaps also from the belief that her powers could calm and subdue nature as well as human passions.[27]

Alongside her civic status and public worship, Aphrodite's importance to individuals in the realms of love, lust and marriage was shared with Eros (the Roman Cupid), 'the limb-melter … [who] overpowers the mind and the thoughtful counsel of all the gods and all human beings'.[28] In the *Theogony*, Eros emerges from primordial chaos at the same time as Gaia – a testament to the perpetual existence of desire on earth – but in other contemporary and later narratives he was seen as the son of Aphrodite and an emissary of her erotic power, using the weapons of war to inflict mortals and gods alike with unbridled passion.[29] Childlike in appearance and character, a Roman marble statue of Eros, thought to be a copy of a work by the celebrated Greek sculptor Lysippus of the fourth century BCE, shows the god as a handsome winged youth, nonchalantly restringing his bow (fig. 49). A lion skin, the impenetrable armour of the legendary hero Heracles, hangs limply unattended on a column behind him, a metaphorical celebration,

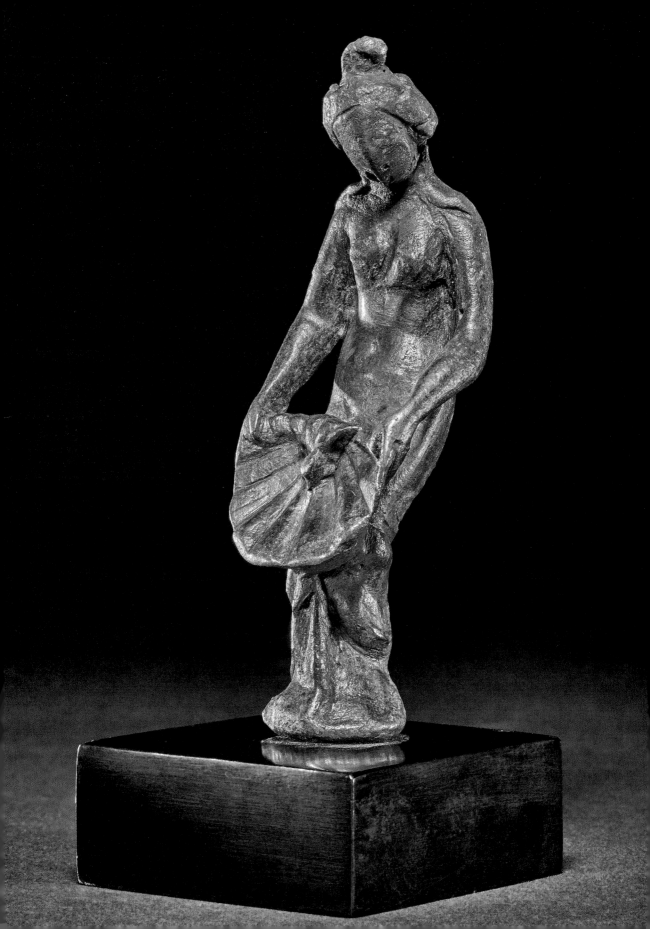

FIG. 49
Statuette of Cupid, 2nd century CE. Rome,
Italy. Marble. 60.5 × 46 × 26 cm.
British Museum, London, 1805,0703.19.

or warning, of the fact that even the most formidable warrior is
defenceless against desire's arrows.

Perhaps unsurprisingly, the young Eros – sometimes depicted in
the form of multiple winged beings known as 'erotes' – appears
more frequently than Aphrodite herself in Greek art that portrays
homoerotic male desire, as does Dionysos, the god of ecstasy,
hedonism and wine. Scenes of older men propositioning or
fondling nude youths were particularly popular on vessels used at
symposia – all-male dining parties, often raucous events, where
wealthy guests might discuss philosophy and politics while engaging
in excessive drinking and orgiastic activities with *hetairai* (educated
and artistically trained courtesans) (fig. 50). Maenads and
ithyphallic satyrs, followers of Dionysos, dance around the outside
of a fifth-century Athenian wine cup, emulating the boisterous and
salacious atmosphere of the *symposium*; when the drinker raised the
cup to his lips he would have been confronted by an image, painted
inside on the base, of a *hetaira* pleasuring herself with two artificial
phalloi (fig. 51).

By contrast, Aphrodite appears prominently in art and literature
relating to female desire and marriage. Far more is known about
male than about female sexual desire in ancient Greece – a product

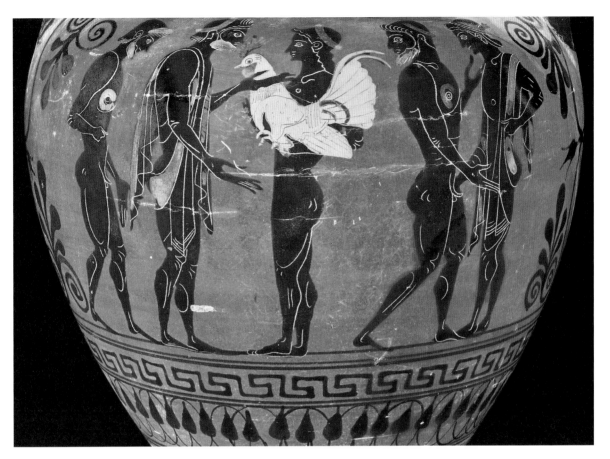

FIG. 50
Black-figure amphora showing older
men propositioning youths (detail),
c. 510 BCE. Greece. Painted pottery.
H. 31.8 cm. British Museum, London,
1842,0407.2.

The cockerel held by the central figure
was a common love gift.

FIG. 51
Red-figured kylix with a nude woman
(detail), 520–500 BCE. Greece. Painted
pottery. 13.5 × 42 × 32 cm (whole object).
British Museum, London, 1867,0508.1064.

FIG. 52
Melian relief depicting a man with a
female lyre-player, perhaps Sappho, and a
male figure, *c.* 480–460 BCE. Greece.
Terracotta. H. 17.5 cm. British Museum,
London, 1842,0728.1132.

of the abundance of literary sources written by and for men. One
rare yet invaluable glimpse into female sexuality from anywhere in
the ancient world comes from the work of the poet Sappho (fig. 52).
Born around 620 BCE into a wealthy family on the Greek island of
Lesbos, she was a prolific writer and her tender lyric poetry was
celebrated in her own lifetime and copied for centuries after her
death. Now known only through fragments, much of her work is
devoted to her longing for lovers, usually female but occasionally
male, and it invokes Aphrodite to be her 'comrade in arms' in
winning their affection. Sappho often speaks directly to Aphrodite
in her poetry, calling on the goddess to mend her broken heart and
turn the affections of her beloved towards her. In her one surviving
complete poem, 'Ode to Aphrodite', the goddess appears as a
benevolent (if slightly exasperated) ally, ready to help the hopelessly
romantic poet in any way she can:

> O my blessed goddess with a smile on your deathless face you asked me
> what the matter was *this* time, what I called you for this time, what I
> now most wanted to happen in my raving heart: 'Whom *this* time
> should I persuade to lead you back again to her love? Who *now*, oh
> Sappho, who wrongs you?'[30]

The importance of Aphrodite to women more broadly is evident in the prolific use of her image on perfume bottles, jewellery, mirrors and all manner of items relating to female beauty throughout Greek and Roman material culture. *Lebetes gamikoi*, large and elaborate high-handled vessels, specifically designed to hold water for the bride's bath before a wedding, were commonly decorated with paintings of Aphrodite and her attendants, as well as domestic scenes of women beautifying themselves and gazing into mirrors. In one example from Campania (fig. 53), Aphrodite, seated right, uses a bird to toy with a cat, while a female attendant stands to the left. Since most women had little, if any, say in the choice of a husband, they may have hoped at least to elicit good treatment in their new homes by emulating the beauty and persuasive powers of Aphrodite and summoning her aid to bring marital harmony and fertility. The importance of Aphrodite to young women on the cusp of marriage and her embodiment of domestic harmony were so culturally ingrained that she continued to be commemorated even in early Christian art. On a silver wedding casket from the fourth century, gifted to an aristocratic Roman lady named Projecta, an inscription wishing Projecta and her groom, Secundus, to 'live in Christ' appears directly below an image of the goddess of desire reclining on a scallop shell (fig. 54), while, on the top of the lid, the portrait of the happy couple is contained in a wreath held up by two winged erotes.

FIG. 53
Lebes gamikos (detail), 340–320 BCE.
Campania, Italy. Painted pottery.
H. 45.7 cm. British Museum, London,
1867,0508.1284.

FIG. 54
Projecta casket, *c.* 380 CE. Rome, Italy.
Silver and gold. 28.6 × 48.8 × 56 cm.
British Museum, London, 1866,1229.1.

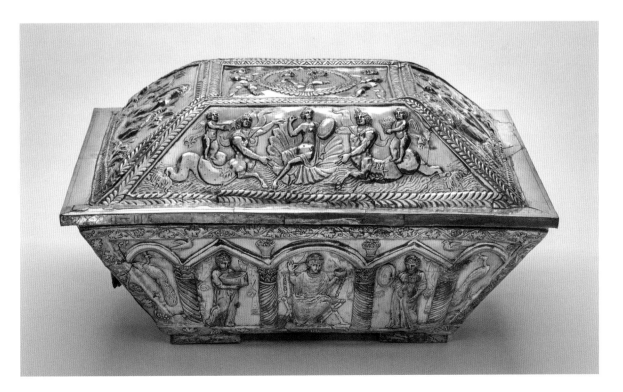

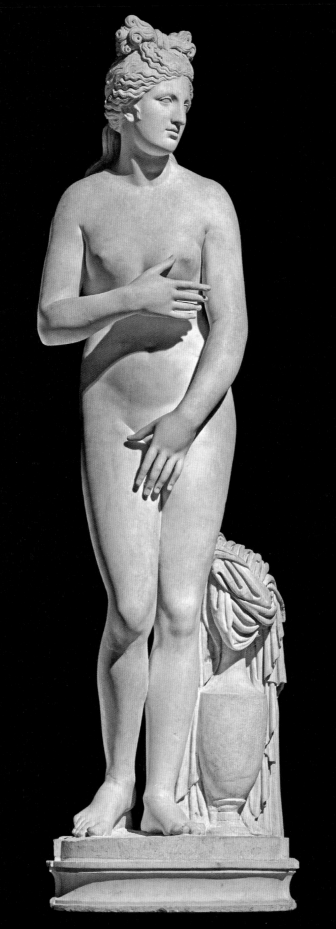

In Western artistic tradition, the popular portrayal of Aphrodite as a beguiling naked woman is often traced back to the work of the celebrated Athenian sculptor Praxiteles, who was active in the fourth century BCE. According to artistic canons of his age, large sculptural nudity was reserved for male gods and heroes, and while Aphrodite was often shown without clothing, such imagery appeared on small figurines and two-dimensional paintings and mosaics. In a radical departure from tradition, at the Temple of Aphrodite in Knidos (in modern western Turkey), Praxiteles unveiled his masterpiece: a cult statue of Parian marble, showing Aphrodite stepping out of her bath. Positioned at the centre of the circular temple so as to be viewed from all angles, the goddess appeared completely naked with an 'arrogant smile' on her lips, reaching for her robe with one hand while covering herself 'unobtrusively' with the other.[31] Some visitors to the temple were reportedly so overwhelmed with desire that they tried to have sex with the statue.[32] While the original has long been lost, it is difficult to overstate the impact of the Aphrodite of Knidos on the visualisation of the goddess in later art. The sensation it created would radiate for centuries throughout the ancient Mediterranean, and the statue was widely reproduced, becoming a model for Roman representations of Venus. Its influence can be clearly seen in a Roman statue of Venus from the second century CE that once stood in a private villa at Campo Iemini, just south of Rome. Differing slightly in pose from the original, she holds both arms in front of her, the curves of her body emphasised as she moves to step forwards, shifting her weight onto one leg (fig. 55). At first glance she seems to be attempting to hide her nudity, as she turns her head and diverts her gaze, yet her hands draw the eye to her genitals and breasts, which she conspicuously fails to obscure. When compared to the frontal nudity and confrontational gaze of Ishtar on the 'Queen of the Night' relief (see fig. 44), the impression is of a less aggressive expression of divinity, and to modern viewers, inured to female nudity in art, she may appear somewhat coy. But the slow deliberation of her movement as she gently brushes her breast, and her parted lips, an echo, perhaps, of the original's smile, may instead convey a full awareness of the impression she is making on her audience – a seductive visualisation of divine sexual power that knowingly overpowers the mind and the senses, not through force but through persuasion.

In many ways, the goddess Venus was the Roman counterpart to Aphrodite. In addition to their iconographic parallels, Venus was similarly worshipped in connection with pleasure, desire and the longings of the heart. However, her status as a civic goddess of victory, statecraft and harmony rose to even greater prominence, encouraged by the political ambitions of prominent Roman

Opposite

FIG. 55
Statue of Venus (the 'Capitoline Venus'),
100–50 CE. Rome, Italy. Marble.
223.5 × 60 × 60 cm. British Museum,
London, 1834,0301.1. Donated by William
IV, King of the United Kingdom.

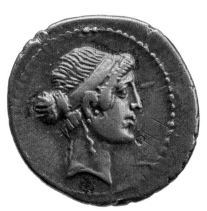

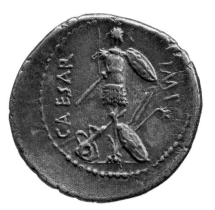

statesmen in the second and first centuries BCE. To understand Venus' central importance to the military culture of Roman politics, it is more helpful to consider her as the goddess of virility than of romantic desire. Within both the Late Republic and the Early Empire, ruling statesmen were often also military generals and it was the goddess Venus whom they thanked for endowing them with their fire for battle on campaign and in the Senate. In the first century BCE the dictators Sulla and Julius Caesar both claimed Venus as their personal patron, the former giving himself the name Epaphroditus ('the man of Aphrodite') (fig. 56) and the latter claiming divine descent from the goddess via her legendary son Aeneas.[33] Caesar, in particular, extensively incorporated Venus' image into his coinage, advertising his closeness to the goddess by pairing her regal portrait with trophies from military campaigns and the winged personification of victory (fig. 57), and established a cult within Rome to Venus Genetrix ('Ancestral' Venus) as forebear of his family and of Rome.

Venus' position at the heart of Roman politics persisted under the empire. In 135 CE Emperor Hadrian inaugurated a double temple in the Roman Forum next to the Colosseum – the largest in the city at the time – to Venus Felix and Roma Aeterna ('Venus of Good Fortune' and 'Eternal Rome'), complete with colossal statues of the two goddesses in enormous domed niches.[34] From at least the late first century CE, Venus became not only the inspiration for the emperor but also the model for women of the imperial house. Coins showing Venus Victrix (Venus 'Bringer of Victory') coupled with portraits of Faustina II (wife of Marcus Aurelius) and Crispina (wife of Emperor Commodus) were perhaps intended to demonstrate the stability of the empire, not only through military victory but also through the marital harmony of the imperial family and the provision of legitimate heirs (figs 58–59).

Top

FIG. 56
Aureus of Sulla, depicting the head of Venus wearing a diadem, with Cupid holding a palm branch (obverse) and two military trophies with a ceremonial jug and horn (reverse), 84–83 BCE. Minted in Italy. Gold. Weight 10.8 g. British Museum, London, R.8359.

Bottom

FIG. 57
Denarius of Julius Caesar, depicting the head of Venus (obverse) and a military trophy (reverse), 44 BCE. Minted in Rome, Italy. Silver. Weight 3.4 g. British Museum, London, 2002,0102.4692. Bequeathed by Charles A. Hersh.

Opposite top

FIG. 58
Aureus of Commodus, depicting the portrait of his wife Crispina (obverse) and Venus holding a sceptre and helmet (reverse), 180–183 CE. Minted in Rome, Italy. Gold. Weight 7.3 g. British Museum, London, 1856,1101.116.

Opposite bottom

FIG. 59
Aureus of Marcus Aurelius, depicting the portrait of his wife Faustina II (obverse) and Venus holding a shield and the figure of Victory (reverse), c. 161–176 CE. Minted in Rome, Italy. Gold. Weight 7.1 g. British Museum, London, 1867,0101.729.

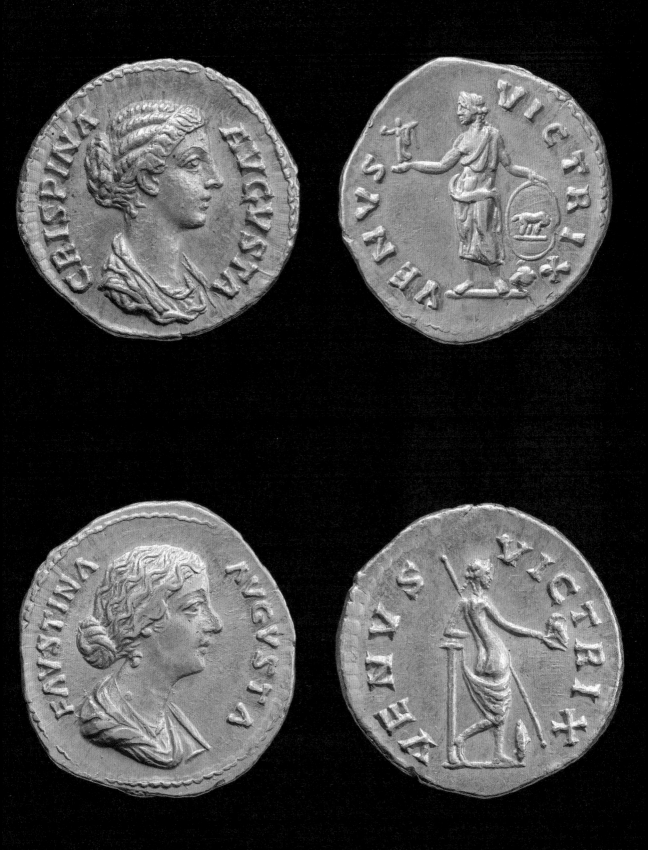

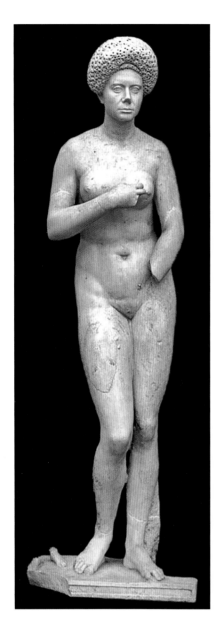

In marble portraiture, the association between aristocratic Roman women and Venus was occasionally represented in life-sized sculptures that combined the lithe, youthful, body of the Aphrodite of Knidos with the matronly portrait head of the patroness (fig. 60). This faintly jarring juxtaposition is perhaps best understood as the female equivalent of the 'heroic nude' – a widely adopted trope in Greek and Roman sculpture, in which a powerful statesman, king or warrior is shown with an unrealistically god-like naked body, not to arouse but to awe. These sculptures were usually commemorative and were sometimes used in funerary monuments, implying that, although the Greek iconography of the seductive nude Aphrodite endured, it was always understood as predominantly sexual but was deployed to flatter the deceased woman's status as the paradigm of marital harmony, prosperity, succession and good fortune, and as the respectable ancestor of her family, as Venus was to Rome.[35]

Across the ancient Middle East and Mediterranean, goddesses of sex and passion were formidable, complex forces. Many parallels can be drawn between the centrality of Inanna/Ishtar and Aphrodite/Venus to the different cultures that venerated them. Their worship encompassed a broad spectrum of human experience, from marriage to the protection of the state, and their influence brought upheaval and disorder and peace and prosperity. In art, however, over the centuries the divine embodiment of passion was transformed from the heavily armed Inanna to lithe and seductive Venus, her nudity becoming an increasingly central expression of her power.

Inanna/Ishtar and Aphrodite/Venus were worshipped within broader religious traditions that viewed gods and goddesses less as models for human behaviour than as inescapable forces to be navigated and appeased. Although themselves the personifications of sex and passion, the sexual narratives of deities often underlined wider understanding of divine actions, and almost all of them were viewed as sexual beings with their own agency. Similarly, within Hindu belief, sex, love and attraction characterise many beliefs about divine forces. While certain goddesses, in particular Radha, are connected with seductive allure, the sexual union of divinities is often associated less with mortal concerns about marriage and relationships and more with understanding the mysteries of the cosmos.

THE UNIFICATION OF SEX AND THE DIVINE

Desire is the root of the universe. From desire all beings are born.[36]

In the religions and philosophies of South Asia, spiritual beliefs surrounding sex and desire have been discussed and represented in religious literature and art for centuries, and while these beliefs are diverse, they carry overwhelmingly positive connotations.[37] According

FIG. 60
Statue of a woman, c. 98–117 CE. Italy. Marble. H. 191 cm. Ny Carlsberg Glyptotek, Copenhagen, inv. no. 711.

This statue is believed to combine the portrait head of Marcia Furnilla, wife of the emperor Titus, with the idealised nude body of the goddess Venus.

to Hindu spirituality, *kama* ('desire') is one of the three essentials of worldly life, along with *dharma* ('religious duty') and *artha* ('material success'). Like Eros, *kama* is occasionally personified as a single divine being (fig. 61), often shown with green or blue skin, who shoots mortals and deities with floral arrows, but it is also an essential and primordial force: the source of joy and happiness in the world as well as the primal generator of life and creation, which manifests to a greater or lesser extent through all divinities, both female and male.

In Hinduism, love, desire and sexual intercourse feature in the iconography and mythology of many deities, and the union of the male and female, prominently displayed in both public and

FIG. 61
Roundel depicting the god Kama holding a bow and flower, 19th century. Andhra Pradesh, India. Leather and paint. Diam. 26.3 cm. British Museum, London, 2008,3010.2. Funded by the Brooke Sewell Permanent Fund.

Kama is riding a *nava nari kunjara*, a composite figure of an elephant formed from the bodies of nine women. The women represent the nine *rasas* (senses) and symbolise both strength and sensual desire.

private art, is considered intrinsic to understanding the fundamental mysteries of the cosmos and of the divine. Sensuous women and *maithuna* – couples in acrobatic sexual poses – which adorn Hindu, Jain and Buddhist temples, can be read in a number of ways: their feminine generative power, emphasised by broad hips and rounded breasts, is considered auspicious, granting prosperity to the temple and the people; coupled with a male partner, they may represent the divine union of the masculine and feminine forces of the universe.[38] This concept is also expressed through one of the most sacred emblems of Hindu iconography, the *Shiva linga* (fig. 62). Found in temples across South Asia, it is a stylised representation of the erect *linga* or phallus of the god Shiva, symbolising his sexual and creative potency. The *linga* is set within the *yoni* or vulva of his female counterpart, the goddess Shakti (the personification of *shakti*, divine feminine power, which is believed to emanate through the universe and animate all things). The union of Shiva and Shakti, visualised in the *Shiva linga*, represents the fusion of masculine and feminine power within Hindu cosmology.[39]

FIG. 62
Shiva linga, probably 1700–1900. India. Sandstone. H. 23.5 cm. British Museum, London, M.653.

Passion and sexual pleasure permeate the story of the goddess Radha. The *Gitagovinda*, a sacred and erotic poem composed in the twelfth century by the Brahman saint Jayadeva, recounts the sensual love between Radha, a beautiful mortal cowherd, and the young god Krishna (an avatar of Vishnu). Charting the highs and lows of their affair, the poem tells of Radha's intense desire for Krishna and her despair when he abandons her for the attentions of other beautiful women. After Radha withdraws from him, Krishna regrets his unfaithfulness and pleads for her return. Although Radha is often viewed as a benevolent force, devoid of the aggression of Ishtar and Venus, the poem is filled with martial metaphors, and Krishna likens his longing for Radha to war, as he sings of his lover:

> Her arched brow is his bow,
> Her darting glances are arrows,
> Her earlobe is the bowstring –
> Why are the weapons guarded
> In Love's living goddess of triumph?
> The world is already vanquished.[40]

Humbling himself beneath her as testament to her ultimate victory, Krishna is reconciled with Radha at the climax of the poem:

> Displaying her passion,
> In loveplay as the battle began,
> She launched a bold offensive
> Above him
> And triumphed over her love.[41]

The text is a celebration of Radha's erotic desire, evoking the ecstasy and pain that accompany the intensity of love. On a metaphysical level, it is often interpreted as expressing the union of *prakriti* (the material world associated with femininity) and *purusha* (the spiritual world associated with masculinity) in Hindu thought, Radha's devotion to Krishna being construed as a reflection of the longing of the mortal soul to be one with the divine. For devotees of Vaishnavism (the worship of Vishnu), Radha is not just Krishna's lover but also his female manifestation and the supreme embodiment of grace and beauty. Her mortal origins are never forgotten, and it is this, along with her pre-eminent status as the most beloved of the divine Krishna, that elevates her as the path to *moksha* ('liberation').[42] In the seventeenth century, the celebrated poet Bihari opened his seven hundred verses on love, the *Satsai*, with a prayer not to Krishna but to Radha, with the words:

'Take away the pain of existence, this cycle of the world, from me Radha … You who are of this world.'[43]

A more volatile side of Radha is explored in the *Radhika-santvanam* ('Appeasing Radha', *c.* 1757–63), a series of erotic poems composed by the Telugu scholar, poet and courtesan Muddupalani. Drawing on her own desires and sexual experience, Muddupalani's work celebrates female sexual agency through Radha, whom the author portrays as dominant in her relationship with Krishna, instructing both her divine lover and his new, inexperienced wife in erotic arts. In a reversal of literary and social expectations, Muddupalani presents Radha as the seducer of Krishna and the instigator of their union, jealously possessive of Krishna's affection when he draws away from her to be with a new wife:

> If I ask her not to get too close
> For it is not decorous,
> She swears at me loudly.
>
> If I tell her of my vow not
> To have a woman in my bed,
> She hops on
> And begins the game of love.
>
> Appreciative,
> She lets me drink from her lips,
> Fondles me, talks on,
> Making love again and again.
> How could I stay away
> From her company?[44]

Muddupalani's poetry was seemingly celebrated in her own time, but a movement to republish her work in 1910, led by the artist and feminist activist Bangalore Nagarathnamma, ignited a fierce controversy, which saw the poems banned by British colonial authorities as a threat to the moral health of society. The publishers were charged with distributing obscene literature and all printed copies were destroyed. The ban was eventually overturned in 1947 and Nagarathnamma's edition finally published in 1952.[45] Today, Muddupalani's characterisation of Radha as active and forthright in the pursuit of her own sexual desire has been welcomed as a positive portrayal of female sexual liberation by some Indian feminists, who argue that if the subject matter of Muddupalani's delicate and harmonious poetry appears vulgar, it is not the work itself but society's prudish and oppressive view of female propriety that demands scrutiny.[46]

As well as poets, the mutual love of Radha and Krishna has long inspired artists. A series of miniatures, painted in gouache

between 1790 and 1810, show the couple in various stages of courtship, embracing one another while lounging on pillows and rugs, dressed in pearls and silks (fig. 63). While these paintings visualise divine love, the setting of Radha and Krishna's tryst is transposed from the forests and countryside of the *Gitagovinda* to opulent courtly palaces, perhaps in response to the influence of the many divinely inspired instructional treatises on sex, seduction and love that circulated in India from around the turn of the first millennium.

The most famous of these works today is undoubtedly the *Kama Sutra*, composed by the high-caste monk Vatsyayana around the third century CE.[47] Far from being merely a handbook of positions, as it is generally characterised in the West, the text is at the same time a devotional hymn inspired by the divine love between Shiva and Shakti and a practical guide to *kama*, concerned with maintaining and upholding *dharma*, *artha* and *kama* in balance, and cultivating the senses to elevate all aspects of sex and seduction to the status of beauty and culture.[48] Unlike later works, which were primarily aimed at married couples,[49] the *Kama Sutra* addresses all people, and, acknowledging the complexities of desire, offers guidance for new lovers, for spouses, on extramarital affairs (which Vatsyayana does not recommend), and on intercourse with multiple or same-sex partners. The text is explicitly aimed at both male and female readers, and women are not considered by Vatsyayana as passive recipients of male ardour but as equally active in the pursuit of their own pleasure. Neither does Vatsyayana advocate for unquestioning loyalty and self-sacrifice on the part of a wife to her husband. He cautions the male reader to treat his wife or wives respectfully and fairly, and warns that, if he does not, they will despise him and leave him for another man or woman.[50]

Similar attitudes can be discerned in Taoist texts from Ming Dynasty China (1368–1644), which are aimed at a male readership and contain medical and spiritual beliefs about intercourse for enhanced health and for procreation. They also stress the importance of ensuring pleasure and happiness for one's partner, for the sake of harmony and spiritual well-being, with warnings directed towards men who neglect this duty.[51] Recalling the civic importance held by Ishtar and Venus, these spiritual manuals were intended to maintain a harmonious society by avoiding the negative consequences of unfulfilled desire, but, here, although the destructive potential of passion is acknowledged, it is not embodied in the female form.

Opposite

FIG. 63
Krishna and Radha embracing on a
terrace, *c.* 1790–1810. India. Gouache on
paper. 25.9 × 19 cm. British Museum,
London, 1880,0.2278.

Sex and the positive expression of feminine power are intrinsic to
Tantra – a branch of Buddhism and Hinduism that developed
around the sixth century CE, which is today practised
predominantly in north-eastern India (particularly Bengal and
Assam), Nepal and Tibet.[52] Based on instructional texts known as
*tantra*s, practitioners (*tantrika*s) are dedicated to the pursuit of divine
awakening through meditation on, and confluence with, cosmic
forces. This is achieved in part by harnessing the subversive and
transformative power of 'taboo' substances such as meat, alcohol,
blood and sexual fluids, some of which are associated conceptually
or physically with the female body. It is believed that all aspects of
the visual, material world (*prakriti*) hold sacred power, which the
adept may channel for spiritual growth.[53] By engaging with these
substances through ritual practice, the *tantrika* confronts and
overcomes emotions such as fear and disgust in the pursuit of
enlightenment.

In Tantric Buddhism, wisdom is conceptually feminine (*prajna*)
and compassion masculine (*karuna*). Since around the eleventh
century CE, the harmonious union of these forces has been
represented figuratively through meditational *yab-yum* ('father–
mother') imagery, which combines a female wisdom goddess with
a male compassion god in sexual embrace (fig. 64). The earliest
Tantric texts advise that *tantrika*s should take on the role of these
deities, and that sexual union should be motivated not by carnal
desire but in order to achieve divinity within oneself.[54] Depending
on one's path, these instructions may be interpreted literally and
performed physically with a partner, or metaphorically and used
as a focus for meditation by celibate monks and nuns, who
embody both female and male roles at once. By channelling
the deities, the Tantric practitioner cultivates the combined
qualities of wisdom and compassion, thus becoming closer to
a divine being.

One of the most important centres for Tantric worship today is
the temple of the Great Mother Goddess Kamakhya in Guwahati,
Assam, which has been the pre-eminent site of Tantric worship
since at least the eighth century CE. According to several Hindu
texts, following the death of his first wife, Sati, the god Shiva
carried her body across the universe, almost destroying the stability
of the cosmos in his despair. In alarm, the other deities entered
Sati's body and tore it to pieces, scattering parts of her across the
earth. Each place where a fragment fell became a *shakti pitha* ('seat
of power') and a site of pilgrimage and shrines.[55] The Kamakhya
Temple is the most sacred of these sites and is said to be the place
where her vulva fell, represented by a naturally formed crevice
overlying a natural spring which is located inside the *garbhagriha*
('womb-chamber') in the temple.[56] Kamakhya's name references

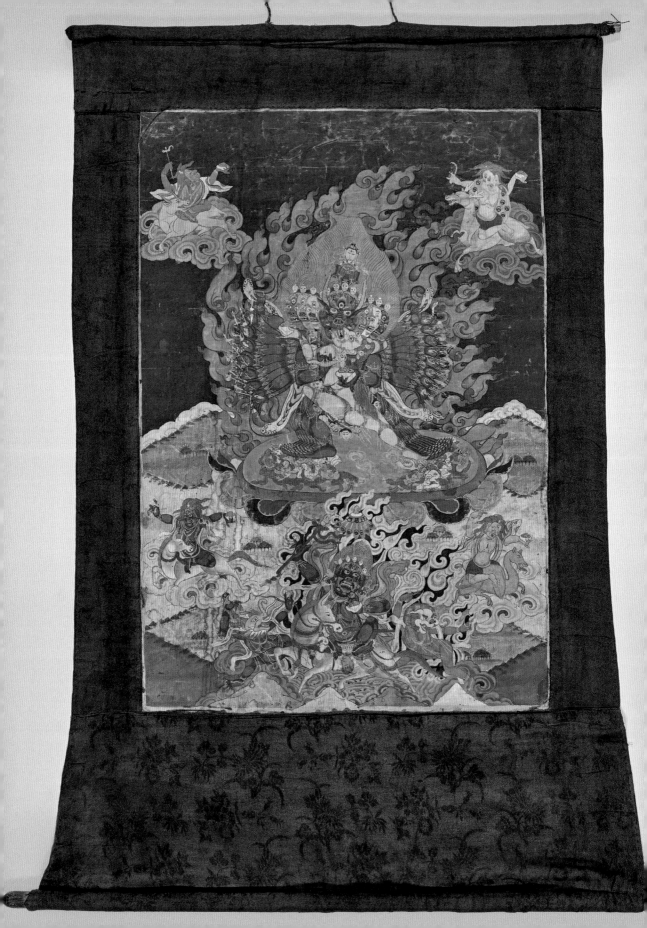

the concept of *kama*, and the stone is worshipped as the goddess herself, the source of creation and reproduction. During the Ambubachi Mela, an annual festival held in June or July to coincide with the monsoon, hundreds of thousands of worshippers from India and abroad gather at the Kamakhya Temple to celebrate the menstruation of the goddess and its life-bringing powers, at a time when natural iron oxide in the water makes the spring flow red.[57] The water trickles over the *yoni* in the temple, giving the impression that the goddess is menstruating. In Tantric tradition, reddened cloths dipped in the spring are said to offer powerful protective aid to the worshipper.[58]

Tantra places not only divine female power as central to spiritual enlightenment, but also women themselves, as embodiments of *shakti* – the active feminine energy that animates the universe – and sources of enlightenment through their sexual and menstrual fluids.[59] A particular emphasis on the power of women is found in the Tibetan *Chandamaharoshana Tantra*, composed in the tenth and eleventh centuries, and the sixteenth- to seventeenth-century *Yoni Tantra*, both of which extol the importance of worshipping the vulva as the source of all creation, and offer instructions on sexual acts that can cleanse practitioners of sins committed in past lives and facilitate union with the divine.[60] In the *Chandamaharoshana Tantra*, the goddess Vajrayogini explains that all women are manifestations of her and she should be worshipped through intercourse:

> With kissing, embrace, and the like,
> One should regularly worship Vajrayoginī.
> If one is able, one should honor her physically,
> If not, one should do so verbally or mentally.
>
> Worshipped by him, pleased,
> I shall grant complete attainment.
> I am none other than the form
> Found in every woman's body.[61]

The instruction of gurus is intrinsic to the initiation of *tantrika*s into ritual mysteries. Texts such as the twelfth- to thirteenth-century *Rudrayamala Tantra* and the later *Tripurarnava Tantra* (sixteenth to eighteenth centuries) make the divine affinity of women explicit by affirming women's natural superiority as gurus and the greater efficacy of their instruction for practitioners over that of male teachers:

> There are no rules for women; all are said to be gurus. Merely by receiving an authoritative mantra, she is the supreme guru. She can teach by means of the authoritative mantra and obtain books. A man does not have such authority, for woman is the supreme deity.[62]

The veneration of women within Tantra is not merely symbolic. Although female *tantrika*s and gurus have been fewer in number than male teachers both historically and today, women's participation in Tantric rites is not seen as an aid to male spiritual development. Rather, it is manifest in active participation for women, aided by Tantra's broad non-observance of binary categorisations, including gender.

'THE DEVIL'S GATEWAY'

The Hindu distinction between *prakriti*, the feminine, sensory world, which encompasses *maya* ('illusion'), and *purusha*, the masculine, spiritual reality, has parallels within Western philosophy and theology. While certain aspects of South Asian belief, such as Tantra, embrace both as essential to spiritual growth, historically this has not been the case in the West. Early Christian writers, influenced by Platonic and Neoplatonic philosophies, were often mistrustful of the body and the natural world of the senses. In the second century CE, the Neoplatonic philosopher Plotinus argued that the soul must be 'cleared of the desires that come by its too intimate converse with the body'.[63] This view was later echoed by the fourth-century Christian theologian St Augustine, who described the physical body as a 'sign' of higher things, not a 'thing' to be pursued in itself.[64] Plotinus, Augustine and many other early Christian writers prized a detachment from the distractions of the body, teaching others to deny physical pleasure and comfort. Virginity and chastity came to be viewed as the ideal expression of spiritual devotion for both women and men, the only permissible exception being sex within marriage for purposes of procreation – a tenet that persists to the present day in the Roman Catholic Church's discouragement of artificial contraception.

EVE

In 313 CE Emperor Constantine declared religious tolerance for Christians within the Roman Empire, and over the course of the following century Christianity became firmly entrenched as the state religion. Early Christian theologians vociferously condemned all other religious faiths, denouncing their deities as devils in disguise. In the life of St Porphyry, written in the fifth century, the Christian saint is reported to have converted the population of Gaza to Christianity by holding up a cross to a figure of Venus, thereby forcing the demon inside to emerge and flee.[65] With the rise of Christianity, sexual desire came to be taught as the antithesis of spiritual experience, rather than as part of it, and its debasement merged with theological notions of the spiritual

inferiority of women articulated through the perception of Eve – the first woman, the first sinner, and the first temptress of Christian thought.

The story known as the Fall of Man is told in Genesis, the first book of the Bible. It tells how the first humans created by God – the woman Eve and the man Adam – were instructed not to eat from the Tree of the Knowledge of Good and Evil, but, tempted by a serpent (whom many interpret as Satan in disguise), first Eve then Adam disobeyed. A tiny intaglio carved in the third or fourth century CE in nicolo (a variety of onyx) was probably once set into a finger ring, to be used as a seal and worn as an expression of faith and belief (fig. 65). Carved in a simple style, with little more than scratches to delineate the figures, Adam and Eve stand on either side of the Tree of Knowledge. The serpent, coiled around the trunk, faces Eve, who reaches her hand towards it, indicating the critical moment when humankind, specifically womankind, disobeyed God. Both figures already wear garments over their genitals, referencing their soon to be awakened shame of nakedness. In scripture the serpent, described as 'the most cunning of all the creatures', spends five verses overcoming Eve's reluctance, persuading her that God has lied and that she will not die if she eats the fruit but will become godlike herself, possessing all knowledge of good and evil. It is from this desire for wisdom that Eve eats: 'So when the woman saw that the tree was good for food, and that it was a delight to the eyes, and that the tree was to be desired to make one wise, she took of its fruit and ate.' Of Adam's participation the passage says: 'and she also gave some to her husband, who was with her, and he ate.'[66] Upon eating, their eyes are opened and they become aware of their naked bodies and try to hide. When God discovers their transgression, they are cast out of paradise, leaving as a legacy the fate of all humankind to be born in sin and to strive for ever to be reconciled with divine bliss until the coming of the Messiah.

The narrative of Adam and Eve is also found in the Qur'an, the foundational text of Islam. In contrast to the biblical narrative, Eve does not eat first: she and her husband are tempted and eat together, just as they are punished and expelled together (7:20–5; 20:120–3). However, in Christian tradition, the passage in Genesis – in particular, the brief half-sentence in which Eve hands the fruit to her husband – has been the subject of some of the most elaborate rewrites in the history of biblical hermeneutics. It has seen Eve turned from a woman seeking wisdom to a *femme fatale* who knowingly condemns humankind to sinfulness and death. In what can only be described as a frantic effort to remove any blame for the Fall from men, over the centuries Christian theologians embellished the couple's interaction to diminish Adam's culpability and place the blame squarely on Eve and women. As early as the second century, Tertullian read into the Bible passage that Eve's

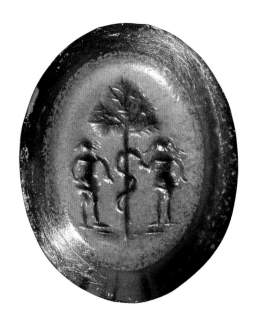

FIG. 65
Intaglio with an incised image of Adam and Eve, 200–400 CE. Italy. Nicolo. 1.4 × 1.1 × 0.4 cm. British Museum, London, 1872,0604.1381.

dangerous seductive allure was instrumental to humankind's fall into sin, writing in a polemic on women's dress:

> do you not know that you [women] are (each) an Eve? The sentence of God on this sex of yours lives in this age: the guilt must of necessity live too. *You* are the devil's gateway: *you* are the unsealer of that (forbidden) tree: *you* are the first deserter of the divine law: *you* are she who persuaded him whom the devil was not valiant enough to attack. *You* destroyed so easily God's image, man [Adam].[67]

To Tertullian, and other patristic authors, Adam was tricked by his wife, who seduced him into tasting certain destruction, grinding down his valiant moral resistance. By the Middle Ages, misogynistic attacks on Eve and the defence of Adam's innocence had become even more shrill: the theologian and chronicler Jacques de Vitry tells us that Eve 'had no rest until she got her husband banished from the Garden of Eden and Christ condemned to the agony of the Cross', and the poet Caedmon takes it upon himself to rewrite the passage entirely so that Adam is chased through Eden by Eve and a devil until he is driven mad – only then, when truly out of his wits, taking the fateful bite.[68] Even in the seventeenth century, in his epic poem *Paradise Lost*, Milton asserts that Adam took the fruit in full knowledge of the consequences but ate so as to stand beside his wife and share in her fate, making him heroic: 'not deceav'd, / But fondly overcome with Femal charm'.[69]

Artistic interpretations of the Genesis narrative in Renaissance and early modern Christian art tended to reflect the influence of the prevailing patriarchal teaching, often showing indications of resistance in the figure of Adam, whether raising his hand in protest – as in Titian's *Fall of Man* (c. 1550) – or quizzically scratching his head, while a slyly smiling Eve hands him the apple. Beginning around the thirteenth century, a tradition emerged in European art for showing not only Eve herself as beautiful and beguiling but also the serpent as distinctly female.[70] The root of this trope may be traced back to the twelfth-century French theologian and prolific biblical commentator Peter Comestor, who claimed that Satan deliberately gave the serpent a face that resembled Eve's the better to entice her.[71] In a woodcut produced in the early sixteenth century by Lucas Cranach the Elder, a half-woman, half-serpent figure whispers in Eve's ear as she hands the forbidden fruit to a seemingly reluctant Adam (fig. 66). The mirror images of the female serpent and Eve convey not only the perceived deviousness but also the foolishness of the female sex, and women's collusive responsibility for the Fall. Unsurprisingly, the condemnation and hyper-sexualisation of Eve within historical Christian art and literature has attracted criticism and ridicule within more recent feminist thought. As the historian Marina Warner notes: 'The fury unleashed against Eve and all her kind is

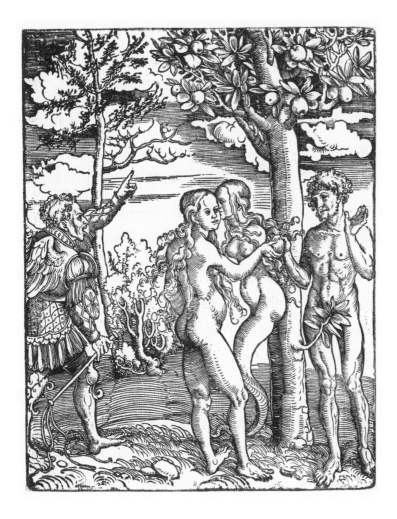

FIG. 66
Lucas Cranach the Elder, *The Fall of Man*, *c.* 1500–15. Germany. Woodcut print on paper. 28.1 × 22.2 cm. British Museum, London, 1927,0518.12.

almost flattering, so exaggerated is the picture of women's fatal and all-powerful charms and men's incapacity to resist.'[72]

Despite the prevailing rhetoric linking seduction and sin with women through Eve, medieval and early modern Christianity also witnessed a growth in mystical writing in which both male and female authors often used highly erotic language and imagery to describe the journey of the soul into God.[73] Echoing Radha's desire for Krishna in Hindu literature, for these authors it was common to represent the soul, or *anima*, as a female figure in bodily embrace with a male figure representing God or Christ, configuring humanity's relationship with the divine in terms of sexual consummation. The female body, previously the vehicle of sin, became a channel of divine redemption and communion. Texts such as these point to the complexity of ideas about sex and the body in Christian thought,[74] and parallel much Buddhist and Hindu art and sacred literature, in which an erotic sensitivity manages to co-exist with an ascetic emphasis on chastity.

The historical Christian notion that sex and female influence distanced one from the divine spread around the world in the wake of Christian evangelism. When Christian missionaries wrote accounts of other cultures, this ingrained association indelibly influenced their understanding of the religious, and sexual, traditions they encountered. Much of popular understanding about pre-Hispanic life and belief in Central and South America is drawn from such accounts, composed by Catholic missionaries, who followed Spanish conquistadors to 'New Spain' in the sixteenth century. The people of pre-Columbian Mexico recorded their religious beliefs through sculpture, monumental architecture and libraries of codices – pictorial manuscripts that included not only rituals relating to their many goddesses and gods, but also laws, genealogies and cultural practices. Almost all Indigenous codices were destroyed during the conquest, though a few were taken to Europe as exotic curios and have survived. Simultaneously, however, new codices were also compiled by Indigenous scribes and Christian missionaries to aid evangelical work through an understanding of the pre-existing beliefs of the population. These later codices are coloured with Christian interpretations, making it difficult to determine which elements stem from Indigenous cosmovisions and which have been edited, embellished or misinterpreted by external commentators.[75]

One deity whose post-colonial interpretation has been distinctly influenced by Christian moralising is the goddess Tlazolteotl. Originally worshipped by the Huaxtec culture, which flourished around the Gulf of Mexico between the tenth and mid-fifteenth centuries, and later by the Mexica (Aztecs), her name in Nahuatl has been translated by some as 'divine excrement'.[76] Pre-conquest Nahua sources indicate that she was associated with sexual behaviour, which was viewed as having a potentially damaging impact on society if excessive, but positive associations with the fertility of humankind and the earth when practised in moderation.[77] While Tlazolteotl inspired sexual desire, she was also petitioned to cleanse transgressions by absorbing the 'filth' of sexual excess committed under her influence. Huaxtec limestone statues, sometimes interpreted as representing Tlazolteotl, show her unclothed from the waist up, with an open mouth, perhaps to consume the guilt of supplicants. On her head she wears a large, elaborate headdress adorned with blooms of cotton plants indicated by circular carvings, possibly connecting her to the enrichment of the earth (fig. 67). Although Tlazolteotl was originally perceived as a dualistic force, for Christian missionaries, deeply ingrained negative associations between sexuality, sin and female power indelibly coloured interpretations of this pre-colonial deity.[78] The Franciscan friar Bernardino de Sahagún, who

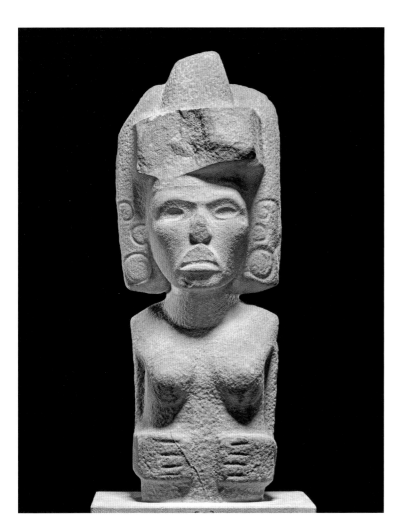

FIG. 67
Statue, believed to be of Tlazolteotl,
900–1521 CE. Mexico. Sandstone. 80.5
× 30 × 19 cm (including plinth). British
Museum, London, Am1842,0611.9.
Donated by Capt. James Vetch.

researched and composed *Historia general de las cosas de la Nueva
España* ('A general history of the things of New Spain'), more
commonly known as the Florentine Codex, described Tlazolteotl
as 'the mistress of lust and debauchery', 'a dirty, filthy and stained
goddess', and acknowledged openly that he had compiled his
compendium on the deities of the Mexica specifically so that 'their
wickedness may be plain'.[79] In a long passage, Sahagún describes
how the deity inspired sexual desire (or, as he puts it, 'evil and
perverseness') and recounts that penitents would confess their
'vanities' – in particular, adultery – to a soothsayer, who
represented Tlazolteotl, and would perform penances that involved
piercing the tongue and inserting reeds into the penis, after which
the goddess 'forgave, set aside, removed [corruption]'.[80]

 An illustration in the mid-sixteenth-century Codex Telleriano-
Remensis, compiled by an unknown Spanish missionary, contains
an illustration of an impersonator of the goddess Tlazolteotl
dressed in white and adorned with cotton (fig. 68).[81] In her hands

FIG. 68
Illustration showing an impersonator of
Tlazolteotl, Codex Telleriano-Remensis,
f. 3r. Paint on parchment. 30 × 21 cm (folio).
Bibliothèque Nationale de France, Paris.

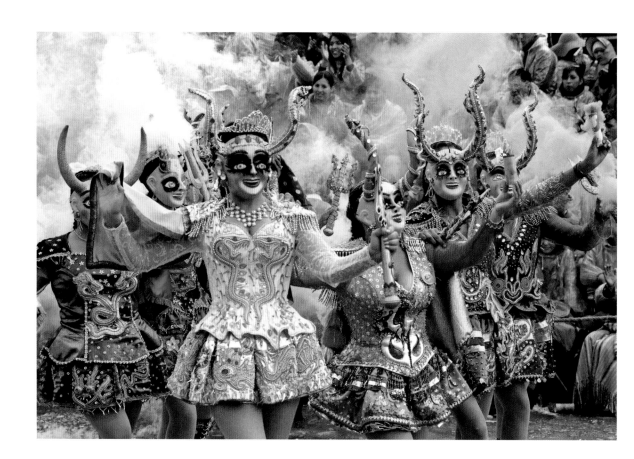

FIG. 69
Dancers perform the Diablada dance during carnival in Oruro, Bolivia, February 2017.

she holds a small circular shield and arrows, and a broom made of reeds. The accompanying text tells us that this was part of the 'sweeping of the roads' festival, particularly important to women, in which houses and roads were swept clean to eradicate evil. The festival involved a period of fasting and the making of sacrifices to vegetation.[82] The dark marks painted around the goddess's lips and on her cheek may represent the stain of the 'excrement' that she consumes. In the text, the author connects Tlazolteotl with Eve and interprets the feast as being celebrated in remembrance of the one 'who sinned by eating the fruit of the tree', calling her the goddess of 'garbage and sin' and saying that since she was the first to sin the people sweep the streets so as to purge her original transgression.[83]

An association between female seduction and sin also exists today in the Diablada (dance of the devils), a folk dance believed to have originated in the mining towns of the Andes but now celebrated across South America during February and March in honour of the Virgen de la Candelaria ('Virgin of the mineshaft'). While there are many variations, the dance celebrates the triumph of good over evil, represented through a carnival enactment of a battle between St Michael and Lucifer. Accompanying the figure of Lucifer in the dance is a troupe of young women wearing vibrant

costumes and elaborate masks with bright, prominent eyes and devil horns (figs 69–70). They represent China Supay (*china* meaning 'female' in Aymara), the wife or counterpart of Supay, an Andean deity of death. Through the influence of Catholicism and the seven mortal sins, the character of China Supay has taken on distinctly negative connotations and now commonly represents the demonic embodiment of lust and seduction, whose role in the dance is to try to tempt the Archangel Michael into sin.[84]

FIG. 70
Mask of China Supay, before 1985. Bolivia.
Painted plaster, hair and glass.
45.5 × 31 × 28.5 cm (whole object). British Museum, London, Am1985,32.44.

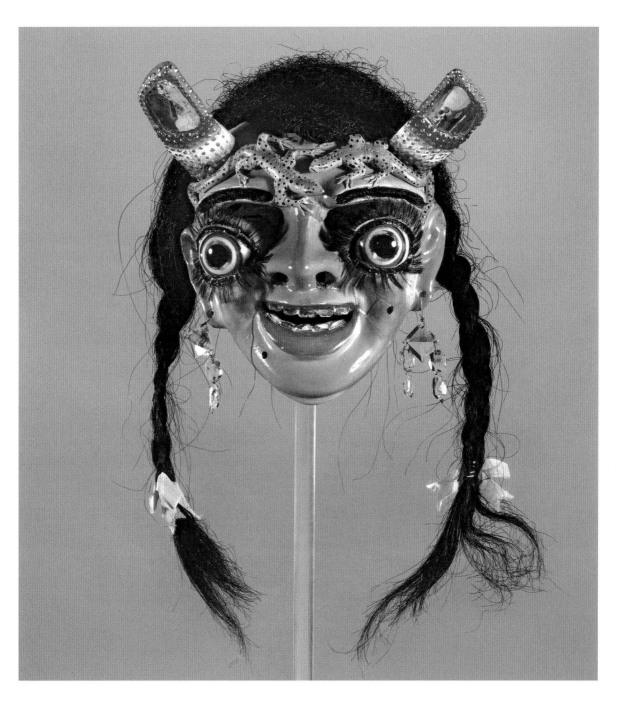

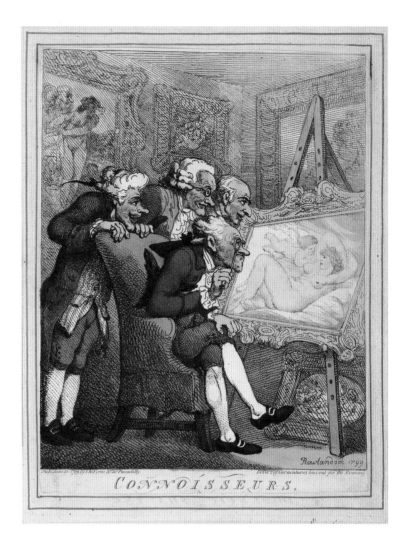

THE EVOLUTION OF VENUS AND EVE

Over the last 2,000 years, the idea of the ancient goddess Venus has become secularised – though not as an empowering emblem of passion, harmony and civic victory, in line with her former divine status, but largely for the erotic appeal of her nudity. Idealised images of Venus (or women flatteringly called Venus) have been a constant feature of Western art and iconography for centuries. Arguably the most famous depiction of Venus in the world today, Botticelli's *The Birth of Venus* (1486) reflects the indirect gaze and posture of Praxiteles' Aphrodite of Knidos. The knowing smile of the sculpture is conspicuously absent in Botticelli's painting, which depicts Venus arriving at the shore just after her birth, seemingly unaware that her naked body is being observed before her attendant covers her up. The resulting impression is not of a deity conscious of, and in control of, her power but of a dreamy ingénue.

Defined by her illicit nudity and once relegated to the private halls of wealthy men, the image of Venus in Western art since the Renaissance can be seen to epitomise the male gaze: the depiction of a woman from a male perspective as the passive object of heterosexual desire. The idea of Venus as a vehicle for the fulfilment of male fantasy was a phenomenon acknowledged and parodied by the eighteenth-century satirist Thomas Rowlandson, whose print *Connoisseurs* (1799) shows four elderly men peering voyeuristically at a painting of the young naked Venus (fig. 71). By the eighteenth century, Venus had also become the patron 'deity' of the so-called 'Hellfire clubs' of Britain, quasi-secret 'gentlemen's' clubs, devoted to hedonism, debauchery and the general undermining of the puritan Christian morality and scientific Enlightenment values of the age. One such group, founded in 1732 in Scotland and known as the Beggar's Benison, claimed that its foundations extended back to Adam and Eve and the origins of sexual knowledge in the Garden of Eden. Either their motto, 'May Prick nor Purse never fail you', or the divine instruction of Genesis 1:28, 'Be fruitful[l] and multiply', appeared on pendants and tokens given out to their members; these featured Adam and Eve on one side and Venus and her lover Adonis on the other, equating the first woman of Christian belief with the pagan goddess of desire (fig. 72).[85]

In the early twentieth century, such depictions of Venus became the target of feminist frustration. In 1914 the suffragette Mary Richardson entered London's National Gallery with a meat cleaver and slashed its newly acquired, prized painting *The Toilet of Venus* (1647–51) by Diego Velázquez. Newspaper reports at the time referred to the damage to the painting in terms of murder, and the

FIG. 72
Beggar's Benison club medal depicting Adam and Eve with a lion in the garden of Eden (obverse), and Venus, Cupid and Adonis alongside a banner with the motto 'Lose no opportunity' (reverse), 1822 or 1826. Scotland. Silver and gold. Diam. 3.4 cm. British Museum, London, MG.997. Donated by Montague Guest.

body of Venus as bruised and mutilated, a response that highlights the passivity with which Venus – once the embodiment of passion – had come to be associated (fig. 73).[86]

Throughout the twentieth and twenty-first centuries, narratives surrounding the female body and nudity in art have largely become the subject of secular rather than religious debate, with images of Eve and Venus employed by artists as a means of exploring wider ideas related to topics including sexuality, gender, identity, colonialism and race. Feminist artists have been attracted to the figures of Venus and Eve as two archetypes of feminine seductive power indelibly imprinted on Western cultural mindsets. Conscious of, and reacting against, the patriarchal bias that has determined the reception of these figures, many have sought to reimagine their narratives in new ways.

Deliberately drawing on the figures of both Eve and Venus, in the late twentieth century the American artists Carolee Schneemann and Hannah Wilke used their own naked bodies to

FIG. 73
Image released by the National Gallery of the *Toilet of Venus* after it was slashed by Mary Richardson. Emery Walker, photograph of the damage to the painting, 1914. National Portrait Gallery, London, CAP00402.

probe ingrained ideals of female passivity, beauty and the tradition of positioning the female form as the object of male gratification. In a photograph from the series *Eye Body: 36 Transformative Actions for Camera* (1963), Schneemann presents herself as subject, combining her frontal nudity with the materials of her artistic environment – paint, chalk, grease – and two garden snakes slithering on her torso, a visual reference to the serpent who tempted Eve (fig. 74). While Eve's 'transgression' instigated a shame of female nudity, Schneemann showcases and celebrates her naked body, complete with visible clitoris, becoming, simultaneously, active seeing subject and object. As she explained, 'The image is disturbing and attractive because of its association with an archaic eroticism, but its contemporary confrontation with taboos remains to be addressed.' The images of this series were initially met with criticism and attacked for being 'narcissistic and lewd'. As Schneemann wrote:

FIG. 74
Carolee Schneemann, *Eye Body* #5, 1963.
USA. Gelatin silver print. 61 × 50.8 cm.
The Museum of Modern Art, New York,
1780.2015.1. Gift of the artist.

FIG. 75
Hannah Wilke, deteriorated *Venus Pareve* chocolate sculpture in Wilke's Greene Street studio, 1982. USA. Photograph by Hannah Wilke. Hannah Wilke Collection & Archive, Los Angeles.

Deteriorated versions of Wilke's *Venus Pareve* sculptures can be found in collections such as that of the Jewish Museum, New York.

Western, masculist art history has been obsessed with the female nude, but the image of a contemporary artist as a genitally sexed nude sets off a tireless round of inquisition: what is the meaning of this 'obscene' image? … A measure of this Western psychosis was clarified when I realized there were only two roles offered for me to fulfill: either that of 'pornographer' or that of emissary of Aphrodite.[87]

In a similar vein, Wilke's *Venus Pareve* (1982) comprises nude self-portrait sculptures cast in kosher chocolate (fig. 75) – the Hebrew word *pareve* indicating food that may be eaten without restriction – critiquing the perception that women's bodies exist purely as objects of male consumption.

More recently, the Kenyan-born artist Wangechi Mutu has incorporated the figure of Eve in a multi-layered diptych collage, *Yo Mama* (2003), which interrogates issues surrounding otherness, violence, female representation and race (fig. 76). Eve is reimagined as the pioneering Nigerian women's rights activist Funmilayo Anikulapo-Kuti, who is known for campaigning against the practice of female genital mutilation and is also the mother of the Afrobeat musician Fela Kuti. Aligning the biblical first woman with African feminist activism, Mutu presents a fantastical female figure triumphantly inhabiting a visionary landscape as she moves between two worlds, while slinging a decapitated serpent over her shoulder and spearing its severed neck with the heel of her stiletto. As the artist explained:

The figure exists in an imaginary outer space, clutching a mangled serpent, the phallic and mythological creature that instigated the downfall of Eve … The image and title are infested with the inherent contradictions that were the experience of a radical like Funmilayo. A visionary and brave fighter, she was caught in the upheaval of the creation of a nation's identity.[88]

In her chimerical constellations of powerful female characters, Mutu seeks to re-create mythological narratives and subvert preconceptions of the feminine, arguing that 'a lot of the stories entrenched in historical and patriarchal religious renderings, are the basis for the maltreatment of women still today.'[89]

❧

Whether viewed positively or negatively, or both, sex is an act that lies at the root of life and is, in human culture, inextricably tied to the dominance of emotional desire over rational thought. It is a primal driving force that has long been attributed to the designs of otherworldly powers. From a sociocultural perspective, sexual passion has often been framed as a powerful yet potentially chaotic force, expressed in belief through dualistic deities who bring both balance

and instability. While Christian narratives have predominantly framed carnal attraction as either a mortal failing or as emanating from demonic rather than divine sources, certain esoteric branches of both South Asian and Christian traditions have approached sexual experience as a means of understanding and achieving spiritual union.

The range of perspectives expressed through literature and ritual practice within and among different cultures emphasises that there has been no single positive or negative approach to sexual attraction in spiritual thought. However, masculine heterosexual perspectives have dominated commentaries on both religion and culture, particularly throughout Eurasian history, and have, more often than not, connected sexual urges with the female body, in turn shaping cultural views of women and their impact on society.

Today, gender-equality movements promote a louder public voice for more diverse perspectives, and such embedded social views are being critiqued and revised. These movements challenge not only attitudes to sexuality but also broader interpretations of instinctual and emotional actions as inherently harmful and feminine – characterisations that are found historically the world over in the many demons, witches and malevolent spirits of human belief and superstition, who are the subject of the following chapter.

FIG. 76
Wangechi Mutu, *Yo Mama*, 2003. USA. Ink, mica flakes, synthetic polymer sheeting, cut and pasted printed paper, painted paper and synthetic polymer paint on paper. 150.2 × 215.9 cm. The Museum of Modern Art, New York, 2511.2005.a–b. The Judith Rothschild Foundation Contemporary Drawings Collection Gift.

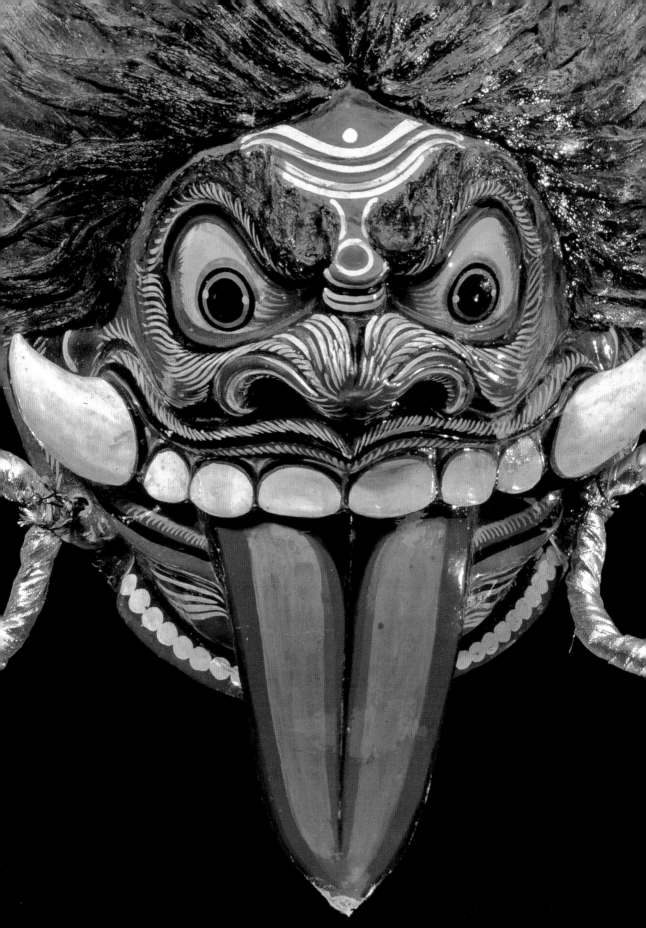

MAGIC
& MALICE

By God, if wommen hadde writen stories,
As clerkes han withinne hir oratories,
They wolde han writen of men moore wikkednesse
Than al the mark of Adam may redresse.

Geoffrey Chaucer, 'The Wife of Bath's Prologue', *The Canterbury Tales*[1]

Across world belief, misfortune has regularly been attributed to the actions of malevolent entities – demons, monsters, witches and divinities intent on destroying or corrupting humankind. Whether intrinsic to religious world-views or existing within local superstition, folklore and legend, these figures personify cultural and spiritual concepts of evil, wielding powers that are held to destabilise social harmony, and bring chaos, misery and suffering to human life. Yet many of these beings are also ambiguous. Despite the terror that accompanies them, they may fulfil an important sociological role, providing an explanation for bad luck and a target for anger and grief, or enforcing moral and social expectations through the threat of supernatural harm: we might wonder whether fear of the hideous child-snatching Dogai of the Torres Strait Western Isles, or the seductive but deadly Slavic *rusalki*, was not actively encouraged by mothers and wives attempting to keep naughty children and philandering husbands in check.[2] Alternatively, their presence in the world may be viewed as a requisite counterpoise to forces of good, operating to maintain cosmic equilibrium; in these cases, while 'evil' forces are to be avoided and perhaps subdued, their existence is considered unavoidable and necessary. Some may even be protective.

In some ancient and modern societies, outspoken, ambitious and independent women have often been viewed with suspicion or disdain, particularly in cultures that place a high value on female domesticity and submissiveness. Such qualities are reflected in the female villains of world belief – who may be divine, demonic or mortal – testifying to deep-seated cultural neuroses concerning the potential of female behaviour to disrupt the status quo. While some of these beings pose a relentless, immortal threat to humanity, others, in legends from ancient Greece to medieval India and Edo

Japan, are overpowered and killed by 'heroic' men, who thereby restore patriarchal order and destroy the threat of unsanctioned female behaviour. Over the course of time, and as cultural norms have been challenged and have changed, many of these traditional 'monsters' have been seen in a new light and have found new meaning as icons of female autonomy and rebellion: their narratives have been revised and rewritten to reflect on the injustices and suffering that permeate their stories, and their images have been appropriated as emblems of women's empowerment.

THE INVERTED MOTHER

The most horrifying trait attributed to many malign female beings is that they attack and kill children. Even with the aid of modern medicine, pregnancy, childbirth and infancy are dangerous times in the lives of both mother and baby. Notably, supernatural forces believed to harm children and pregnant women are overwhelmingly perceived as female themselves, embodying a perverse inversion of maternal protection.

LAMASHTU

> She is monstrous, the Daughter-of-Anu, who wreaks havoc among
> the babies.
> Her paws are a snare net, her bosom spells death.
> Cruel, raging, malicious, rapacious, violent,
> […]
> She lays hands on the womb(s) of women in labour,
> she pulls the babies from (the hold of) the nannies,
> suckles (them), sings (to them), and covers (them) with kisses.[3]

Fear of diabolical female beings, who bring death rather than life to the young, can be found as early as ancient Mesopotamian belief. First mentioned in early Sumerian texts, Lamashtu, the child-snatcher and bringer of disease, was the most feared goddess of ancient southern Iraq. The daughter of the sky god, Anu (in Sumerian, An), she specifically preyed on pregnant women and new-born infants, stealing the foetus from the womb and suckling infants with her poisoned milk. Spells surviving from the second millennium BCE describe how, with long claw-like fingers, she slithered into the houses of women in labour like a snake.[4] Lamashtu was portrayed in art with the head of a lion and the ears and teeth of a donkey; she appears in an image engraved on a Neo-Assyrian protective amulet with taloned feet, standing on the back of an ass. In each hand she grasps a snake, while a pig and a dog – animals considered to be unclean – suckle at her breasts (fig. 77).[5] Variously said to have been cast out of heaven for her

wickedness, or sent to earth by her father to control the human population, she could be kept at bay through complex rituals and amulets.[6] One spell describes how dust from liminal spaces such as doorways and street crossings should be mixed with dust from the temples of Ishtar and Ninurta (a protective warrior god) and moistened to make a plaque, which should then be inscribed with celestial signs and the words 'Fierce is the Daughter of Anu', to be hung above the bed. In addition, Lamashtu's sacred names should be painted on the doors and windows, along with images of watchdogs named 'Fast-is-his-attack', 'Watch-all-night' and 'Overthrow-the-wicked-one'.[7] An alternative line of defence was to summon the aid of the demon Pazuzu by placing a stone or metal amulet bearing his image around the neck of a woman in labour (fig. 78). The sight of Pazuzu was thought to deter Lamashtu from entering a bedroom and harming a mother or child. Best known today as the demon who possesses the young Regan in the film *The Exorcist* (1973), in ancient Mesopotamia Pazuzu was the bringer of plague and storms, but would battle with Lamashtu out of mutual hatred.[8]

LILITH

Lamashtu embodied the horror of infant mortality, and her inhumanity is emphasised by her bestial form. However, in later Middle Eastern and European belief, the fear of infant death assumed a darkly sexual aspect in the form of Lilith.[9] Since the late first millennium CE, Lilith has been known within Jewish demonology as the first wife of Adam and the consort of Satan. Her origins are often thought to lie in Mesopotamian demons known as *lilitu* (feminine) and *lilu* (masculine), respectively succubus and incubus-like beings, said to prey on men, women and children, bringing death and sterility.[10] Over the centuries, this unruly and ill-defined rabble of malevolent beings gradually coalesced into a single, terrifying, and undoubtedly female, demon. This transitional stage from many to one is witnessed on incantation bowls created during the sixth to eighth centuries CE in what is now Iraq. These roughly made ceramic bowls, buried upside down under the thresholds of houses, were inscribed with personalised charms to protect the named patrons from a dizzying array of demonic forces. The swirls of texts that cover their inner, and sometimes outer, surfaces contain magical incantations, secret names of demons, and drawings, so that when the specified demon came near, it would be trapped beneath the bowl and bound by the spell. The name Lilith appears with striking regularity, sometimes grammatically singular and feminine, but also masculine or plural. In the centre of one bowl appears a rare early image of Lilith in female form, with wild hair and exposed breasts, struggling madly against bindings that hold her ankles and wrists, with her arms

FIG. 78
Amulet showing the head of the demon Pazuzu, 800–500 BCE. Iraq. Copper alloy. H. 9 cm (approx.). British Museum, London, N.275.

Opposite

FIG. 77
Amulet depicting the demon Lamashtu standing on an ass and suckling a dog and a pig, 800–550 BCE. Iraq. Stone. 12.7 × 6.4 cm. British Museum, London, 1925,0715.1.

crossed in front of her chest (fig. 79). The accompanying text makes clear the fear she inspired:

> The evil Lilith who leads astray the hearts of human beings and appears in a dream of the night and appears in a vision of the day. She roasts [her victims] and casts [them] down, as a nālā-demon [nightmare demon] she falls [upon them], she kills boys and girls, [male] babies and [female] babies. She is subdued and sealed from the house and threshold of Bahrām-Gušnasp[.][11]

The name of the petitioner, Bahram-Gushnasp, suggests that he was a follower of Zoroastrianism (an ancient pre-Islamic religion of Iran still practised today). Incantation bowls were made by people of many faiths living in the region and demonstrate a widespread fear of Lilith that crossed religious boundaries. The perception of Lilith as a succubus who attacks sleeping victims is also found in the Talmud, the foundational text of Jewish law, composed around 500 CE, which warns men, and perhaps also women, not to sleep in a house alone in case they are attacked by Lilith.[12] Legal language was commonly employed in the banishment of Lilith. An incantation bowl inscribed in Mandaic (indicating that the author followed the Gnostic religion of Mandaeism), was created to protect a woman named Bashniray

Opposite

FIG. 79
Incantation bowl against Lilith, with an illustration showing the demon captured and bound, 500–800 CE. Iraq. Painted pottery. Diam. 17.6 cm. British Museum, London, 1974,1209.2. Donated by M. Mahboubian.

FIG. 80
Incantation bowl against Lilith, 500–800 CE. Iraq. Painted pottery. Diam. 18.5 cm. British Museum, London, 1881,0714.3.

after a particularly terrifying nightmare; it employs the language of divorce, addressing Lilith as 'eldest of the female goddesses' and compelling her to leave with her dowry (fig. 80). Other magico-religious methods to repel Lilith, used across the Middle East and Mediterranean, included carrying gems or sewing them into clothing for protection. A small oval gem, carved in haematite and dating to the fourth century CE, shows a mounted male rider, identified as the biblical King Solomon, trampling Lilith under his horse and piercing her with a spear. On the other side are engraved the Greek words σφραγίς θεοῦ ('Seal of God') (fig. 81).

Lilith was first described as Adam's first wife in the satirical text *The Alphabet of ben Sira* (c. 700–1000 CE). According to the anonymous author, Lilith was the first woman created by God (Genesis 1:27), and – unlike Eve, who was made from Adam's body – she was formed at the same time and from the same earth as her husband. In Eden, Adam insisted that Lilith lie under him during sex as a mark of his superiority, but she refused, claiming that they were equals.[13] When Adam complained to God about Lilith's insubordination, she fled Eden, settling near the Red Sea, and refused to return, even when ordered to by God and his angels. The episode ends with Lilith declaring that her only purpose is to destroy babies – a seemingly incongruous statement, but no doubt based on her reputation, already well-established in earlier sources, as the cause of infant mortality.

This interpretation of Lilith as the anti-Eve was expanded in the branch of Jewish mysticism known as Kabbalah, which developed from esoteric interpretations of Hebrew scripture and secret revelations from God. Kabbalist scholars extended Lilith's cosmic status, coming to view her as the consort, or female counterpart, of Satan. This status gave rise to the Kabbalist belief that Lilith and Satan (often called Samael) were deliberately created by God from a singular form – as were Eve and Adam, of whom they are a diabolical mirror image – and that they will ultimately be destroyed by the coming of the Messiah.[14] In some Kabbalist accounts, God is also described as both male and female, so while Lilith and Satan mirror the first humans in Eden, they are also the bi-gendered inversion of the divine.[15]

Since the nineteenth century, Lilith's cultural relevance has grown exponentially. No longer only discussed in religious contexts, she has come to embody a simmering and intractable defiance of patriarchal moral expectations. Her reputation as the untamed woman, the reverse of conservative feminine decorum, captured the imagination of Romantic painters and poets, who presented her in the guise of a fantasy as much as threat. Danger vies with attraction in Dante Gabriel Rossetti's *Lady Lilith* (1866–8), in which a fair-skinned woman languorously combs her flowing auburn hair, an emblem of female sexuality in Pre-Raphaelite painting. A watercolour version of the painting made in 1867 was originally

Opposite

FIG. 81
Intaglio depicting a rider stabbing a woman, probably Solomon and Lilith, 4th century CE. Eastern Mediterranean. Haematite. 2.9 × 1.8 cm. British Museum, London, 1986,0501.5.

posed by the model Fanny Cornforth, Rossetti's lover (fig. 82). Lilith is shown absorbed by her reflection in a mirror, subverting the stereotype of the passive Victorian ingénue.[16] Rossetti attached lines from Goethe's *Faust* to the original frame: 'Beware … for she excels all women in the magic of her locks, and when she twines them round a young man's neck, she will not ever set him free again.'[17] Lilith was also a source of fascination for decadent poets and artists of the *fin de siècle* looking for transgressive subject matter that would upset the status quo. Inspired by the unsettling imagery of artists such as Aubrey Beardsley, a 1920s lithograph by the symbolist illustrator and draughtsman Henry Weston Keen presents a brooding, muscular Lilith, naked apart from a black robe, which swirls around her, and seated above a pile of skulls and tiger lilies (fig. 83). Backlit by a large nimbus, she glowers from under heavy black hair, her eyes cast in shadow, projecting a more menacing aura than Rossetti's quietly seductive interpretation.

Writing in 1984, the feminist art historian Virginia Allen interpreted Rossetti's *Lilith* as an expression of the anxieties of both the artist and his audience in relation to the growing movement for women's emancipation and the threat of the 'New Woman' in

FIG. 82
Dante Gabriel Rossetti, *Lady Lilith*, 1867. England. Watercolour and gouache (after version in oil on canvas, 1866–8, Delaware Art Museum). 51.3 × 44 cm. The Metropolitan Museum of Art, New York, 08.162.1. Rogers Fund, 1908.

FIG. 83

Henry Weston Keen, *Lilith*, 1925–30.
England. Lithograph on oriental paper.
30.3 × 14.2 cm. British Museum,
London, 1935,1128.11. Donated by Miss
M.V. Barnes through Arnold Keen.

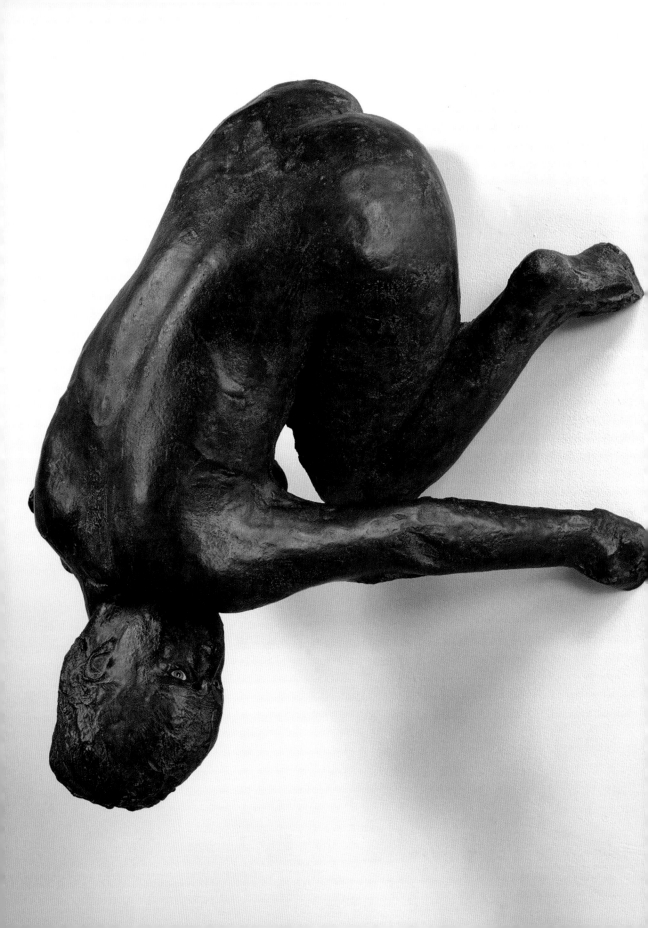

Victorian Britain. Allen argued that Rossetti's Lilith represented an independent and intellectual woman, freed from the burdens of domesticity, and perceived as a modern destroyer of patriarchy.[18] Embracing this ideal, many authors and activists from the mid-twentieth century onwards have been drawn to Lilith as an unapologetic icon of feminist resistance, autonomy and equality. Her name has been given to the Jewish feminist magazine founded in 1976 with the tagline 'Independent, Jewish and Frankly Feminist'; to a music festival of the 1990s, Lilith Fair, organised by the Canadian singer–songwriter Sarah McLachlan, which promoted female solo artists and female-fronted bands; and to a Texan charity providing financial aid to women wanting to access abortions.

In art, too, Lilith continues to fascinate, with painters such as the Argentinian–Italian Surrealist Leonor Fini drawing on her in their work. Playing with verisimilitude, the American artist Kiki Smith's arresting sculpture *Lilith* (1994) was cast from the body of a real woman (fig. 84). Her piercing eyes of blue glass directly confront the viewer through a sharp turn of the head as she crouches on all fours against the wall, endowing the sculpture with an unsettlingly lifelike quality. Tellingly, Smith positions the figure so that her anatomy is not visible, preventing a voyeuristic view of her body. This vision of Lilith is both defiant and unnerving, possessing an intangible quality that resists fixed interpretations – a nod, perhaps, to her shifting identity through time. In the words of the artist, 'Lilith becomes this disembodied spirit that goes off and wreaks havoc and doesn't want to be subjugated. Here she is transcending gravity and the constraints of her body.'[19] Yet despite her modern identity for some as a feminist ally, for others Lilith's reputation for malevolence remains alive. Smith recalls that when her work was acquired by the Metropolitan Museum of Art in New York in 1996, one Jewish employee, who was pregnant at the time, refused to go into the room where the sculpture was installed out of superstition that the demon would harm her child.[20]

CIHUATETEO

While the reception of Lilith as a positive, empowering force is a relatively recent phenomenon, other spiritual figures connected with infant death have long held a morally ambiguous cultural status.

> And when the baby had arrived on earth, then the midwife shouted; she gave war cries, which meant that the little woman had fought a good battle, had become a brave warrior, had taken a captive, had captured a baby.[21]

To the Mexica (Aztecs), childbirth was war. Mothers who died in childbirth were honoured like fallen warriors and deified for their bravery and sacrifice. They became Cihuateteo ('divine women')

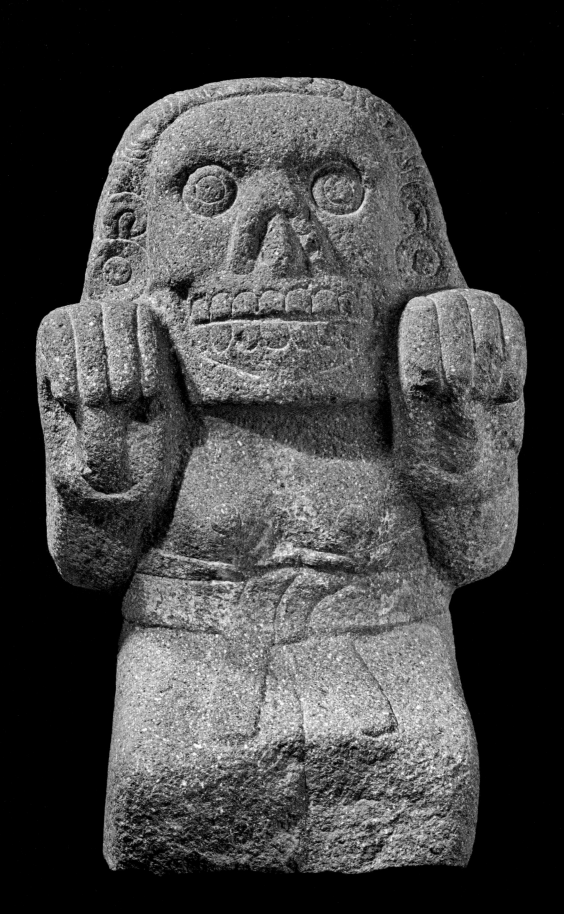

and did not go to Mictlan, the land of the dead, but to Cihuatlampa ('the land of women') located in the western sky. As fallen male warriors were believed to accompany the sun as it rose in the east, the Cihuateteo, dressed for battle, accompanied the sun as it set.[22] The Spanish Franciscan friar Bernardino de Sahagún, who recorded Indigenous practices of the Mexica in the sixteenth century, observed that young men would try to steal body parts of women who died in childbirth, requiring their graves to be guarded for four days after burial. If their theft was successful, the men would wear the body parts, such as a finger, as a talisman to bring them strength and courage in battle.[23]

Sahagún also records that, as well as being honoured, the Cihuateteo were feared. The danger they posed appears to stem from a belief that their lost chance of motherhood would compel them to seek redress from the living. On five days of the Aztec calendar, the Cihuateteo were believed to descend to earth, causing paralysis and madness to anyone who encountered them, and stealing the children of the living to substitute for their own lost offspring. A statue, carved in the fifteenth or early sixteenth century from volcanic rock, depicts the terrifying, kneeling image of a Cihuateotl (fig. 85). Wild, bulging eyes stare out of her corpse-like face and, with teeth bared, she raises her hands in front of her like claws. Large ear ornaments denote her former beauty and her lower body is wrapped in a skirt, leaving her chest exposed. This statue would originally have stood in a shrine dedicated to the Cihuateteo or at a crossroads, where such beings were believed to appear, intended perhaps as a focus for sacrifices to appease the spirit or designed to scare her away.[24] On top of her head, among the tight curls of her hair, is carved the glyph for the date '1 Monkey', denoting the day on which she was believed to appear.

TRANSFORMED THROUGH SUFFERING

Suffering and injustice feature prominently in the stories of many mythological monsters from across world beliefs. The snake-haired Medusa of Greek and Roman mythology, who turned people to stone with a single look, was in some ancient accounts a survivor of rape. In the Hindu epic the *Ramayana*, the grieving nymph Taraka is transformed into a monstrous cannibal when she tries to avenge the death of her husband; and in Balinese literature, the witch Rangda sends a plague upon her city when no man has the courage to marry her daughter. Considerable ambiguity permeates these stories: in myth, the anger and power of these female figures is turned against society, and they are usually killed (by a man) so that the status quo may be restored; but other interpretations – some stretching back centuries – have been inclined to view them as far more sympathetic, and even protective, forces.

Opposite

FIG. 85
Figure of a kneeling Cihuateotl, *c.* 1400–1521. Mexico. Andesite. 74 × 45 × 42 cm. British Museum, London, Am1990,10.1.

FIG. 86
Architectural moulding (antefix) in the
form of Medusa's head, *c.* 500 BCE. Italy.
Painted terracotta. 30 × 33.4 × 11 cm.
British Museum, London, 1877,0802.4.
Donated by Alessandro Castellani.

MEDUSA

The gorgon Medusa, with her petrifying stare, is one of the
best-known monsters of ancient Greek mythology and has long
occupied a complicated position in Western thought. As a
favourite villain of modern computer games and fantasy literature,
her image in popular culture tends to be one of pure evil, but her
power both to harm and to protect, and the story of her death at
the hands of the hero Perseus, have been the subject of moral
debate and cultural reinterpretation from the classical world to the
present day.

The most familiar myth surrounding Medusa recounts how
Perseus, son of Zeus and the mortal princess Danaë, was ordered
by the wicked king Polydectes to bring him the head of Medusa
– a supposedly impossible task, which was intended to result in the
young man's death, leaving Polydectes free to marry Perseus'

mother. With the help of the goddess Athena and the god Hermes, Perseus tracked down Medusa and her sisters to their home across the ocean and, using a reflective shield to avoid looking directly at Medusa, he stealthily decapitated her in her sleep. On his journey home, Perseus used Medusa's still-powerful severed head to kill his rivals for the hand of the Ethiopian princess Andromeda, and again to turn Polydectes to stone, before gifting it to Athena, who mounted it on her breastplate.[25]

The power of Medusa's stare made her one of the most important and popular subjects in classical art. She is typically depicted face on as an emblem of protection, as seen on a terracotta moulding created around 500 BCE (fig. 86). Once attached, as part of a set, to the roof of a temple or a private house in Capua, southern Italy, her monstrous face, bearded, and with large tusks, lolling tongue and bulging eyes, was designed to ward off any malevolent forces that approached. In this form, her imagery adorned all manner of public monuments and private objects.

In most versions of the myth, Medusa appears as little more than a plot device designed to emphasise Perseus' bravery in defeating such a terrifying foe. However, the Roman poet Ovid, writing around 8 CE, embellished the story, imbuing the character of Medusa with greater pathos. In his poem *Metamorphoses*, Ovid tells us that Medusa was once a mortal woman, famed for her beauty, who was violated by the god Neptune (the Greek Poseidon) in the temple of Minerva (Athena). Outraged, Minerva turned her anger on Medusa by transforming her luxuriant hair into snakes and ensuring that anyone who looked at her would die.[26] Hellenistic and Roman depictions of Medusa sometimes reflect the humanity of this origin story. An intaglio exquisitely carved in cornelian some time in the second or first century BCE (fig. 87) shows Medusa's youthful face in profile, fully compliant with the classical standards of Greek beauty. Her countenance is sorrowful as her head tilts slightly forward, and her eyes are downcast. The artist may have intended to capture the tragic moment of her transformation, as small wings sprout from her temples and nascent snakes, still in hair-like form, writhe around her cheek and neck.

Throughout centuries, the story of Medusa as either villain or victim has been adopted and interpreted to suit diverse political and social agendas.[27] Rationalist authors from the fourth century BCE to the sixth century CE argued that the legend of Medusa was inspired by an actual North African queen, who ruled with her sisters and was killed by a man named Perseus, but they do not all agree on the moral implications. To the otherwise obscure author Palaephatus, believed to have been writing in Athens in the fourth century BCE, Perseus was a greedy and unscrupulous pirate who murdered the noble queen when she refused to bow to his demands.[28] But to the Roman author Diodorus Siculus, of the

FIG. 87
Intaglio of Medusa, 100 BCE–100 CE. Greece or Rome, Italy. Cornelian and gold. 2.1 × 1.8 × 0.3 cm. British Museum, London, 1867,0507.388.

first century BCE, and the early Christian author Fulgentius, Perseus embodied the righteous order of patriarchy, which, aided by wisdom (Athena), brought down the unnatural aberration of female rule.[29]

Medusa's physical appearance has also elicited diverse opinions. The early fifteenth-century poet Christine de Pizan, in her pioneering feminist novel *The Book of the City of Ladies* (1405), wrote that it was Medusa's beauty, not her repulsiveness, that stunned and immobilised onlookers as if they had been turned to stone – an interpretation that also influenced Gianni Versace to make the mask of Medusa the emblem of his fashion empire.[30] More commonly, though, the hideous screaming face of Medusa has been employed in Western art and literature as a metaphor for chaos and anxiety, which must be overcome with stability, personified by the triumphant Perseus. To Francis Bacon, writing in the early seventeenth century, Medusa represented war; to Karl Marx, she personified the lurking dangers of capitalism; and to Freud and his followers she embodied the psychological fear of castration that a man experiences at the sight of his mother's genitals.[31] These readings of the ancient myth focused on the duty of individuals, society, or men specifically to embody Perseus and thus overcome and conquer a monstrous threat.

From at least the eighteenth to the twentieth centuries in Europe, the image of Medusa was used prominently in political propaganda as a metaphor for political turmoil and revolution, as may be seen on a medal, minted in 1794 in Berlin and designed to show the horrors of the French Revolution (fig. 88). Intended to discourage similar stirrings in Germany, it was produced as part of a set of six, each commemorating a prominent victim of the Terror. The obverse shows the regal bust of the French queen Marie Antoinette, crowned with a diadem, and wearing a cameo of her husband King Louis XVI on her corsage. On the reverse appears Medusa, shown not as a decapitated head but as a living being, dressed in rags with sinewy muscles and sagging breasts, holding a flaming torch and an unfairly weighted scale in which a crown and a scroll reading 'La loi' ('the law') are outweighed by a dagger. In the exergue beneath her feet is inscribed 16 October 1793, the date of Marie Antoinette's execution, contrasting the death of the queen by guillotine with the still-living emblem of mob rule.[32] Similar propaganda is still used today, often as a symbol of opposition to women's power: during the lead-up to the 2016 American election, Hillary Clinton was frequently associated with the ancient gorgon by supporters of Donald Trump, who superimposed his face onto that of Perseus holding the decapitated, dripping head of Medusa-cum-Clinton, an adaptation of the Renaissance artist Cellini's celebrated bronze. The image went viral and could be purchased on T-shirts, bags and mugs.

While this negative portrayal still permeates Western culture, in the twentieth century a number of writers and artists took a personal interest in Medusa and her myth, drawn to her identity as a victim of sexual assault, who is murdered by an intruder in her home. Within second-wave feminism, Medusa was redefined as a figurehead for feminist rage, defiance and resistance, her terrifying power turned to confront misogyny and violence against women. In the 1970s, feminist theorist Hélène Cixous rejected Freud's famous metaphor in her landmark essay 'The Laugh of Medusa' (1975), which exhorts women as authors to embrace their individual voice, sexuality and authority. Critiquing the view of 'woman' as either passive or monstrous, Cixous called for a more complex definition of the feminine, presenting a defiant and self-conscious Medusa in control of her own image: 'You only have to look at the Medusa straight on to see her. And she's not deadly. She's beautiful and she's laughing.'[33] An essentialist position was assumed by the lesbian author Elana Dykewomon in her compendium of poetry and fiction of 1976, *They will Know me by my Teeth*, which featured the classical, grotesque mask of Medusa on the front cover and was explicitly for sale only to women. Ten years later, the feminist activist Emily Culpepper published a powerful account of her experience of fighting off an attacker in her home, describing herself as 'staring him out, pushing with my eyes'.[34] Her face is bursting and 'contorting with terrible teeth', her hair is 'hissing'. Later, conjuring up the emotions she felt in front of the mirror, she recalls:

> As I felt my face twist again into the fighting frenzy, I turned to the mirror and looked. What I saw in the mirror is a Gorgon, a Medusa, if *ever* there was one … I knew then why the attacker had become so suddenly petrified.[35]

While historic interpretations have used the figure of Medusa as a canvas for projection, Culpepper embodies her as an emblem of strength and – in contrast to the original myth – survival.

In the twenty-first century Medusa has lost none of her provocative power. A heated debate erupted in 2020 when a statue by the Argentinian artist Luciano Garbati was unveiled opposite the courthouse in Lower Manhattan. The bronze reverses the power dynamic of the original myth by showing a victorious Medusa, sword in hand, grasping the severed head of Perseus by the hair. However, its unveiling was not well received by some proponents of the #MeToo movement, who criticised the decision to install a slim, hairless statue by a male artist, which adhered to sexualised white Western standards of beauty. Moreover, Medusa holds the head of Perseus rather than that of her rapist, Poseidon.[36] The ensuing discussion over the appropriateness of the message

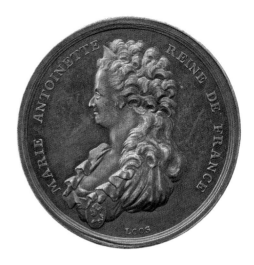

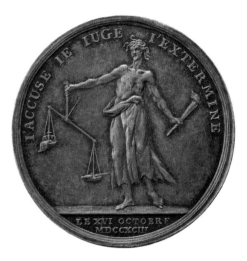

FIG. 88
Daniel Friedrich Loos, medal commemorating the execution of Marie Antoinette, showing the bust of Marie Antoinette (obverse) and anarchy and injustice personified as Medusa (reverse), 1794. Germany. Silver. Diam. 3 cm. British Museum, London, 1947,0607.637. Bequeathed by Dr Sidney Fairbairn.

and iconography, which saw others praising the involvement of male artists in the #MeToo movement, demonstrates the continued relevance of Medusa's 2,000-year-old story to modern Western gender politics, along with a renewed factionalism centred on who is permitted to tell it.

TARAKA

While Medusa's story has been appropriated for diverse purposes for centuries, other mythological monsters from across world cultures raise similar questions about societal aggression against women and the historic demonisation of female agency and rebellion. In West Bengal, Chhau dances are community-wide celebrations that enliven the Shiva Gajan festival at Loharia Temple during New Year celebrations. Recognised in 2010 by UNESCO as a form of Intangible Cultural Heritage, Chhau performances are traditionally held at night by all-male dancers, combining dance and ritualised combat in re-enactment scenes from local folklore and the famous Sanskrit epics the *Ramayana* (composed 650–350 BCE) and the *Mahabharata* (before 200 CE). Colourful, intricate masks, expensive to produce and exquisitely crafted from papier mâché and clay, are combined with elaborate costumes to transform performers into deities, demons and heroes. One such mask, made by contemporary Indian artist Sri Kajal Datta, shows the face of the monster Taraka in all her hideous glory. As in the mask of Medusa, her long red tongue hangs between boar-like tusks, as she glares at the viewer with red-rimmed eyes (fig. 89).

The *Ramayana* follows the quest of the young hero Rama to free his wife, Sita, from the demon Ravana and to return home to be crowned king. In the poem, one of Rama's first challenges is to kill the giant Taraka, who devours anyone who passes through the forest in which she dwells. When first told of his mission, Rama asks how Taraka became so powerful, and he is told that she was once a beautiful nature spirit, granted to her father as a gift from the god Brahma and given the strength of 1,000 elephants. When her husband, Sunda, was killed by the sage Agastya, Taraka, overcome with grief, vowed revenge, but when she tried to attack, Agastya cursed her to become a shape-shifting cannibal whose monstrous outer form would reflect her inner rage.

A cynical reader may question the wisdom of turning an already vengeful nymph with super strength into a yet more dangerous giant ogress, and indeed Taraka embarks on an indiscriminate murderous rampage, which results in the death and suffering of many other sages and innocent travellers. It is clear from the text that Rama is hesitant about killing Taraka, since it is ignoble to kill a woman, but his duty as a prince is to protect his people.

Opposite

FIG. 89
Workshop of Sri Kajal Datta, dance mask showing the face of Taraka, 1994. West Bengal, India. Papier mâché, clay and fibre, painted. 53 × 47 × 16.5 cm. British Museum, London, As1995,17.2. Donated by Daniel J. Rycroft.

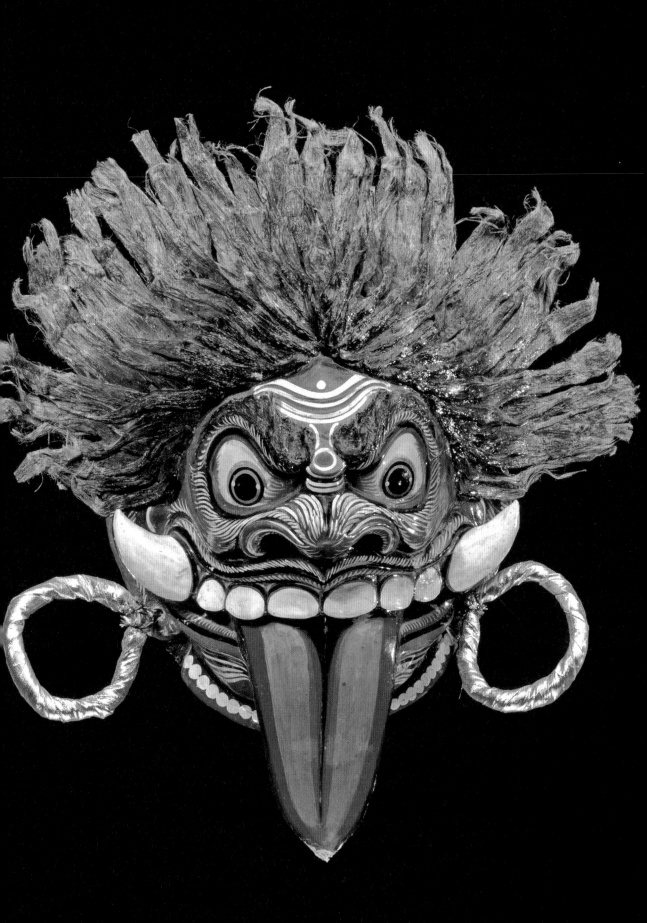

Unlike certain accounts of Medusa, little sympathy for Taraka's plight is expressed in the narrative, but she is also largely spared condemnation, specifically, for being female. Taraka is vilified for the same reasons as the multitude of other male and female demons who populate Hindu belief: she chose brute strength and aggression in pursuit of personal satisfaction, over righteousness and acceptance.

RANGDA

Masks are used in drama and religious ritual to instruct, mediate and entertain. From around the fifth to the fifteenth centuries CE, some of the islands that now form Indonesia, currently the world's largest Muslim nation, were Buddhist and Hindu. The population of Bali remains predominantly Hindu today, and within both Balinese and Indian Hinduism, good and evil are believed to exist in a constant state of flux, which maintains cosmic balance. On Bali, these forces are sometimes manifest in Barong, the leonine male protector of the people, and Rangda, the leader of demons. Rangda's name means 'widow' or 'childless woman', and she and Barong engage in constant battle, in which neither is fully victorious, re-enacted at temple sites through ritualised masked dance dramas lasting from dawn to dusk. The elaborate costumes of the performers are, by tradition, crafted on auspicious days from materials considered to have magical properties, and are stored in temples when not in use. However, since the twentieth century, modern replicas have become popular with tourists, and shortened versions of the dance are performed as entertainment for visitors across the island. A mask of Rangda, carved from wood in the twentieth century, shows only her face, with black skin, bulging eyes and huge teeth. Boars' tusks protrude from her face and the top of her head like horns (fig. 90). Such masks are paired with an enormous white wig filled with tassels and braids that flow to the ground, an elongated tongue made from red and gold fabric, long spindly fingers and layers upon layers of robes that completely obscure the human form of the performer underneath (fig. 91).[37] Traditionally, Rangda's role is danced by a respected member of the community, who usually falls into a trance during the performance, believed to be possessed by Rangda herself.

Like Medusa, Rangda occupies a morally ambivalent position, since her power may also function as a protective force. In religious contexts, performances of the battle between Rangda and Barong occur at times of societal crisis, when it is necessary to re-establish equilibrium between good and evil. They may also be performed at times of social disorder attributed to the actions of evil spirits, in particular *leyak*s – shape-shifting demons who, in their true form, appear as hideous floating heads with trailing

Opposite top

FIG. 90
Mask showing the face of Rangda, mid-20th century. Bali, Indonesia. Painted wood, gilding and boars' tusks. 27 × 31 × 15.5 cm. British Museum, London, As1984,13.13.

Opposite bottom

FIG. 91
Dancer portraying Rangda in full costume during a performance of her battle with Barong. Ubud, Bali, Indonesia, 2013.

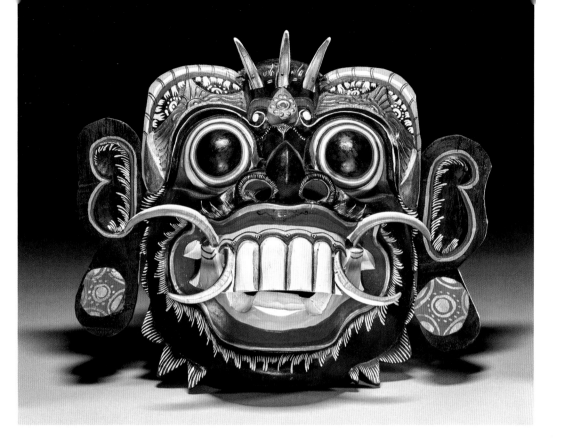

guts. When Rangda is induced to appear, through the dance, the *leyak*s are believed to flock to their leader, leaving the people temporarily in peace.[38]

In both art and literature, Rangda is closely connected to the goddess Durga. In South Asian Hinduism, Durga is viewed as a serene yet formidable warrior, battling the forces of chaos for the good of the cosmos (see chapter 4), but in Indonesian Hinduism she has acquired a distinct identity as a terrifying goddess of death and black magic.[39] A puppet made of stretched buffalo skin with horn handles shows Dewi Premoni (the Javanese name for Durga) with clawed hands, large teeth (symbolising a lack of control) and wild hair tangled with limbs from dismembered bodies. Her blue skin may be intended to resemble the colour of a putrefying corpse (fig. 92). Such puppets are used in traditional Javanese shadow-puppet theatre, called *wayang kulit* or 'skin theatre'. Performances are often based on Hindu literary myths and may last throughout the night, during which a single *dalang* ('puppeteer'), accompanied by a gamelan orchestra, manipulates the puppets against a white sheet, lit by a hanging lamp. A popular subject for *wayang kulit* performances is the *Calon Arang*, a part-historical, part-mythological Javanese–Balinese text first written down in the sixteenth century but believed to have existed in oral traditions since the eleventh.[40] The account is set during the reign of the historical King Airlangga (*c.* 991–1049). Calon Arang (Rangda)

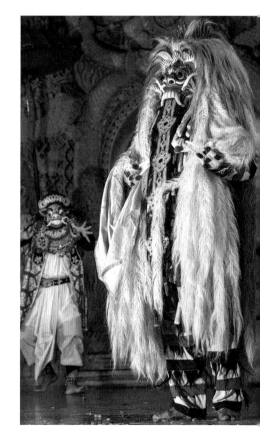

FIG. 92
Shadow puppet of Dewi Premoni
(Durga), late 18th to early 19th century
(before 1816). Java, Indonesia.
Skin, horn and gold. 75.5 × 23.5 cm.
British Museum, London,
As1859,1228.536. Donated by Rev.
William Charles Raffles Flint.

is a widow, whose reputation as a powerful witch has frightened away all suitors for her beautiful and kind-natured daughter. Distraught at her daughter's plight, she vows revenge on the kingdom, and, gathering her followers at a cemetery, summons Durga to bestow a blessing on her design to inflict a terrible pestilence upon the city. Durga consents and disease spreads through the kingdom. The desperate king calls upon a sage named Mpu Bharada for help, who conspires with Calon Arang's daughter to look at the witch's magical books, which equip him to turn her incantations against her. Finally, Calon Arang is killed but not before Mpu Bharada cleanses her of her sins and finds a husband for her daughter.

As with the story of Taraka, Calon Arang's uncontrolled rage and inability to accept misfortune with equanimity lead to her being seen as the villain of the story. However, the subtext that identifies these failings with female emotion, to be subdued and overcome by male wisdom, appears to be more apparent here than in the *Ramayana*, in which the heroic male also battles with numerous arrogant and impetuous male demons.

KIJO

The theme of transformation, whether through suffering or the inability to control emotion, is particularly prominent in Japanese mythology and folklore, in which female demons, witches and monsters outnumber male ones. Japanese belief has historically combined Shinto and Buddhist spiritual concepts alongside Chinese Confucian philosophy. During the Edo period (1615–1868), women were typically viewed as inferior to men, and in 1729 the influential philosopher Kaibara Ekiken published his *Onna daigaku* ('Great learning for women'), which outlined the proper behaviour expected of women within the military class. While reflecting the broader morality of the age, which advocated self-denial and obedience to superiors for all members of society, the *Onna daigaku* was aimed specifically at women, and this highly influential book, popularly given to brides as a wedding gift, informs the reader that women are responsible for all the failings of marriage, and society more broadly, because of their inherent weakness, sinfulness and stupidity.

> When the husband issues his instructions, the wife must never disobey them … Let her never even dream of jealousy … If her jealousy be extreme, it will render her countenance frightful and her accent repulsive, and can only result in completely alienating her husband from her, and making her intolerable to his eyes.[41]

This belief in the deforming power of jealousy in women is also expressed in the *kijo* (literally, 'demonic woman'), a mortal woman

who transforms physically into a demon (*oni*) through her own jealousy. Stories about *kijo* are popular in traditional Noh theatre. Performed in Japan since the fourteenth century, these masked and elaborately costumed performances draw on Shinto and Buddhist beliefs and are populated by deities, demons and mythical heroes. The transformation of a *kijo* is expressed through a *hannya* mask, which is usually dark red and demonic in appearance. The mask of an ordinary woman is deftly switched for the *hannya* mask on stage, through the actor's sleight of hand, to convey visually the character's physical loss of humanity. A variant of the *hannya* mask, called the *namanari*, is used at the first stage of transformation when the woman is not quite demonic, but is no longer fully human either. The facial grimace is not yet exaggerated, and her high black eyebrows, a sign of aristocratic beauty, remain clearly visible, but her usually milk-white skin has taken on a distinct pink glow and horns protrude from her temples. The precision employed in the crafting of these masks is designed to allow the actor to express the complex emotional turmoil of the character through performance: when the actor confronts the audience face on, the gaping, fanged mouth and glaring eyes conjure an image of pure rage, but when the head is tilted downwards, the lowering brow alters the expression to one of suffering and despair (fig. 93).

Hannya means 'wisdom', specifically the enlightened wisdom of Buddhist belief, which has the power to defeat *kijo*. One of the most famous *kijo* in Japanese literature is Kiyohime (Princess Kiyo), whose story is most famously told in the Noh play *Dōjōji*.[42] Thought to have been composed in the fifteenth century, but derived from moralising tales known from the eleventh, the play draws on the story of Kiyohime and a young Buddhist priest named Anchin. As a young girl, Kiyohime falls in love with the handsome priest, who stops at her father's home each year on pilgrimage. Her father jokes with her that one day she will marry Anchin, knowing full well that this is impossible because of his religious vows, but Kiyohime takes his joke to heart, and when she comes of age she confronts Anchin and asks when they will be married. Alarmed at the young woman's feelings, Anchin tries to evade her until her sadness turns to rage and she transforms into a fire-breathing serpent. Terrified, Anchin hides inside the bronze bell of Dojo temple, but Kiyohime coils herself around it, heating the metal with her fiery breath until the priest is roasted alive.[43] In the play, which takes place years after these events, all women have been banned from entering Dojo temple, but the spirit of the serpent-woman, disguised as a beautiful dancer, charms a servant into allowing her access, supposedly to cleanse her sins. Dramatically leaping inside the bell, she emerges wearing the *hannya* mask, a reflection of her true form, and wreaks havoc until the power of the gathered monks' prayers expels her and she dives into a river nearby.[44]

In the *Dōjōji*, male piety and nobility are juxtaposed with lustful, destructive female emotion – perhaps to justify the exclusion of women from Buddhist ceremonies at the time it was written.[45] In pre-modern Japanese society, quiet obedience was the highest virtue a woman could possess, and Kiyohime's emotional response to heartbreak physically transforms her into something not only hideous but dangerous. Noh theatre was not simply entertainment, and the *kijo* provided a moral lesson about the perils to good order that would ensue if women lacked the attitude of self-effacement expected of them.

Even late in the Edo period, the female demons and monsters of Japan's past continued to fascinate, and the early part of the nineteenth century saw a craze for all things supernatural. Japanese art, literature and theatre became filled with samurai warriors, who, like the heroes of Greek and Sanskrit epic, confronted and destroyed female demons. Utagawa Kuniyoshi (1797–1861), a prodigious draughtsman from a humble background, was celebrated as one of the leading artists of the day, renowned for his illustrations of macabre and heroic myth.[46] His famous *ukiyo-e* ('floating world') coloured woodblock print *Takiyasha the Witch and the Skeleton Spectre* shows, over three sheets, a *gashadokuro*, an enormous, ravenous skeleton. It has been summoned by the sorceress

FIG. 93
Suzuki Nohzin, *namanari* mask for Noh theatre, *c.* 1994. Japan. Wood. 21 × 17 × 9.7 cm. British Museum, London, 1994,0421.10. Donated by Suzuki Nohzin.

When the mask is worn by an actor its position can be used to convey a range of emotions, from rage (*left*) to anguish (*right*).

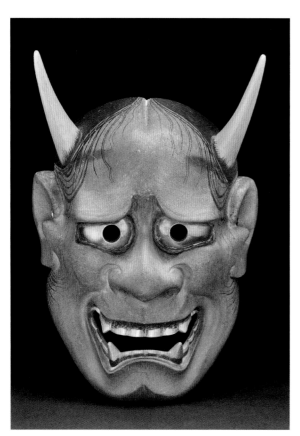
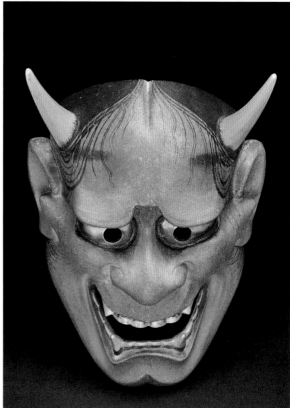

Takiyasha-hime (meaning roughly 'Princess waterfall demon warrior'), seen reciting incantations from a scroll to the left, and it looms over the young samurai Oya no Taro Mitsukuni (fig. 94). Mitsukuni, who has been sent by the emperor to kill Takiyasha-hime, wrestles with one of her henchmen on the floor of her dilapidated home. The story of Takiyasha-hime, and her ultimate defeat by Mitsukuni, is partly linked to historical events. Takiyasha-hime is considered to derive from the daughter of the historical samurai Taira no Masakado, who led an unsuccessful uprising against the emperor in 939 CE. Masakado was executed but after his death, his sympathisers deified him and made offerings to appease his vengeful spirit: a tradition that continues to this day at a shrine in Tokyo, where Masakado's severed head was supposedly displayed. The story then continues in oral legend. To eradicate all remnants of the rebellion, the emperor hunted down Masakado's family, but his young daughter escaped and, after studying the art of frog magic for many years, became a powerful sorceress. Hearing rumours of her plans to continue her father's struggle, the samurai Oya no Taro Mitsukuni set out to find her at her now dilapidated family home. When he found her, the sorceress unleashed a monstrous skeleton to kill him, but in the ensuing battle Mitsukuni emerged victorious, defeating both the spectre and the witch.[47]

WITCHES

There are many reasons why people, both in history and today, have found themselves accused of being witches. The term is broad, but whether used as a casual insult or a legal charge, it is

FIG. 94
Utagawa Kuniyoshi, *Takiyasha the Witch and the Skeleton Spectre*, 1845–6. Japan. Coloured woodblock print on paper. 58.1 × 93.6 × 3.2 cm (framed). British Museum, London, 1908,0418,0.2.1-3.

usually directed towards people believed to possess magical or otherwise inexplicable power – either through their own agency or through harnessing that of spiritual beings – which they use to influence and harm others. In Europe's and North America's not-too-distant past, and still around the world today, accusations of witchcraft have had tragic consequences for millions of people: some men, many children, but overwhelmingly women have been executed, lynched, tortured or banished owing to fear of their supposed malevolent power.

HEKATE

The goddess Hekate is one of the most enigmatic deities of the classical world. Her reputation as the infernal 'goddess of witchcraft' has become cemented in modern popular culture and stretches back to classical belief, but it is a narrow characterisation of a complex and multifaceted ancient divinity. To the Greeks and Romans, Hekate was associated with liminal times and places, and, importantly, stood between life and death at the entrance to the underworld; yet her powers encompassed protection and guidance. Her famous triform image appears in Greek art from the fifth century BCE onwards, and a Roman statue, believed to represent the goddess, shows her with three bodies and three faces, each young, with flowing hair and crowned with diadems (fig. 95). In her six hands she holds a rope and the handles of torches and daggers, now lacking their metal blades. Her flaming torches, common attributes in both sculpture and painting, situate her in darkness but associate her with guiding light, and she is often also shown holding keys to illustrate her power to open or bar the way. Around the base of the statue a dedicatory inscription reads 'Aelius Barbarus, freedman of the emperors, bailiff of this place, placed this gift to the goddess.' As a goddess of transition, Hekate is often represented in statues set up at entranceways to private and sacred spaces – perhaps as implied by the inscription here – or at road junctions, where each of her three faces looks down a different path.[48]

Hekate's earliest and fullest literary description is found in Hesiod's epic poem *Theogony* of the seventh century BCE, which contains an extended hymn in praise of Hekate just before the birth of the Olympian gods.[49] In Hesiod's account, she is not an underworld deity but is said to hold dominion over the earth, sky and sea. She appears to stand apart and distinct from the gods who follow, as if she is more ancient and more honoured than they are, and Hesiod is keen to stress that even Zeus, king of the Olympians, pays Hekate special respect above all others. The reason for this reverence is made clear when Hesiod explains that success or failure is determined by Hekate's will: she can stand protectively in harm's way or step aside, as she chooses.

A primordial but ambivalent force, Hekate was given the epithet *kourotrophos*, the 'nurse of the young', by Hesiod, and the contemporary but unknown author of the *Hymn to Demeter* describes her as 'tender-hearted'.[50]

In some later Greek, but particularly in Roman literature, Hekate's underworld associations become more pronounced, and she is portrayed as a more sinister force. Her approach was said to be heralded by howling dogs and she is no longer honoured by Zeus but now by Circe, Medea and Erichtho, the sorceresses and witches of classical literature, who make sacrifices to her and vows before her altar for aid in their magic. The shift in the conception of Hekate in literature may have been influenced by actual magical rituals of the Hellenistic and Roman periods. A prayer in Greek found in a papyrus handbook of incantations and magical formulas from Egypt, dated *c.* 275–375 CE, is directed to triple-headed Selene, the goddess of the moon, and addresses her by many names, including Persephone and Hekate, describing her in demonic terms as bull-faced, having snakes coiled across her brow, stalking graveyards and consuming the dead. A connection with Persephone, the underworld and dark magic is also evident in Lucan's unfinished epic poem *Pharsalia* (composed between 61 and 65 CE), in which the general Sextus Pompeius consults the old, pale and haggard witch Erichtho in order to divine his future. The 'darling of hell', Erichtho lives in shadows and tombs, tearing up corpses for necromancy with her 'withered hands'.[51] The magic she is said to practise reflects the formulas known from surviving magical codices of the period, which were aimed at harnessing and controlling divine power and directing it as the practitioner wills, and she commands Hekate to appear:

> And thou, too, Hecate,
> Who to the gods in comely shape and mien,
> Not that of Erebus, appear'st, henceforth
> Wasted and pallid as thou art in hell
> At my command shalt come.[52]

To Lucan, Hekate existed both in the heavens in radiant form and in hell as Persephone, 'the last and lowest form of Hekate', through whom the witch gains access to the dead. She is often characterised as an infernal aspect of other deities rather than a distinct being, emanating through them, particularly Selene, goddess of the moon (Roman Luna) and Artemis, goddess of the hunt (Diana). Artemis' domain was the wilderness beyond 'civilised' society, where she hunted with her all-female retinue.

FIG. 95
Triple statue of Hekate, *c.* 161–200 CE.
Italy. Marble. H. 78 cm. British
Museum, London, 1805,0703.14.

It is within Greek literature that the concept of the witch begins to appear, not only as an object of fear but also as a sexual fantasy. Sorceresses such as Medea and Circe are described as beautiful and from foreign lands, possessing arcane knowledge that they use to help or hinder heroic adventurers who also become their lovers. Circe is most famously described in Homer's *Odyssey*, composed in the eighth century BCE. Daughter of Helios, the god of the sun, she is explicitly referred to as *thea* ('goddess') herself, but also as *polypharmakou* (sometimes translated as 'witch' but more accurately meaning 'knowing many drugs').[53] Living alone on the island of Aeaea, she feigns welcome when the adventurer Odysseus' crew arrive at her home, but secretly spikes their food with magical herbs, transforming them into pigs. An etching by the Genoese artist Giovanni Benedetto Castiglione, made in the mid-seventeenth century, shows Circe sitting contemplatively among overgrown ruins with grimoires (magicians' books) spread around her feet and a wand drooping from her hand. She wears 'oriental' dress, an artistic shorthand at the time for exoticism and esoteric knowledge; in front of her lies a pile of armour, and to the right jostles a

FIG. 96
Giovanni Benedetto Castiglione, *Circe Changing Ulysses' Men into Beasts* c. 1645–55. Italy. Etching on paper. 21.5 × 30.5 cm. British Museum, London, W,6.37. Bequeathed by Clayton Mordaunt Cracherode.

throng of various animals – the men who once wore it. As she rests her cheek on one hand, she looks almost bored, as if this magical transformation was too easy, but her pose also perhaps evokes a sense of her isolation (fig. 96).[54]

A modern reader of Homer's epic poem may feel that, as a woman living alone, Circe's response to a band of unknown, armed men appearing at her door was not so unreasonable, as proposed in Madeline Miller's novel *Circe* (2019), which retells the episode from the perspective of the sorceress. In the original version, Circe eventually meets her match in Odysseus, a man famed for his cunning and guile, who protects himself from her poisoned wine with his own magical herbs. She eventually returns his crew to their former selves and becomes his devoted lover. This battle of wits between woman and man was interpreted in 1891 by the Pre-Raphaelite artist John William Waterhouse in his painting *Circe Offering the Cup to Ulysses* (fig. 97), in a scene that highlights not only the magical but also the erotic power of the demi-goddess. Circe, seated on a throne of roaring lions and wearing a sheer dress, dominates the frame, raising a wand in one hand and holding out a cup in the other. At first, she seems to be offering the cup directly to us. Only later do we notice the small figure of Odysseus (Ulysses) reflected in the mirror behind her, hunched apprehensively as he reaches for his sword. Waterhouse's painting depicts the sorceress at the pinnacle of her power, contrasting her centrality, scale and posture with the diminutive form of Odysseus. Created at a time when calls for women's emancipation were being voiced in Britain, its depiction of the gender dynamics between the two protagonists and of witchcraft as a source of power and independence have made the work a touchstone for those who identify as witches today:

> This, and other Waterhouse paintings are much beloved by many modern witches and Pagans! … In this image I see a confident and powerful woman, daring the man/Odysseus in front of her to attempt to harm her … She does not hide in a protective stance, but holds her arms confidently open, brandishing her magical tools as a warning … embodying female divinity itself, and literally looks down her nose at her intruder. This intruder is not only the man in the mirror, but the viewer of the painting, prompting us to question what is our intention towards her? Do we offer respect, admiration, identification? Or suspicion, derision, or objectification?[55]

In Homer's poem, Circe is not a vengeful harbinger of evil but a beautiful, wilful and independent fantasy woman, whom the hero will eventually 'tame' and bring under his control – a portrayal that can also be read into Waterhouse's painting. However, later Roman authors painted a darker and more aggressively sexual picture of Circe. To Ovid she was a 'demon goddess', and Horace

FIG. 97

John William Waterhouse, *Circe Offering the Cup to Ulysses*, 1891. England. Oil on canvas. 148 × 92 cm. Gallery Oldham, Greater Manchester, 3.55/9.

wrote that she turns men into 'shapeless and witless vassals of a harlot mistress'.[56] When the sea god Glaucus begs her for a love potion to win the affections of the beautiful nymph Scylla, Circe, wanting Glaucus for herself, pours an elixir into Scylla's bathing pool, transforming her into a hideous monster (fig. 98). Scylla, who was also sometimes considered the daughter of Hekate,[57] appears in art with the face and upper body of a young woman, but from her waist emerge tentacles ending in baying dogs which, according to Homer, she used to snatch men from their ships if they sailed too close to her cave.[58]

While Greek and Roman poets and playwrights delighted in telling stories about sorceresses, in equal parts exciting and dangerous, the handful of fictional witches stands in contrast to contemporaneous evidence for the use of curses and spells among the population, as well as legislation against harmful magic. The use of spells is known from the archaeological discovery of inscribed sheets of papyrus or lead, often hidden in cemeteries or embedded in the walls or foundations of buildings. Typically these texts called upon chthonic (underworldly) powers to secure the affection of a beloved (sometimes by violence), to turn the object of desire away from a rival, or to harm an enemy.[59] Judging by the names of the authors, they were employed relatively equally by both men and women. By contrast, legal prohibitions against the use of magic – particularly common in the Roman world – tends to be directed towards men as the assumed practitioners.[60]

WITCH-HUNTS

While the Romans sought to eradicate some uses of malevolent magic by law, their polytheistic faith also incorporated magico-religious ideas into their vision of the divine, epitomised by the goddess Hekate, and there is little agreement among scholars of Greek and Roman spirituality about how 'magic' should, or can, be distinguished from religious practices.[61] Approximately 1,000 years later, the monotheistic Christianity of late medieval and early modern Europe came with a far more binary definition of good and evil, and exercised a tighter grip on the spiritual path of the population. The eleventh to the sixteenth centuries were a time of growing religious tension in Europe, which saw attacks by the Roman Catholic Church against any persons or groups that challenged its hegemony, branding their spiritual views heretical and their practitioners in league with Satan – including emerging Gnostic and Protestant Christian sects, along with Jewish people and Muslims. Practising harmful magic was one of many accusations levelled against any 'heretic', along with sexual promiscuity and child-killing.[62] However, until the late fifteenth century, these accusations were rarely specific to gender, as anyone who challenged the orthodoxy of the Church was viewed as equally deceived by the devil.[63]

The tide began to turn with the publication of the *Malleus maleficarum* ('Hammer of [female] witches') (1487) by the German Dominican monk and inquisitor Heinrich Kramer – a book in which 'the twofold process of the feminization and diabolization of witchcraft … reached its peak'.[64] While acknowledging the possibility that men could practise harmful magic, more than any other demonological text of the time, the *Malleus* uses scriptural interpretation and classical literature to identify witchcraft as a predominantly female art (fig. 99).[65]

FIG. 98
Jug handle in the form of Scylla, 300–100 BCE. Greece. Bronze and silver. 15.9 × 10.5 × 11 cm. British Museum, London, 1873,0820.91.

[I]t should be not called the heresy of men who do works of harmful magic [*maleficorum*] but of women who do works of harmful magic [*maleficarum*] so that the derivation is taken from the party with the better claim to it. Blessed be the Most High who continues to preserve the male sex from such a great disgrace right up to the present day. For he was willing to be born and suffer for us as a man, and therefore granted this immunity and exemption for men.[66]

The events leading up to the publication of the *Malleus* are worth considering. As an inquisitor, Kramer had already attempted to prosecute at least fifty women for witchcraft in Innsbruck (now in Austria) in 1485. His methods – in particular, his advocacy of torture as a means of extracting confessions and his incessant questioning of suspects about their sexual behaviour – were controversial and met with disapproval from magistrates and even his fellow inquisitors.[67] One of the women accused of witchcraft was Helena Scheuberin, an outspoken woman who turned Kramer's accusations back on him, condemning his obsession with witches as a heresy in itself and encouraging others to ignore his teachings.[68] During her trial, Kramer's scrutiny of her sexual conduct was dismissed as irrelevant by the other judges. Scheuberin was acquitted, along with the thirteen other women accused with her, and Kramer was expelled from the diocese in disgrace.[69] It is these events that are believed to have spurred Kramer to write a detailed defence of his theories and methods, and circulate them in the *Malleus*. Writing in a question-and-answer style designed to be comprehensible to laypersons and magistrates, as well as to clergymen, Kramer sought to demonstrate three key points: the real existence of harmful magic in the world; the wicked actions performed by witches; and how witches should be brought to justice.[70] He asserted that witches are motivated by a lack of faith (*infidelitas*), by self-interest (*ambitio*) and by a lack of moral restraint (*luxuria*). His accounts of their supposed behaviour indicate a pronounced bias against women, whom he associates with Eve as the originator of sin in the world; he accuses such women of indulging in orgies with incubi (male demons), killing children as sacrifices to evil spirits (singling out midwives, in particular), suckling animals from extra teats, and participating in secret women-only meetings.

The initial reception of the *Malleus* in the late fifteenth and early sixteenth centuries was mixed. Kramer was viewed as a fanatic and his extreme views were generally met with outrage from the Roman Catholic Church and ridicule in humanist intellectual circles in Germany. In the early sixteenth century, the German printmakers Albrecht Dürer and his student Hans Baldung 'Grien' produced several prints that appear to satirise the portrayal of the 'evil female witch' outlined in Kramer's work. Baldung's print *The Witches' Sabbath*, of 1510, in particular, makes

FIG. 99

Malleus maleficarum, Nuremberg: Anton Koberger, 1494. Paper with linen, goatskin and green cloth binding. 23.8 × 36 cm (open). Cambridge University Library, Inc.4. A.7.2[4165], ff. 57–8.

The text here (Part II, Question 1, Chapter 7) discusses how witches use magic to make men's penises disappear. The illustration, added by a reader, may have been intended to highlight the content of this section of the text.

humorous reference to several themes found in Kramer's work: the night-time scene, which shows witches preparing a potion, surrounded by bones and animal familiars, seems to mock the sexualisation of witches' rituals through the opened legs and strategically placed pitchfork of the woman flying on a billy goat, itself a symbol of lust (fig. 100).[71] The limp, flaccid sausages that hang on a branch to the left of the scene may be a comic take on a belief, strongly emphasised by Kramer, that witches steal men's penises and hoard them in birds' nests.[72]

Dürer's godfather, the publisher Anton Koberger, printed copies of the *Malleus* in Nuremberg in the 1490s, and both Dürer and Baldung may have been familiar with it.[73] Whether or not the two artists were directly influenced by the *Malleus*, it is notable that their prints overwhelmingly show women practising witchcraft. Although originally intended as satirical, their work may have helped to cement a growing popular association, long latent in Western art and imagination, between magic and women.[74] Despite condemnation of the *Malleus* from intellectuals and the Church, Kramer's ideas found a serious audience across Central Europe.[75] Thirteen reprints were produced before 1520, and sixteen more between 1567 and 1670. Religious instability in Europe was intensifying at this time, beginning in the early sixteenth century with the Protestant Reformation and eventually leading to the

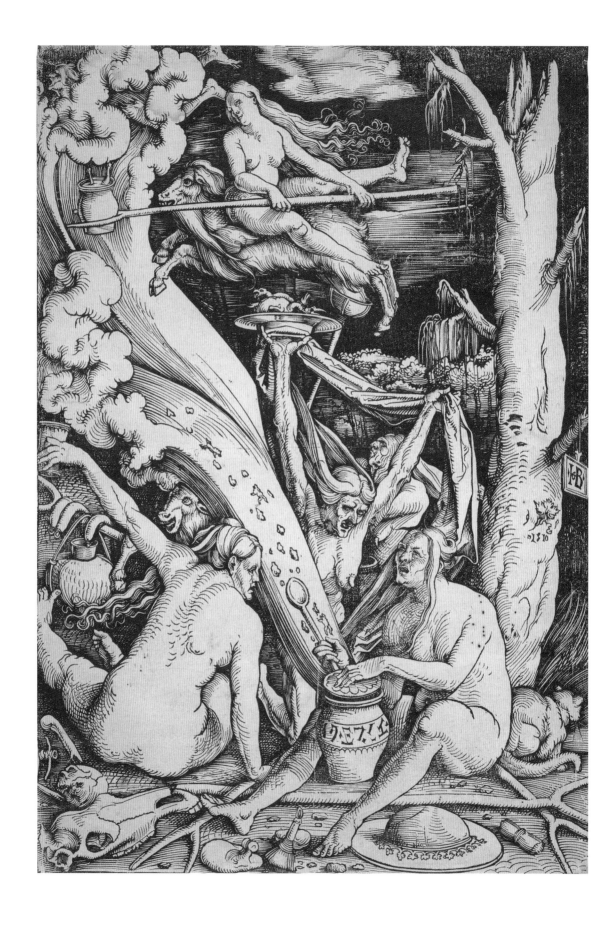

outbreak of the Thirty Years War (1618–48). When combined with the terror induced by the earlier outbreak of bubonic plague in the mid-fourteenth century, which continued to flare up sporadically until the eighteenth century, the stage was set for a very real fear that the devil was hard at work. In the closing decades of the sixteenth century the fear of witchcraft spilled over into active and widespread persecution.[76]

Archival studies drawing on historical accounts and legal records from Spain to Finland have been undertaken to explore the impact of 'witch-hunts' on the social and spiritual fabric of early modern Europe. While the total number of people executed on charges of witchcraft from the late sixteenth century to the end of the seventeenth century is unknown, a conservative estimate suggests a figure of around 40,000.[77] Recent scholarship is drawing greater attention to the persecution of men on charges of witchcraft during this period, particularly in some northern regions such as Iceland and Estonia, interrogating the complex gender bias more thoroughly than has previously been the case. There is little dispute, however, that women made up the majority of the accused. Evangelical teachings on the greater susceptibility of women to the influence of the devil contributed strongly to the fact that roughly 75–80 per cent of those targeted as witches were women, and in certain regions, such as Denmark, as many as 90 per cent.[78]

In Europe the last execution on charges of witchcraft occurred in Switzerland in 1782.[79] The gradual decline in witch trials throughout the eighteenth century is attributed to wide-ranging social and intellectual changes, including advances in scientific research and industrialisation during the Enlightenment. Yet a fascination with magic and 'witches' has not been left behind, and the end of the witch-hunts was to be followed by a new craze for witches – one that would have much more favourable consequences for women.

THE OCCULT REVIVAL

Throughout the eighteenth, nineteenth and twentieth centuries, growing interest among Western intellectuals in what has become known as 'Western esotericism' led to the foundation of several societies and new religious movements dedicated to magic and alternative spirituality. Foremost of these was the Hermetic Order of the Golden Dawn, a secret society dedicated to the study and practice of magic. Drawing on the philosophies of Rosicrucianism, the Golden Dawn combined eclectic interests, such as the revitalisation of ancient Egyptian, Greek and Roman religion, Hindu and Buddhist philosophy, Kabbalah, astronomy, metaphysics and the occult. It founded its first temple in London in 1888, dedicated to Isis-Urania ('Heavenly' Isis), followed by many

Opposite

FIG. 100
Hans Baldung Grien, *The Witches' Sabbath*, 1510. Germany. Woodcut print on paper. 37.5 × 25.9 cm. British Museum, London, 1852,1009.203.

others across Europe and the USA. Although modelled on Masonic lodges, with hierarchical orders and initiation rituals, one notable difference between the Golden Dawn and Freemasonry was the admission of women on a par with men, and the membership of the new order is said to have included leading authors, artists and poets of the time, including W.B. Yeats, the actor and suffragette Florence Farr and, for a brief time, the occultist Aleister Crowley.[80]

Outside secretive societies, a key figure who had a wide impact on the perception of magic at this time was Margaret Murray. A respected Egyptologist and First Wave feminist, Murray had a side-interest in the occult. In her monograph *The Witch-Cult in Western Europe* (1921), she argued that the 'witchcraft' practised during the early modern period was not devilry but the surviving remnants of pagan worship in Europe.[81] Despite the thin evidence on which the theory was constructed and an initially mixed, later hostile, critical reception, Murray's work was instrumental in changing the public perception of witchcraft in the twentieth century from a terrifying Satanic conspiracy to a legitimate and ancient religion based on pre-Christian beliefs.

This new interpretation of magic is reflected in the work of Surrealist artist Ithell Colquhoun. During the 1940s she made a number of works informed by her own esoteric beliefs surrounding the spiritual powers of ancient monuments and the ability of women to act as conduits for a divine feminine energy that she believed pervaded all of nature.[82] These include a series of drawings of female figures encased within stone monuments (fig. 101), which were inspired by traditional lore that ancient stone circles – including two Nine Maidens monuments in Cornwall, where Colquhoun was living – were once women transformed to stone as punishment for dancing on the Sabbath. Colquhoun believed that such monuments could invoke sacred experiences by functioning as channels for energies flowing under the earth's surface, which erupt at these sites, points that she referred to as 'Fountains of Hecate'.[83] Another drawing, produced around the same time, is entitled *Three Growing Forms* (fig. 102), and may be based on the Cornish monument Mên-an-Tol. In this work, Colquhoun used automatism, a technique employed by many Surrealist artists aiming to generate images from the unconscious. For Colquhoun, automatism was a magical practice, an act of divination that could uncover spiritual forces. In watercolour added to the drawing, Colquhoun employed the Hermetic colour scheme of blue, red and yellow, which here represent feminine, masculine and unified energies, relating to her interest in alchemy and the possibility of transcending binaries and opposites.[84] Colquhoun's works present a positive view of magic, as an empowering practice that involves both living in harmony with the natural world and absorbing its powers.

FIG. 101
Ithell Colquhoun, *Dance of the Nine Maidens*, 1940. Cornwall, England. Watercolour and ink on paper. 45 × 29 cm. Tate, London, TGA 201913.

Also gaining prominence in the 1940s was Gerald Gardner, a key figure in the early development of the modern religion of Wicca. Gardner was especially influenced by the ideas of Margaret Murray and Aleister Crowley and claimed that he was descended from a Scottish woman named Grissel Gairdner, who was burnt as a witch in 1610, and that he had been initiated into a secret coven of witches in the New Forest in 1939. He readily embraced the public and media curiosity that his beliefs and personality attracted, but his devotion to the poetry of Crowley was not shared by other members of his Bricket Wood coven, in particular the high priestess Doreen Valiente (fig. 103), who largely edited out Crowley's influence from the *Book of Shadows*, the foundational text of Gardnerian Wicca, fearing that he was too toxic and controversial to be associated with the new, inclusive faith.[85] Although less well known outside Wiccan communities, Valiente was as important as Gardner for establishing Wicca as a modern religion, and is credited with composing much of its primary scripture, including *The Charge of the Goddess*, an incantation that is still recited as part of many Wiccan ceremonies.

FIG. 102
Ithell Colquhoun, *Three Growing Forms*, 1941. UK. Pen, black ink and watercolour on paper. 32.4 × 43.5 cm. British Museum, London, 1990,1109.147.

From its founding in the UK in the mid-twentieth century, Wicca proliferated and diversified throughout the Western world, gaining large followings in the 1960s and 1970s as one of a number of countercultural movements. Today, those who would define themselves as Wiccans or Modern Pagans follow a variety of paths. Some branches, notably Dianic Wicca, founded in the 1970s in California by the Hungarian feminist activist and author Zsuzsanna Budapest, admit only female members and exclusively revere female divinities.[86] However, the majority of Wiccan groups share a belief in gender egalitarianism, and a survey of Wiccan and Modern Pagan communities in the UK and USA, published in 2004, concluded that these paths appealed only slightly more to women than to men.[87] Speaking in 2021, Merlyn Hern, one of the founders of the UK-based Children of Artemis, remarked, 'Wicca is about balance. It's a bit of a counter-balance to traditional society in that the female is given the lead role, but it is still a balance.'[88]

In 1974 an organisation named the Covenant of the Goddess was established by Californian covens to act as a centralised administrative and legal body for Wicca, which hosts councils for

representatives from participating covens but does not interfere in
the autonomy of each. Since 1993, members of the Covenant of
the Goddess have participated in the Parliament of the World's
Religions, demonstrating growing acceptance of Wicca as a
recognised world faith. In a marked departure from the Satan-
worshipping stereotype of the seventeenth century, modern
witches hold a range of personal beliefs in, and relationships
with, divine forces, variously perceived as female, male, neither or
both.[89] Most have no formal doctrines or texts, and focus more
on personal mystical experience than on dogma, understanding
their beliefs as an autonomous, alternative spirituality. As Jenny
Cartledge, a supporter of the Children of Artemis, reflects:

> Witchcraft has helped me acknowledge who I am and acknowledge that
> I have a different view of the world and a different way of being me.
> My craft helps me care for myself and continually learn and improve.
> Witchcraft helped me understand that I am and part of something
> much greater than the world we see.[90]

The popularity of witchcraft as a spiritual path has developed alongside a continuing fascination with witches in Western fiction. In popular culture, the association between witchcraft and women remains tenacious. From Glinda to Hermione Granger, Sabrina the Teenage Witch and the *Charmed* sisters, this new breed of fictional witch is young, independent, intelligent and, above all, uses her magical power for good. Even the Wicked Witch of the West has had a sympathetic makeover in the enormously popular stage show *Wicked*. Nonetheless, beyond fiction, the term 'witch' continues to hold strongly pejorative and derogatory connotations around the world. Outspoken, independent and successful women, from Hetty Green and Susan B. Anthony to Hillary Clinton and Margaret Thatcher, have been branded 'witches' by their critics – usually a casual insult that says nothing about their social or political agendas but everything about the attitude of many people to ambitious women encroaching on a traditionally 'male' sphere. But, regrettably, it is not always a casual insult: in many parts of the world, fear of witches and their use of dark magic still grips popular imagination with devastating consequences.[91]

A report of 2013 by the Witchcraft and Human Rights Information Network, a non-profit organisation that aims to tackle human rights abuses related to accusations of witchcraft, estimated that the number of victims each year ran into the thousands, and identified cases in forty-one countries across the globe.[92] Accusations of witchcraft can result in social ostracism, forced displacement, torture, mutilation and murder.[93] In circumstances that mirror those of early modern Europe, the majority of people persecuted for witchcraft today are still women, along with children and anyone perceived to be mentally or physically 'different'.[94] A belief in witchcraft is particularly prevalent in Papua New Guinea, and, despite changes to the law in 2013 that reclassified the killing of persons accused of sorcery as murder carrying the death penalty, in 2015 four women were beaten, burnt and tortured after being accused of magically removing a man's heart.[95] In Ghana, the government has taken steps since 2012 to close six 'witch camps' in the rural north of the country, where predominantly elderly women, many suffering from depression or dementia, live in deplorable conditions after being banished from, or fleeing, their homes following witchcraft accusations. However, women's rights organisations such as ActionAid have protested that without corresponding cultural efforts to eradicate the belief in witchcraft and to allow the women to return home safely, these camps actually provide their only safe haven.[96]

In 2017 the UN held its first conference on human rights abuses perpetrated through fear of witchcraft, in response to the growing frequency of attacks globally, a lack of coherent effort on the part

of local judiciaries to enforce existing laws, and the failure of governments to engage with the growing problem at a cultural level.[97] In spite of such efforts, the tightening of legislation in several countries, and the increasing severity of punishment with which those convicted of witchcraft-related violence are threatened, popular belief often remains stubbornly ineradicable.

Across world cultures and through the ages, female demons, monsters, witches and malevolent female deities share marked similarities. They are independent, usually unmarried or widowed, perhaps living alone or with other women outside the pale of society; they are wilful and ambitious, acting to advance their own interests; they may be old and ugly, past the age of bearing children – or young and seductive, eliciting an 'intense fear of the disordering power of female sexuality'.[98] Historically, these beings have represented an inversion of culturally idealised femininity, exaggerating the horror that accompanies women, as Kramer would put it, 'when they go beyond the boundaries of their proper status'.[99] Many of the figures discussed in this chapter are not viewed as deities, and the myths and legends that accompany them often have a distinctly moralising tone that aims to influence real-world behaviour. As attitudes shift over time, those same characteristics, which once made such figures fearful, are today finding new meaning as expressions of empowerment to gender-equality movements, particularly in the Western world. At the same time, the autonomy, aggression and arcane wisdom possessed by the witches, demons and monsters of world belief are also qualities shared by some of the most revered and beloved warrior goddesses of modern and ancient faiths, to whom we turn next.

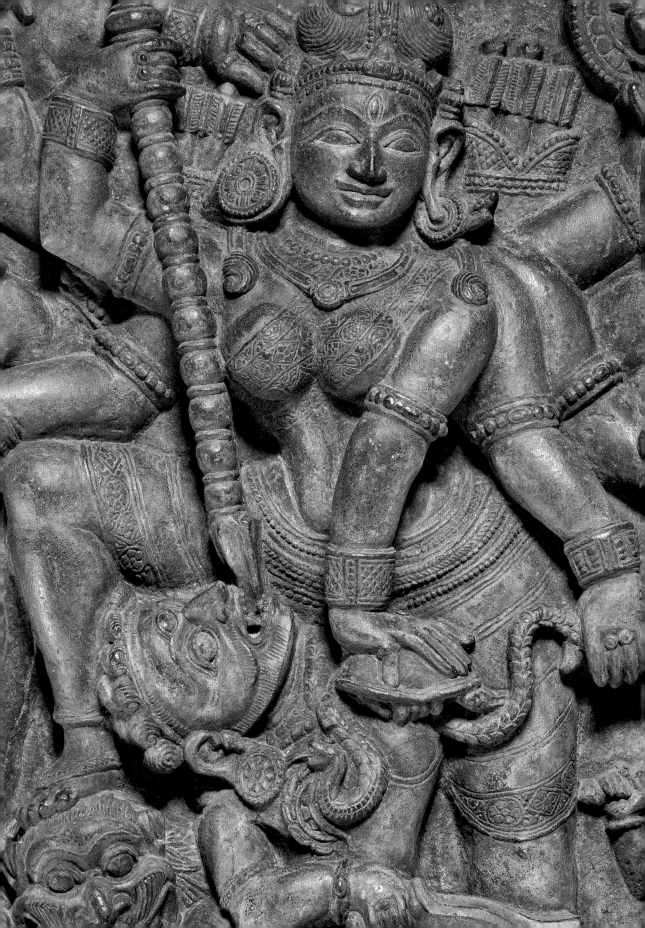

JUSTICE
& DEFENCE

But, O Goddess, the fact that Mahisha, having

 seen (your face) angry, terrible with knitted brows,

 in hue like the rising moon, did not immediately

Give up his life is exceedingly wondrous – for who can

 live, having seen Death enraged?

Devi Mahatmya, 4.12[1]

War is often considered the exclusive preserve of men, but warrior women, queens who commanded vast armies, and armed regiments of female soldiers populate world history. Many have passed into legend as a source of cultural pride, such as Boudica, the British queen of the Iceni, who led an armed rebellion against the Romans in 60–1 CE; Joan of Arc, whose strategic advice and presence on the battlefield changed the fortunes of the French against the English during the Hundred Years War; and Nakano Takeko, the Japanese samurai who led her unofficial 'Women's Army' in the Boshin civil war of 1868–9. Increasingly well known today, because they inspired the fictional Dora Milaje in Marvel's film *Black Panther* of 2018, are the 'Dahomey Amazons', the personal bodyguards of the king of the West African kingdom of Dahomey in the eighteenth and nineteenth centuries. Dubbed 'Amazons' by European commentators in reference to the legendary race of female horseback warriors who appear in the art and literature of classical Greece, in the local Fon language they were known as *mino* ('our mothers') and by the 1850s they were recorded as making up over a third of the kingdom's army, fighting against neighbouring powers and French colonial forces until Dahomey was conquered in the Second Franco-Dahomean war of 1892–4.[2]

Although martial and regal women are numerous in the pages of history, they are often viewed as anomalous. Their actions and memories have done little to change prejudices around the world today against women serving in the military or as political leaders, or to challenge gender stereotypes that habitually view strategy, bravery and physical strength as 'masculine' rather than 'feminine' traits. Indeed, even nineteenth-century Dahomeyan accounts, relayed by Europeans, imply that within their culture

the *mino* were considered 'men', while the soldiers they fought and defeated were 'women', underlining the fact that a long-established female military force was insufficient to change ingrained gender preconceptions.[3]

In contrast, female warrior spirits and deities inhabit the spiritual beliefs of both the ancient and the modern worlds, confronting and destroying chaos and instability through superior wisdom and ferocity. They preside over concepts that range from the maintenance of justice and moral order to the unleashing of apocalyptic violence. These forces are both loved and feared, often transgressing the expectations placed upon mortal women in the societies where they are worshipped, yet the resilience and protection they embody is intrinsically linked to cultural models of feminine energy or perceptions of women themselves, inspiring us to re-evaluate what we understand by the term 'feminine'.

STRENGTH AND PROTECTION

WOMEN AND POWER IN THE LUBA EMPIRE

The spiritual strength and authority of women is integral to many traditional West and Central African spiritual and cultural beliefs.[4] The Luba Empire in what is now the south-eastern Democratic Republic of the Congo (DRC) reached its height in the early eighteenth to late nineteenth centuries, before its established power structures were fragmented and curtailed by Belgian colonialism between 1885 and 1960.[5] In the past, Luba peoples encompassed several kingdoms, and these important traditional entities continue to influence modern political and social structures. The name Luba refers to a cultural, political and spiritual world-view based on shared histories, expressed through mnemonic artworks and oral traditions that are common to many different groups within the DRC and surrounding regions.[6]

Within the traditional Luba world-view, spiritual observance infuses many aspects of cultural life, particularly the need for virtuous social and political conduct, which is believed to ensure the protection of spirits and ancestors.[7] Women and feminine strength are held in particular regard: while the most senior political offices have always been held by men, power itself is perceived as feminine and as intimately associated with women through the belief that they possess an essential connection to life.[8] Women are viewed as more closely connected to the spiritual realm than men, and consequently fulfil sacred and civic roles in upholding the ethical and moral health of society and maintaining the favour of the spiritual world for the protection of the state. Banze Mukangala, a Luba officeholder, explained it in these terms in an interview in 1989: 'The power comes from women.

Even if a man reigns on the throne, one recognizes nevertheless the dignity of the woman as a source of power. It is from her that power emanated.'[9]

This concept is reflected in the predominance of female imagery within Luba art, particularly on objects linked to royal authority and the protection of the people. Stools used as ceremonial thrones and staffs of office are almost always carved in the form of a woman (fig. 104). These figures may represent women of royal heritage, or be understood as symbolic expressions of royal power. Figures are sometimes shown touching their breasts, which are said to contain 'royal prohibitions', protected and upheld by the women of the royal house.[10] These carvings typically bear the hallmarks of Luba beauty, including scarification and elaborate hairstyles – physical reflections of their spiritual prestige.[11]

Power and its enactment reside in an ambiguous understanding of gender, in which feminine and masculine are fused – a non-binary perception also expressed through the lack of gendered names in Luba society.[12] Although male figures are rare in Luba art, this concept may be reflected in rare hermaphroditic figures, possessing both female breasts and male genitalia, expressing the inherent unity of worldly and sacred power in Luba thought (fig. 105).[13] Similarly, kings and chiefs, though biologically male, are sometimes referred to, and depicted in art, as women. The Luba professor of religious studies at California State University, Mutombo Nkulu-N'Sengha, explains that 'Kingship is the people and the king's role is to protect the people, to ensure human flourishing and to serve the spirit … At the centre of this is life and women are the ones giving life. The foundation of kingship is the woman.'[14]

Believed to be conduits to the spiritual world, women themselves possessed political influence as dignitaries in royal courts, acting as advisers and ambassadors, and historically the king's wife, mother and sister held considerable status.[15] Furthermore, when a king died his spirit was believed to be reincarnated as a woman, who, when identified from within the community, enjoyed considerable privileges, channelling his spirit as an adviser to the new king (who was not the son of the former king but the son of his sister), or sometimes herself governing as a chief.[16] Women also hold great prominence as priestesses and diviners – the 'master problem-solvers of Luba society' resolving crises through medicinal and spiritual healing, determining truth in matters of dispute and identifying criminals.[17] Bowls are the most important items used in divination and are held by carved female figures (fig. 106). In line with royal symbology, these figures portray women as the containers of spiritual knowledge or as representations of spirits, including the first ancestral diviner of the Luba peoples, Mijibu wa Kalenga, who was, by most accounts, a man; the carved figures bearing bowls therefore emphasise

Opposite left

FIG. 104
Stool supported by a standing female figure with arms raised, *c.* 19th century. Democratic Republic of the Congo. Wood. 42.5 × 20 × 21 cm. British Museum, London, Af1949,46.479. Purchased with contribution from Art Fund (as National Art Collections Fund).

Opposite right

FIG. 105
Kneeling figure, possibly showing female and male sexual characteristics, 19th century. Democratic Republic of the Congo. Wood. 36 × 9.3 × 9.8 cm. British Museum, London, Af1904,0611.18.

the strength of women's bodies to carry and communicate spiritual forces.[18]

The importance of femininity in traditional Luba concepts of authority is associated with life-giving creative power and moral wisdom rather than physical strength or aggression; this power is viewed as residing within women themselves. Few overtly aggressive female spiritual beings are known from traditional African belief systems. One notable exception is the Yoruba *orisha* ('spirit') Oya, whose name means 'She Tore'. *Orisha* are closely associated with the power of the natural world, and Oya embodies the energy of the air and wind, giving life but also causing storms, lightning, tornados and fire. Sometimes viewed as the companion of the axe-wielding *orisha* of thunder and lightning, Shango, Oya is envisioned as a warrior. She represents a powerful energy associated with destruction, but also positive and cleansing transformation.[19] The concept of linking natural phenomena with violence embodied in a female being can also be found in the religious beliefs of ancient Egypt.

FIG. 106
Seated female figure holding a divination bowl, *c.* 19th century. Democratic Republic of Congo. Wood. 16.3 × 31.2 × 19.6 cm. British Museum, London, Af1954,+23.1532. Donated by the Wellcome Institute for the History of Medicine.

Writing in the fifth century BCE, the Greek historian Herodotus described the Egyptians as 'religious to excess, beyond any other nation in the world'.[20] The religious beliefs of ancient Egypt permeated every aspect of human existence, recognising countless goddesses and gods of varying degrees of prominence within different cities, who are now known through a wealth of monumental and devotional art and texts. Visualisation of divine forces was commonly linked to nature and was often expressed artistically through theriomorphic beings (deities in the form of animals). Sekhmet ('the Powerful One') was the Egyptian goddess of annihilation through war and disease. Depicted in art with the head of a lioness, she embodied the ferocious and terrifying aggression of the pre-eminent hunter in the North African landscape, and was petitioned by pharaohs and common people alike to direct her destructive power towards their enemies rather than themselves. In art, Sekhmet often wears a solar disc on her head, equating her power with the intense and scorching heat of the desert and with that of her father Ra, god of the sun. However, she was also known as the 'Mistress of Life' and often carries an ankh, the symbol of life, which she offered to those who enjoyed her favour.[21] She was widely venerated throughout Egypt, but her primary cult centre was at Memphis (now part of Cairo) in northern, or Lower, Egypt, and she rose to prominence during the New Kingdom (c. 1550–c. 1070 BCE), a golden age of prosperity and stability.

As well as bringing pestilence, Sekhmet was also petitioned to cure disease. Her priests were physicians who administered magical and medical remedies for ill health, as well as performing prayers and rituals to pacify the goddess.[22] Her healing and protective power may account for her popularity on amulets. Thousands have been discovered from Egypt, made of materials ranging from faience to gold, showing leonine goddesses enthroned or standing, either alone or as part of a group of deities. Sekhmet was the most prominent of several lioness-headed goddesses venerated at different periods and in different regions in Egypt, including Mut ('the Mother') venerated in Thebes; Pakhet ('She who Scratches') in Middle Egypt; and the goddesses Bastet and Wadjet in their leonine forms. It is often impossible to know which specific lioness goddess an amulet was intended to represent, though all embodied powers of protection (figs 107–112).[23] A particularly fine amulet made of gold takes the form of a hollow case surmounted by the intricately moulded head of Sekhmet, wearing the solar disc and a rearing cobra, a symbol of royalty (fig. 113); a loop at the back suggests that it would have been attached to a chain to be worn, and it may have contained a written spell or prayer. It was discovered in a grave on the island of Sardinia, indicating that the

Overleaf (top left to bottom right)

FIG. 107
Amulet of a lioness-headed goddess within an architectural setting, c. 1069–305 BCE. Egypt. Glazed composition. 2.2 × 1 × 0.5 cm. British Museum, London, 1838,0405.12.

FIG. 108
Amulet of a lioness-headed goddess, 720–525 BCE. Egypt. Glazed faience. 10.5 × 2.4 × 2.8 cm. British Museum, London, 1895,1115.11.

FIG. 109
Amulet of a seated, lioness-headed goddess, perhaps Sekhmet, c. 900–700 BCE. Egypt. Glazed faience. 5.7 × 1.7 × 3.6 cm. British Museum, London, 1913,0308.5. Donated by H.L. Hansard.

FIG. 110
Amulet of a lioness-headed goddess, perhaps Bastet, 664–332 BCE. Egypt. Silver and gold. 2.8 × 0.7 × 1 cm. British Museum, London, 1897,0112.14.

FIG. 111
Amulet of a seated, lioness-headed goddess, c. 664–332 BCE. Egypt. Cornelian. 3.6 × 1.3 × 2.3 cm. British Museum, London, 1946,1204.119. Donated by Mrs Marion Whiteford Acworth JP.

FIG. 112
Amulet of a seated, lioness-headed goddess, perhaps Sekhmet, c. 664–332 BCE. Egypt. Red jasper. 2.9 × 1.8 cm. British Museum, London, 1952,1213.16. Donated by Mrs Marion Whiteford Acworth JP.

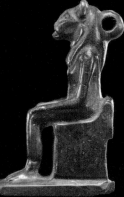

worship, or worshippers, of Sekhmet spread well beyond Egypt in the first millennium BCE.

In myth, Sekhmet's terrifying potential for savagery is most comprehensively expressed through *The Myth of the Heavenly Cow*. Also known as *The Destruction of Mankind*, this text was written on royal tombs of the 18th and 19th Dynasties, including those of the pharaohs Tutankhamun (d. 1323 BCE), Seti I (d. 1290 BCE) and Rameses II (d. 1224 BCE), but it was probably known from earlier periods. According to the narrative, humankind rebelled against Ra, and, in an act of divine retribution, the sun god sent his daughter Sekhmet, his 'Eye', to earth to destroy his creation. The murderous frenzy with which she rampaged through the land, and her delight in the death and suffering she brought, was so terrible that Ra regretted his harshness and ordered her to stop, but Sekhmet's rage was uncontrollable and she would not obey. To end the carnage, Ra ordered copious amounts of beer to be dyed red with ochre and put in her path. Thinking it was blood, she drank it and became so intoxicated that she forgot her anger and left the earth in peace.[24]

In some versions of this myth, Ra first calls on Hathor ('the Heavenly Cow'), to enact his will, and she sheds her radiant form to take on the terrifying aspect of Sekhmet. Hathor was identified by the Greeks as the counterpart to Aphrodite, and was similarly known as 'the Golden One'. Her worship is believed to extend back to the 1st Dynasty in Egypt (2920–2770 BCE), possibly earlier, and she was venerated as the goddess of prosperity, joy and beauty, connected with the abundance and fertility of the Nile floods.[25] Most often represented in art as either a cow or a woman with bovine ears (fig. 114), she was also the goddess of music and dance, and her face often adorns *sistra*, rattle-like instruments used in both secular and religious celebrations. Her small face and distinctly pointed ears can be seen on the handle of a *sistrum* held by a beautifully incised granite figurine of a musician from the 19th Dynasty (1307–1196 BCE). The use of hard stone (granite or basalt) suggests that the figure was made for a temple, and it may have been intended to represent a priestess wearing an elaborately braided wig, a headpiece and a large *menat* necklace (fig. 115).[26]

This mythical association between the fierce Sekhmet and the gentle Hathor – contrasting expressions of a singular divine force – may have been inspired by Egypt's natural landscape and climate, reflecting the relentless heat of the summer, just before the onset of the rains and the flooding of the Nile, which initially runs red with silt. This brings regeneration and new life to the land, represented by the transformation of Sekhmet back into Hathor.[27] Inscriptions on the Temple of Hathor at Dendera (near the modern city of Qena) record that this annual event was marked by the Festival of Drunkenness, which celebrated 'the

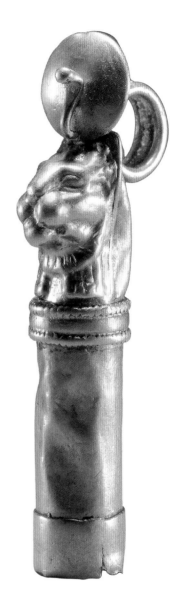

FIG. 113
Amulet in the form of a case in two parts, 700–200 BCE. Sardinia. Gold. 3.2 × 0.6 × 1.2 cm. British Museum, London, 1856,1223.1399.

return of the Distant Goddess' through intoxication and also blood sacrifice.[28]

In keeping with her dual nature, Sekhmet was petitioned in times of both war and peace and praised as the leader of the Egyptian army, but also placated with offerings to pacify her bloodlust and bring stability to the kingdom. A branding iron from the 18th Dynasty (1550–1295 BCE), made from bronze and bearing the bust of the goddess, was probably used to mark sacrificial cattle belonging to her temple (fig. 116). During the reign of the pharaoh Amenhotep III (c. 1391–1353 BCE), the grandfather of Tutankhamun, Egypt was united, wealthy and

Opposite

FIG. 114
Menat-counterpoise amulet, c. 1390–1352 BCE. Bronze. Egypt. 14.7 × 4.8 × 0.3 cm. British Museum, London, 1888,0512.69.

This bronze *menat*-counterpoise was used to offset the weight of large ceremonial necklaces. Its openwork design shows Hathor's three manifestations: in human form (*top*), half-human, half-cow (*centre*), and as a cow in a barge (*base*). The throne name of King Amenhotep III (Nebmaatre) is written below her wig.

FIG. 115
The upper body of a female figure, 1292–1189 BCE. Egypt. Granite/basalt. 31 × 18 × 16.1 cm. British Museum, London, 1853,0822.3.

FIG. 116
Branding stamp in the image of
Sekhmet's head (facing right) and upper
torso, *c.* 1550–1295 BCE. Egypt.
Bronze. L. 15.5 cm. British Museum,
London, 1928,0604.1.

relatively peaceful. Amenhotep (fig. 117) is remembered for his
ambitious building programme, and many landmarks still visible
in Egypt were constructed under his reign, including the Temple
of Luxor and large parts of the religious complex at Karnak.
Among these was a vast mortuary complex, commissioned for
himself, on the east bank of the Nile, which was filled with
hundreds of large statues of Sekhmet. Each was carved from
black granodiorite and showed the goddess either seated or
standing. The total number is unknown, but examples are
displayed in most major archaeological museums across the world,
and more are regularly uncovered during archaeological
excavations.[29] The style of these statues varies little in detail: the
goddess appears with finely carved whiskers and ruff, wearing a
long wig and tight-fitting dress which reaches to her ankles.
Usually, her head is adorned with a solar disc fronted by a cobra,
though these symbols were sometimes carved separately and
many have been lost. When standing, she holds a papyrus sceptre
(the symbol of Lower Egypt) in her left hand and an ankh in
her right; when seated, she is shown with an ankh resting on her
left knee. In one example, her lower legs and solar disc are now
lost, but the top of an ankh is visible in her right hand and she
holds the papyrus sceptre in her left (fig. 118).

The profound veneration of Sekhmet served not only to reflect
the pharaoh's strength and military prowess, but also to keep the
goddess pacified so that she would not destroy the prosperity of
Amenhotep III's reign, or the pharaoh himself, with war and
pestilence.[30] When Amenhotep III's mortuary temple fell into
disrepair, many of the statues of Sekhmet were moved to the
sacred precinct of the Great Mother Goddess Mut, in Karnak,

Opposite

FIG. 117
Head and upper torso of a statue of
Amenhotep III, *c.* 1391–1353 BCE.
Sandstone. Egypt. 26 × 31 × 23.4 cm
(head); 29 × 47 × 19 cm (torso). British
Museum, London, 1979,1017.37–38.

where many still stand today. Mut was also represented with the head of a lioness, and the worship of Sekhmet and Mut was closely interlinked in the New Kingdom, perhaps lending Sekhmet a more maternal aspect.[31] A green-glazed amulet, probably made between 1070 and 712 BCE, shows Sekhmet or Mut offering her breast to a child, perhaps a young pharaoh, whom she holds close to her body – an image that situates her as the source of strength and life (fig. 119).

It is these more benevolent, protective, aspects of Sekhmet's ancient significance that have come to the fore in renewed worship of the goddess today within modern Kemeticism (a branch of Modern Paganism that venerates the deities of ancient Egypt).[32] Far distant from her North African homeland, the Temple of Goddess Spirituality in Cactus Springs, Nevada, is dedicated to the contemporary worship of Sekhmet. Founded in 1993, the temple is located in the Mojave Desert, yet the perception of Sekhmet has been adapted in accordance with the ecofeminist and anti-capitalist beliefs of the temple's founder, Genevieve Vaughn. In Nevada, Sekhmet is honoured as a goddess of life and fertility who can protect nature against human destruction, and her temple is provocatively situated next to a nuclear testing site.[33]

In the ancient city of Memphis, Sekhmet was worshipped alongside the creator god Ptah, who was considered her husband, and together they were closely connected with the goddess Ma'at, the embodiment of divine justice and order. A relief, now in Amsterdam, shows the pharaoh Ptolemy II Philadelphus (r. c. 283–246 BCE) offering a diminutive figure of Ma'at, depicted as a seated woman wearing a feather headdress, to Ptah (fig. 120). Sekhmet, holding her characteristic papyrus staff and ankh, stands behind Ptah and is addressed in the accompanying inscription as 'mistress of all foreign lands … mistress of the sky'.[34] Represented in Egyptian art in both anthropomorphic form and simply as a feather, Ma'at was the truth against which the hearts of the deceased were weighed to determine whether they had lived an honest life. If the scales balanced, the soul was permitted to pass through into the afterlife. If they did not, the heart was devoured by the monstrous goddess Ammit, formed of parts of the three most feared creatures in Egypt: the jaws of a crocodile, the front legs of a lion and the hind legs of a hippopotamus. Aside from a small temple in Karnak, shrines dedicated specifically to Ma'at are uncommon, yet she appears within the temples of other deities and in association with images of pharaohs and priests, who, like Ptolemy II, can often be seen offering a small image of Ma'at to the presiding deity. This iconography, along with her epithet, 'Food of the Gods', suggests that she was viewed not only as a divinity, but as the guiding principle for all deities and rulers.[35]

Opposite

FIG. 118
Standing statue of Sekhmet, c. 1539–1292 BCE. Egypt. Granodiorite. 165 × 51 × 94 cm. British Museum, London, .50.

FIG. 119
Green-glazed amuletic figure of Sekhmet or Mut, c.1070–712 BCE. Egypt. Glazed faience. 8.1 × 2.6 × 2.5 cm. British Museum, London, 1913,0111.6.

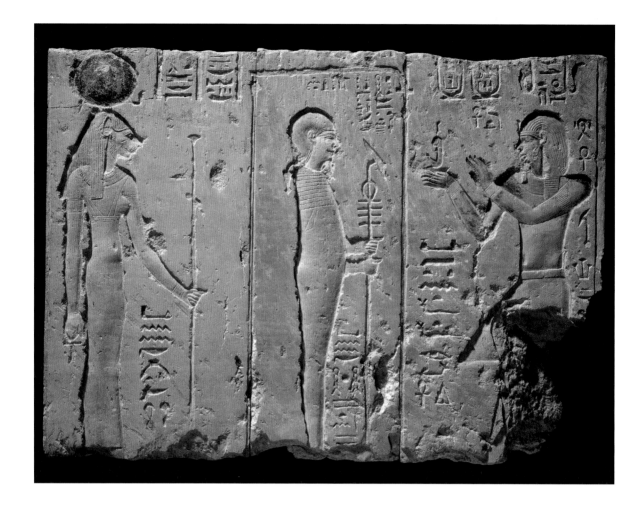

FIG. 120
Relief, *c.* 283–246 BCE. Egypt. Limestone.
44 × 65 cm. Allard Pierson, University of
Amsterdam, APM08795 and APM08796.

Ptolemy II (*right*) presents a statuette
of Ma'at to the god Ptah (*middle*), with
Sekhmet standing behind (*left*).

The personification of justice in female form, with balanced scales, has existed in Western iconography for millennia, passing through ancient Greece, where she was recognised as Dike or Themis, and the Roman goddess Iustitia, whose iconography acquired a sword, representing the enforcement and swift finality of the law. Although she is now viewed as a personification rather than a divinity, the classically draped Lady Justice with scales and sword remains a familiar sight atop law courts across the globe – a somewhat incongruous secular symbol, since for most of Western history, and widely in the modern world, women themselves have been excluded from the compilation of laws and the exercise of legal judgment. In Greek and Roman culture, a similar apparent paradox extended not only to justice but to all aspects of male-dominated public life – from the military to academia and government – which were believed to be presided over by divine female influence.

The Greek goddess Athena embodied military strength and strategy; civic governance through justice and order; economic growth through industry; and the elevation of the mind through art, philosophy and science. Daughter of the sky god, Zeus, she was the tutelary deity of the city-state of Athens, a formidable naval power and famed, particularly in the sixth to fourth centuries BCE, as a centre of art and scholarship. The Parthenon temple, built in the fifth century BCE and dedicated to Athena Parthenos (Athena 'the Maiden'), still dominates the Athenian skyline from the Acropolis, where the goddess was also worshipped as Athena Polias (Athena 'of the City') and Athena Promachos (Athena 'the Champion').[36] In the inner sanctum of the temple once stood a colossal ivory and gold statue, designed by Pheidias, the pre-eminent sculptor of fifth-century BCE Athens. Although the work itself is now lost, surviving descriptions and smaller-scale copies indicate that it showed the city's patron goddess standing upright and wearing an elaborately decorated helmet, projecting an air of resolute authority. In her left hand rested a shield and a spear, while her right hand supported a figure of Nike, the winged goddess of victory.[37]

Greek and later Roman depictions of Athena (Roman Minerva) invariably show her in the guise of a youthful woman, dressed in armour and long robes, over which she wears a distinctive breastplate called an *aegis*, fringed with snakes and mounted with the severed head of Medusa (see chapter 3). A magnificent full-scale sculpture, known today as the Ince Athena owing to its former display at Ince Blundell Hall in Lancashire, is a Roman copy of a Greek statue and originally stood in the Roman port city of Ostia (fig. 121). Wearing a simple dress called a *peplos* under her *aegis*, the goddess stands in a relaxed pose, her weight on her right leg, and wears her long hair swept back beneath a Corinthian helmet placed high on her forehead. Her head is slightly tilted, lending the figure a contemplative air and encapsulating her status as a martial deity who embodies intellect dominant over emotion, and strategy over brute strength. The upward curl of the fingers of her left hand suggests that she once held a spear, which was possibly made from metal, and her outstretched right hand may have once held an image of Nike, restored, perhaps erroneously, in the eighteenth century as an owl, which was a common attribute of the goddess in ancient Greece and is still a symbol of wisdom today.

Worship of a goddess of war within Greek religion is believed to have been influenced in part by a multitude of martial female deities venerated across the Mediterranean and ancient Near East throughout the second and first millennia BCE. Prominent among these were the volatile and ruthless warrior goddesses Astarte and Ishtar (see chapter 2), and the Semitic goddess Anat.[38] A series of mythological texts, discovered in the ancient Syrian city of Ugarit

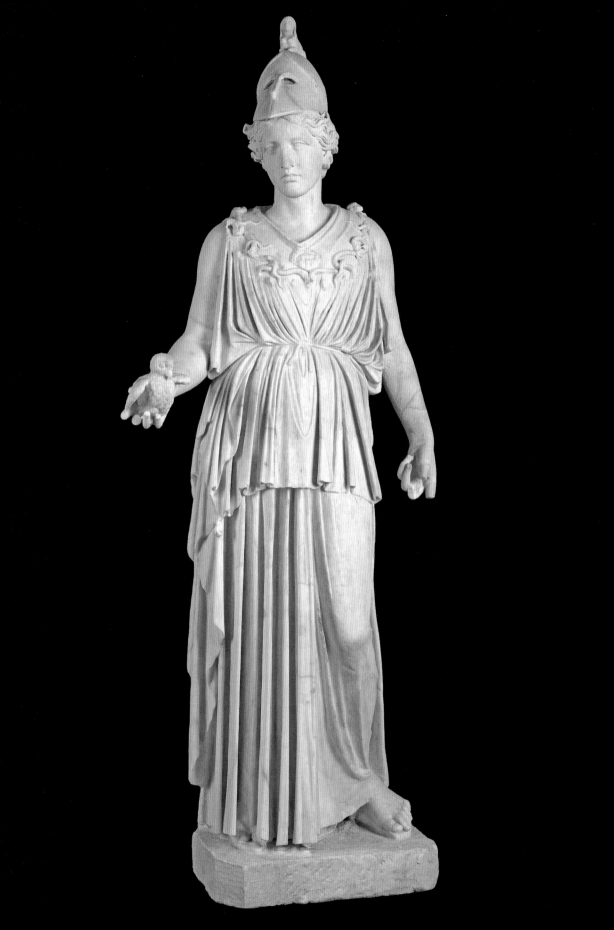

and dating between 1500 and 1200 BCE, describe Anat as a violent goddess, who delighted in the slaughter and gore of battle.[39] Anat was closely aligned with her brother and lover, the great god Baal – a variant, in familial terms, of Athena's relationship with Zeus and Sekhmet's with Ra, but positioning her no less securely as the warrior general and strong arm of the chief male deity. Considerable syncretism existed in the worship of Anat, Astarte and Ishtar; they may perhaps be viewed as different names for a shared concept of a female warrior deity worshipped throughout the interconnected cultures of North Africa and the Near East. Like Athena 'the Maiden', Anat was often given the epithet 'Virgin', but explicit praise of her sexual relationship with Baal indicates that the honorific should be understood as meaning 'unmarried' and independent of domestic responsibilities, rather than 'chaste'.[40]

While the influence of these goddesses on the early manifestation of Athena is largely accepted, her later characterisation was indelibly shaped by Athenian culture, which championed philosophy, judicial debate, democratic politics and segregated roles for women and men in society. Over time the unbridled violence of her predecessors appears to have been dropped from the character of the city's tutelary goddess, as was their sexual agency. What came to be enshrined in Athenian literary myth was the cerebral, rather than the emotional, drive of Athena – a goddess who 'has no pleasure in the deeds of golden Aphrodite' – exemplified by the story of her birth directly from the head of her father.[41] A favourite subject for Greek artists, the myth of Athena's birth is captured on an Attic amphora created around 510 BCE in the black-figure technique (fig. 122). It shows Zeus, the king of the gods, enthroned in the centre of the scene, flanked by two unidentified female figures. According to the myth, Zeus had eaten his pregnant wife, Metis, whose name means 'cunning wisdom', in fear of a prophecy that a child born to her would be mightier than its father. Later, complaining of a terrible headache, he instructed the smith god Hephaestus to break open his head with his axe. Hephaestus, axe in hand, can be seen to the right of the scene, turning back in surprise as Athena, brandishing a spear, fully grown and fully armed, leaps from Zeus' head. Beneath Zeus' throne, in a distinctive running pose, is the small, winged figure of the messenger goddess Iris, ready to spread the news to the other deities.

Along with her birth from her father rather than a mother, in other mythological narratives Athena appears more closely aligned to men than women. She has little to do with female mortals, preferring the company of male heroes such as Heracles, Perseus and Odysseus, to whom she acts as a guide and protector. Occasionally, in drama, she was even characterised as hostile to female interests. In Aeschylus' play *The Eumenides* ('The kindly ones'; *c.* 458 BCE), which celebrates the establishment of Athenian jurisprudence by the goddess herself, Athena declares:

Opposite

FIG. 121
Statue of Athena (the Ince Athena), 1st century CE (Roman copy after a Greek original, *c.* 400 BCE). Italy. Marble. 183 × 66 × 68 cm. National Museums Liverpool, World Museum, 59.148.8.

'No mother gave me birth. I honour the male, in all things but marriage. Yes, with all my heart I am my Father's child.'[42] This literary characterisation, along with Athena's status as the patron of politics, law, academia and the military – public institutions that actively excluded women in classical Athens – has sometimes led to her being interpreted in modern scholarship as the upholder and defender of patriarchy, an interpretation that has caused her to be rejected, historically, as an inspiring figure within twentieth-century feminist thought.[43] Influenced by contemporary anthropological thinking on the ancient matriarchal origins of human culture, the classical scholar Jane Ellen Harrison (1850–1928) viewed Athena as having once been an ancient fertility deity, who sided with the patriarchy in the overthrow of matriarchal religion. As a result, Harrison advocated that she should be shunned by feminists. Assessing Athena's Greek form as 'a sexless thing, neither man nor woman', she lamented: 'we cannot love a goddess who on principle forgets the Earth from which she sprung'.[44] Similarly drawn to Athena's lack of sexual or maternal characteristics in myth, in the 1970s the American classics professor Sarah B. Pomeroy wrote: 'Athena is the archetype of the masculine woman who finds success in what is essentially a man's world by denying her own femininity and sexuality.'[45] These interpretations of her character are largely based on the portrayal of Athena in literature which, as for other Greek deities, often does not fully reflect the spectrum of Athena's importance in the lives of worshippers, within either Athens or the wider Mediterranean world.

Although largely absent from public leadership, Athenian women were responsible for ensuring the good order and well-being of the household and contributed economically to the city through the production of crafts, of which Athena was the patron deity. Athena's importance in these areas of women's lives is expressed in some of the earliest Greek poetry. One of the *Homeric Hymns* to Aphrodite, believed to have been composed in the seventh century BCE, praises the broad spectrum of Athena's guidance to all people:

> She first taught earthly craftsmen to make chariots of war
> and cars variously wrought with bronze,
> and she, too, teaches tender maidens in the house
> and puts knowledge of goodly arts in each one's mind.[46]

She was particularly honoured as the patron of weaving, traditionally practised by women of all socio-economic statuses and an occupation that provided a livelihood for poorer women. This art was central to Athena's most important festival in Athens, the Panathenaia, in which a new robe, specially woven for her ancient, highly sacred statue, was presented to the goddess – a

Opposite

FIG. 122
Black-figure neck amphora,
c. 510 BCE. Greece. Painted pottery.
45.1 × 28 × 29 cm. British Museum,
London, 1837,0609.27.

scene believed to be depicted on the East Frieze of the Parthenon (see p. 10).[47] More broadly, women were actively involved in the religious life of the city, and scenes of worship were popular in Athenian art. A red-figure neck amphora, created around 460–450 BCE, depicts a woman preparing to pour a libation at the feet of Athena (fig. 123). Although the woman is not specifically identified as a priestess in the scene, the major cults of Athena Polias and Athena Nike ('Victorious Athena') were presided over by women chosen from among aristocratic families of Athens. These roles carried both sacred and civic importance, as the priestesses were responsible for maintaining the goddess's divine favour for the safety and protection of the city through the proper performance of sacrifices and rituals, as well as for conveying Athena's wishes to the people in times of civic crisis.[48] The names of at least twenty-five priestesses of Athena Polias are known through dedicatory inscriptions, indicating the public esteem and commemoration they received for their service.[49]

Athena's representation in ancient art as a woman in the armour of a man, reflected in Harrison's assessment of her as 'neither man nor woman', perhaps illustrates her all-encompassing authority over both women's and men's contributions to the well-being of the state. Her role as the goddess of crafts tends to receive less popular attention today than her martial status, but has appealed to some contemporary artists, such as the British sculptor and medallist Avril Vaughan, who, in 1988, produced a medal entitled *Athena and Me* (fig. 124). One side shows a portrait of the sculptor at work, with Athena's owl perched on her shoulder and depicted in relief in a contemporary style. On the other side, the classical bust of Athena appears in the style of an ancient intaglio. Together, the two faces of the medal thus contrast the goddess's ancient and modern significance and her 'light and dark' aspects.[50]

MINERVA

From around the eighth century BCE, Greek culture and religion were carried to Italy through colonisation and trade, and evolved in conjunction with Italic beliefs. As part of this complex and multi-directional process, the local goddess Minerva became nearly indistinguishable from Athena. Presiding over war, wisdom and art, Minerva was portrayed in Roman art almost identically to the Greek Athena, and much of Athena's mythology was adopted into Roman literature.

Archaeological excavations of sacred sites dedicated to Minerva indicate that she, like Athena, had a broader significance in the lives of worshippers than her literary presentation would suggest. The oldest known sanctuary to Minerva in Italy has been excavated in the coastal city of Lavinium, which flourished during the sixth to the fourth centuries BCE. Votive offerings to the goddess

FIG. 124
Avril Vaughan, *Athena and Me* medal, 1988. UK. Bronze. Diam. 7.6 cm. British Museum, London, 1992,1022.1. Donated by Avril Vaughan.

Opposite

FIG. 123
Red-figure neck amphora, 460–450 BCE. Greece. Painted pottery. H. 36 cm. British Museum, London, 1867,0508.1059.

included terracotta statues of young girls with cropped hair, and others of older, veiled women adorned with jewellery, suggesting that rituals were performed in the service of Minerva to mark a woman's development from child to adult. Other offerings included models of breasts and infants, as well as bridal chests, indicating Minerva's importance to the lives of people within the region. Gifts of loom weights were perhaps connected to her role as the patron of industry and crafts.[51]

Minerva's centrality within Roman state religion is demonstrated by her worship alongside Jupiter (Greek Zeus) and Juno (Greek Hera), king and queen of the Roman pantheon, as part of the Capitoline Triad. Festivals and sacrifices in honour of the Triad were designed to ensure the continued prosperity of the Roman state, and a major temple dedicated to the three deities was situated on the Capitoline Hill in Rome. As the Roman Empire expanded across Europe, North Africa and the Levant, so too did the veneration of all Roman deities. Roman religion was broadly tolerant of other faiths and the worship of numerous Celtic, Middle Eastern and North African deities was assimilated into Roman provincial, and sometimes state, religion. Through a process known as *interpretatio romana*, the religious practices of conquered peoples were elided with those of Roman religion, and a local deity would often come to be identified with one from the Roman pantheon, so that the two were worshipped as a pair or as a single syncretistic divinity at particular sacred sites.[52]

Following the annexation of Britain from 43 CE, Minerva came to be identified with the local goddess Sulis, an otherwise unrecorded deity, seemingly connected with health and healing since she was worshipped at the site of a natural thermal spring in Bath. Around 70 CE the site was transformed into an enormous temple and bathing complex, which attracted local people and pilgrims until around the fifth century CE. Excavations of the sanctuary in the eighteenth century uncovered the head of a magnificent gilt bronze statue of Sulis–Minerva, along with altars set up by wealthy donors in thanks for her patronage. But it is the finds dredged from the sacred pool itself that give us a rare glimpse into the goddess's significance to private worshippers. Along with offerings of coins, jewellery and metal tableware, over a hundred thin sheets of lead were found, often rolled up or folded and inscribed with curses that called upon the goddess to exact revenge on named or unnamed persons who had wronged the dedicator in some way (fig. 125a–c).[53] Written by both women and men, in formal Latin or vernacular languages, the vast majority implored the goddess to help return stolen property – commonly money, farming equipment, jewellery, and even bathing tunics presumably stolen from the site itself – and to inflict ruthless punishments on the thieves.[54] The use of lead curse tablets is known throughout the Greek and Roman worlds, and Athena–Minerva is not the only

FIG. 125A–C
Defixiones (curse tablets), *c.* 175–275 CE
(*top left and right*), *c.* 275–400 CE (*left*).
Roman Britain. Lead alloy. 14.9 × 9.6 ×
0.2 cm (largest piece). The Roman Baths,
Bath & North East Somerset Council,
BATRM 1983.13.b.148 (Tab Sul 54),
inv. no. 20,004; BATRM 1983.13.b.23
(Tab Sul 65), inv. no. 671; BATRM
1983.13.b.44 (Tab Sul 5), inv. no. 477.

The inscriptions read:

Top left I, Arminia, complain to you,
Sulis, [that] you consume Verecundinus
(son of) Terentius, who has [stolen…]
two silver coins from me. You are not
to permit [him] to sit or lie [or … or]
to walk [or] (to have) sleep [or] health,
[since] you are to consume (him) as soon
as possible; and again … [not] to reach…

Top right To Minerva the goddess Sulis
I have given the thief who has stolen
my hooded cloak, whether slave or free,
whether man or woman. He is not to buy
back this gift unless with his own blood.

Left Docimedis has lost two gloves.
[He asks] that [the person] who has stolen
them should lose his minds [*sic*] and his
eyes in the temple where (she) appoints.

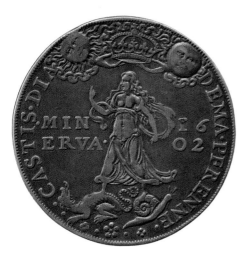

FIG. 126
Medal of Elizabeth I (obverse), with
Minerva (reverse), 1602. British Isles.
Silver. Diam. 3.8 cm. British Museum,
London, 1897,0605.1.

deity petitioned in this way, but the tablets dedicated to Sulis–
Minerva in Britain constitute one of the largest concentration of
finds at a single site.[55] They also reveal a darker side to the
goddess's worship – a side appealed to by those for whom judicial
processes were not available and who hoped to settle private
disputes through divine intervention. At Bath, at least, Minerva
still presided over justice, but this local veneration of the goddess
appears to place her closer to the Egyptian Sekhmet as the
bringer of disease and retribution than to the Athenian ideal
of jurisprudence.

The enduring influence of Greek and Roman culture on
Western government, education and law has preserved with it the
place of Minerva at the helm as the personification of strength and
virtue. Her renowned chastity, chiming with Christian moral
values, upheld her stately reputation and saved her the fall from
grace that awaited Venus. From the sixteenth century onwards, the
allegory of Minerva was used to complement and justify female
leadership. Queens such as Elizabeth I of England and Ireland,
Queen Anne of Great Britain and Ireland, and Catherine the
Great of Russia were presented in art and literature as incarnations
of Minerva, an idealised image of female resolution, intelligence
and stability that appears widely on commemorative medals
(fig. 126). One British medal, minted in 1743 to commemorate
English military support for the Habsburg queen Maria Theresa,
draws heavily on classical imagery, casting Neptune as the symbolic
embodiment of English naval power. On the reverse, he
approaches Maria Theresa, who sits surrounded by Venus, Juno
and Minerva – flattering personifications of her beauty, dignity and
courage (fig. 127). The obverse bears a portrait of the queen,
crowned with a laurel wreath and wearing the unmistakable *aegis*
of Minerva under her robes. At the same time, Minerva's
androgynous image has also been used to celebrate male military
leadership, a tradition that stretches back to the coinage of
Alexander the Great in the fourth century BCE. In the eighteenth
and nineteenth centuries, her image appears on medals
commemorating both the French emperor Napoleon Bonaparte
and his British adversary the Duke of Wellington (figs 128–129),
and she is seen today on the United States Medals of Honor for
both the army and the navy, the highest military awards for bravery
in combat, while the air force medal shows the Statue of Liberty.

Opposite top

FIG. 127
Lorenzo Maria Weber, medal of
Maria Theresa, ruler of the Habsburg
dominions, shown wearing the *aegis* of
Minerva (obverse), and with Venus, Juno,
Minerva and Neptune (reverse), 1743.
British Isles. Bronze. Diam. 8 cm. British
Museum, London, M.8472.

Opposite middle

FIG. 128
Pierre Ferrier, medal of Napoleon
Bonaparte (obverse), with Minerva
(reverse), 1796. Geneva, Switzerland.
Bronze. Diam. 4 cm. British Museum,
London, M.2611.

Opposite bottom

FIG. 129
Benjamin Wyon, medal of the Duke of
Wellington (obverse) with Minerva and
Mars (reverse), 1821. British Isles.
Bronze. Diam. 5 cm. British Museum,
London, M.5783.

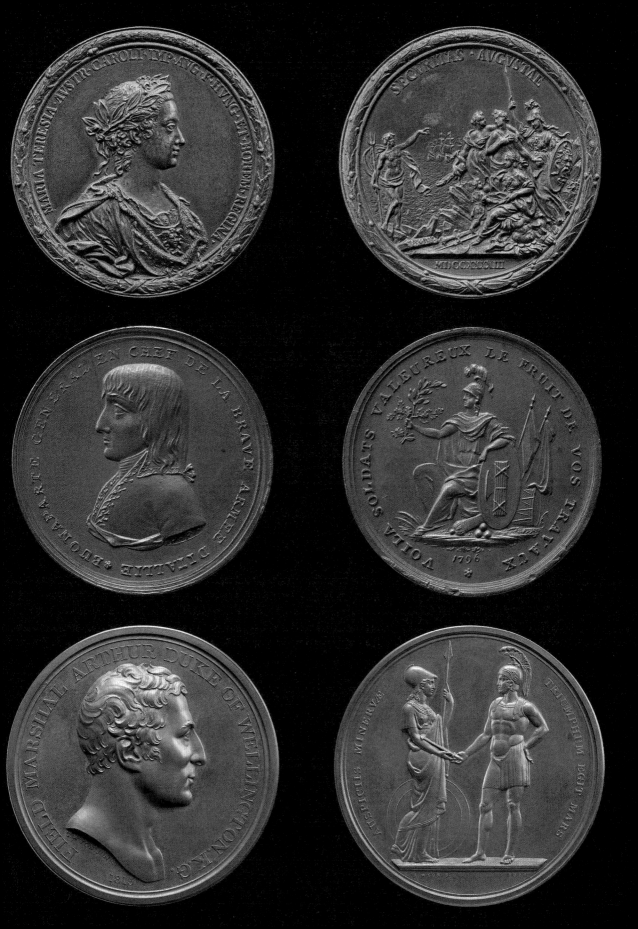

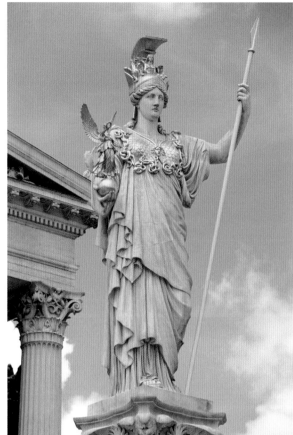

Left

FIG. 130
Marcello Mascherini, *Minerva*, 1955–6.
Belgium. Bronze. H. 4.5 m.

This depiction of Minerva stands by the
River Scheldt in Antwerp, Belgium.

Right

FIG. 131
Karl Kundmann, Pallas Athena fountain
(detail of statue), *c*.1880. Austria. Marble
and gold.

This neoclassical statue of Athena stands
on top of the Pallas Athena fountain,
which is in front of the Austrian
Parliament building in Vienna.

Although all three medals display female figureheads, to date
only one has ever been awarded to a woman – the surgeon and
feminist pioneer Dr Mary Edwards Walker, who won the army
medal in 1865.

Athena–Minerva's armed and austere figure continues to adorn
university and government buildings, law courts, battle sites,
libraries and military insignia around the world as testimony to
her enduring role in defining Western concepts of civilisation
(figs 130–131). Having shed her religious status as a deity, she
epitomises moral rectitude, and has found a place throughout
European history both as defender of the status quo and as leader
in the vanguard for change: while other religious and classical
symbols were removed during the French Revolution, Minerva's
image remained in the Place de la Révolution as an icon of
Liberty.[56] She is also increasingly finding a more welcoming
reception within feminist ideologies in the West, and her name has
been given to several educational and professional initiatives
designed to promote women within traditionally male-dominated
industries such as science and technology.[57]

SHAKTI: MANIFESTING POWER

MAHADEVI

In much of contemporary Hindu belief, femininity is intimately related to *shakti* ('power') – the cosmic energy to act and create. This association between 'femaleness' and action is reflected in the worship of many formidable warrior goddesses. In narrative myth, these goddesses battle against *asura*s – demonic forces of chaos, fear, ignorance and arrogance – symbolising their ability to teach worshippers to defeat these qualities within themselves.

The origins of Hindu religious traditions are much debated, potentially stretching back to the Indus Valley Civilisation of north-western India and modern Pakistan (*c.* 3300–1300 BCE), which, like many other early Eurasian cultures, emphasised female imagery in their art (see chapter 1).[58] Hinduism consists of many diverse spiritual traditions, which are usually, however, referred to in the singular for convenience. Throughout the long history of the faith, the worship of female deities has increased significantly. The earliest Hindu scriptures, the Vedas (*c.* 1500–500 BCE), focus predominantly on male deities.[59] However, in later Sanskrit literature, such as the famous epic poems the *Ramayana* (*c.* 650–350 BCE) and the *Mahabharata* (before 200 CE), and especially the Puranas – a vast body of sacred texts composed between the fourth and fourteenth centuries CE – the praise of female deities becomes increasingly apparent, and these texts include the first mentions of many of the most beloved goddesses of modern Hindu belief such as Parvati, Durga, Radha, Sita and Kali.[60] This literary shift was accompanied by an increase in the visibility of female divinities within Hindu art, where they often appeared in conjunction with male deities as divine couples, reflecting a more equal expression of power between the feminine and the masculine.[61]

All Hindu traditions recognise the unity of female and male divine forces. Largely as a development from Puranic texts, three 'henotheistic' branches of Hinduism have become prominent today, which worship a particular deity as the supreme power over existence and the cosmos – the Absolute, or *brahman* – while also recognising many other deities. The three branches are Shaivism, which reveres Shiva; Vaishnavism, which is devoted to Vishnu; and Shaktism, which worships *shakti* personified as Mahadevi, the Great Goddess. Shaktism is predominant within eastern India, particularly Bengal. To followers of Shaktism, Mahadevi is the dynamic energy that gives life to all existence and power to all deities – the singular source of creation, preservation and destruction in the universe. One of the earliest scriptures honouring Mahadevi is the *Devi-bhagavata purana* (first millennium CE), a foundational text within Shaktism. It portrays the goddess as both terrifying and

beautiful, benevolent and destructive, and describes her appearance before the gathered *deva*s ('gods'):

> Thousands of heads, eyes and feet were seen in that form ... Horrible, Awful, That appearance looked terrific to the eyes, heart and mind. The Devas thus beheld and began to utter cries of horror and consternation; their hearts trembled and they were caught with immoveable senselessness. 'Here is the Devi, our Mother and Preserver.'
> [...]
> The World Mother, the Ocean of Mercy, seeing the Devas terrified, withheld Her Fearful Cosmic Form and showed Her very beautiful appearance, pleasing to the whole world ... Her eyes emitted rays of kindness; Her face was adorned with beautiful smiles. The Devas became glad at this and bowed down to Her in a peaceful mind[.][62]

To followers of Shaktism, all female deities, both gentle and fierce, are expressions of Mahadevi, or *shakti*. Analogous with the Christian conception of the Holy Trinity as both one and three deities, Mahadevi is both singular and infinitely varied; so while the many goddesses of Hindu tradition are viewed as diverse beings, they are also intimately connected as the immanent manifestations of the Great Goddess. This is most clearly expressed in the *Devi Mahatmya* ('The Greatness of the Goddess'), a narrative hymn to Mahadevi composed between 400 and 600 CE, in which she is called upon by the gods to save them from the *asura*s, who threaten the stability of the cosmos. One of the most famous and popular texts in India today, it extols the power of Mahadevi as she manifests in a series of gentle and ferocious forms, including the warrior Durga, the radiant Parvati and the utterly terrifying Kali, 'the epitome of fierce womanhood'.[63]

DURGA

In the early passages of the *Devi Mahatmya*, the gods have been cast down to earth by the buffalo demon Mahisha, who has grown too powerful for them to defeat, and has taken over the heavens with his army of *asura*s. Angered and frustrated by their situation, the gods gather together and their 'rage' and 'splendour' burst out of their bodies, merging into the singular form of Durga, the warrior manifestation of Mahadevi, who appears before them 'like a flaming mountain':[64]

> ... filling the triple world with her radiance,
> Causing the earth to bow down at the tread of her feet, scratching the sky with her diadem.
> Making all the nether regions tremble at the sound of her bowstring[.][65]

Opposite

FIG. 132
Durga slaying the buffalo demon Mahisha, 15th century. India. Schist. 58 × 38 × 15.5 cm. British Museum, London, 1872,0701.77. Donated by Mrs John Bridge, Miss Fanny Bridge and Mrs Edgar Baker.

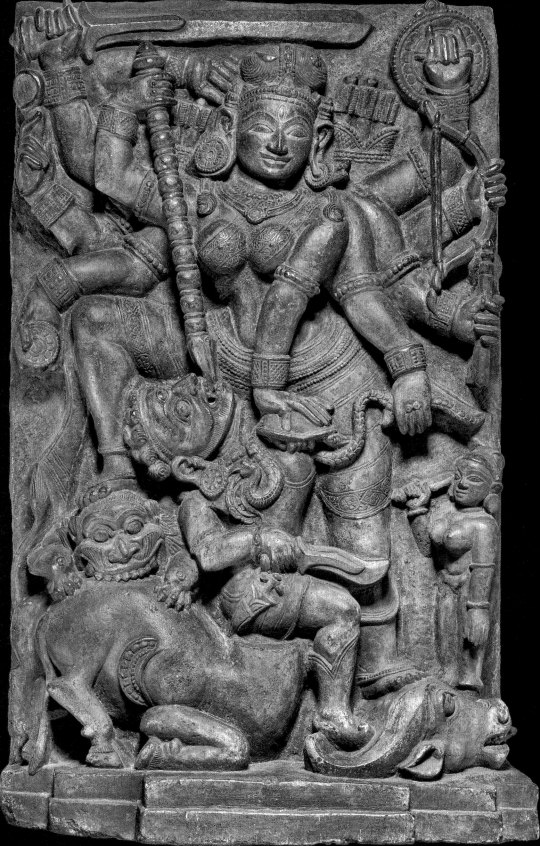

Durga, whose name means 'unassailable', is one of the best-loved goddesses in South Asia. The invincible slayer of demons, she is also serene, composed and dazzlingly beautiful, as she rides on the back of a lion, carrying all the weapons of the gods in her many arms. In the long passage that follows her first appearance in the *Devi Mahatmya,* Durga single-handedly destroys the demon army, severing heads and limbs and effortlessly breaking their weapons 'as if in play'.[66] Throughout the brutal scenes of battle, the goddess is called Ambika ('Mother') and hailed as the power that releases the world from suffering.

The violent protective power of Durga has been celebrated in art since at least the seventh century through the image of Durga Mahishasuramardini (Durga 'the Slayer of Mahisha'), which captures the climactic scene of the hymn, in which the goddess slays Mahisha himself.[67] On a dark grey schist relief, dating to the fifteenth century, Durga stands with one foot on the head of the dead buffalo and the other on her lion mount, which sinks its teeth into the buffalo's rump (fig. 132). Mahisha, in human form, has emerged from his disguise only to be instantly captured with a noose and impaled through the mouth by Durga's spear. Despite the violence occurring in the lower half of the scene, the goddess herself gazes outwards, her expression conveying inner calm and control, not unlike the meditative pose of the Ince Athena, who exudes composure while she carries the instruments of war. Durga's third eye on her forehead represents her enlightened omniscience and her total mastery over the forces of ignorance, while her ten arms fan out around her, filling the frame with a panoply of weapons.

In Hindu practice, the visualisation of deities in sculpture and painting is an instrumental meditative aid, allowing the devotee to focus on the spiritual qualities that they seek to emulate. Traditional Hindu religious art is often made in accordance with particular rules governing the iconography, appearance and attributes of each deity, and the image of Durga Mahishasuramardini is created widely in sacred art today with the same devotion and composition. It is also reproduced in popular prints and small figurines for private worship. When encountered within a sacred space, images such as this fulfil an active role in ritual worship by permitting *darshan* – reciprocal communion between the viewer and the deity by means of a dynamic visual exchange, through which the deity bestows a blessing upon the worshipper.

PARVATI

The destruction of Mahisha by Durga marks only the first victory for Mahadevi within the *Devi Mahatmya*. Later in the hymn, the gods are once again overthrown by *asuras* and travel to the Himalayas to call upon Mahadevi in her form as the goddess

Opposite

FIG. 133
Four-armed figure of Parvati, 10th century. India. Sandstone. 64.5 × 40 × 22 cm. British Museum, London, 1872,0701.110. Donated by Mrs John Bridge, Miss Fanny Bridge and Mrs Edgar Baker.

Parvati. Receptive to their praise and entreaties, just as the fierce Sekhmet emerged from the gentle Hathor in the Egyptian *Myth of the Heavenly Cow*, so Durga emerges from the 'sheath' of the golden-skinned Parvati to do battle on the gods' behalf.[68]

Parvati, whose name means 'Daughter of the Himalayan Mountains', is widely venerated as the partner of Shiva, the great god of destruction, who dissolves the universe at the end of time. The inseparability of the couple is expressed most literally through the figure of Ardhanarishvara ('the Lord who is Half Woman') depicted in art since the first century CE with a half-female, half-male body divided vertically.[69] Parvati is envisioned as the archetypal wife in Hindu thought. Sensuous and beautiful, she often appears in art at her husband's side in a display of mutual devotion and marital harmony. She can be interpreted as the socialised and domesticated projection of her eccentric and ascetic husband, whom she compels to engage with worldly concerns instead of withdrawing into meditation and drug-induced stupor, as is his tendency. Like other female–male pairings, Parvati is Shiva's *shakti*, the source of his power. The *Saundarya Lahari* ('Flood of beauty') a hymn to Mahadevi in the form of the goddess Parvati, attributed to the eighth-century CE sage Adi Shankara, opens with the lines:

> When Shiva is enjoined with Shakti, he is empowered to create.
> If the lord is not thus he is indeed unable to even move.[70]

A sculpture, carved in high relief in the tenth century CE, from Mathura, Uttar Pradesh, shows a four-armed Parvati as the central and largest figure, adorned with jewels and sheer fabric (fig. 133). She wears her matted hair piled on her head in a style known as *jatamukuta*, symbolic of her asceticism. Surrounding her are numerous female attendants and in niches around her head are small images of her husband Shiva (centre top) and their children, the elephant-headed Ganesha, the god of overcoming obstacles, and Skanda, the god of war. The stone is pierced through to allow light from behind to illuminate the goddess and her entourage, an effect underscored in the iconography by the sun surrounding her head. Despite the abundance of figures that fill the scene, the image is imbued with a sense of calm and tranquillity, which radiates from the goddess herself as she extends her lower right hand in a gesture of generosity.

KALI AND CHAMUNDA

Durga emerges from Parvati in the *Devi Mahatmya* in order to defeat the demon Sumbha, who believes he is entitled to take this beautiful goddess as his wife, and arrogantly underestimates her power because she is a woman. Sumbha dispatches a general

and 60,000 demons to bring Durga to him by force, but she burns the general to ashes by emitting a sound, and annihilates the army with her lion. Apparently unperturbed, Sumbha dispatches two more generals, Chanda and Munda, on the same errand, but his persistence infuriates Durga, whose rage concentrates in her brow and bursts forth as Kali ('the Black One'), the *shakti* of Durga herself.[71] Horrifying in appearance, emaciated, with reddened eyes and a long lolling tongue that hangs from her gaping mouth, Kali appears on the battlefield clothed only in a tiger skin and a garland of severed heads.[72] She proceeds to slaughter the *asuras*, delighting in the bloodshed, and cuts off the heads of Chanda and Munda before presenting them to Durga as a gift.[73]

Alongside Durga, Kali is one of the most prominent and widely venerated goddesses in India, particularly in north-eastern India, where she is commonly addressed as Ma Kali ('Mother Kali'). Both loved and feared for her formidable power and aggression, she is approached as the auspicious Great Mother: the goddess of enlightened wisdom and salvation, who transcends time and death, destroys ignorance and guides her followers to *moksha* ('enlightenment'). In art she often appears naked except for a skirt of severed arms around her waist and a long garland of heads around her neck, dancing wildly, with her unbound hair streaming behind her. In her many hands she is usually shown gripping a blood-drenched sword and a freshly severed head. Although superficially terrifying, the bloodied heads that she wears and carries represent her power to destroy the ego, setting her followers free from worldly concerns, and the belt of severed arms signifies that she liberates them from the cycle of death and rebirth, which she achieves through the many weapons she wields.[74]

Connected to Parvati through Durga, Kali is sometimes also viewed as the partner of Shiva, and traditional depictions show her trampling on the pale and supine body of her husband (fig. 134). This image is widely interpreted as representing Kali in the aftermath of her destructive rampage: having drunk much blood, Kali became intoxicated, and her frenzied dancing threatened to destroy the cosmos, prompting Shiva to throw himself under her feet. The shock of trampling on her husband subdues her rage, and reflects the feeling among many worshippers that the goddess Kali is a formidable yet dangerous expression of female power:[75]

Ma Kali is worshipped and feared. She is looked at as a mother Goddess who creates things but she can be the same person who can destroy it. As Hindus, we do not associate feet with anything good or pious or religious and husbands in our culture – rightly or wrongly – are supposed to be equivalent to Gods. So she's put her foot on her God. I'm not saying by any means go and do that but she's empowered, she's that angry that she's put her foot on her husband.[76]

FIG. 134
Kali Standing on Shiva, c. 1895. India. Colour lithograph. 41 × 30.5 cm (sheet). British Museum, London, 2003,1022,0.27. Funded by the Brooke Sewell Permanent Fund.

The scene takes place in the aftermath of a battle, indicated by body parts strewn around the field. The gods Vishnu and Brahma and a third figure are seen in the clouds to the top left.

The image of Kali standing on Shiva can also be interpreted as a metaphysical rather than a narrative scene. According to Hindu cosmology, we are living in the age of Kali – the present cycle of cosmic creation and dissolution. Kali's dynamism, contrasted with Shiva's inertia, situates her as the active expression of his consciousness and can even be read as illustrating her superior power, since, without her, the great god is passive, and appears as a corpse.[77] The image thus conveys the essential power (*shakti*) of Kali in union with Shiva; through them, as one, the universe is created and maintained, and will ultimately be destroyed.

In her most wrathful form, Kali is given the name Chamunda, a title bestowed upon her by Durga in the *Devi Mahatmya* in honour of her victory over Chanda and Munda.[78] Chamunda is the destroyer of the ego and of illusion (*maya*), the false distinction between opposites, including the mind and the body, the self and the universe. The upper part of an eleventh-century sculpture of Chamunda, from Malwa in modern Madhya Pradesh, shows the goddess as emaciated, with a visible ribcage and bulging eyes (fig. 135); in appearance, she is the antithesis of the voluptuous and composed Parvati, yet within Shaktism they are viewed as emanations of the same divine force. Like Parvati, Chamunda's matted hair represents her asceticism and is piled up above her corpse-like face and bound with a band of skulls. Her bony arms fan out around her, and in her hands she holds a skull cup, a snake and a dagger. This image of Chamunda inspires fear but encapsulates the compassionate guidance that she offers to worshippers: her weapon designates her power to destroy the ego, emphasised in the sculpture by the skulls around her head and at her left shoulder, as well as by the human-skull cup filled with wine or blood that she drinks from, her emaciated frame symbolising her ravenous insatiability.[79] Chamunda also embodies the more transgressive aspects of Tantric belief, which embrace the carnal and macabre as sources of power.[80] Tantric deities, both female and male, are often terrifying and aggressive in appearance. Their violence is necessary to overpower ignorance, and their ferocity compels devotees to confront their fears, as only by doing so can they overcome and destroy the impediments to spiritual awakening.[81]

The Kalighat Temple in Kolkata is one of the busiest and most sacred pilgrimage destinations for devotees of Shaktism today, and it has been devoted to the worship of Kali since the fifteenth century. The distinctive sacred image of the goddess, displayed within the *garbhagriha* ('womb-chamber'), is festooned with floral garlands and red cloth, and her three prominent red eyes permit *darshan* with the thousands of devotees who visit the temple every day.[82] Traditionally, temples to Kali are often built near cremation grounds, reflecting her existence in the liminal state between life and death, and the worship of Durga, Kali and Chamunda

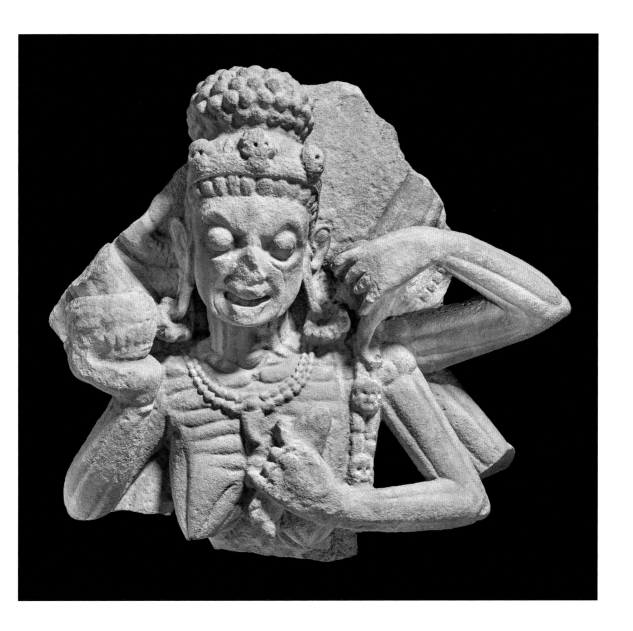

FIG. 135
Figure of Chamunda, 11th century.
India. Sandstone. 59.5 × 61 × 16 cm.
British Museum, London 1872,0701.84.
Donated by Mrs John Bridge,
Miss Fanny Bridge and Mrs Edgar Baker.

sometimes involves blood sacrifice. Goats are typically offered to the goddesses and the sacrifice is performed using a *ramdao*, a ceremonial sword–axe with a curved blade, designed to ensure decapitation with a single stroke (fig. 136). The removal of the head again signifies the severing of the ego, and the animal offering is viewed as the embodiment of the donor's pride, ignorance and greed, which are destroyed by the goddess in an act of compassion. Kali herself is usually depicted holding a *ramdao*, and many such blades have an eye etched on them, so that the goddess may directly witness the sacrifice.[83] Although animal sacrifice is still practised at Kalighat and some other Hindu temples today, many worshippers around the world choose to dedicate symbolic sacrifices of vegetarian food and flowers.[84]

FIG. 136
Ramdao (sword–axe), 1800–1940. Nepal. Iron, other metal and wood. 92.7 × 17 × 4.6 cm. British Museum, London, 1947,1112.11. Donated by Mrs A. Crooke.

The detail (*above left*) shows the eye of Kali on the blade.

In northern and eastern states of India, in particular West Bengal, Orissa, Bihar and Jharkhand, as well as parts of neighbouring Nepal, a major celebration within the Hindu religious calendar is the Durga Puja – a festival lasting several days, held in the Hindu month of Ashvin (September/October) after the monsoons. Communities come together to welcome the arrival of Durga by constructing huge clay statues of the goddess, beautifully painted and adorned with fabrics and garlands, in her characteristic pose vanquishing Mahisha. At the close of the festival, amid music, dance, fireworks and performance art, the statues are paraded through the streets towards the Ganges River or the shore of the Indian Ocean, where they are submerged in the water, dissolving the clay and signifying the departure of the deity for another year (fig. 137).

The close of the Durga Puja marks the beginning of preparations for the Kali Puja, which is celebrated by the construction of temporary shrines (*pandals*) in public and private, and similarly by the creation of large icons of the goddess, fabulously adorned and paraded in the streets. The Bengali artist Kaushik Ghosh is one of many artists based in Kolkata who create these devotional images, made either using traditional clay for *puja* celebrations, or modern alternatives, such as fibreglass for display in temples. A new icon made by Ghosh in 2021 for the British Museum recreates the style of his works of the goddess Kali used during the Kali Puja (fig. 138a–b). Kali appears with black skin, her tongue hanging out of her mouth as she dances on the body of Shiva. A large crown, embellished with gold leaf, sits on her head behind her third eye. In her left hands she grasps a blood-stained *ramdao* and head and with her right hands she makes the *abhaya mudra* (top) and *varada mudra* (bottom), symbolising fearlessness and generosity respectively. After the icon

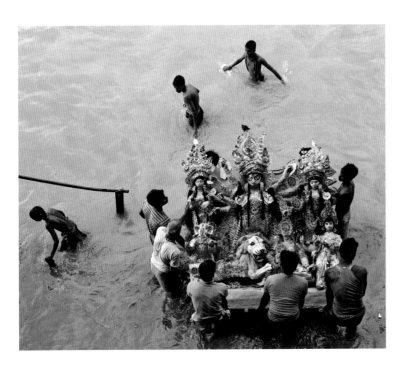

arrived in London in January 2022, members of the London Durgotsav Committee, who run an annual Kali Puja in Camden and who commissioned the work with the British Museum, performed a blessing ceremony to appease the goddess's wrath and ask her permission to be displayed.

Kali is the focus not only of the Kali Puja in the eastern states of India, but also of the Pongala festival in the southern state of Kerala, the largest festival for women in the world today. For ten days in February and March, millions of women of different faiths (Hindus predominantly, but also Buddhists, Christians and Muslims) and from different communities congregate in Thiruvananthapuram, the capital of Kerala, to make food for the goddess Bhadrakali, a fierce and auspicious form of Kali, who grants prosperity. Pongala means 'to boil over', and in throngs that fill the city, women cook a simple rice porridge dish on makeshift stoves (fig. 139). This is believed to renew the strength of the goddess and bring good fortune for the coming year, signified by the boiling over of the pots.[85]

The Pongala festival was originally associated with hope for abundance and success at the first harvest, but women who participate in it now are also likely to ask the goddess for success in their careers or at university, and for the health of their families. Women interviewed at the festival in 1997 reported a sense of strength granted to them by the goddess to bear any hardships they were confronting, and a feeling of renewed hope and courage for the future, through a belief that Mahadevi was protecting them. They also expressed a sense of oneness with other women of

FIG. 138A–B
Kaushik Ghosh, Kali icon, 2021. India.
Fibreglass, wood, ply, oil-based colour,
cloth, jute hair, gold thread, pearls,
nails, beads. 155 × 80 × 40 cm. British
Museum, London, 2022,3005.1.

Images from the artist's studio show him
working on the Kali icon.

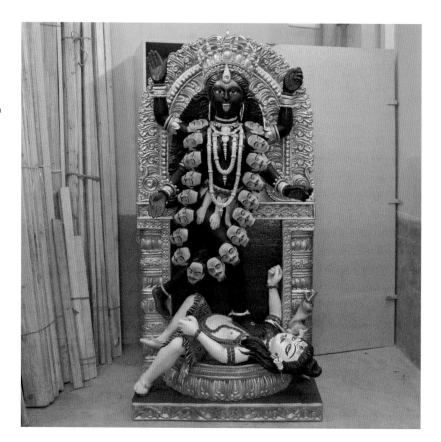

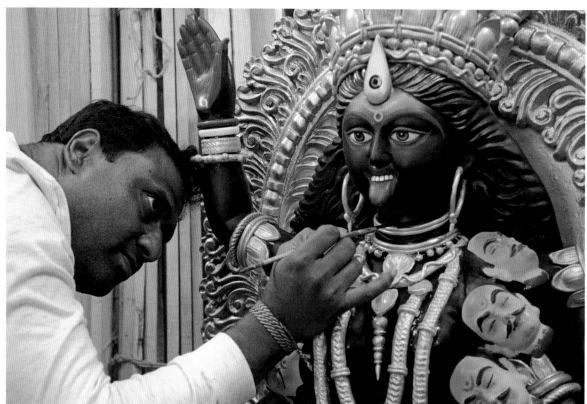

different faiths and social classes, which does not always exist outside the period of the festival.[86]

In a passage from the end of the *Devi Mahatmya*, quoted at the beginning of this book (p. 13), a sage, offering praise to Mahadevi, asserts that 'each and every woman in the various worlds' are portions of the Great Goddess.[87] There is much debate, predominantly among academics, about whether Hindu goddesses can, or should, be seen as feminist or as empowering icons for women's liberation movements.[88] While Hindu deities, whether female or male, transcend mortal concerns and are not traditionally viewed as role models for human behaviour, the veneration of formidable goddesses has impacted attitudes to women and female agency, particularly in north-eastern India, where their worship is most fervently observed, and for many worshippers the connection between Durga, Kali and female empowerment is unequivocal:

I feel that we all have that Durga and Kali within us. For me that's very important. When a girl has the power or the strength to stand against any kind of violence, any kind of injustice happening to her, we always say 'she has become very powerful like Kali or Durga'. It might be a compliment, or it might be that people are scared.[89]

FIG. 139
Women preparing food as part of the 10-day Pongala festival at the Attukal Temple, Thiruvananthapuram, Kerala, India, in March 2018.

FIG. 140
Chitra Ganesh, *Eyes of Time*
(installation view), 2014.
Brooklyn Museum, New York.

Recently, feminist activists and artists of South Asian heritage across the world have drawn on the inspiration of Hindu goddesses, in particular Kali, to explore female representation, authority and empowerment.[90] The British Indian artist Sutapa Biswas (b. 1962), who has incorporated Kali's image into her work, explains why she is attracted to the ferocious goddess: 'What I love about Kali is that she's so transgressive ... It's still considered fearful for women to be possessive of themselves – sexually, powerfully, intellectually – but a figure like Kali gives us permission to be and do just that.'[91]

Similarly, Brooklyn-based multimedia artist Chitra Ganesh regularly combines influences from Eastern and Western art, historical and futuristic narratives, and popular culture to probe cultural responses to gender identity. Her installation *Eyes of Time* (2014) at the Brooklyn Museum juxtaposed historical objects from the museum, depicting Sekhmet and Kali, with a large-scale, site-specific mural of Kali, to explore female power and the plurality of definitions of femininity (fig. 140). Her mural was displayed as a counterpart to Judy Chicago's infamous work *The Dinner Party*, a triangular table with thirty-nine place settings reserved for historical and sacred women, including one for Kali. The popularity of Kali within some feminist movements has occasionally been met with concern. The Indian feminist academic Rajeswari Sunder Rajan has argued that Hindu goddesses should not be secularised for political or social ends, and a lack of distinction between the sacred and profane may pave the way for

radicalised and extremist religious movements.[92] For others, on an individual level, the uncompromising fortitude represented by female warrior deities inspires reflection on their own inner power and opens up the arena for a broader debate on how feminine power can be understood and expressed.

<div align="center">☙</div>

Whether identifying and punishing criminals, defeating armies or battling cosmic disorder, divinities play an integral role in maintaining justice and order in many world faiths. Deities who fulfil these roles provide reassurance that harmful forces – human or spiritual – will meet their death and destruction at the hands of a superior power. The identification of righteousness and strength as manifestly female qualities has found expression in a number of historical and contemporary societies, either in the worship of a singular divine being such as Sekhmet or Athena, or in a broader association of femininity, power and moral rectitude, as represented by Luba tradition and in the Hindu concept of *shakti*. The independence and fighting spirit of the goddesses discussed in this chapter represents a side to femininity that is often overlooked culturally or is labelled as 'masculine', a designation that identifies these qualities as aberrant when expressed in women and locates them comfortably within gender stereotypes. Acknowledging that such qualities are possible within all gender identities promises to provide a rich source of future inspiration for gender-equality movements around the world.

Spiritual beliefs linking justice, leadership and the power to overcome obstacles to female mental and physical strength can be interpreted broadly. Despite their overt aggression, the ancient goddess Sekhmet and the contemporary goddess Kali were and are approached as mothers, who protect their worshippers from harm and free them from fear. They reflect a duality in the concept of motherhood – as both gentle and strong, compassionate and fierce – that also finds expression in some of the most widely revered maternal spiritual beings of the ancient and modern worlds, who can be found in the next chapter.

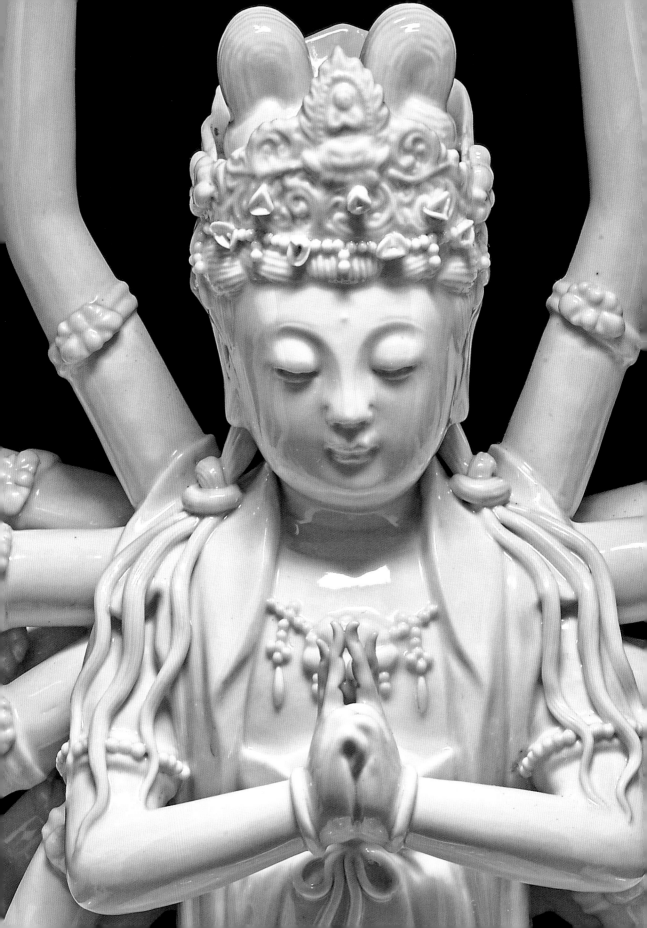

COMPASSION
& SALVATION

Your pure light, free from defilement, is the sun
of wisdom dispelling all darkness; it can quell the
calamities of winds and fire, and illuminate the
whole world.

'The Universal Gateway of Guanyin Bodhisattva', *The Lotus Sutra*[1]

Many of the major global religions of today teach that mortal
life is imperfect. Within some Abrahamic faiths – Judaism,
Christianity and Islam – as well as in Buddhism and Hinduism,
human existence may be perceived as a linear or cyclical period
of suffering, atonement or preparation, from which devotees may
progress, through divine grace, introspection and/or personal
growth, to a better existence hereafter. Within these religions,
spiritual beings may be petitioned by the faithful for strength and
wisdom to withstand and overcome the tribulations of life and their
own mortal failings, and to achieve a more perfect state of being. In
this context, the love, comfort and patience of a parent towards a
child has long provided a metaphor for spiritual love and guidance.

Traditionally, many cultures throughout history have assigned
the care of the young and the vulnerable to women, and
correspondingly viewed qualities such as gentleness and the
alleviation of suffering as intrinsically feminine. In some spiritual
traditions, the concept of the loving, protective mother has come
to represent an ideal of divine compassion. Expressing wisdom
and compassionate non-judgment, maternal figures offer relief
from worldly hardship, guidance towards salvation, or liberation
and protection from harm. While these beings may or may not be,
according to orthodoxy, the highest power within a faith, they are
often uniquely important in the daily lives of worshippers because
of their closeness and accessibility to humankind.

The spiritual figures discussed in this chapter are commonly
referred to as 'mothers', yet while some are honoured alongside
their own children, for others, the expression of motherhood is less
literal, and all are approached as embodiments of mercy, comfort

and strength. Perceived as existing close to the mortal plane, they are the guides and pathways to paradise, and are believed by some actively to come to the aid of those in danger, manifesting before worshippers in times of need, projecting a ceaseless and undiscriminating concern for all of humankind. Their veneration has proliferated across diverse cultures for hundreds, if not thousands, of years, and has seen them interpreted in many varied and personal ways.

HEAVENLY QUEENS

ISIS

The image of the nursing mother pervaded the art of ancient Egypt, from depictions of low-born women nursing their children to adult pharaohs suckling at the breast of a goddess, symbolising the transference of life, strength and divinity from deity to ruler.[2] Intimately associated with motherhood, the goddess Isis is known from inscriptions dating back to around 2500 BCE. These earliest texts, known as the Pyramid Texts and inscribed on the walls of royal tombs, connect Isis with the funerary rituals that prepared the deceased pharaoh for entry into the afterlife. Over the centuries, her importance grew to cosmic proportions, spreading to all levels of Egyptian society, and she became the pre-eminent goddess of Egypt. She was associated, alongside rebirth and royal power, with universal creation, wisdom, magic and protection.[3] From around 700 BCE, images of the goddess enthroned and nursing her son Horus – often in the form of amulets or figurines carved in stone or cast in bronze – were among the most common iconographic representations in Egyptian art (fig. 141). In these depictions, Isis often appears in human form, wearing either the hieroglyph for 'throne' on her head, which designates her as the seat of royal power, or alternatively a sun disc encircled with bovine horns, which equates her with Hathor, the goddess of beauty, joy and sexuality (see chapter 4).[4]

Isis was both the divine mother and wife of the pharaoh, who in life was identified with her son Horus, and in death with her husband Osiris.[5] The symbolism of Isis offering her breast to Horus identified her as the source of power and nourishment to the pharaoh, and she appears to have held an important role in official ritual for the security of the state and royal family. The expansion of her worship in the later periods of Egyptian history coincided with growing personal piety, through which the people of Egypt increasingly sought individual bonds with their deities for personal salvation.[6] Isis was central to this phenomenon and her temple at Philae, in Aswan – constructed under Pharaoh Nectanebo I (r. 380–362 BCE) but used through and even beyond the Roman

FIG. 141
Statue of Isis and Horus, *c.* 400–300 BCE.
Egypt. Bronze, gold and copper.
26.9 × 7.2 × 14.8 cm. British Museum,
London, 1868,1102.3.

Isis, nursing her divine son, is shown
enthroned and crowned with an elaborate
headdress, comprising a sun disc encircled
by the horns of the goddess Hathor.

period (until about the sixth century CE) – is covered with hundreds
of graffito prayers, written on the walls by worshippers, priests and
temple attendants, who dedicated their names, and in several cases
the names of their mothers, to the goddess 'forever'.[7] Using the
everyday script of demotic (as opposed to ceremonial hieroglyphics),
these prayers associate many other goddesses, in particular Hathor,
with Isis' all-encompassing power, and hymns from the temple hail
her as 'the Lady of Heaven, Earth and the Netherworld, having
brought them into existence', attesting to her universal authority in
the eyes of her worshippers.[8]

Amulets also reveal evidence of personal connections between
worshippers and deities of the Egyptian pantheon, and were both

carried in life and buried with the dead, carefully positioned on the body and wrapped in cloth bindings during the mummification process. The *tyet* amulet, or the 'girdle of Isis', was positioned on the neck or chest of the deceased (fig. 142). These distinctive amulets were shaped like a tied sash, resembling the ankh (the symbol of life), and were usually carved in a red stone such as jasper or cornelian, symbolising the blood of the goddess.[9] An unusual and particularly personal amulet, with suspension rings indicating that it may have been worn, was cast from copper alloy in the shape of an offering table. Two vessels stand to either side of several flat loaves (moulded in low relief), over which a priest with a shaven head pours liquid (fig. 143). The design implies that water or another liquid may have been poured over the amulet, perhaps as a libation to the goddess, and allowed to flow out of the spout at the front, which is decorated with a large frog. Frogs and locusts were symbolically connected with fertility owing to their prolific reproduction, and an inscribed prayer on the base reads: 'Isis who gives life to [Bes-seped?], (the child) of Pawenhatef, born of Nebhuy.'[10]

The most famous narrative myth relating to Isis celebrates her protective power as both mother and wife. The story is known in its fullest version from the Greek author Plutarch, writing in the first century CE, who probably synthesised several versions of the myth. Plutarch relates that Isis, along with her siblings Osiris, Nephthys and Set, were the children of Nut, goddess of the sky, and Geb, god of the earth (see chapter 1). She married her brother Osiris and assisted him in his reign as king, during which time Osiris brought agriculture, religion and law to Egypt. Jealous of his brother's power, Set murdered Osiris and cut his body into fourteen parts, scattering them across the land. In an ensuing battle, Set was overthrown, and Isis, distraught, tracked down and reassembled the different parts of her husband, except for his penis, which had been eaten by fish.[11] Fashioning a new one, Isis reanimated Osiris for long enough to conceive their child, Horus.[12] Isis' protective and life-giving powers are commemorated in a small but exquisitely carved statue, dating to approximately 590–530 BCE. Osiris, who appears in his characteristic mummified guise as ruler of the dead, holds a crook and flail – symbols of kingship – and wears his distinctive feathered atef-crown. Isis, about twice the size of her husband, stands behind him, supporting and shielding him on both sides with protective wings (fig. 144). She wears a long wig and an almost imperceptible dress, indicated only at the neckline, and a headdress consisting of the solar disc and horns of Hathor, positioned on top of a crown of rearing cobras. Another cobra can be seen on her forehead, symbolising royalty. The statue is believed to have stood originally in a shrine dedicated to Osiris at the temple complex at Karnak, Thebes, and a short inscription below the feet of Osiris records that it was dedicated by a male official named Sheshonq, who acted as the chief steward for the

FIG. 142
Tyet amulet, *c.* 1400 BCE. Egypt. Cornelian. 4.6 × 2 × 0.5 cm. British Museum, London, 1857,0811.20.

Incised on this amulet is a hieroglyphic text from the Book of the Dead, spell 156: 'You have your blood, O Isis; you have your power, O Isis; you have your magic, O Isis. The amulet is a protection for this Great One which will drive away whoever would commit a crime against him.'

FIG. 143
Amulet in the form of an offering table,
c. 1400 BCE. Egypt. Copper alloy. 5 ×
8.5 × 8.5 cm. British Museum, London,
1937,1125.1. Donated by David L.
Davis in memory of L.J. Davis, with
contribution from Art Fund (as National
Art Collections Fund).

Opposite

FIG. 144
Statue of Isis protectively shielding
Osiris, *c.* 590–530 BCE. Egypt. Siltstone.
81.3 × 17 × 47 cm. British Museum,
London, 1895,0511.51.

Divine Adoratrice, a senior priestess in the service of Amun (the
supreme god of Thebes).[13] In two longer inscriptions on the upper
surface of the base and around its sides, Sheshonq addresses Isis as
'Mistress of the Sky and Mistress of all the gods, who protects her
brother Osiris and overthrows his enemies', and then invokes her
divine aid with the words: 'Remember me, my beloved Mistress! I
followed the course of your water; give me the reward consisting
of a long life and a beautiful burial at its end, [and grant that] my
name continues without being destroyed.'[14]

ISIS IN GREECE AND ITALY

In the second half of the first millennium BCE, worship of Isis
spread rapidly around the eastern Mediterranean, particularly after
332 BCE, when Egypt was conquered by Alexander the Great and
was subsequently ruled by the Macedonian Ptolemaic dynasty.[15]
Greek literature and inscriptions sometimes equated Isis with other
female deities known to Greek religion, in particular Demeter and

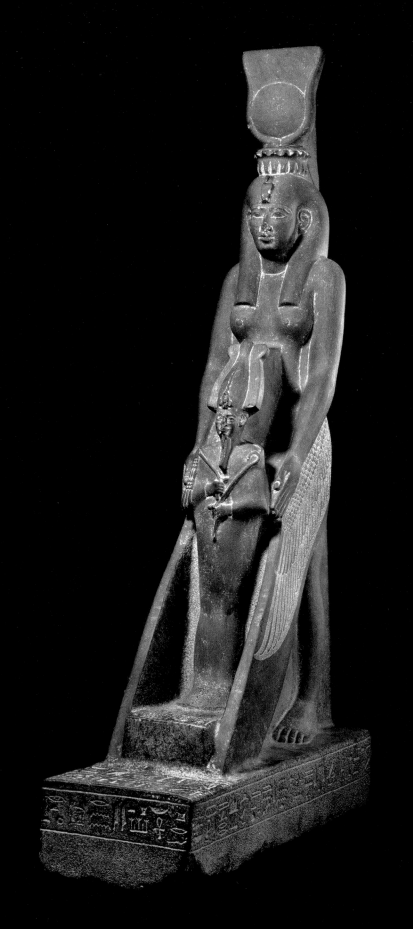

FIG. 145
Isis Anasyromene figure, 3rd–2nd century BCE. Egypt. Terracotta. 36.8 × 10.2 × 6 cm. British Museum, London, 1888,0601.III. Donated by Egypt Exploration Fund.

Aphrodite, through her association with fertility and sexuality.[16] In art, images of Isis Anasyromene (Isis 'Revealing the Womb'), adorned with elaborate headdresses overflowing with fruit, were produced as terracotta figurines, with many examples discovered at the Greek–Egyptian settlement of Naukratis in the Nile Delta (fig. 145). The deity is shown lifting her dress to reveal her pubic area, combining imagery of Isis and Aphrodite with allusions to sex and the abundance of the earth. On the Greek mainland, Isis came to be worshipped alongside Demeter at Eleusis (see chapter 1), an alliance that draws on the two deities' associations with agricultural fertility, rebirth and motherhood.[17] Women's involvement in the worship of Isis can be seen on a funerary relief from the ancient Greek city of Smyrna, on the western coast of Turkey, dating from the second to first century BCE (fig. 146). It commemorates a woman identified as Isias, daughter of Metrodoros, whose name suggests that she was a priestess of Isis in the city. Isias appears in the central panel beneath a tree, wearing long flowing robes. She carries a distinctive bucket, which has been interpreted as imitating the shape of a breast, and a key, indicating her guardianship of a temple.[18] A wreath at the top of the stele is engraved with the words 'the people', and indicates an honour bestowed upon Isias for civic service.

By the second century BCE, veneration of Isis had reached Rome, and over the following centuries temples to the goddess were constructed across the Roman Empire, including in Rome itself, Italica (modern Spain), Londinium (England), and Byblos (modern Lebanon).[19] The worship of Isis seems to have been particularly popular among non-aristocratic classes and may have been viewed by some devotees as henotheistic (that is, directed to one supreme deity, but not at the exclusion of others). She appears in literature and dedicatory inscriptions as an all-encompassing, all-powerful divinity, not unlike Mahadevi as she is regarded in Shaktism (see chapter 4).[20] The most famous exposition of this approach to Isis appears in the *Metamorphoses* (or *The Golden Ass*) by the philosopher and author Apuleius of the second century CE. Believed to have been adapted from an older Greek original, the novel tells the story of an aristocratic young man named Lucius, who is magically transformed into an ass and undergoes beatings, exploitation and a life of bearing burdens before he is eventually saved by the goddess Isis. Appearing before the desperate and broken Lucius as his saviour, Isis declares:

I [am] the mother of the universe, mistress of all elements, the first offspring of the ages: mightiest of deities, queen of the dead, and foremost of heavenly beings … With my nod I rule the starry heights of heaven, the health-giving breezes of the sea, and the plaintive silences of the underworld. My divinity is one, worshipped by all the world under different forms, with various rites, and by manifold names.[21]

FIG. 146
Funerary stele of Isias, 2nd–1st century
BCE. Smyrna (modern Turkey). Marble.
121 × 58.4 × 10.2 cm. British Museum,
London, 1772,0703.1. Donated by
Matthew Duane and Thomas Tyrwhitt.

The passage goes on to name all of the deities identified as manifestations of Isis in different parts of the Mediterranean world, including Minerva, Venus, Diana, Proserpina and Hecate.[22] Lucius' encounter with the goddess marks a turning point in his fortunes; he recovers his human form and worldly status, and undergoes a series of complex ritual initiations into the Mysteries of Isis. This was one of several 'mystery religions' practised across the Greek and Roman worlds, in which aspects of worship were open only to those who had been formally initiated. Like other mystery religions – which included the Eleusinian Mysteries devoted to Demeter and Persephone, and the worship of the god Mithras, and of the sun god Sol Invictus – the ritual practices of the Mysteries of Isis were shrouded in secrecy. It is known about today largely through Apuleius' fictionalised account, sporadic mentions by other authors such as Plutarch, and excavations of temples to Isis, which often incorporated a subterranean chamber, perhaps relating to chthonic rituals. Although details of the membership of the society and the beliefs of initiates are unclear, the cult seems to have placed emphasis on eschatological and soteriological beliefs (that is, to do with the end times and with salvation), and directed worship towards the cultivation of a close personal relationship between the initiate and the goddess. This was a divergence from public Roman religion, which predominantly focused on the protection and well-being of the state.[23]

Devotion to Isis among the masses (particularly the poor, women and other typically disenfranchised groups), along with the more secretive elements of her worship, were sometimes viewed as subversive by the Roman elite, and occasionally met with intolerance. Despite the testimony of authors such as Apuleius and Plutarch – who may have been initiates into the Mysteries of Isis themselves – that a period of sexual abstinence was required for members, critics, including the Roman poets Ovid and Juvenal, alleged that worship of Isis encouraged promiscuity in women and that her temples were used as brothels.[24] In 28 BCE the Emperor Augustus banned the construction of temples to Isis and other Egyptian deities within the city of Rome, while his successor, Tiberius, crucified priests of Isis as part of a wider attempt to eradicate religious beliefs felt to be injurious to the state, which also included Christianity.[25]

The iconography of Isis nursing her son remained popular in Greek and Roman art, and did not change radically from that of pre-Roman Egypt, but it assumed a more naturalistic aesthetic. A Roman moulded terracotta figurine, created around 200 CE, depicts Isis as regal, and enthroned, wearing a small but distinctive horned sun disc on her head; she raises her leg to lift her child, and supports his head as she offers him her breast with her other hand (fig. 147). To modern, Western eyes, it is difficult not to see such depictions as precursors to the ubiquitous

Christian sacred image of the Virgin Mary holding her son Jesus. However, scholarly opinion is divided on whether or not imagery of Isis and Horus influenced early depictions of Mary and Jesus, particularly since the *Maria lactans* (the 'Nursing Madonna') is not definitively attested in Christian art until the seventh century CE.[26]

The transition between polytheistic 'paganism' and Christianity that took place within the late Roman Empire was a gradual and fractious process. In early Christian theology, there was intense debate, in which prominent ecclesiastical leaders engaged on both sides, as to the validity of understanding pre-Christian iconography and spiritual philosophies as perversions or precursors of Christian 'truths'. Belief in half-mortal, half-divine children born of a mortal mother and divine father had a long history in pre-Christian literature and mythology, examples including such notable figures as Perseus, Heracles and Helen of Troy. Similarly, it was not unknown for divine mothers, such as Isis herself and Kore (Persephone), to be referred to figuratively as 'virginal', superficially resembling Christian belief in the birth of Jesus by the Virgin Mary. These parallels caused extreme anxiety and were denounced by some Christian commentators, such as Justin Martyr (*c.* 100–165 CE), while others, such as Origen (*c.* 185–*c.* 253 CE), embraced them as foreshadowing the miraculous birth of Christ.[27] It is perhaps no coincidence that Mary was declared Theotokos ('Mother of God') at Ephesus in 431 CE, a city with a long history of worshipping Artemis, the virgin goddess of the moon and of childbirth.[28]

A clear line of succession between Isis (or any classical goddess) and Mary cannot be established, and to draw too close a parallel between the two figures would be an oversimplification of their significance within their respective faiths. However, the narratives of both are filled with maternity, loss and suffering, and there are certainly superficial iconographic parallels, which do not stem, in the case of Mary, from Christian scripture. While there is no apparent chronological overlap of Isis *lactans* and *Maria lactans* imagery, the earliest known examples of the *Maria lactans* in art are found in Egypt, and the possibility remains that images of Isis holding the child Horus were understood by some early Christian devotees, familiar with the worship of divine maternity, as images of Mary and her child.[29]

THE VIRGIN MARY

Mary is one of the most familiar and recognisable spiritual figures in the world. She is honoured as the virgin mother of Jesus, who is accepted in Christianity as the Messiah and the son of God, and in Islam as an important prophet. Across all Christian and Islamic denominations, Mary is considered canonically non-divine, yet she nonetheless plays a prominent role in the spiritual and cultural lives of millions of people around the globe. She is commonly perceived

FIG. 147
Statuette of Isis preparing to suckle Horus, *c.* 200 CE. Roman. Terracotta. 14 × 8.5 × 4 cm. British Museum, London, 1849,0811.6.

as 'blessed' by God, and is sometimes viewed as the foremost of saints – mortals whose exemplary actions and piety are believed to make them worthy of particular honour after death, and who are approached by others for inspiration and guidance.

Veneration of Mary has grown significantly throughout the last 2,000 years. Popular devotion to her, both in the past and today, is sometimes at odds with orthodox doctrine, and she has acquired a plurality of meanings for individuals, different branches of Christianity and Islam, and other religious systems over time. The breadth and diversity of these interpretations may perhaps reflect her visibility as the most prominent female figure within the Abrahamic tradition, and have sometimes provoked fierce debate surrounding her nature and her agency in the lives of the faithful.

Canonical references to Mary in the Bible are few and provide little detail of her life and character beyond the Annunciation (the announcement by the angel Gabriel that she had been chosen to bear God's son) and the birth of Jesus. By contrast, she receives greater scriptural attention in the Qur'an, in which she is the only woman identified by name and to have a *surah* (chapter) named for her.[30] In the Qur'an, Maryam is described as *siddiqa* ('the righteous one'). Details of her early life are narrated alongside the events surrounding the conception of her son, 'Isa, who is recognised as one of the prophets and described as 'a mercy from God'. In the *surah* Al 'Imran (chapter 3), Maryam's mother vowed to dedicate her unborn child to God to undergo religious instruction – an honour traditionally reserved for boys – but when she gave birth to a girl, God accepted the child into his service.[31] Later, in the *surah* Maryam (chapter 19), Maryam gives birth to 'Isa alone and in agony, and God provides nourishment and comfort for her. There are traditions in which Muslim women recite the *surah* Maryam before or after childbirth.[32] This *surah* has been described as important for not only bringing comfort and strength to women during this time, but also for encouraging male readers to understand the experiences of women.[33]

Maryam's elevated status in Islamic belief derives from the struggles, suspicion and suffering she experienced as a girl in the service of God and later as an unwed mother, and her unshakable faith and virtuous actions in the face of adversity.[34] Viewed as favoured by God above all women, her devotion and resolve are considered a model for all people.[35] Speaking about her own perception of Maryam, Nusrat Ahmed, South Asia Gallery Lead at Manchester Museum, explains that 'Learning about Maryam and hearing about her trials … the things we go through in life will be nowhere near as severe, but she didn't lose hope or faith, which I feel is the message Allah sends to us about her.'[36]

Figural representation is rare in Islamic art, and the Qur'an is never illustrated. The story of Maryam, among other narratives, is evoked through recitation of Qur'anic verse and through calligraphic art. One work, of 1980, by Sudanese artist Osman Waqialla includes

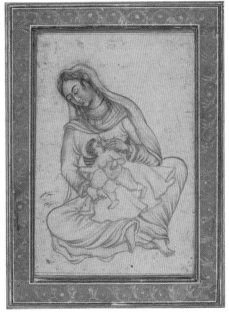

the whole of *surah* Maryam inscribed on vellum, with verse markers
highlighted in gold. It is composed of tiny *naskh* script, which is woven
around the first five letters of the *surah, kaf ha ya 'ayn sad*, rendered in
large, bold *thuluth* script (fig. 148). Such letters, which open twenty-
nine of the 114 *surahs* of the Qur'an, are known as the 'mysterious
letters of the Qur'an' and are believed to be imbued with protective
qualities.[37] Figural representations of Maryam, showing events
in her life, are sometimes found in Mughal miniature paintings.
Incorporating and adapting elements of European and Hindu art, a
drawing by a Mughal artist shows Maryam seated cross-legged, with
'Isa playing on her lap (fig. 149). An inscription records that the artist
dedicated the image to the Mughal emperor Jahangir, the Muslim
ruler of South Asia from 1605 to 1627, before he came to the throne.
When Jahangir was born, his Hindu mother was given the title
'Maryam of the Age', and when he became emperor, Jahangir used
imagery of Maryam and 'Isa on one of his royal seals.[38]

Within Christianity, Mary occupies a prominent position in Catholicism and Eastern Orthodoxy. Viewed as closer to the divine than other mortals, she is approached as an active intercessor for the faithful, appealing to the mercy of her son on their behalf. This role of Mary is explicitly expressed in the Hail Mary prayer, traditionally recited daily by Catholics – 'Holy Mary, Mother of God, pray for us sinners now and at the hour of our death' – which became popular in its current form around 1550 and is recited with the aid of a rosary or prayer beads, equivalent to those long used in Buddhist and Islamic worship (fig. 150).[39]

The recognition of Mary as the one who guides the faithful to God is expressed in one of the oldest icons in Christian art: the Hodegetria ('She who shows the way'). Icons are sacred images often believed to have been divinely inspired, which serve to concentrate the mind of the viewer on veneration.[40] Tradition holds that the original Virgin Hodegetria was painted from life by the apostle St Luke in the first century CE and transported from the Holy Land to Constantinople (modern Istanbul), the capital of the Byzantine Empire, in the fifth century CE, to be housed in a dedicated monastery.[41] The original is lost, but the image survives in multiple copies and is one of the most sacred images in Russia, where a version (or, as some believe, the original) was taken in the eleventh century. This version, known as the 'Hodegetria of Smolensk' after the first city that received it, is credited with having the power to repel invaders.[42] Another version painted in egg tempera on wood in the sixteenth century in Yaroslavl, Russia, shows Mary holding the child Jesus and gesturing towards him with her right hand, emphasising her role in directing the faithful towards God (fig. 151). Christ holds a scroll and makes a sign of blessing. The image is encased in a silver-gilt revetment, an elaborate cover that serves to embellish the sacred image while also protecting it, particularly against smoke damage from candles and incense used in worship; it was further adorned in the nineteenth century, when a turquoise halo was applied to each figure.

MARY AND EVE

One of the first beliefs surrounding Mary to enter into doctrine was her perpetual virginity, not only before but also after the birth of her son, which was introduced by the Lateran Council of 649 CE.[43] Accepted as dogma in both Catholic and Orthodox faiths, this aspect of Mary's nature is contested among Protestant denominations and has long been a source of contention for feminist progressives.[44] In the Magnificat, Mary's song of praise in the gospel of Luke, Mary gives her consent (*fiat*) to bearing God's son, thereby leading to the birth of the Messiah and the redemption of humankind. In Early Christian discourse, Mary's obedience to

FIG. 150
Rosary with pendant crucifix, 19th century. Lourdes, France. Wood. L. 390 cm (string and crucifix). British Museum, London, 1900,1117.32. Bequeathed by Henry Spencer Ashbee.

Opposite

FIG. 151
The Mother of God Smolenskaya icon, 16th century. Yaroslavl, Russia. Brass, enamel and silver. 74.5 × 52.5 × 3.8 cm. British Museum, London, 1998,1105.27. Donated by Ella Wentworth Dyne Steel.

God's will led to her being contrasted with Eve, whose disobedience brought sin, suffering and sexual knowledge into the world through the Fall (chapter 2). Consequently, Mary's virginal status was brought into sharp focus and her entire existence argued to have been free of any acts considered sinful.[45] Moreover, Mary's independent volition in accepting God's plan is argued by some within the Catholic Church to afford her an active role in the salvation of humankind, and the status of 'co-redeemer' with Christ.[46] This is expressed in a late medieval French statuette of Mary and the Child, carved from ivory in the thirteenth century (fig. 152). Mary, seated on a throne and regally dressed in a belted gown and embellished cape, wears a crown over her traditional veil as she supports her son on her left arm. Christ holds a goldfinch to his chest (a bird that was symbolic of his Passion and crucifixion, owing to the blood-red markings on its head). Unlike the Hodegetria image, mother and son are turned to face each other in a gesture of mutual tenderness characteristic of late thirteenth-century depictions.[47] The informality of their interaction conveys their humanity, yet at the base of the scene Mary's foot emerges from her robe and effortlessly crushes a hybrid monster with the head of a human and a winged body, symbolising her agency in the triumph of good over evil.

Across Western Europe devotion to the Virgin Mary flourished from about the 1300s. Churches and altars were dedicated in her honour, and her status and role within the Christian faith were enhanced through new theological doctrines, including those of her own Immaculate Conception (her birth without taint of original sin) and Assumption (her entry into heaven, at the end of her life, to be united with her son).[48] Although it did not become Catholic dogma until 1950, the Assumption of Mary has been celebrated since *c.* 600 CE, when a feast day was inaugurated by the Byzantine emperor Maurice as an annual celebration on 15 August, the observance of which rapidly spread throughout the Christian world.[49] This elevation in the status of Mary, ascribing to her life otherworldly phenomena comparable (if only superficially) to the divine attributes of her son, was reflected in both private and sacred art. The Assumption of Mary, when she rose from her deathbed before crowds of mourners and ascended into the sky, and her subsequent coronation, became favourite compositions for medieval and Renaissance artists. In the volute of the enamelled head of a crozier (a bishop's staff), Mary, having been taken up to heaven, sits beside her adult son, turning to face him with hands together in prayer (fig. 153). This example was created around 1235 in Limoges, France, a centre famed for the production of exquisite enamelled religious objects. Christ, the slightly larger of the two figures, places a crown on his mother's head, designating her Queen of Heaven.

As the pre-eminent expression of femininity within Christianity, Mary's importance to women of the faith has been prominent in

Opposite

FIG. 152
Statuette of the Virgin and Child, *c.* 1275–1300. France. Ivory and gold. 22.7 × 8 × 6 cm. British Museum, London, 1856,0623.141.

art and devotional writing since at least the twelfth century.[50] The promotion of her status at this time has been read by some as coinciding with the rising influence of aristocratic women across Europe in the early second millennium CE and the rule of several powerful and devout queens and queens regent across Europe – in particular, Blanche of Castile, mother of Louis IX; Adelaide of Montserrat of Sicily, mother of Roger II; and Eleanor of Aquitaine, mother of Richard and John, kings of England.[51] It also coincided with the emergence of a new female spirituality, which spread across medieval and early modern Europe as a proliferation of mystical and visionary texts were created by, or on behalf of, women both within and outside the Catholic Church. Combined with keen theological debate on sophiology (the wisdom of God personified in scripture as female), a new form of Mariology emerged, identifying Mary with divine wisdom and suggesting her perpetual existence in the mind of God from the beginning of creation.[52] Notable in this field was the twelfth-century German Benedictine abbess Hildegard of Bingen, a prolific author and composer of sacred music, in whose works the figure of Sophia, or Wisdom, regularly appears as the divine mother, bride or queen. Hildegard believed that Mary was the 'Sister of Wisdom', and as the vessel of the Incarnation she was at the centre of God's plan for the world, residing in his heart, the place to which all creatures are predestined to come. In the Dendermonde manuscript of her collection of liturgical songs, *Symphonia armonie celestium revelationum*, Mary is honoured in twelve songs, while none is addressed directly to Christ. Hildegard interposed songs to Mary between those dedicated to God the Father and the Holy Spirit, hierarchically positioning Mary in the place of the second person of the Holy Trinity (traditionally the Father, Son and Holy Spirit).[53] In praise of Mary, Hildegard writes: 'O branch, God foresaw your flowering on the first day of his creation'; and 'You are the shining lily, the point before all creation where God fixed his gaze.'[54]

Devotion to Mary in mystical texts continued until at least the seventeenth century, when the Franciscan abbess and mystic María de Jesús de Ágreda composed her most famous work, *Mística ciudad de Dios* ('The mystical city of God'). While Hildegard's writings relate no direct visions of the Virgin, this lengthy text records private revelations that María de Ágreda was said to have received from the 'Heavenly Queen' herself. Sometimes referred to as a biography of Mary, the text is a vivid account of the Virgin's life, and includes a passage in which Christ on the cross entrusts the divine power of the heavens on earth to his mother:

> I desire that She shall be Mistress of angels and men, claim over them full possession and dominion and command the service and obedience of all. The demons shall fear Her and be subject to Her. All the irrational creatures, the heavens, the stars, the planets, the elements with all the

Opposite

FIG. 153
Head of a crozier showing the Coronation of the Virgin, *c.* 1250. Limoges, France. Copper, gold and enamel. H. 33.5 cm. British Museum, London, 1853,1113.1.

living beings, the birds, the fishes and the animals contained in them, shall likewise be subject to Her and acknowledge Her as Mistress, exalting and glorifying Her with Me ... whatever She shall ask for mortals now, afterwards and forever, We shall concede according to her will and wishes.[55]

Throughout her text, María de Ágreda expresses Mary's constant position by the side of Christ during his life and death, foregrounding Mary's experiences as a mother, and drawing a parallel between her suffering and that experienced by her son. In doing so, she emphasises Mary's personal status in the events leading to the redemption of humankind.[56]

Texts such as these point to the special importance of Mary and her story to the lives of women – a subject that has continued in more recent art. In 2002 the Portuguese artist Paula Rego chose to position Mary's experience at the centre of her work in a series of large-scale pastels depicting episodes from the Virgin's life, commissioned for the chapel of the presidential palace in Lisbon. Known for her narrative works exploring and interrogating female representation, in these pieces, Rego sought to emphasise the human reality of Mary's experience. In a visceral image of childbirth, *Nativity*, Rego depicts Mary supported by an angel while grasping her swollen abdomen in pain (fig. 154). In other works, Rego elevates Mary's status, placing her at the centre of scenes that have traditionally focused on her son. In a crucifixion image, *Lamentation*, Rego removes Christ from view, centring the composition on a mournful Mary at the foot of the cross alongside Mary Magdalene. In these works, Rego sought to reinterpret Mary's life from a woman's perspective, highlighting the physicality and vulnerability of her experience. As Rego described it:

> [It is] Mary telling the story ... It is about Mary, not about Christ ... the story is a human story ... The whole point of that story was that Jesus was a man and Mary was a woman giving birth ... They are people! ... They are flesh and blood ... If the story is going to have power it has to have relevance to each of us, today, as we live.[57]

MARY AND POPULAR WORSHIP

For centuries, Mary has maintained an especially intimate place in the lives of Roman Catholics around the world, particularly in the context of popular piety. Mary is viewed by many as a close, even tangible, presence, appearing physically to those in need and directly interceding to save those who pray to her. Pope John Paul II, an ardent Mariologist, attributed his survival of an assassination attempt in 1981 directly to Mary, whom he credited with deflecting the bullets and preventing a fatal wound. He placed one of the bullets extracted from his body in the crown of the statue of Our Lady of Fátima in Portugal in thanks (fig. 155).[58]

FIG. 154
Paula Rego, *Nativity*, 2002. Pastel on
paper, mounted on aluminium.
54 × 52 cm. Belém Palace, Lisbon.

Thousands of apparitions of Mary have been reported across
the world, with a remarkable increase in the number of claimed
sightings throughout the nineteenth and twentieth centuries.[59]
These are individually investigated by the Catholic Church, and a
few – in France, Portugal, Mexico and Ireland – have been officially
recognised as 'worthy of belief'.[60] Whether supported by the
Vatican or not, the sites where Mary is said to have appeared often
become important places of pilgrimage. One key site is Lourdes in
France, where it is claimed the Virgin was seen multiple times in
1858; today it is a major healing sanctuary, attracting millions of
pilgrims every year, many hoping for miraculous cures from illness.

FIG. 155
Crown of the statue of Our Lady of Fátima, with the bullet placed under the jewelled cross by Pope John Paul II in 1982, on the anniversary of an attempt on his life. Chapel of the Apparitions, Sanctuary of Fátima, Portugal.

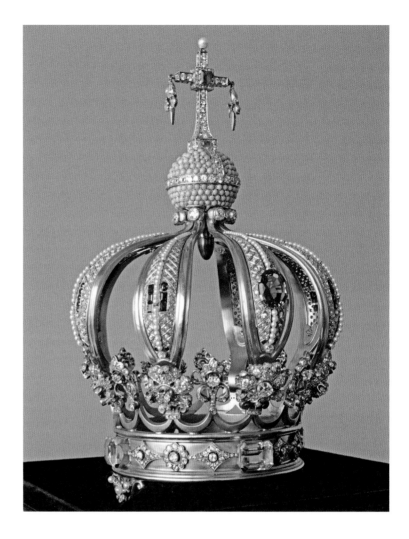

Sacred amulets, medals and souvenirs are sold at these sites for private worship (figs 156–157). The 'Miraculous Medal' is a particularly popular Catholic amulet, supposedly created upon the express direction of Mary herself to the French nun, and later saint, Catherine Labouré, who, in 1830, reported seeing a vision of Mary standing on a globe with rays of light emanating from her hands, with the signs of an 'M' and a cross. Mary instructed Labouré to make medals of the revelation, which would bring grace to the wearer, and these small oval medals are often worn, carried or strung on rosaries as symbols of devotion (fig. 158).

By the sixteenth century, images of the Virgin Mary were ubiquitous across Europe, and were carried across the world by missionaries, traders and armies as part of European imperial expansion.[61] As Catholicism reached, and evolved in, different parts of the world, sometimes in places already imbued with a long history of worshipping female spiritual power, she came to be associated with many pre-existing ideas of the divine feminine.

FIG. 156
Decorative medal, 1958. Lourdes,
France. Alloy. 4 × 3.2 × 0.1 cm (with
suspension ring). British Museum,
London, 1992,0113.3219.

Commemorative medal celebrating
the centenary of the apparition of the
Virgin Mary to St Bernadette at Lourdes
(obverse), with Pope Pius XII blessing the
four great churches of Rome (reverse).

FIG. 157
Lourdes pilgrim badge, 1960s. England.
Aluminium. 3.6 × 2.8 cm. British
Museum, London, 1978,1218.3. Donated
by Joe Cribb.

One of the earliest and best-known apparitions of Mary
reportedly occurred in December 1531 on the hill of Tepeyac in
modern Mexico City, where a young man named Juan Diego
was visited multiple times by a woman who identified herself
as the Virgin. Speaking to him in his native Nahuatl language,
she instructed him to build a church in her honour. As proof of

FIG. 158
Rosary, 20th century. UK. Plastic, aluminium, white metal and alloy. L. 41.1 cm. British Museum, London, 1992,0113.6705.

Attached to this rosary (*left*) are 3 'Miraculous Medals' (*details centre and right*) and 9 other medals of Christ and several Catholic saints, including St Thomas More and St Winifred.

Opposite

FIG. 159
Popotillo representation of the Virgin of Guadalupe, 1980s. Mexico. Straw and cardboard. 35 × 27.5 cm. British Museum, London, Am1989,12.368.

her presence, she caused flowers to bloom out of season and told Juan Diego to take them to the bishop of Mexico City in his cloak. When Juan Diego opened the cloak in front of the bishop, it was imprinted with the image of the Virgin herself.[62] A church was built on the site of the vision to house the sacred cloak and rapidly began to attract pilgrims, to the alarm of Franciscan missionaries such as Fray Francisco de Bustamante, who in 1556 condemned the belief that the cloak had miraculous powers as nothing short of idolatry. Also concerned was Bustamante's fellow Franciscan Bernardino de Sahagún, who observed that the site of Tepeyac had once been sacred to the Mexica (Aztecs), and worshippers at the new church were referring to the mother of Christ as 'Tonantzin', a name in Nahuatl denoting a maternal female divinity.[63] These protestations did little to stem the tide, and congregations of both Mexicans and Spaniards continued to grow, necessitating the construction of a new, bigger church in 1622 and another in 1709.[64] Known today as the Basilica of Our Lady of Guadalupe, it is the most visited Catholic site in the world, attracting upwards of 22 million devotees a year from around the globe. The image depicted on the cloak is now ubiquitous in sacred and popular art across Mexico. The Virgin of Guadalupe appears in one such devotional image from the 1980s, which was created in vibrant colours and made using a technique originating in pre-Columbian art called *popotillo*, in which straw is boiled and dyed before being applied to a support to create a mosaic image (fig. 159).[65] Standing on a crescent moon supported by an angel, Mary appears alone, with head inclined and hands folded in prayer. From under a golden crown, a long blueish-green mantle, covered in stars, flows to her feet, and all around her she emanates rays of light. Her skin is

characteristically dark, in accordance with how she was said to have appeared in 1531. The belief that Mary appeared as an Indigenous woman on Mexican soil has long made her, in the minds of many, an icon of Mexican patriotism and national pride; in 1810 her banner was carried by revolutionaries seeking to overthrow Spanish rule, and in 1820 José Miguel Fernández y Félix, the first president of Mexico, marked the country's independence by changing his name to Guadalupe Victoria.[66]

Mary's popularity within world spirituality and the diversity of ways in which she is viewed have seen her aligned with, or adopted into, spiritual beliefs beyond Christianity and Islam. In Cuban Santería she is sometimes identified with the Yoruba spirit Oshun (see chapter 1), and in Haitian Vodou, a religion that celebrates many powerful spirits known as *lwa*, Mary's image has come to be connected with both Ezili Freda, the gentle, seductive *lwa* of love and beauty, and Ezili Dantò, the fierce *lwa* connected with vengeance and defence of the oppressed. Ezili Dantò is most commonly represented today in the guise of Mary, an image famously exemplified by a Polish icon of Mary and Christ, both shown with dark skin, known as Our Lady of Częstochowa. Images of the icon may have been brought to Haiti with Polish soldiers sent by Napoleon in 1802 in a failed attempt to crush the Haitian revolution – the most successful revolt of enslaved peoples in world history, during which many of the soldiers switched sides and fought with the Haitians.[67] To many Haitians, the child in the image is identified not as Mary's son Jesus but as Ezili Dantò's daughter Anaïs, and the distinctive scars on the mother's right cheek are interpreted by some as battle wounds sustained while fighting in the revolution.[68]

This martial capacity of Mary to defend the vulnerable and overthrow oppression is not unique to Haiti, but has been considered an aspect of her strength since at least the seventh century CE, when an icon of Mary was reportedly carried around the walls of the besieged city of Constantinople to assure the inhabitants of her protection.[69] More personal protective imagery of the Virgin and Child is seen on a German steel plackart (breastplate), made around 1540 (fig. 160). Resembling the composition of Our Lady of Guadalupe, a central embossed gilt image of Mary stands on a crescent moon, surrounded by a sunburst, and cradles her son in her arms. This representation is based on the common identification of Mary as the woman in labour who appears in St John's vision of the apocalypse in the last book of the New Testament, 'clothed with the sun, with the moon under her feet and a crown of twelve stars on her head'.[70]

MARY AND THE MODERN WORLD

The history of Mary in world faith is long and convoluted and she has been interpreted in a multitude of ways. In Islamic as well as

Christian scripture, Mary/Maryam appears as an independent
figure possessed of the wisdom of acceptance in troubled times.
While to some this has been seen as submission, to others she has
been interpreted as a symbol of fortitude and moral strength, which
has often seen her assume a direct and visible role in struggles
against oppression and protection of the vulnerable. A divisive
figure in twentieth and twenty-first-century Western feminist
thought, she has been interpreted both as an inspiration for women,
who elevates reverence for femininity within Christian belief, and
alternatively as an oppressive exemplar of domesticity and chastity,
used to culturally define and enforce female behaviour. Viewing her
as symbolic of the subordination of the female to the male in the

FIG. 160
Breastplate from a set of body armour,
with image of the Virgin and Child,
c. 1540. Germany. Steel and gold.
37.9 × 39.8 × 14 cm. British Museum,
London, 1881,0802.49. Bequeathed by
William Burges.

mother-and-son relationship, Simone de Beauvoir wrote in 1949: 'For the first time in human history the mother kneels before her son; she freely accepts her inferiority. This is the supreme masculine victory, consummated in the cult of the Virgin'.[71] Similarly, in 1976 the feminist historian Marina Warner concluded her seminal study of the Virgin Mary, *Alone of All her Sex*, with the prediction that devotion to Mary would eventually fade into obscurity, since canonical teachings on her nature could not be reconciled with feminist cultural aspirations, though she qualified her assertion by observing: 'Although Mary cannot be a model for the New Woman, a goddess is better than no goddess at all.'[72]

Conversely, other feminist thinkers have argued that, far from being dispensed with, the figure of Mary should be reinterpreted within modern realities to reinvigorate belief in the feminine divine. As the philosopher and psychoanalyst Luce Irigaray writes: 'It is astonishing that many women, in particular women mindful of their liberation, today want to imitate Jesus or his male disciples, rather than Mary.'[73] For Irigaray, Mary represents the repressed feminine divine, which she considers a necessary condition of female subjectivity that must be uncovered and reframed in order to destabilise patriarchal religious imagery. As the patron saint and protector of Russia, it was Mary that the punk band Pussy Riot called on in their 2012 Punk Prayer to 'be a feminist' and remove President Putin from office.[74] For some Islamic feminist commentators, it has been argued that the vow of Maryam's mother to dedicate her unborn child to undergo religious instruction, and God's acceptance of a female child, demonstrate divine will in the education of girls.[75]

The image of Mary has attracted artists as a means of critiquing prevailing sexist and racist stereotypes and constructs in Western cultural and religious thought, drawing on her status as a figure of comfort to those in need, as well as her prevalence throughout the history of Western religious iconography.[76] In 1997, the ground-breaking group exhibition *Sensation* at the Royal Academy of Art in London included the iconic and fiercely critiqued mixed-media piece *The Holy Virgin Mary* by the Turner Prize winner Chris Ofili (1996; fig. 161). Depicted against a gleaming background of orange resin and glitter, evoking the gold of religious icons, Ofili's Black Virgin Mary is surrounded by fluttering images of women's buttocks taken from pornographic magazines. Positioned on the floor and leaning against a wall, the work is supported by two balls of elephant dung, another taking the place of Mary's exposed breast. The artist described the painting as a modern interpretation of the 'sexually charged' depictions of the Virgin Mary he had seen in the National Gallery, London.[77] Ofili commented in 1995 that he wanted to see 'what people's response would be' to the use of elephant dung – a recurring motif in his work – as a way to challenge and draw attention to Western cultural expectations:

Opposite

FIG. 161
Chris Ofili, *The Holy Virgin Mary*, 1996. Acrylic, oil, polyester resin, paper collage, glitter, map pins and elephant dung on canvas. 243.8 × 182.8 cm. Museum of Modern Art, New York, 211.2018.a–c. Gift of Steven and Alexandra Cohen.

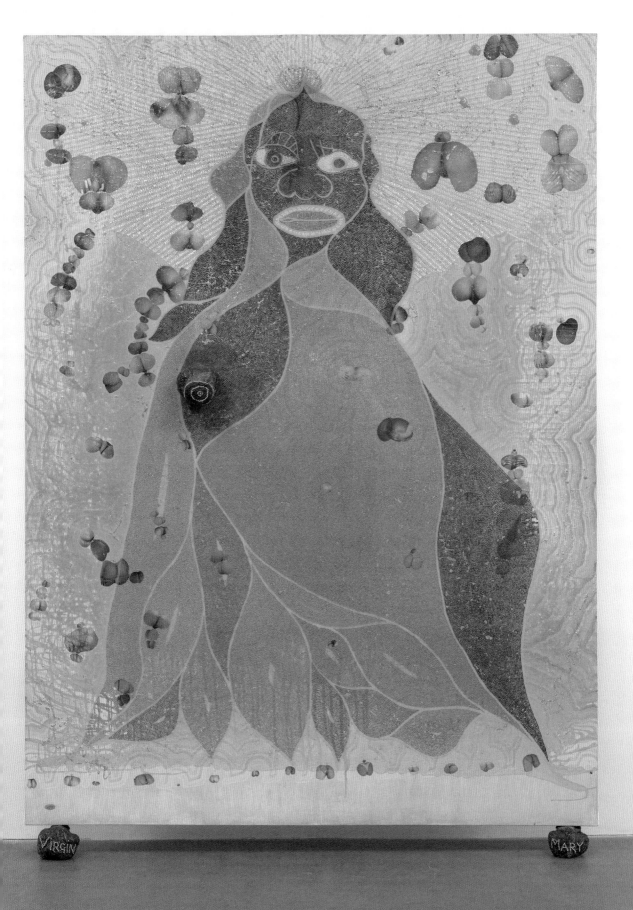

People in Germany thought I was some kind of witch doctor. In England people thought I was pulling the wool over their eyes, that it was a candid camera situation […] It's what people really want from black artists. We're the voodoo king, the voodoo queen, the witch doctor, the drug dealer, the *magicien de la terre*. The exotic, the decorative. I'm giving them all of that, but it's packaged slightly differently.[78]

The prescience of these comments becomes clear in the context of the reaction to *The Holy Virgin Mary*. In 1999, when the exhibition moved to the Brooklyn Museum, the then mayor of New York, Rudy Giuliani, threatened to withdraw funding from the museum – an indication of the strength of feeling that still surrounds how the Mother of God should be perceived and portrayed.

Other contemporary artists who have confronted similar themes of race and sexuality through the image of the Virgin have also attracted criticism from conservative religious groups. Mary appears prominently in the work of Renée Cox, a Jamaican–American artist who identifies as Catholic and is known for her provocative images, in which she places Black models, including herself, at the centre of Christian iconography as a challenge to the overwhelming whiteness of traditional Christian art. Some of her works consciously re-create and parody the aesthetics of celebrated historical artworks – for example, her *Yo Mama* series in the 1990s, in which she portrayed herself as the Virgin. Interrogating conventional understandings of 'maternal' imagery, Cox positioned herself as both a mother and a sexual woman.

COMPASSION AND WISDOM IN BUDDHIST BELIEF

The pious fervour directed towards the Virgin by both men and women throughout history may be attributed to her official status as a saint and an intercessor, but in popular belief Mary is often approached as a powerful being in her own right: it is Mary who is appealed to for aid and, when aid arrives, it is Mary who is thanked.[79] Mary's ambiguous status within Christianity – at the same time mortal and celestial – along with that of other saints, has long been paralleled in the Buddhist concept of the Bodhisattva. These are enlightened beings, sometimes considered to have once been mortal, who, rather than leave the bonds of earthly suffering and ascend to Buddhahood, remain close to the living in order to guide others on their journey towards spiritual awakening.

Buddhism is a transnational faith that arose in the fifth century BCE from the philosophy of Siddhartha Gautama, an Indian prince who renounced his wealth and status for the spiritual life of a mendicant. Developing a philosophy that has become known as the Four Noble Truths, Gautama taught that human desire lay at the root of suffering, trapping all sentient beings in an eternal cycle of death

and rebirth (*samsara*). One can escape this cycle only by achieving an enlightened state of perfect wisdom and compassion (*nirvana*), which results in a sublime emptiness and detachment from worldly illusion. Once spiritually awakened in this way, one is reborn as a Buddha and leaves *samsara* for a higher state of being.

While Gautama Buddha is said to have taught that all people may become awakened by following his teachings, some early Buddhist texts such as the *Bodhisattvabhumi* (third century CE) and the *Nidanakatha* (composed no later than the sixth century CE), insist on maleness as a requirement for advancing on the path to Buddhahood and interpret rebirth in any other form as a sign of imperfection – a view that still resonates in some Buddhist traditions today.[80] Nonetheless, early Buddhism found a particular following among women keen to free themselves from oppressive domestic home lives and gain release and independence by pursuing a spiritual path. The voices of these early female adherents are preserved in the *Therigatha* ('Verses of the elder nuns') – a remarkable compilation of poems, written by a community of senior nuns in India and dating from the time of the historic Buddha up to the late third century BCE. These women came from both wealthy and poor backgrounds and the poems attest their commitment to the pursuit of an aesthetic life against the social expectations of the time. Many recall suffering experienced at the hands of relatives or the pain of the loss of a child, and many reflect on the liberation that their adherence to Buddhism afforded them, alongside the advice and support of other women in the community.[81] In one short poem by a woman named Soma, she begins by imagining the demon Mara taunting her that she will never achieve enlightenment because 'it's not possible for a woman, especially one with only two fingers' worth of wisdom', to which she responds:

> What does being a woman have to do with it?
> What counts is that the heart is settled
> And that one sees what really is.
>
> What you take as pleasures are not for me,
> The mass of mental darkness is split open.
> Know this, evil one, you are defeated, you are finished.[82]

The historical Buddha is believed to have attained enlightenment some time between 490 and 400 BCE, and in the following centuries his teachings spread rapidly across Asia, where his philosophies were approached and interpreted in light of differing cultural and spiritual beliefs. Three major schools of Buddhism are practised today: Theravada, Mahayana and Vajrayana. The oldest of these is Theravada ('Teaching of the Elders'). Now practised predominantly in South-East Asia and Sri Lanka, Theravada Buddhism teaches that enlightenment is achieved

FIG. 162
Book cover, 13th century. Tibet.
Painted wood. 27.4 × 71.9 × 3.5 cm.
British Museum, London, 1973,0514.1.
Funded by the Brooke Sewell Permanent
Fund.

Painted inner book cover showing
Prajnaparamita flanked on each side by
three rows of Bodhisattvas and monks;
the outer face is carved with Buddhas.

through self-determination, and, broadly speaking, traditionally
places less emphasis on the agency of spiritual beings as guides to
enlightenment than the later schools. Mahayana ('Great Vehicle')
Buddhism, which emerged between around 150 BCE and 100 CE,
is the largest school of Buddhism in the world and is practised
predominantly in China, Japan, Korea and Vietnam, while
Vajrayana ('Diamond Thunderbolt Vehicle') is the dominant school
of Buddhism in Tibet, Bhutan, Mongolia and Nepal. These later
schools evolved as the faith spread eastwards into China and north
into the Himalayas, and incorporate the guidance of a wide range
of spiritual beings concerning their practice. In both Mahayana
and Vajrayana Buddhism, the perfect wisdom that allows one to
reach nirvana is conceived as female, embodied by the goddess
Prajnaparamita. First recorded in scripture in the *Perfection of
Wisdom in Eight Thousand Lines*, composed around the second
century CE, Prajnaparamita is the source of transcendent wisdom.
In Tibetan art she is most often shown on elaborately carved or
painted book covers of 'Perfect Wisdom' texts, surrounded by a
multitude of Buddhas or Bodhisattvas (fig. 162). She is considered
to be the mother of all Buddhas, teacher to all those who seek
enlightenment and the ultimate and everlasting source of wisdom:
while Buddhas come and go, she is eternal and surpasses them in
glory since they only obtain what she, in essence, is.[83]

THE PERCEIVER OF SOUNDS

One of the most prominent and popularly venerated spiritual
beings within Mahayana and Vajrayana Buddhism is the
Bodhisattva of Compassion, known in South Asia and Tibet as
Avalokiteshvara, in China as Guanyin, and in Japan as Kannon.
In each case the name means 'Perceiver of Sounds', denoting the
Bodhisattva's ability to hear the lamentations of those who are
suffering and, as the saviour of humankind during this life and

beyond, to guide followers towards nirvana.[84] In Mahayana and Vajrayana Buddhism, enlightened beings are believed to have a physical form (Sanskrit: *nirmanakaya*), in which they may appear before, and be comprehended by, mortals. This form is represented in art and may be either female or male, yet the true nature (Sanskrit: *dharmakaya*) of these beings is formless.[85] Unbeholden to all binaries, enlightened beings, in their most perfect manifestation, are without gender distinction.

The Bodhisattva of Compassion first emerged in Buddhist art in India around the first or second century CE. Avalokiteshvara was traditionally depicted in male form, and still is in the Vajrayana Buddhism of Nepal and Tibet, where compassion is often aligned with masculine agency and wisdom with feminine agency.[86] As Buddhism spread eastwards, the earliest Chinese depictions of Guanyin also bear a distinctly male appearance. However, during the Song Dynasty (960–1279), and for reasons that are still poorly understood but perhaps reflect the influence of Indigenous goddesses and legendary heroines of China, the embodiment of compassion came to be represented through female imagery.[87]

Popularly called 'Goddess of Mercy', Guanyin is the manifestation of the Bodhisattva of Compassion venerated across China today. Depicted in art primarily as a young woman radiating serenity and calm, Guanyin is believed to provide protection to all who call for help, intervening directly and actively to save those in danger by means of miraculous apparitions, the locations of which become important pilgrimage sites for worshippers.[88] A large bronze statue of Guanyin, made after the thirteenth century, shows the Bodhisattva seated, one leg bent and the other hanging to the ground in a pose known as *lalitasana* ('royal ease'). She sits on top of a high base that takes the form of a lotus flower – a symbol of enlightenment, since it grows upwards through murky water (representing *samsara*) to bloom in the sunlight at the surface. Dressed in fine robes, armlets and neck ornaments, with both hands she makes the *shuni mudra* ('gesture'), symbolising patience, and bows her head in meditation (fig. 163). In Buddhist art, images of spiritual beings are not objects of veneration themselves but are used as aids to meditation, encouraging the viewer to reflect on and cultivate the qualities represented by the figure depicted. As a student in Taiwan, the German interfaith leader and Zen Buddhist teacher Maria Reis Habito recalled encountering an image of Guanyin and questioning the master of the monastery on the use of idols, who replied: 'This is not an idol; this is you.'[89]

Across China, images of Guanyin adorn homes, places of work and public spaces, and often show her dressed in white robes and carrying prayer beads as a symbol of her own piety.[90] Prayer beads may be used by her devotees as an aid to meditation and to keep track of the number of repetitions of the Bodhisattva's mantra. In the original Sanskrit this is 'Om mani padme hum',

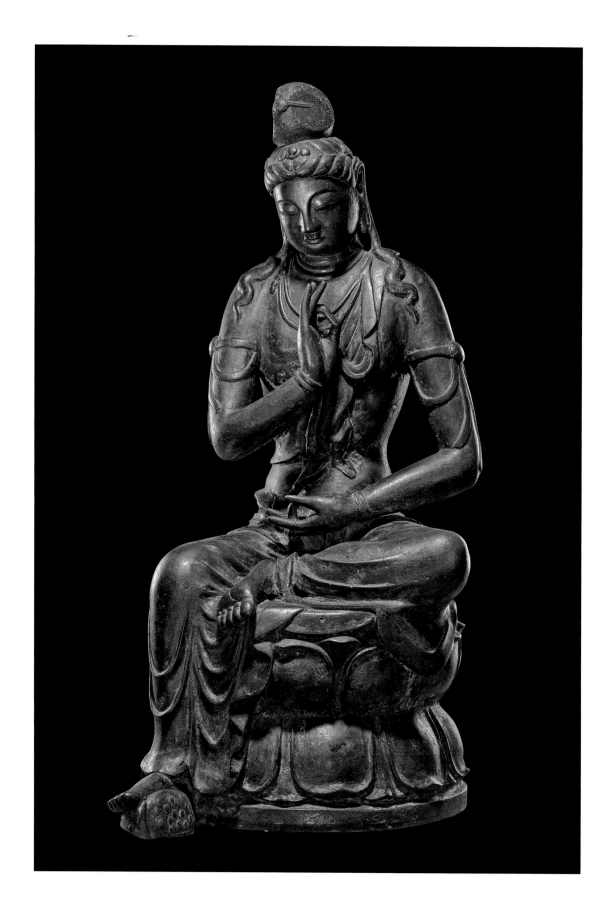

which is sometimes translated as, 'Hail, the jewel in the lotus', although Buddhist mantras are not primarily intended to have literal meaning but project profound sounds. 'Om' is the sacred sound of the universe and of the perfect body, speech and mind of the Buddha; 'mani' ('jewel') affirms the practitioner's commitment to achieving enlightenment; 'padme' ('lotus') is indicative of wisdom; and 'hum' indicates a single indivisible consciousness.[91] Each repetition is believed to bring spiritual benefits to the reciter, aiding the journey to enlightenment either for that person or for others.

In Tibetan art, Avalokiteshvara is often depicted with many arms and heads, symbolising an infinite ability to hear and reach all in need – a visual expression of the Bodhisattva's limitless compassion that remained popular in Chinese depictions of Guanyin (figs 164–165). In addition to Guanyin's transformation in art from male to female form, gender fluidity is intrinsic to the

Opposite

FIG. 163
Bodhisattva Guanyin, seated on a lotus base, after 1260. China. Bronze, lacquer and gold. 116 × 62 × 60 cm. British Museum, London, 1952,1217.1. Donated by P.T. Brooke Sewell, Esq. from John Sparks Ltd.

Below, left to right

FIG. 164
Standing figure of Avalokiteshvara, with 11 heads and 6 arms, 1750–1850. Tibet. Wood and gold. 40 × 21.5 × 3.1 cm. British Museum, London, 1895,0408.24. Donated by Sir Augustus Wollaston Franks.

FIG. 165
Figure of Guanyin with 18 arms seated on a lotus, *c.* 1700–22. China. Porcelain. 41 × 20 × 11.5 cm. British Museum, London, 1980,0728.93. Bequeathed by Patrick J. Donnelly.

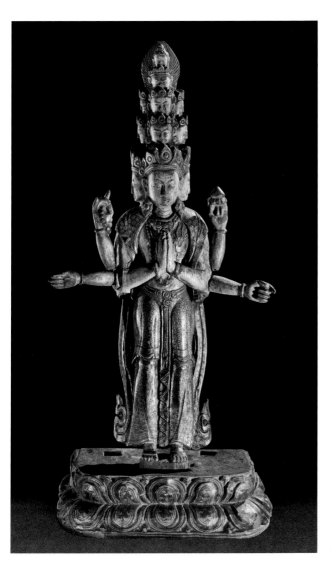

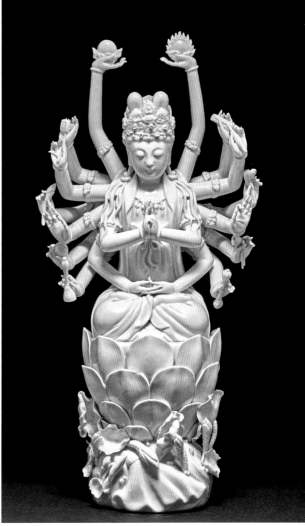

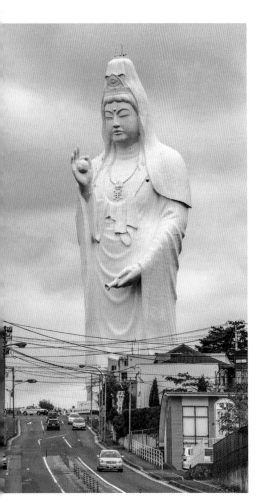

FIG. 166
Statue of Kannon, 1991. Reinforced
concrete and white fluororesin. H. 100 m.
Sendai, Japan.

In her right hand she holds the
wish-fulfilling jewel and in her left
a vessel. The inside of the statue is
accessible to visitors and contains other
statues of Kannon in her different forms,
as well as 108 other Buddhist statues.

Opposite

FIG. 167
Kato Nobukiyo, hanging scroll, 1796.
Japan. Paint on paper. 132 × 38.2 cm
(excl. mount). British Museum, London,
1881,1210,0.4.JA.

In this scroll painting, the figures are
the Bodhisattva of Wisdom, Seishi (*left*),
Buddha Amida (*centre*) and Kannon
(*right*).

comprehension of the Bodhisattva in all traditions. The *Lotus Sutra* (*c.* 100 CE) is one of the most important texts for Mahayana Buddhism, and contains a chapter dedicated to the greatness of the Perceiver of Sounds, describing the Bodhisattva's power to free sentient beings from physical danger, including fire, drowning and assault, as well as spiritual harm caused by fear, anger, lust and ignorance, when their name is recited. The *Lotus Sutra* teaches that the Bodhisattva may appear in the world in thirty-three different forms, changing from male to female, young to old, Buddha to layperson, human to animal, depending on which form would be most effective for the spiritual advancement and salvation of each individual.[92] While all enlightened beings in Buddhist belief ultimately exist on a higher plane, beyond physical form, Guanyin's explicit gender fluidity, both in art and as conceptually expressed in the *Lotus Sutra*, has led to the adoption of the Bodhisattva of Compassion as a contemporary icon for growing transgender communities and LGBTQ+ movements in China and around the world.[93]

In Japan, Guanyin is known as Kannon and similarly depicted as female in visible form. Kannon has been venerated since the sixth century CE and is one of the most important figures in Pure Land Buddhism, the most popular branch of Buddhism practised in Japan today. When Kannon appears alone in Japanese art, it is often in the aspect of Nyoirin Kannon ('Wish-fulfilling' Kannon), who carries a sacred jewel (*nyoi hoju*) and who grants the prayers of the faithful.[94] Nyoirin Kannon is portrayed in both private and public art: a colossal statue, wearing streaming white robes and holding the sacred jewel, dominates the skyline of the northern Japanese city of Sendai. At 100 metres high, it was the tallest statue in the world on its completion in 1991 (fig. 166). Kannon is not only believed to alleviate suffering in life, but also to guide the deceased towards paradise, acting as an emissary between the human world and Amida (Sanskrit: Amitabha), the Buddha of Infinite Light. To be reborn in the Western Paradise is the ultimate aim of Pure Land Buddhism, and images of Kannon, with Amida and the Bodhisattva of Wisdom, Seishi, are among the most popular images in Japanese Buddhist art. One classic composition, showing the triad descending on clouds to welcome the souls of the dead, was painted in 1796 by the otherwise obscure Edo official Kato Nobukiyo (1734–1810), who recorded on the work itself that he completed it at the age of sixty-three. In an exceptional act of piety, every line and coloured area in the scroll is made up of spidery characters from the three most sacred *sutras* (texts) of Pure Land Buddhism (fig. 167).

In the *Lotus Sutra*, the Perceiver of Sounds is said to grant sons and daughters to those who desire children. This aspect of the Bodhisattva's power has acquired heightened significance in China, where Guanyin is often invoked for help with conception and childbirth, and representations of Songzi Guanyin

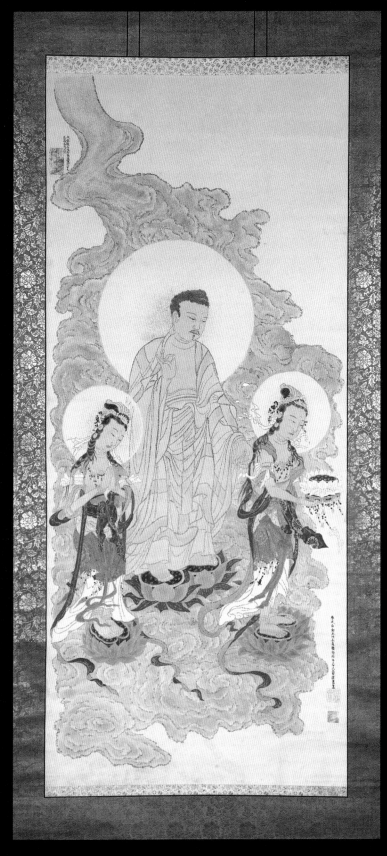

('Child-Giving' Guanyin) show the Bodhisattva accompanied by a child.[95] When Catholicism was introduced to China around the sixteenth century, many parallels were drawn between Guanyin and the Virgin Mary, conflating Christian and East Asian Buddhist belief in the female embodiment of compassion and the intermediary between the earthly and spiritual planes. By the seventeenth century, porcelain figurines of Songzi Guanyin enthroned and holding a child in her lap, produced in the famous kilns at Dehua, were exported to Europe as 'Sancta Marias' (fig. 168). Similar parallels were drawn in Japan, and when Christianity was criminalised under penalty of death between the late sixteenth and mid-seventeenth centuries, images of Kannon were used in place of Christian iconography for secret worship. Following the reinstatement of religious freedom, worship of 'a Buddha by the name of Santa Maria' – considered to be a manifestation of Kannon – is recorded in official Japanese records as late as 1857, and the legacy persists today in small Kakure Kirishitan ('Hidden Christian') communities in the Japanese Goto Islands.[96]

GUANYIN IN POPULAR BELIEF

Across China, many written and oral legends exist about Guanyin's past lives and miraculous manifestations on earth.[97] In some of these stories, Guanyin's physical beauty and seductive allure are important tools in her salvific work, attracting people to her and holding their attention long enough to enable her to share with them her wisdom and compassionate desire for their moral growth. Depictions of Guanyin carrying a fish basket are sometimes seen as relating to one of the most popular of these stories, in which the Bodhisattva is said to have appeared in a remote fishing village. Variations on the narrative are numerous, but in all of them the people of the village were initially unconcerned with Buddhist teachings and leading dissolute lives. Guanyin appeared to them disguised as a beautiful young woman, and the men of the village were immediately enamoured. She promised to marry the one who could memorise multiple Buddhist scriptures by heart in the shortest time. Through repeated readings of the texts, their meaning was absorbed and eventually the whole village was converted to the pursuit of enlightenment. Having achieved her objective, Guanyin vanished as mysteriously as she had arrived.[98]

Many female spiritual beings connected in Buddhism with wisdom and compassion are viewed as physically beautiful. In Christian tradition, female seduction has often been interpreted as a snare, which drags one away from the divine (see chapter 2), and female sexuality as something to be suppressed in order to gain moral and spiritual authority (see chapter 4). Conversely, in

Opposite

FIG. 168
Figure of Guanyin enthroned with child and attendants, 18th century. China. Porcelain. 37.7 × 16.3 × 10.2 cm. British Museum, London, Franks.51.+A. Donated by Sir Augustus Wollaston Franks.

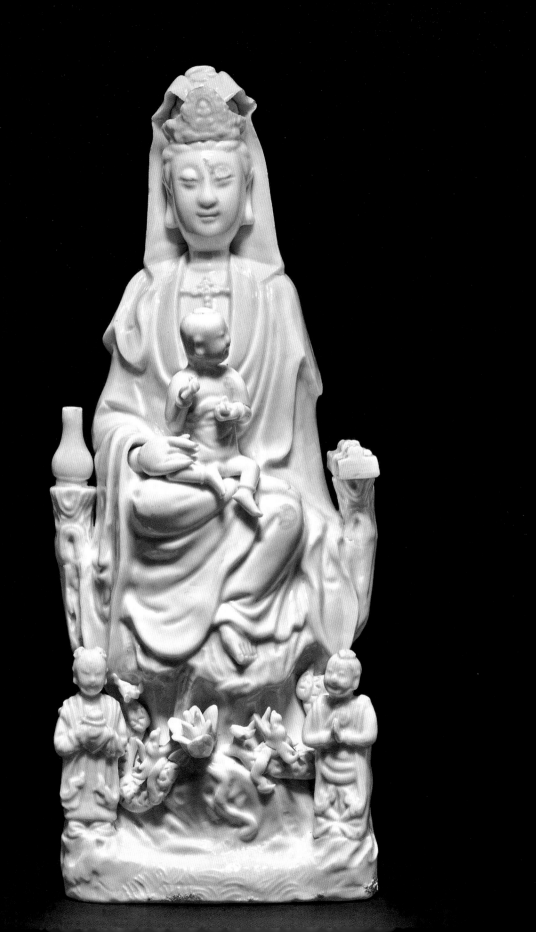

Buddhist tradition, the physical attractiveness of many female enlightened beings is perceived as a force that draws mortals towards them, thereby enhancing spiritual understanding and ultimately leading towards salvation.

TARA

The beauty and attractiveness of Guanyin in some Chinese legends are qualities also possessed by Tara, the most prominent female spiritual being in Tibetan Buddhism. Vajrayana Buddhism has been practised in Tibet and the surrounding Himalayan regions since the eighth century CE. It is an esoteric school of Buddhism, which incorporated and expanded many aspects of Tantric Hinduism, including the prominent veneration of female power.[99] While Mahayana Buddhism teaches that attaining enlightenment takes many lifetimes, Vajrayana Buddhists believe that, through intense meditation, asceticism and yogic practices, enlightenment may be achieved in a single lifetime.[100] Practitioners seek the guidance of a master yogini (feminine) or yogi (masculine), and recognise many Buddhas, Bodhisattvas and other spiritual guides, one of whom a devotee may follow as a personal deity.

Revered variously as a goddess, a Bodhisattva or a Buddha, Tara is the embodiment of infinite compassionate wisdom and enlightenment, the saviour who lifts her followers out of mortal suffering and guides them towards nirvana. Her name means 'She who Carries Across', since it is through her that one can pass from an imperfect to a perfect state of being. She is said to be exquisitely beautiful, and in art takes the form of a youthful woman with long black hair; she is draped in silks and glittering jewels, and either sits on or holds a lotus. While gazing at her image, one is reminded of her boundless compassion for all sentient beings, which encourages those who meditate on her to cultivate this quality in themselves, and, in doing so, to advance on the path towards perfect wisdom and equanimity.[101] Like the images of Mary that are claimed to possess miraculous powers, images of Tara have been said to speak, weep fluids that cure disease, and distribute wealth to the poor.[102]

Tara emerges in the art and literature of South Asia around the seventh century CE and her veneration spread rapidly. By the eighth century she was described as the mother of Buddhas and as synonymous with enlightenment itself, the supreme wisdom of all Buddhas, past, present and future.[103] After a period of suppression in the ninth century CE, Buddhism and the veneration of Tara flourished again in Tibet from the eleventh century. This is often credited to the renowned Indian monk and scholar Atisha, who was invited to Tibet to reinvigorate Buddhism in that mountainous region. According to legend, the invitation to attempt the perilous journey across the Himalayas was not initially appealing to the already famous Indian scholar, yet Atisha was advised by Tara

herself in a vision to accept this mission, despite the danger to his own life, so as to spread the faith. He remained in Tibet until his death in 1054.[104]

Besides her role in the spiritual lives of individuals, Tara is honoured as the mother and guardian of the people of Tibet, where she is known as the 'Liberator from the Eight Great Fears' (Ashtamahabhaya Tara), since meditating on her can save adherents from the dangers of snakes, elephants, lions, fire, thieves, drowning, captivity and demons.[105] Two popular oral traditions have emerged in Tibet about Tara's birth. In one, the Bodhisattva Avalokiteshvara had made a vow to release all beings from *samsara*, but, in gazing out on the sufferings of living beings, was overwhelmed with grief at the magnitude of the task and wept a pool of tears. From the murky depths of the pool sprung a lotus, which, growing through the waters, emerged at the surface as a beautiful bloom. Seated in the flower was Tara, who vowed to share Avalokiteshvara's mission. With Tara to share the burden, Avalokiteshvara's strength was renewed and together they ceaselessly resumed the task.[106] She and Avalokiteshvara are often worshipped together as companions. The psychologist Rachael Wooten, who has written on Tara's impact on her own life and work, has interpreted the origin of Tara from Avalokiteshvara's tears in this way:

> The teachings associated with the legend of Avalokiteshvara offer comfort and inspiration when you face critical turning points or challenges. You may find yourself passionately involved in a social justice issue, striving to make progress, yet the most vulnerable people continue to suffer while those in power refuse to help. The obstacles seem insurmountable, creating a temptation to give up or turn away. In times like these, the story of Avalokiteshvara can inspire you to ask Tara for help, to grieve, to rest, and to continue working for a worthy cause.[107]

A second popular tradition, recorded in the seventeenth century by the Tibetan scholar Taranatha, tells how, aeons ago in a previous world, Tara was a pious princess named Yeshe Dawa (meaning roughly 'Moon of Knowledge'). Her constant devotion to the teachings of the Buddha of the age impressed some well-meaning monks, who advised her to aspire to be reborn as a man in her next life so that she could complete the path to enlightenment. Yeshe Dawa rebuked the monks for their attachment to worldly illusion by saying: 'There is neither man nor woman nor self nor personhood nor notion of such. Attachment to [the designations] "male and female" is meaningless, and deludes worldly people with poor understanding.' She then continued with a vow: 'Many desire enlightenment in a man's body while not even a single [person] strives for the benefit of sentient beings in a woman's body. Therefore, I shall work for the benefit of sentient beings in a woman's form as long as samsara has not been emptied.'[108]

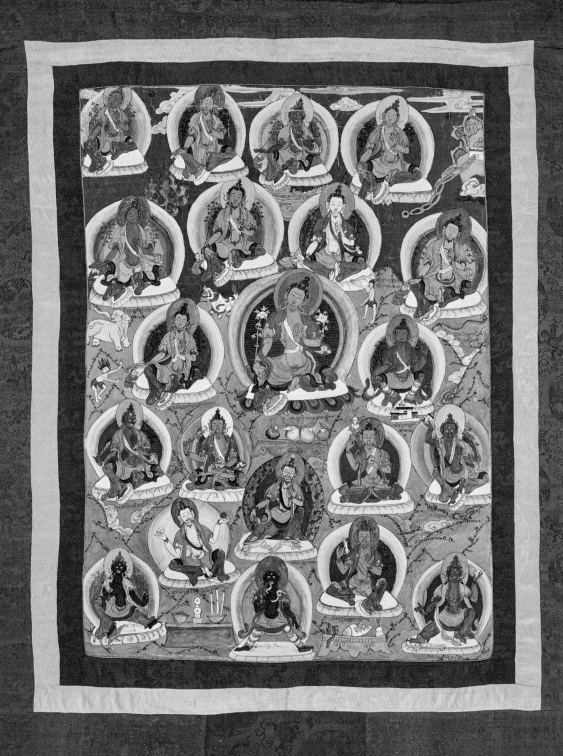

With this vow she renewed her meditations with such focus that each day millions of souls were released from *samsara*, and, continuing in this way for tens of thousands of years, she was eventually reborn as the Buddha Tara.[109]

Like Guanyin, Tara is believed to manifest in many different forms – traditionally, there are twenty-one. These are celebrated in the 'Twenty-One Praises of Tara and their Benefits' – a long liturgy in honour of the forms of Tara that is recited daily by many Tibetans. The prayer begins with an invocation to Tara, during which the worshippers may prostrate themselves, calling on her to appear with her attendants. It then continues with praises addressed to each of her forms.[110] The most popular and commonly depicted expression of Tara is Green Tara, shown as the central and dominant figure on a nineteenth-century *thang-kha* (fig. 169), a painting mounted on a scroll of fabric that may be hung on the wall of a monastery to instruct students in the natures of spiritual figures or as an aid to focus meditation. Green Tara is surrounded by diminutive images of her other forms – multiplications of herself that she disseminates through the world in order to liberate all living beings. Collectively, these manifestations express the range of her powers to conquer fear and ignorance; the upper registers show her peaceful embodiments, progressing to fiercer emanations further down the image. Green Tara herself is associated with dynamic action. In her most recognisable pose, she is shown seated on a lotus with her left leg tucked under her and her right leg hanging down in front; her foot touching the ground indicates her connection to the world of suffering and her potential to spring into action when she is needed.

Another popular form of Tara is White Tara, seen directly above and to the right of Green Tara's head in the *thang-kha*. White Tara is associated with wisdom – in particular, the wisdom associated with constructive compassion. Her colour symbolises the light that emanates from her body; when meditated upon, in its different colours or wavelengths, white is believed to have curative powers. This manifestation of Tara is meditated upon for healing, long life and the neutralisation of bad karma for the worshipper and for others.[111] Unlike Green Tara, White Tara usually sits with both legs crossed in a fully meditative pose, with her right hand in the gesture of divine generosity and her left hand over her heart (fig. 170). She is immediately recognisable from her seven eyes, including an eye of omniscience on her forehead and wisdom eyes on the palms of her hand and soles of her feet.

Long life, bestowed by White Tara, grants the devotee time to accrue merit, or positive karma, which may be achieved in part through the creation of artistic depictions.[112] These often take the form of *tsa tsa*s (moulded clay images of spiritual beings, typically in the form of a plaque). Adepts may be set the task of crafting 100,000

FIG. 170
Figurine of White Tara, 1700–1900. Tibet. Gilded bronze. 17.2 × 12.3 × 8.3 cm. British Museum, London, 1907,0527.2.

Opposite

FIG. 169
Thang-kha showing the twenty-one forms of Tara, 1800–1900. Tibet. Painting on cloth. 120 × 96.3 × 4.1 cm. British Museum, London, 1898,0622,0.22.

Each manifestation of Tara is labelled in Tibetan according to the vice she subdues or the power she possesses.

FIG. 171
Group of six *tsa tsa*s made in
contemplation of Tara and two
Buddhas of longevity, Amitayus and
Ushnishavijaya, 19th century. Tibet.
Clay. H. 5.9 cm (largest piece).
British Museum, London, 1880.741–3,
1880.770, 1880.773–4.

in their lifetime – a spiritual process that also involves focusing the
mind on their guiding deity and reciting mantras. *Tsa tsa*s are sacred
objects that can be sold or given to other Buddhist devotees, worn as
protective amulets, or placed in a dedicated position in the home or
at a shrine as a focus for offerings and prayer; in every case, the *tsa tsa*
endows the recipient with merit (fig. 171).

In the course of Tibetan history, prominent women credited with
spreading the teachings of Buddhism have come to be recognised
as embodiments of Tara. These women include Bhrikuti-devi and
Wen-cheng, the Nepalese and Chinese wives of Songtsen Gampo,
the seventh-century king and founder of the Tibetan Empire, who
encouraged their husband to bring Buddhism to Tibet and promote
its spread.[113] Throughout the long history of Tibetan Buddhism,
female mystics, sages and yoginis have been celebrated, but they are
often not as well known as they deserve to be. The most prominent

female Tibetan teacher today is Her Eminence Jetsun Kushok Rinpoche, elder sister of the Sakya Trizin, leader of the Sakya school of Buddhism in Tibet. After studying and teaching alongside her brother in Tibet and India, Jetsun Kushok emigrated to Vancouver, Canada, with her husband and three young sons in the early 1970s. As Tibetan Buddhism gained a following in North America in the 1970s, she was encouraged to return to teaching by the Sakya Trizin and the Dalai Lama. Today, she has founded centres for Buddhist teaching across North America and travels internationally to instruct adherents in the faith.[114]

☙

Adoration of Great Mothers – Mary, Guanyin and Tara – has crossed borders, cultures and religious traditions as testimony to their enduring and universal spiritual appeal. Their care, expressed through strength, guidance, solace and protection, is often recognised as maternal, whether or not they are viewed as mothers themselves. As spiritual guides, they have been adopted and transformed to the needs of different individuals and social movements – either for endurance or resistance in times of hardship throughout history and into the modern world – and will no doubt continue to evolve as time goes on. Through these figures, and earlier deities such as Isis, femininity and maternity are intimately aligned not only with compassion but also with universal wisdom and guidance.

The characterisation of compassion as masculine and wisdom as feminine in Buddhism – the opposite of cultural norms in the West – reminds us that gender associations are not universal truths but irregular cultural constructs.[115] As knowledge and beliefs become increasingly accessible between diverse cultures, via shared media, these divergent views compel us to question our own understandings of femininity and masculinity. By exposing traditional assumptions to more nuanced interpretations, we may hope to open the door to new, more flexible definitions that are able to encompass a range of strengths, embracing all gender identities. These views have existed in spiritual traditions for thousands of years and we may hope that, in the future, they make a more pronounced transition into cultural perceptions of all people.

Grow the Tea,
then Break the Cups

Wangechi Mutu in conversation with Lucy Dahlsen

I make images that resemble us, to bring us back our stories, to bring us to life.

Over the past two decades, Wangechi Mutu's work has addressed the representation of women across diverse cultural traditions and histories. Citing divine feminine energy as 'an eternal source of inspiration', Mutu seeks to challenge what she sees as a schism between the way in which we worship the female image yet denigrate human women. Through a variety of media, including painting, collage, sculpture, performance and video, Mutu explores questions of self-image, gender, religion, cultural trauma, ecology and environmental destruction. First recognised for paintings and collages concerned with the myriad forms of misrepresentation visited upon female bodies – especially Black female bodies – in the contemporary world, she creates powerful hybrid figures, which subvert ingrained preconceptions and open up possibilities for new symbols of the feminine.

In recent years, Mutu has increasingly worked with sculpture. As a natural evolution of the artist's earlier collages, these bricolage forms incorporate an array of unexpected found objects and natural materials, such as Kenyan soil, wood, feathers, sand, tea, synthetic hair and other elements – many of which are imbued with cultural significance. Echoing their diverse composition, the ideas that coalesce in Mutu's works are varied. She has long been driven by a need to challenge the notion that there could ever be one way of telling a story, stating 'when there is one voice it is domineering, problematic and often fictional'. Instead, drawing on her own cross-cultural identity and experience, Mutu brings disparate ideas and mythologies into conversation, blending, for instance, East African creation stories with imagery from popular culture. In turn, Mutu's practice can be understood as a site of construction, a unique form of myth-making in which she exposes hidden narratives of exclusion and builds new ways of seeing, relating, communicating and understanding.

Mutu's work *Grow the Tea, then Break the Cups* (2021), displayed for the first time in *Feminine power*, shows the bust of a female figure emerging from blackened soil (fig. 172a–b). Crowned with a tin can, she is decorated with hair and feathers, with jutting sticks of wood forming an armour-like structure. Her torso is embedded with fragments of a porcelain teacup, suggestive remnants of Kenya's colonial past, while shards of quartz instil the figure with healing properties. Seemingly disposable waste is given a new life, broken parts reformulated to create a whole. Rooted in the environment of Mutu's home, this serene, regal divinity meets us as a guide and guardian of the earth from which she is made.

Born in Nairobi, Kenya in 1972, Wangechi Mutu currently works between New York and Nairobi.

Opposite and overleaf

FIG. 172A–B
Wangechi Mutu, *Grow the Tea, then Break the Cups*, 2021. Kenya. Soil, charcoal, paper pulp, wood, brown quartz, porcelain, crystal, ornaments, oyster shell, tin can, hair. 94 × 43 × 29.8 cm. Victoria Miro Gallery.

LUCY DAHLSEN: There's a tendency, sometimes, to view art historical or religious narratives as fixed stories and this is compounded by the ways in which they've been repeated and reinforced over time. Your work disrupts these structures. You've worked a lot with collage and bricolage. Could you talk about this form of creation and meaning making?

WANGECHI MUTU: My feeling is these many religions, mythologies, schools of thought, art histories, even the sciences that we've come up with – they're all 'languages' and methods to investigate and dig up information about who we are. They are clues to try and make sense of ourselves and the world around us. Who are we? Why are we here? Is there an explanation for our behaviour, our attractions, our cruelty towards one another, our differences and lack thereof, our evolution and supposed advancement till today?

Nature is the biggest library for these answers. The natural world, where we fit in, is full of life and death and contains the explanation of our origins and our fate. This looking and searching, digging, breaking, making, moulding, fiddling and discovering by creating things is what occupies me; it's how I communicate what I think I know – through art-making.

LD: This book, and the exhibition it accompanies, explores the female image and the diversity of ways in which femininity has been constructed and embodied across different religious and mythological traditions – from the ancient world to today. There is an emphasis in your work on reworking images rather than starting from scratch – working with and reformulating received ideas in a way that speaks to and reflects your own experience. What is the importance, for you, in this engagement with the past?

WM: We are some of our mothers, and we are some of our fathers, they are all inside of us making us into separate *wholes*. All of us, male and female or non-binary, are carried into birth within a woman's body. This is the greatest focus of my collage. Within the extraordinariness of this miraculous machine and this incubator; the female body, we are combined, brewed, blended and fused into one. Through collage I'm saying that we are made through combining and union. Like the earth, we absolutely know and understand how important women are in sustaining, caring, and protecting us all, but women are still targeted in particularly violent, symbolic and disrespectful ways.

LD: You've spoken about your deep connectivity to your environment and the natural world. I was struck by your recent film *My Cave Call* (2020), which takes place in the Suswa Cave, an ancient holy cave in a stretch of the Great Rift Valley in Kenya – a fertile region known for its associations with the regeneration of life and preservation. In the film you play a woman who transforms into a mythical horned being and performs a ritual as she gradually fills the cave with smoke. You've described the performance as a prayer to nature. I'm curious to hear more about what this transformation speaks to.

WM: Art-making for me is restorative and healing for everyone, the viewer, the spaces where the work is exhibited. We've made art for tens of thousands of years, recording the hopes, wishes, births and deaths,

the spells, curses, love affairs, stories, theories, the accomplishments and fears of the people. Using motion to draw, dance, call out and even repair injustice on the planet's body and the bodies of people.

Human beings have to stop abusing one another, as if there are any long-term benefits, because there aren't. None of us is in any race or competition that can ever be won. Slavery, colonisation, industrialisation; all systems built on the falsehood of progress, greed programmes that destroy and deprive all people of their justice. Building on the backs of other human beings by ravaging, squandering and pillaging depletes the earth and us all. The planet is intelligent and alive and constantly reminding us what it can be like, if we treated each other fairly.

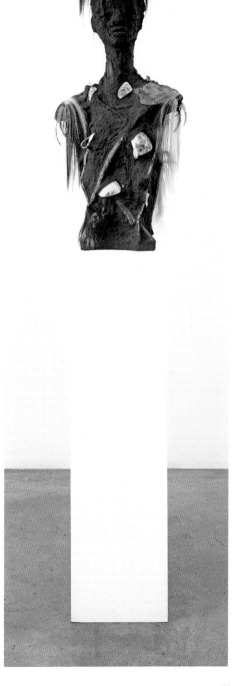

LD: Part of the exhibition explores the representation of protective female warrior deities across different traditions, including the Hindu goddesses Durga and Kali Ma and the ancient Egyptian Sekhmet. *Grow the Tea, then Break the Cups* presents a regal, armoured divinity. She relates to your *Sentinels*, a series of standing figures that you've described as divine feminine soldiers or guardians. What are they guarding and protecting against?
WM: Neglecting our female side and our women people, who carry our intelligence in the fibre of our bodies. We have all come here, painfully, through women. We benefit so much from women leading in roles of human survival. I feel that in general women think about the future, different species, more than men. Women's intellect, instincts and intuition are essential if we want to continue living in this world.

LD: You've been drawn to Eve and the narrative of the Fall in many of your works. A recurrent theme in the exhibition – which comes up in several traditions – is a theological distinction between the corporeal world and the realm of immateriality and consciousness. Is this distinction something you think about?
WM: 'Eve', or the idea of the original mother or first human female, comes not so much from the Christian Bible. The oldest cultures that sprung from the Rift Valley and the Nile, from East Africa, have the longest art histories and the first divine mother–female of origination shows our nature being separated from our natural world.

LD: The final section of the exhibition looks at the ancient Egyptian goddess Isis, the Virgin Mary and the Buddhist Bodhisattvas Guanyin and Tara. Each of these 'mothers' demonstrate a closeness to humankind, and embody mercy and compassion. There's a theme of attending to the experience and suffering of others, which is prominent in your work. Which figures have inspired you?
WM: Maitu, Mama, Mary, Mummy, Maria, Mother, Maa, Mara, Maya, Madre, Mum, Magda.

LD: What does 'feminine power' mean to you?
WM: Hail Mary full of grace the Lord is with Thee.

Notes

INTRODUCTION

1 *Devi Mahatmya*, 11.4–5, trans. Thomas B. Coburn, *Encountering the Goddess: A Translation of the Devī-Māhātmya and a Study of its Interpretation*, Albany, NY: State University of New York Press, 1991, p. 74.

2 Rajeswari Sunder Rajan, 'Is the Hindu Goddess a Feminist', *Economic and Political Weekly*, 33 (1998), pp. 34–8.

3 Rita M. Gross, 'Hindu Female Deities as a Resource for the Contemporary Rediscovery of the Goddess', *Journal of the American Academy of Religion*, 46 (1978), pp. 269–91, at p. 271 (original emphasis).

4 Kartikeya C. Patel, 'Women, Earth and the Goddess: A Sakta-Hindu Interpretation of Embodied Religion', in *Goddesses and Women in the Indic Religious Tradition*, ed. Arvind Sharma, Leiden: Brill, 2005, pp. 50–71, at p. 50.

5 Jo Ann Hackett, 'Can a Sexist Model Liberate Us? Ancient Near Eastern "Fertility" Goddesses', *Journal of Feminist Studies in Religion*, 5 (1989), pp. 65–76, at p. 75; Elisabeth Benard and Beverly Moon, 'Introduction', in *Goddesses Who Rule*, ed. Elisabeth Benard and Beverly Moon, Oxford: Oxford University Press, 2000, pp. 3–13, at p. 5.

6 Jill Cook, *Ice Age Art: The Arrival of the Modern Mind*, London: British Museum Press, 2013, pp. 16–17.

7 Ibid., p. 18.

8 Ibid., pp. 61–107.

9 Ibid., pp. 99–102.

10 Many thanks to Jill Cook for providing this information and for her advice on this section of the text.

11 For a summary of Yarmukian sites and excavated finds, see Yosef Garfinkel, 'The Yarmukian Culture in Israel', *Paléorient*, 19 (1993), pp. 115–34.

12 Tamar Noy, 'Seated Clay Figurines from the Neolithic Period, Israel', in *Archaeology and Fertility Cult in the Ancient Mediterranean: Papers Presented at the first International Conference on Archaeology of the Ancient Mediterranean, University of Malta, 2–5 September 1985*, ed. Anthony Bonanno, Amsterdam: John Benjamins Publishing Company, 1986, pp. 63–8.

13 Garfinkel, 'The Yarmukian Culture in Israel', p. 124.

14 Ibid.

15 J. Lesley Fitton, *Cycladic Art*, London: British Museum Press, 1989, pp. 84–90.

16 Cook, *Ice Age Art*, pp. 67–8; Sarah M. Nelson, 'Diversity of the Upper Paleolithic "Venus Figurines and Archeological Mythology"', *Archeological Papers of the American Anthropological Association*, 2 (2008), pp. 11–22, at p. 12.

17 Jill Cook, 'What's in a Name? A Review of the Origins, History and Unsuitability of the Term *Venus Figurine*', *Die Kunde: Zeitschrift für Niedersächsische Archäologie*, 66 (2015), pp. 43–72, at pp. 61–3.

18 Nelson, 'Diversity of the Upper Paleolithic', pp. 16–17.

19 Paul Mellars, 'Origins of the Female Image', *Nature*, 459 (2009), p. 176, cited in Cook, 'What's in a Name', p. 68; Cook, *Ice Age Art*, pp. 37–41; Nelson, 'Diversity of the Upper Paleolithic', p. 16.

20 Marija Gimbutas, *The Goddesses and Gods of Old Europe*, new updated edn, London: Thames & Hudson, 1982, pp. 152–96; Marija Gimbutas, *The Living Goddess*, Berkeley: University of California Press, 1999, pp. 112–25; Anne Baring and Jules Cashford, *The Myth of the Goddess: Evolution of an Image*, London: Viking Arkana, 1991, pp. 3–105.

21 For a summary of the development of this theory, see Cynthia Eller, *The Myth of Matriarchal Prehistory: Why an Invented Past won't give Women a Future*, Boston: Beacon Press, 2000, pp. 30–55.

22 Ibid., pp. 93–156; Lynn Meskell, 'Goddesses, Gimbutas and New Age Archaeology', *Antiquity*, 69 (1992), pp. 74–86.

23 Eller, *The Myth of Matriarchal Prehistory*, p. 13.

24 Paul Richard, *Washington Post*, 26 May 1984.

25 Mona Saudi, *Mona Saudi: Forty Years in Sculpture*, Beirut: Mona Saudi, 2006, p. 13.

1 CREATION & NATURE

1 Ulli Beier (ed.), *Yoruba Myths*, Cambridge: Cambridge University Press, 1980, p. xiii.

2 Michael Ashkenazi, *Handbook of Japanese Mythology*, Santa Barbara, CA: ABC-CLIO, 2003, p. 187.

3 Gustav Heldt (trans.), *The Kojiki: An Account of Ancient Matters*, New York: Columbia University Press, 2014, pp. xiii–xvi.

4 Ibid., pp. 7–9.

5 Ashkenazi, *Handbook of Japanese Mythology*, pp. 278–9.

6 Ibid., pp. 254–5.

7 Ibid., pp. 277–8; Catherine Ludvik, 'Uga-Benzaiten: The Goddess and the Snake', *Impressions*, 33 (2012), pp. 94–109, at pp. 98–9.

8 Ludvik, 'Uga-Benzaiten', pp. 99–108.

9 The terms Mexica and Aztec are not strictly interchangeable. For an explanation, see Eduardo Matos Moctezuma and Felipe Solis Olguin, 'Introduction', in *Aztecs*, ed. Eduardo Matos Moctezuma and Felipe Solis Olguin, London: Royal Academy of Arts, 2003, pp. 14–21, at p. 15.

10 Mary Miller and Karl Taube, *An Illustrated Dictionary of the Gods and Symbols of Ancient Mexico and the Maya*, London: Thames & Hudson, 2018, pp. 127–8.

11 'Traditional' is used here and throughout this book by the author to denote spiritual and cultural systems which pre-date the arrival and adoption of Christianity and Islam in many parts of the world, and which have evolved in complex and sometimes synchronistic ways alongside Abrahamic faiths.

12 Charles Ebere, 'Beating the Masculinity Game: Evidence from African Traditional Religion', *CrossCurrents*, 61 (2011), pp. 480–95, at pp. 484–6; Molefi Kete Asante and Ama Mazama (eds), *Encyclopedia of African Religion*, 2 vols, Los Angeles and London: Sage, 2009, vol. I, p. 264.

13 Asante and Mazama (eds), *Encyclopedia of African Religion*, vol. I, pp. 440–1, 692–3.

14 Ibid., pp. 270–3, 411–13.

15 Sandra E. Greene, 'Religion, History and the Supreme Gods of Africa: A Contribution to the Debate', *Journal of Religion in Africa*, 26 (1996), pp. 122–38, at p. 129–32.

16 Janet Martin Soskice, *The Kindness of God: Metaphor, Gender, and Religious Language*, Oxford: Oxford University Press, 2008, pp. 35–51.

17 Grace M. Jantzen, *Becoming Divine: Towards a Feminist Philosophy of Religion*, Bloomington, IN: Indiana University Press, 1999, pp. 172–3; David Wheeler-Reed, 'What the Early Church Thought about God's Gender', *The Conversation*, 1 August 2018, available at https://theconversation.com/what-the-early-church-thought-about-gods-gender-100077 (accessed 1 November 2021).

18 'The Father', pt I, §2, ch. 1, art. 1, para. 2, in *Catechism of the Catholic Church*, available at www.vatican.va/archive/ENG0015/__ P17.HTM (accessed 24 December 2021).

19 Mary McClintock Fulkerson and Sheila Briggs, 'Introduction', in *The Oxford Handbook of Feminist Theology*, ed. Mary McClintock Fulkerson and Sheila Briggs, Oxford: Oxford University Press, 2012, pp. 1–20; Erhard S. Gerstenberger, *Yahweh the Patriarch: Ancient Images of God and Feminist Theology*, Minneapolis, MN: Fortress Press, 1996, pp. ix–xii.

20 Sebastian Brock, 'The Holy Spirit as Feminine in Early Syriac Literature', in *After Eve: Women, Theology and the Christian Tradition*, ed. Janice Martin Soskice, London: Collins, 1990, pp. 73–88, at p. 81.

21 Proverbs 3:18–20 (New International Version); see also Proverbs 8:22–31.

22 Rosemary R. Ruether, *Sexism and God-Talk: Towards a Feminist Theology*, Boston, MA: Beacon Press, 1983, p. 70.

23 Mary Daly, *Beyond God the Father: Towards a Philosophy of Women's Liberation*, London: SCM Press Ltd, 1993, p. 34.

24 Kenneth A. Cherney, Jr., 'Gender-Neutral Language, with Special Reference to NIV 2011', available at https://web.archive.org/web/20150618072352/www.wels.net/sites/wels/files/gender-neutral%20NIV%20

2011%20article%20edited.pdf (accessed
18 November 2021).

25 Jantzen, *Becoming Divine*, p. 173.

26 Judy Chicago, *The Birth Project*, New York:
Doubleday, 1985, pp. 4–7.

27 'Meet the Artists: Judy Chicago, The Birth
Project', *Art Basel*, 9 January 2019, available at
www.youtube.com/watch?v=O8ouH6zhI_8
(accessed 18 November 2021).

28 Miriam Robbins Dexter and Victor H. Mair,
*Sacred Display: Divine and Magical Female Figures
of Eurasia*, Amherst, NY: Cambria Press,
2010, p. 91.

29 Starr Goode, *Sheela na gig: The Dark Goddess
of Sacred Power*, Rochester, VT: Inner
Traditions, 2016, p. 5.

30 Anthony Weir and James Jerman, *Images
of Lust: Sexual Carvings on Medieval Churches*,
London and New York: Routledge, 1999,
pp. 14–15; Barbara Freitag, *Sheela-na-gigs:
Unravelling an Enigma*, London: Routledge,
2004, pp. 17–18.

31 Juliette Dor, 'The Sheela-na-gig: An
Incongruous Sign of Sexual Purity?',
in *Medieval Virginities*, ed. Ruth Evans,
Sarah Salih and Anke Bernau, Toronto:
University of Toronto Press, 2003, pp. 33–55,
at pp. 35–6.

32 Freitag, *Sheela-na-gigs*, pp. 19–24; Dor, 'The
Sheela-na-gig', pp. 33–55.

33 Weir and Jerman, *Images of Lust*, pp. 11–17;
Freitag, *Sheela-na-gigs*, pp. 25–32, 43–9.

34 Freitag, *Sheela-na-gigs*, pp. 104–6.

35 For more information about the project,
see www.projectsheela.com (accessed
1 November 2021).

36 Yaba Amgborale Blay, 'Asase Yaa', in
Encyclopedia of African Religion, ed. Asante
and Mazama, vol. I, pp. 73–4.

37 Patricia Mathews-Salazar, 'Becoming all
Indian: Gauchos, Pachamama Queens and
Tourists in the Remaking of an Andean
Festival', in *Festivals, Tourism and Social Change:
Remaking Worlds*, ed. David Picard and Mike
Robinson, Bristol: Channel View
Publications, 2006, pp. 71–83, at pp. 71, 75–6.

38 Ibid., pp. 77–80.

39 Nigel Leask, *Curiosity and the Aesthetics of Travel
Writing, 1770–1840: From an Antique Land*,
Oxford: Oxford University Press, 2004, p. 278.

40 Cecelia F. Klein, 'A New Interpretation
of the Aztec Statue called Coatlicue,
"Snakes-her-Skirt"', *Ethnohistory*, 55 (2008),
pp. 229–50.

41 Steven R. Fischer, *Island at the End of the
World: The Turbulent History of Easter Island*,
London: Reaktion Books, 2005, p. 27;
Alice Christophe, 'Moai', British Museum
website, available at www.britishmuseum.
org/about-us/british-museum-story/
contested-objects-collection/moai (accessed
24 December 2021).

42 Thomas S. Barthel, 'Female Stone Figures
on Easter Island', *Journal of the Polynesian
Society*, 67 (1958), pp. 252–5.

43 See the Metropolitan Museum of Art's
catalogue entry for 1979.206.1478, available
at www.metmuseum.org/art/collection/
search/313666 (accessed 20 November 2021).

44 Ibid.; see also Barthel, 'Female Stone
Figures', p. 254, n. 9.

45 Recorded in 2014. See the object entry for
Oc,+.2597 on the British Museum Collection
Online website, available at www.british
museum.org/collection/object/E_Oc-2597
(accessed 24 December 2021).

46 'Origins of Māori Weaving', Museum
of New Zealand / Te Papa Tongarewa
website, available at https://collections.
tepapa.govt.nz/topic/3612 (accessed
20 November 2021).

47 Mick Pendergrast, 'The Fibre Arts', in *Maori
Art and Culture*, ed. Janet M. Davidson and
D.C. Starzecka, London: British Museum
Press, 1996, pp. 114–46, at p. 126.

48 Suzanne MacAulay and Kura Te
Waru-Rewiri, 'Maori Weaving:
The Intertwining of Spirit, Action and
Metaphor', *Textile Society of America Symposium
Proceedings*, available at https://core.ac.uk/
download/pdf/18198118.pdf (accessed
20 November 2021), p. 196.

49 Pendergrast, 'The Fibre Arts', p. 115.

50 Ibid., pp. 115, 136–9.

51 Naomi Simmonds, 'Mana wahine:
Decolonising Politics', *Women's Studies Journal*,
25, no. 2 (2011), pp. 11–25, at pp. 14–16.

52 Pendergrast, 'The Fibre Arts', p. 116.

53 For a nuanced discussion, see Simmonds,
'Mana wahine'.

54 Hesiod, *Theogony*, ll. 116–38, in *Theogony.
Works and Days. Testimonia*, ed. and trans.
Glenn W. Most, Cambridge, MA: Harvard
University Press, 2018, pp. 12–13.

55 Richard H. Wilkinson, *The Complete Gods and
Goddesses of Ancient Egypt*, London: Thames
& Hudson, 2017, pp. 160–1.

56 Ibid., pp. 105–6.

57 For example, on the ceiling of the tomb
of Rameses VI; ibid., p. 90.

58 Ibid., p. 129.

59 R. Canals, *A Goddess in Motion: Visual Creativity
in the Cult of María Lionza*, New Directions
in Anthropology, vol. XLII, New York:
Berghahn Books, 2017, pp. 1–3.

60 Barbara Placido, '"It's all to do with words":
An Analysis of Spirit Possession in the
Venezuelan Cult of María Lionza', *Journal of
the Royal Anthropology Institute*, 7 (2001),
pp. 207–24; Girish Gupta, 'Venezuelan Cult
Draws Tens of Thousands of Followers',
Reuters, 31 October 2011, available at www.
reuters.com/article/us-venezuela-cult-
idUKTRE79U48D20111031 (accessed 20
November 2021).

61 Rhodri Davies, 'The Cult of Maria Lionza',
Al Jazeera, 18 November 2011, available
at www.aljazeera.com/features/2011/11/
18/the-cult-of-maria-lionza (accessed
20 November 2021).

62 Charles Russell Coulter and Patricia Turner,
Encyclopedia of Ancient Deities, Routledge, 2000,
p. 377.

63 Object entry for 2014,2029.2 on the British
Museum Collection Online website,
available at www.britishmuseum.org/
collection/object/E_2014-2029-2
(accessed 21 December 2021).

64 Yves Rodrigues and Noel Francis Singer,
Nat-Pwe: Burma's Supernatural Sub-Culture,
Gartmore, Scotland: Kiscadale, 1992,
pp. 318–19.

65 Melford E. Spiro, *Burmese Supernaturalism*,
enlarged edn, Abingdon: Routledge, 2017,
pp. 113–15.

66 Tamara Ho, 'Transgender, Transgression,
and Translation: A Cartography of Nat
Kadaws: Notes on Gender and Sexuality
within the Spirit Cult of Burma', *Discourse:
Journal for International Studies in Media and
Culture*, 31 (2009), pp. 273–317, at p. 274.

67 T. Richard Blurton, *Hindu Art*, London:
British Museum Press, 1992, pp. 10–13.

68 David R. Kinsley, *Hindu Goddesses: Visions
of the Divine Feminine in the Hindu Religious
Tradition*, Berkeley, CA: University
of California Press, 1986, p. 8.

69 Ibid., pp. 10–11.

70 Ibid., pp. 20–1.

71 Ibid., pp. 19–22.

72 Ibid., p. 22.

73 *The Vishnu Purana: A System of Hindu Mythology
and Tradition*, trans. H.H. Wilson, Calcutta,
India: Punthi Pustak, 1961, book I, ch. IX,
p. 62.

74 Ibid., pp. 76–9.

75 Kinsley, *Hindu Goddesses*, pp. 28–9.

76 John Guy, 'The Divine Androgyne: Shiva,
Parvati and Sexual Syncretism in Indian
Art', in *Goddess: Divine Energy*, ed. Jackie
Menzies, exh. cat., Sydney: Art Gallery
of New South Wales, 2007, pp. 69–75, p. 73.

77 *The Vishnu Purana*, trans. Wilson, book 1,
ch. 8, pp. 50–2; book 1, ch. 9, p. 64.

78 Anonymous, 'To Demeter', Homeric Hymn
2, ll. 302–33, in *Homeric Hymns*, ed. and trans.
Hugh G. Evelyn-White, Cambridge, MA:
Harvard University Press, 1914.

79 Sue Blundell, *Women in Ancient Greece*,
London: British Museum Press, 1995, p. 43.

80 Ibid., pp. 42–3; Sarah B. Pomeroy, *Goddesses,
Whores, Wives and Slaves: Women in Classical
Antiquity*, new edn, London: Pimlico, 1994,
pp. 76–7.

81 Joan Breton Connelly, *Portrait of a Priestess:
Women and Ritual in Ancient Greece*, Princeton,
NJ: Princeton University Press 2007,
pp. 230–2.

82 Ibid., pp. 64–5.

83 Cited in Pomeroy, *Goddesses, Whores, Wives
and Slaves*, p. 78.

84 H.S. Versnel, 'The Festival for Bona Dea
and the Thesmophoria', *Greece & Rome*,
39 (1992), pp. 31–55, at p. 37.

85 Knud Rasmussen, *Across Arctic America:
Narrative of the Fifth Thule Expedition*, New
York and London: G.P. Putnam's Sons, 1927,
p. 30.

86 Amber Lincoln, Jago Cooper and Jan Peter
Laurens Loovers (eds), *Arctic*, exh. cat.,
London: Thames & Hudson and British
Museum Press, 2020, p. 294.

87 'Lucassie Kenuajuak', Beauchamp Art
Gallery website, available at https://
beauchampartgallery.com/pages/
kenuajuak-lucassie (accessed 23 December
2021).

88 Many thanks to Amber Lincoln for her advice on this section of the text.

89 This version of the narrative was recorded in Greenland in the 1920s; see Rasmussen, *Across Arctic America*, pp. 27–35 (including coverage of ritual approaches to Sedna).

90 Liam M. Brady, 'Freshwater Sources and their Relational Contexts in Indigenous Australia: Views from the Past and Present', in *Sacred Waters: A Cross-Cultural Compendium of Hallowed Springs and Holy Wells*, ed. Celeste Ray, London: Routledge, 2020, pp. 97–109, at pp. 99, 105.

91 Luke Taylor, 'Manifestations of the Mimih', in *The Power of Knowledge, the Resonance of Tradition*, ed. Luke Taylor et al., Canberra: Aboriginal Studies Press for the Australian Institute of Aboriginal and Torres Strait Islander Studies, 2005, pp. 182–98, at p. 190.

92 Many thanks to Gaye Sculthorpe for her advice on this section of the text.

93 Taylor, 'Manifestations of the Mimih', p. 190; see also 'Owen Yalandja', *Maningrida Arts & Culture*, available at https://maningrida.com/artist/owen-yalandja (accessed 20 November 2021).

94 Asante and Mazama (eds), *Encyclopedia of African Religion*, vol. I, pp. xxvi, 74.

95 Joseph M. Murphy and Mei-Mei Sanford, 'Introduction', in ibid., pp. 1–9, at p. 2; Ebere, 'Beating the Masculinity Game', p. 487.

96 Ifa divination verse on creation; quoted and translated in Rowland Abiodun, 'Hidden Power: Òsun the Seventeenth Obù', in *Òsun Across the Waters: A Yoruba Goddess in Africa and the Americas*, ed. Joseph M. Murphy and Mei-Mei Sanford, Bloomington, IN: Indiana University Press, 2001, pp. 10–33, at pp. 16, 30.

97 Ibid., pp. 16–18.

98 Ibid., pp. 25–6.

99 Ibid., p. 21.

100 Ibid., pp. 10–11.

101 David Ogungbile, 'Eérìndínlógún: The Seeing Eyes of Sacred Shells and Stones', in *Òsun Across the Waters*, ed. Murphy and Sanford, pp. 189–212, at p. 198.

102 Asante and Mazama (eds), *Encyclopedia of African Religion*, vol. I, pp. 509–10.

103 Ibid., pp. 505–6.

104 Jacob Olupona, 'Òrìsà Òsun: Yoruba Sacred Kingship and Civil Religion in Òsogbo, Nigeria', in *Òsun Across the Waters*, ed. Murphy and Sanford, pp. 46–67, at pp. 57–8.

105 Ibid., pp. 59–65.

106 Quoted in ibid., p. 65.

107 Murphy and Sanford, 'Introduction', p. 4–5.

108 Joseph M. Murphy, 'Yéyé Cachita: Ochún in a Cuban Mirror', in *Òsun Across the Waters*, ed. Murphy and Sanford, pp. 86–101, at pp. 95–6. For a critique of this popular characterisation by female devotees of Oshun in American spiritual traditions, see Rachel Elizabeth Harding, '"What part of the river you're in": African American Women in Devotion to Òsun', in *Òsun Across the Waters*, ed. Murphy and Sanford, pp. 165–88.

109 Murphy, 'Yéyé Cachita', p. 98.

110 Isabel Castellanos, 'A River of Many Turns: The Polysemy of Ochún in Afro-Cuban Tradition', in ibid., pp. 34–45, at pp. 34–5.

111 Ibid., pp. 38–9.

112 Asante and Mazama (eds), *Encyclopedia of African Religion*, vol. I, pp. 150–3.

113 Manuel Vega, 'Mãe Menininha', in *Òsun Across the Waters*, ed. Murphy and Sanford, pp. 84–6.

114 Ieda Machado Ribeiro dos Santos, 'Nesta cidade todo mundo é d'Oxum: In this City Everyone is Oxum's', in ibid., pp. 68–83, at pp. 68–76.

115 Henry John Drewal, 'Introduction: Charting the Voyage', in *Sacred Waters: Arts for Mami Wata and Other Divinities in Africa and the Diaspora*, ed. Henry John Drewal, Bloomington, IN: Indiana University Press, 2008, pp. 1–18.

116 Henry John Drewal, 'Mami as Artists' Muse', in *Mami Wata: Arts for Water Spirits in Africa and its Diasporas*, ed. Henry John Drewal, Los Angeles: Fowler Museum at UCLA, 2008, p. 206.

117 Henry John Drewal, 'Interpretation, Invention, and Re-Presentation in the Worship of Mami Wata', *Journal of Folklore Research*, 25, nos 1–2 (1988), pp. 101–39, at p. 110.

118 Asante and Mazama (eds), *Encyclopedia of African Religion*, vol. I, p. 404.

119 Jeremy Coote and Jill Salmons, 'Mermaids and Mami Wata on Brassware from Old Calabar', in *Sacred Waters: Arts for Mami Wata*, ed. Drewal, pp. 259–75, at p. 271.

120 Ibid., p. 259.

121 Ibid., pp. 260–2.

122 Drewal, 'Interpretation, Invention, and Re-Presentation in the Worship of Mami Wata'.

123 Charles Gore and Joseph Nevadomsky, 'Practice and Agency in Mammy Wata Worship in Southern Nigeria', *African Arts*, 30, no. 2 (1997), pp. 60–9, at p. 67.

124 Many thanks to Jill Salmons for her advice on this section of the text; private communication, July 2021.

125 Phyllis Galembo, *Maske*, London: Chris Boot, 2010, p. 53; Chika Okeke-Agulu, 'Introduction: The Persistence of Memory', in ibid., pp. 4–9, at p. 7.

126 Ibid., p. 79.

127 Okeke-Agulu, 'Introduction: The Persistence of Memory', p. 7.

128 Alex Van Stipriaan, 'Watramama / Mami Wata: Three Centuries of Creolization of a Water Spirit in West Africa, Suriname and Europe', *Matatu: Journal for African Culture and Society*, 27 (2003), pp. 323–37, at p. 330.

129 Gore and Nevadomsky, 'Practice and Agency in Mammy Wata Worship', p. 60.

130 Robert A. Voeks, *Sacred Leaves of Candomblé: African Magic, Medicine, and Religion in Brazil*, Austin, TX: University of Texas Press, 2010, pp. 56, 77, 81; Mikelle Smith Omari-Tunkara, *Manipulating the Sacred: Yorùbá Art: Ritual and Resistance in Brazilian Candomblé*, Detroit, MI: Wayne State University Press, 2005, pp. 76–87.

131 Asante and Mazama (eds), *Encyclopedia of African Religion*, vol. I, p. 404.

132 Drewal, *Mami Wata*, p. 72.

133 Gore and Nevadomsky, 'Practice and Agency in Mammy Wata Worship', p. 65. For other similar personal accounts see Mei-Mei Sanford, 'Living Water: Òsun, Mami Wata, and Olókùn in the Lives of Four Contemporary Nigerian Christian Women', in *Òsun Across the Waters*, ed. Murphy and Sanford, pp. 238–50.

134 Katy Jenkins, 'Unearthing Women's Anti-Mining Activism in the Andes: Pachamama and the "Mad Old Women"', *Antipode*, 47 (2015), pp. 442–60.

135 David Humphreys, 'Rights of Pachamama: The Emergence of an Earth Jurisprudence in the Americas', *Journal of International Relations and Development*, 20 (2017), pp. 459–84.

2 PASSION & DESIRE

1 Sophocles, Fragment 941, ll. 1–8, in *Sophocles, vol. III: Fragments*, ed. and trans. Hugh Lloyd-Jones, Cambridge, MA: Harvard University Press, 2003, p. 405.

2 Mark E. Cohen, 'The Incantation-Hymn: Incantation or Hymn?' *Journal of the American Oriental Society*, 95 (1975), pp. 592–611.

3 'The Exaltation of Inana (Inana B)', in *The Electronic Text Corpus of Sumerian Literature*, ed. J.A. Black et al., t.4.07.2, ll. 20–33, available at https://etcsl.orinst.ox.ac.uk/cgi-bin/etcsl.cgi?text=t.4.07.2# (accessed 6 September 2021).

4 Rivkah Harris, 'Inanna-Ishtar as Paradox and a Coincidence of Opposites', *History of Religions*, 30 (1991), pp. 261–78.

5 Gwendolyn Leick, *Sex and Eroticism in Mesopotamian Literature*, London: Routledge, 1994, pp. 55–8.

6 Ibid., p. 159.

7 Will Roscoe, 'Priests of the Goddess: Gender Transgression in Ancient Religion', *History of Religions*, 35 (1996), pp. 195–230, at pp. 213–17; Harris, 'Inanna-Ishtar as Paradox', p. 270; Leick, *Sex and Eroticism*, p. 159.

8 Leick, *Sex and Eroticism*, pp. 109–10; Rosemary Ruether, *Goddesses and the Divine Feminine: A Western Religious History*, Berkeley, CA and London: University of California Press, 2005, pp. 55–8.

9 'A Praise Poem of Šulgi', in *The Electronic Text Corpus of Sumerian Literature*, ed. J.A. Black et al., t.2.4.2.24, ll. 31–52, available at https://etcsl.orinst.ox.ac.uk/cgi-bin/etcsl.cgi?text=t.2.4.2.24 (accessed 6 September 2021).

10 Marie-Christine Ludwig and Christopher Metcalf, 'The Song of Innana [sic] and Išme-Dagan: An Edition of BM 23820+23831', *Zeitschrift für Assyriologie*, 107 (2017), pp. 1–21.

11 For a full discussion of the significance of this plaque and its interpretation as Ishtar, see Dominique Collon, *The Queen of the Night*, British Museum Objects in Focus, London: British Museum Press, 2005.

12 Although not a common feature of images of Ishtar, bird talons did not necessarily indicate malevolent beings in Mesopotamian art. For a discussion, see Jeremy Black and Anthony Green, *Gods, Demons and Symbols of Ancient Mesopotamia: An Illustrated Dictionary*, London: British Museum Press, 1992, pp. 43–4.

13 For a discussion of this theory, as well as the anachronistic theory that the 'Queen of the Night' represents the Jewish demoness Lilith, see Collon, *The Queen of the Night*, pp. 39–45. The Danish historian Thorkild Jacobsen has argued that the 'Queen of the Night' relief specifically shows Ishtar in her descent to Ereshkigal's realm; Thorkild Jacobsen, 'Pictures and Pictorial Language (The Burney Relief)', in *Figural Language in the Ancient Near East*, ed. M. Mindlin et al., London: School of Oriental and African Studies, University of London, 1987, pp. 1–11.

14 Leick, *Sex and Eroticism*, p. 223.

15 'Inana's Descent to the Nether World', in *The Electronic Text Corpus of Sumerian Literature*, ed. J.A. Black et al., t.1.4.1, ll. 354–8, available at https://etcsl.orinst.ox.ac.uk/cgi-bin/etcsl.cgi?text=t.1.4.1# (accessed 2 September 2021).

16 Ibid., ll. 73–7.

17 A.R. George (ed. and trans.), *The Epic of Gilgamesh*, London: Penguin Books, 1999, Tablet VI, pp. 47–54.

18 Leick, *Sex and Eroticism*, pp. 164–5.

19 Tzvi Abusch, 'Ishtar's Proposal and Gilgamesh's Refusal: An Interpretation of "The Gilgamesh Epic", Tablet 6, Lines 1–79', *History of Religions*, 26 (1986), pp. 143–87.

20 Many thanks to Sebastien Rey and Jonathan Taylor for their advice and feedback on Inanna/Ishtar.

21 Diana K. McDonald and Jacqueline Karageorghis, 'Aphrodite's Ancestors', in *Aphrodite and the Gods of Love*, ed. Christine Kondoleon and Phoebe C. Segal, Boston, MA: Museum of Fine Arts, 2011, pp. 17–39.

22 Thanks to Thomas Kiely for this observation.

23 Hesiod, *Theogony*, in *Theogony. Works and Days. Testimonia*, ed. and trans. Glenn W. Most, Cambridge, MA: Harvard University Press, 2018, ll. 192–200. An alternative version of Aphrodite's mythological birth is recorded in Homer's *Iliad*, book V, in which she is said to be the daughter of Zeus and Dione, a Titan connected with the sea and prophecy. However, this version appears to have had less influence on the later literature and art of Aphrodite.

24 Stephanie L. Budin, 'Aphrodite Enoplion', in *Brill's Companion to Aphrodite*, ed. Amy Claire Smith and Sadie Pickup, Leiden: Brill, 2010, pp. 79–112; Gabriella Pironti, 'Rethinking Aphrodite as a Goddess of Work', ibid., pp. 113–30, at pp. 120–5.

25 Stephanie L. Budin, 'Simonides' Corinthian Epigram', *Classical Philology*, 103 (2008), pp. 335–53. Vinciane Pirenne-Delforge and

Gabriella Pironti, 'Greek Cults of Aphrodite', in *Aphrodite and the Gods of Love*, ed. Kondoleon and Segal, pp. 41–61, at p. 46.

26 Ibid., p. 47.

27 Ibid.

28 Hesiod, *Theogony*, ed. and trans. Most, ll. 120–3.

29 Ibid., ll. 120–2. Christine Kondoleon, 'Eros, Child of Aphrodite', in *Aphrodite and the Gods of Love*, ed. Kondoleon and Segal, pp. 107–47, at pp. 107–8.

30 Sappho, *The Poetry of Sappho*, trans. Jim Powell, Oxford: Oxford University Press, 2007, p. 3. For the Greek, see Edgar Lobel and Denys Page, *Poetarum Lesbiorum Fragmenta*, Oxford: Clarendon Press, 1955, LP1.

31 'In the midst thereof sits the goddess – she's a most beautiful statue of Parian marble – arrogantly smiling a little as a grin parts her lips'; Pseudo-Lucian, *Amores (Affairs of the Heart)*, trans. M.D. MacLeod, Cambridge, MA: Harvard University Press, 1967, vol. III, 13, p. 169.

32 Ibid., p. 173.

33 Budin, 'Aphrodite Enoplion', p. 106.

34 Ibid.; James Davidson, 'Venus Genetrix outside Rome', *Phoenix*, 48 (1994), pp. 294–306.

35 Rachel Kousser, 'The Female Nude in Classical Art: Between Voyeurism and Power', in *Aphrodite and the Gods of Love*, ed. Kondoleon and Segal, pp. 149–87; Sadie Pickup, 'Venus in the Mirror: Roman Matrons in the Guise of a Goddess. The Reception for the Aphrodite of Cnidos', *Visual Past*, 2 (2015), pp. 137–54.

36 Alice Boner and Sadasiva Rath Sarma (trans.), *Silpa Prakasa: Medieval Orissan Sanskrit Text on Temple Architecture*, Leiden: Brill, 1966, verse 499, p. 103.

37 Richard Shusterman, 'Asian ars erotica and the Question of Sexual Aesthetics', *Journal of Aesthetics and Art Criticism*, 65 (2007), pp. 55–68.

38 Jane Casey, 'The Goddess as Divine Lover: *Maithuna* Imagery in Himalayan Art', in *Goddess: Divine Energy*, ed. Jackie Menzies, exh. cat., Sydney: Art Gallery of New South Wales, 2007, pp. 257–68, at p. 257.

39 Imma Ramos, *Tantra: Enlightenment to Revolution*, exh. cat., London: British Museum Press and Thames & Hudson, 2020, p. 67.

40 Jayadeva, *Gitagovinda*, III.14–15, in *Love Song of the Dark Lord: Jayadeva's Gitagovinda*, ed. and trans. Barbara Stoler Miller, New York: Columbia University Press, 1977, p. 85.

41 Ibid., XII.10, p. 123.

42 B.N. Goswamy, 'Radha: From Beloved to Goddess', in *Goddess: Divine Energy*, ed. Menzies, pp. 43–63, at p. 56.

43 Quoted in ibid., p. 56.

44 Translated by B.V.L. Narayanarow, in *Women Writing in India*, vol. I: *600 B.C. to the Early 20th Century*, ed. Susie Tharu and Ke Lalita, New York: Feminist Press at the City University of New York, 1991, p. 120.

45 Ibid., vol. I, pp. 1–7, 116–20.

46 Manu S. Pillai, 'Muddupalani, the Woman who had no Reason for Shame', *The Hindu*,

2 June 2018, available at www.thehindu.com/society/history-and-culture/the-woman-who-had-no-reason-for-shame/article24057695.ece (accessed 6 September 2021).

47 W. Doniger and S. Kakar (eds), *Kamasutra*, Oxford: Oxford University Press, 2009, 7.2.57.

48 W. Doniger, *Redeeming the Kamasutra*, Oxford: Oxford University Press, 2016, pp. 37–9.

49 For example, the *Koka Shastra* (twelfth century CE) and the *Anangaranga* (sixteenth century CE).

50 Doniger and Kakar (eds), *Kamasutra*, pp. xxviii–xxxix.

51 Shusterman, 'Asian Ars Erotica'.

52 For a detailed discussion of Tantra and the importance of the divine female within Tantric belief, see Ramos, *Tantra*.

53 Jackie Menzies, 'Kali and the Wisdom Goddess', in *Goddess: Divine Energy*, ed. Menzies, pp. 131–45, at p. 131.

54 Ramos, *Tantra*, pp. 15–18, 141.

55 Hugh B. Urban, *The Power of Tantra: Religion, Sexuality, and the Politics of South Asian Studies*, London, New York: I.B. Tauris, 2010, pp. 34–5.

56 Imma Ramos, 'The Visual Politics of Menstruation, Birth, and Devotion at Kamakhya Temple in Assam', in *Visual Histories of South Asia*, ed. Annamaria Motrescu-Mayes and Marcus Banks, Delhi: Primus Books, 2018, pp. 52–68, at p. 55.

57 Ramos, *Tantra*, pp. 8–9.

58 Ramos, 'The Visual Politics of Menstruation', pp. 61–2.

59 Ramos, *Tantra*, pp. 15–17; Ramos, 'The Visual Politics of Menstruation', p. 57.

60 Ramos, *Tantra*, pp. 63–5.

61 Dharmacharkra Translation Committee and Chökyi Nyima Rinpoche, *The Tantra of Caṇḍamahāroṣaṇa*, 2016, available at https://read.84000.co/translation/toh431.html (accessed 17 December 2021), vv. 8.20–1.

62 Quoted in Ramos, *Tantra*, pp. 101–2.

63 Plotinus, *The Six Enneads*, trans. Stephen MacKenna and B.S. Page, London: P.L. Warner, Medici Society, 1917, §5, available at www.sacred-texts.com/cla/plotenn/enn065.htm (accessed 5 December 2021).

64 'Medieval Semiotics', *The Stanford Encyclopedia of Philosophy*, ed. Edward N. Zalta, Winter 2012 edn, available at https://plato.stanford.edu/entries/semiotics-medieval (accessed 6 September 2021).

65 Mark the Deacon, *The Life of Porphyry, Bishop of Gaza*, ed. George Francis Hill (Oxford: Clarendon Press, 1913), pp. 70–1; Jane Collins Long, 'The Survival and Reception of the Classical Nude: Venus in the Middle Ages', in *The Meanings of Nudity in Medieval Art*, ed. Sherry C.M. Lindquist, London: Routledge, 2016, pp. 47–64, at p. 47.

66 Genesis 3:6 (New Revised Standard Version).

67 Tertullian, *De cultu feminarum* (On female fashion), book 1, ch. 1, trans. Rev. S. Thelwall, available at www.tertullian.org/anf/anf04/anf04-06.htm#P265_52058 (accessed 6 September 2021).

68 Quoted in Jean M. Higgins, 'The Myth of Eve: The Temptress', *Journal of the American Academy of Religion*, 44 (1976), pp. 639–47, at p. 640.

69 Ibid., p. 643. John Milton, *Paradise Lost*, 1667/74, book IX, ll. 998–9, available at https://milton.host.dartmouth.edu/reading_room/pl/book_9/text.shtml (accessed 17 December 2021).

70 John K. Bonnell, 'The Serpent with a Human Head in Art and in Mystery Play', *American Journal of Archaeology*, 21 (1917), pp. 255–91, at p. 255.

71 Petrus Comestor, *Historia libri Genesis*, quoted in Bonnell, 'The Serpent with a Human Head', p. 256.

72 Marina Warner, *Alone of all her Sex: The Myth and the Cult of the Virgin Mary*, 2nd edn, Oxford: Oxford University Press, 2016, p. 59.

73 Such authors included Bernard of Clairvaux, Hadewijch, Marguerite Porete and Margery Kempe. See Bernard of Clairvaux, *On the Song of Songs*, trans. Kilian Walsh, Shannon: Irish University Press, 1971; Hadewijch, *Hadewijch: The Complete Works*, trans. Columba Hart, New York: Paulist Press, 1989; Marguerite Porete, *Marguerite Porete: The Mirror of Simple Souls*, ed. and trans. Ellen L. Babinsky, New York: Paulist Press, 1993; Margery Kempe, *The Book of Margery Kempe: A New Translation, Contexts, Criticism*, ed. and trans. Lynn Staley, New York: Norton, 2001.

74 For further reading, see Caroline Walker Bynum, *Fragmentation and Redemption: Essays on Gender and the Human Body in Medieval Religion*, New York: Zone Books, 1991; Louise Nelstrop et al., *Christian Mysticism: An Introduction to Contemporary Theoretical Approaches*, London: Taylor & Francis Group, 2009, esp. ch. 4, pp. 85–106; Amy Hollywood, *Sensible Ecstasy: Mysticism, Sexual Difference, and the Demands of History*, Chicago: University of Chicago Press, 2002.

75 Eloise Quiñones Keber (ed.), *Codex Telleriano-Remensis: Ritual, Divination, and History in a Pictorial Aztec Manuscript*, Austin, TX: University of Texas Press, 1995, pp. 107–12.

76 Cecelia F. Klein, 'Teocuitlatl, "Divine Excrement": The Significance of "Holy Shit" in Ancient Mexico', *Art Journal*, 52, no. 3 (1993), pp. 20–7.

77 Pete Sigal, *The Flower and the Scorpion: Sexuality and Ritual in Early Nahua Culture*, Durham, NC: Duke University Press, 2011, pp. 37–8.

78 Ibid., pp. 43–52; Klein, 'Teocuitlatl, "Divine Excrement"'; Thelma Sullivan, 'Tlazolteotl-Ixcuina: The Great Spinner and Weaver', in *The Art and Iconography of Late Post-Classic Mexico*, ed. Elizabeth Hill Boone, Washington, DC: Dumbarton Oaks, 1982, pp. 7–37.

79 Bernardino de Sahagún, *Florentine Codex: General History of the Things of New Spain* [*c.* 1540–75], vol. I: *The Gods*, ed. and trans. Arthur J.O. Anderson and Charles E. Dibble, Santa Fe, NM: 1970, pp. 23, 67.

80 Ibid., pp. 23–4.

81 Keber (ed.), *Codex Telleriano-Remensis*, p. 9.

82 Ibid., pp. 143–4.

83 Ibid., p. 254.

84 Many thanks to María Mercedes Martínez Milantchí and Jago Cooper for their advice on the interpretations of China Supay and Tlazolteotl.

85 For a historical summary of the Beggar's Benison club, see Julie Peakman, *Lascivious Bodies: A Sexual History of the Eighteenth Century*, London: Atlantic, 2005, pp. 129–47.

86 Catherine McCormack, *Women in the Picture: Women, Art and the Power of Looking*, London: Icon Books, 2021, pp. 26–32; Kristen Renzi, 'Safety in Objects: Discourses of Violence and Value. The *Rokeby Venus* and *Rhythm 0*', *SubStance*, 42 (2013), pp. 120–45, at pp. 125–30.

87 Carolee Schneemann, 'The Obscene Body / Politic', *Art Journal*, 50, no. 4 (1991), pp. 28–35.

88 Wangechi Mutu, quoted on the website of the Museum of Modern Art, New York, available at www.moma.org/collection/works/96792 (accessed 6 September 2021).

89 Joyce Bidouzo-Coudray, 'Wangechi Mutu Takes on Transmutation as a New Form of Existentialism', *Another Africa*, 13 October 2015, available at www.anotherafrica.net/art-culture/wangechi-mutu-takes-on-transmutation-as-a-new-form-of-existentialism (accessed 6 September 2021).

3 MAGIC & MALICE

1 Geoffrey Chaucer, 'The Wife of Bath's Prologue', *The Canterbury Tales*, ll. 693–6, in *The Riverside Chaucer*, ed. F. N. Robinson and Larry D. Benson, Oxford: Oxford University Press, 2008.

2 Margaret Lawrie (comp. and trans.), *Myths and Legends of Torres Strait*, St Lucia: University of Queensland Press, 1970, pp. 100–4.

3 Walter Farber, *Lamashtu: An Edition of the Canonical Series of Lamashtu Incantations and Rituals and Related Texts from the Second and First Millennia B.C.*, Winona Lake, IN: Eisenbrauns, 2014, p. 179.

4 Ibid., pp. 1–4, 281.

5 Jeremy Black and Anthony Green, *Gods, Demons and Symbols of Ancient Mesopotamia: An Illustrated Dictionary*, London: British Museum Press, 1992, pp. 115–16.

6 Farber, *Lamaštu*, p. 3.

7 BM 1929,1012.34; Lam II, trans. in Farber, *Lamaštu*, pp. 169–71.

8 Black and Green, *Gods, Demons and Symbols of Ancient Mesopotamia*, p. 30.

9 Siegmund Hurwitz, *Lilith, the First Eve: Historical and Psychological Aspects of the Dark Feminine*, trans. Gela Jacobson, Einsiedeln: Daimon Verlag, 2009, pp. 32–3.

10 Black and Green, *Gods, Demons and Symbols of Ancient Mesopotamia*, p. 118.

11 Thanks to James Nathan Ford for translating this text for the British Museum in 2021.

12 Babylonian Talmud, *Shabbat* 151b; Hurwitz, *Lilith, the First Eve*, p. 101.

13 Ibid., pp. 119–21.

14 This interpretation is mentioned in both the Zohar, the foundational text of Kabbalah, written by the Spanish rabbi Moses de León in the early fourteenth century, and in the thirteenth-century *Treatise on the Left Emanation* by Isaac ben Jacob ha-Kohen.

15 Joseph Dan, 'Samael, Lilith, and the Concept of Evil in Early Kabbalah', *AJS Review*, 5 (1980), pp. 17–40.

16 Griselda Pollock, *Vision and Difference: Femininity, Feminism and Histories of Art*, London: Routledge, 2003, p. 197.

17 Online entry for *Lady Lilith*, Metropolitan Museum of Art, New York, acc. no. 08.162.1, available at www.metmuseum.org/art/collection/search/337500 (accessed 31 January 2022).

18 Virginia Allen, '"One strangling golden hair": Dante Gabriel Rossetti's *Lady Lilith*', *Art Bulletin*, 66 (1984), pp. 285–94.

19 Kiki Smith, private communication to Lucy Dahlsen, 28 October 2021.

20 Ibid.

21 Bernardino de Sahagún, *Florentine Codex: General History of the Things of New Spain* [*c.* 1540–75], ed. and trans. Arthur J.O. Anderson and Charles E. Dibble, 13 vols, Santa Fe, NM: 1969, vol. VI: *Rhetoric and Moral Philosophy*, p. 167.

22 Manuel Aguilar-Moreno, *Handbook to Life in the Aztec World*, Oxford: Oxford University Press, 2007, p. 169.

23 Sahagún, *Florentine Codex*, ed. and trans. Anderson and Dibble, vol. VI, pp. 161–5.

24 H.B. Nicholson with Eloise Quiñones Keber, *Art of Aztec Mexico: Treasures of Tenochtitlan*, exh. cat., Washington, DC: National Gallery of Art, 1983, pp. 67–8; Bernardino de Sahagún, *Florentine Codex: General History of the Things of New Spain* [*c.* 1540–75], ed. and trans. Arthur J.O. Anderson and Charles E. Dibble, 13 vols, Santa Fe, NM: 1979, vol. V: *The Omens*, p. 41.

25 Apollodorus, *Biblioteca*, book II, ch. 4, §§2–3, trans. James George Frazer, Cambridge, MA: Harvard University Press, 1921, available at http://data.perseus.org/citations/urn:cts:greekLit:tlg0548.tlg001.perseus-eng1:2.4.2 (accessed 20 December 2021).

26 Ovid, *Metamorphoses*, book IV, ll. 791–803, trans. Frank Justus Miller, rev. G.P. Goold, Cambridge, MA: Harvard University Press, 1916.

27 For an extensive overview of how the Medusa myth has been interpreted over the centuries, see Marjorie B. Garber and Nancy J. Vickers (eds), *The Medusa Reader*, New York: Routledge, 2003.

28 Palaephatus, *On Unbelievable Tales*, in Garber and Vickers (eds), *The Medusa Reader*, pp. 20–2.

29 Garber and Vickers (eds), *The Medusa Reader*, pp. 26–9, 47–8.

30 Interview with Mark Seal, 'The Versace Moment', 1996, quoted in Garber and Vickers (eds), *The Medusa Reader*, p. 276.

31 Francis Bacon, 'Perseus, or War', *The Wisdom of the Ancients* (1609), quoted in Garber and Vickers (eds), *The Medusa Reader*, pp. 69–71; Karl Marx, *Capital* (1867), quoted in ibid., pp. 77–8; Sigmund Freud 'Medusa's Head',

from 'The Infantile Genital Organisation' (1922–3), quoted in ibid., pp. 84–6.

32 Michel Hennin, *Histoire numismatique de la Révolution Française*, Paris: Merlin, 1826, no. 536, p. 362.

33 Hélène Cixous, 'The Laugh of the Medusa', trans. Keith Cohen and Paula Cohen, *Signs*, 1 (1976), pp. 875–93, at p. 885.

34 Emily Erwin Culpepper, 'Ancient Gorgons: A Face for Contemporary Women's Rage' (1986), quoted in Garber and Vickers (eds), *The Medusa Reader*, pp. 238–46, at p. 244.

35 Ibid., pp. 244–5.

36 Julia Jacobs, 'How a Medusa Sculpture from a Decade Ago became #MeToo Art', *New York Times*, 13 October 2020, available at www.nytimes.com/2020/10/13/arts/design/medusa-statue-manhattan.html (accessed 16 September 2021).

37 Sarah Weiss, 'Rangda and the Goddess Durga in Bali', *Fieldwork in Religion*, 12 (2017), pp. 50–77, at p. 56.

38 Ibid., pp. 74–5.

39 Ibid., pp. 67–8; N.W.P. Ariati, 'The Journey of a Goddess: Durga in India, Java and Bali', PhD dissertation, Charles Darwin University, Darwin, 2009, p. 22.

40 English translations of the *Calon Arang* are not readily available, but the story is summarised in Ariati, 'The Journey of a Goddess', pp. 56–61.

41 Kaibara Ekiken, 'Greater Learning for Women', in *Women and the Wisdom of Japan*, London: John Murray, 1914, pp. 38–9.

42 Richard M. Dorson, *Folk Legends of Japan*, Tokyo and Rutland, VT: C.E. Tuttle Co., 1961.

43 Gregory Irvine, 'Japanese Masks: Ritual and Drama', in *Masks: The Art of Expression*, ed. John Mack, London: British Museum Press, 2013, pp. 130–49, at p. 145.

44 Samuel L. Leiter, *Historical Dictionary of Japanese Traditional Theatre*, Lanham, MD: Scarecrow Press, 2014, p. 85.

45 Susan Blakeley Klein, 'When the Moon Strikes the Bell: Desire and Enlightenment in the Noh Play Dōjōji', *Journal of Japanese Studies*, 17 (1991), pp. 291–322.

46 Melinda Takeuchi, 'Kuniyoshi's "Minamoto Raikō" and "the Earth Spider": Demons and Protest in Late Tokugawa Japan', *Ars Orientalis*, 17 (1987), pp. 5–38.

47 Many thanks to Alfred Haft and Rosina Buckland for their advice on this section of the text.

48 These shrines (Hekateia) are mentioned by several Greek and Roman authors, such as Aristophanes (*Wasps*, ll. 799ff, 804ff; *Frogs*, ll. 440ff) and Ovid (*Fasti*, book I, ll. 141ff). Hekateia positioned in doorways can be seen on the Roman frescos in Room M of the Villa of Publius Fannius Synistor, *c.* 50–40 BCE, originally from Boscoreale, now in the Metropolitan Museum of Art, New York.

49 Hesiod, *Theogony*, ll. 411–52, in *Theogony. Works and Days. Testimonia*, ed. and trans. Glenn W. Most, Cambridge, MA: Harvard University Press, 2018.

50 Ibid, l. 451; Anonymous, 'To Demeter', *Homeric Hymn 2*, l. 25, in *Homeric Hymns*,

ed. and trans. Hugh G. Evelyn-White, Cambridge, MA: Harvard University Press, 1914.

51 Lucan, *Pharsalia*, book VI, l. 513, ed. and trans. Edward Ridley, London: Longmans, Green and Co., 1905.

52 Ibid., book VI, ll. 731–5.

53 Homer, *Odyssey*, book X, l. 276.

54 Deanna Petherbridge, *Witches & Wicked Bodies*, exh. cat., Edinburgh: National Galleries of Scotland in association with the British Museum, 2013, p. 37.

55 Thank you to the Children of Artemis for their helpful and insightful interpretations of this subject, and to Olivia Ciaccia, PhD candidate at the University of Bristol, for providing this response to Waterhouse's painting (private communications).

56 Ovid, *Metamorphoses*, book XIV, l. 275; Horace, *Epistles*, book I, 2.23–25, in *Satires. Epistles. Art of Poetry*, trans. H. Rushton Fairclough, Cambridge, MA: Harvard University Press, 2005.

57 Apollonius of Rhodes, *Argonautica*, book IV, ll. 828–9, ed. and trans. William H. Race, Cambridge, MA: Harvard University Press, 2009.

58 Homer, *Odyssey*, book XII, ll. 85–100.

59 Lindsay C. Watson, *Magic in Ancient Greece and Rome*, London: Bloomsbury Academic, 2019, pp. 34–43; Daniel Ogden, *Magic, Witchcraft and Ghosts in the Greek and Roman Worlds: A Sourcebook*, Oxford: Oxford University Press, 2009, pp. 227–44.

60 Ogden, *Magic, Witchcraft and Ghosts*, pp. 102–14, 275–99; Watson, *Magic in Ancient Greece and Rome*, pp. 190–5.

61 For summaries, see Ogden, *Magic, Witchcraft and Ghosts*, pp. 4–7; Watson, *Magic in Ancient Greece and Rome*, pp. 1–3.

62 For example, in *Errores Gazariorum* ('Errors of the Cathars') (1437), an anti-witchcraft treatise by an unknown author.

63 Kimberly B. Stratton, 'Interrogating the Magic-Gender Connection', in *Daughters of Hecate: Woman and Magic in the Ancient World*, ed. Kimberly B. Stratton and Dayna S. Kalleres, Oxford: Oxford University Press, 2014, pp. 16–17.

64 Tamar Herzing, 'The Bestselling Demonologist: Heinrich Institoris's *Malleus maleficarum*', in *The Science of Demons: Early Modern Authors Facing Witchcraft and the Devil*, ed. Jan Machielsen, London: Routledge, 2020, pp. 53–67, at p. 61.

65 Jakob Sprenger is also cited as one of the original authors of the *Malleus maleficarum* but it is widely believed that he was not involved in its compilation and that Kramer was the main, if not the sole, author; see Henricus Institoris and Jakob Sprenger, *The Malleus maleficarum* [1486–7], ed. and trans. P.G. Maxwell-Stuart, Manchester: Manchester University Press, 2007, p. 30.

66 Trans in ibid., pp. 74–5.

67 Ibid., p. 26.

68 Hans Peter Broedel, *The Malleus maleficarum and the Construction of Witchcraft: Theology and

Popular Belief*, Manchester: Manchester University Press, 2003, pp. 1–3.

69 Ibid.

70 Herzing, 'The Bestselling Demonologist', p. 54.

71 Margaret A. Sullivan, 'The Witches of Dürer and Hans Baldung Grien', *Renaissance Quarterly*, 53 (2000), pp. 333–401.

72 Petherbridge, *Witches & Wicked Bodies*, p. 44; Institoris and Sprenger, *The Malleus maleficarum*, ed. and trans. Maxwell-Stuart, pp. 152–3.

73 Petherbridge, *Witches & Wicked Bodies*, p. 15.

74 For an overview of artistic depictions of witches from the Renaissance to contemporary art, see ibid.

75 Walter Rummel, '"I confess that I have been ignorant": How the *Malleus maleficarum* Changed the Universe of a Cleric at the End of the Fifteenth Century', in *Demonology and Witch-Hunting in Early Modern Europe*, ed. Julian Goodare, Rita Voltmer and Liv Helene Willumsen, London: Routledge, 2020, pp. 65–85.

76 Joseph Klaits, *Servants of Satan: The Age of the Witch Hunts*, Bloomington, IN: Indiana University Press, 1985, p. 27.

77 Leo Ruickbie, *Witchcraft Out of the Shadows: A Complete History*, London: Robert Hale, 2004, p. 74.

78 Lara Apps and Andrew Gow, *Male Witches in Early Modern Europe*, Manchester: Manchester University Press, 2003, p. 25. The Danish figures are from a lecture by Dr Louise Nyholm Kallestrup, 'Fire and Fear: Witches in History and the Identities of Today', available at www.youtube.com/watch?v=CdEIAWaW2xs, at 22:30 mins (accessed 18 December 2021).

79 Ruickbie, *Witchcraft Out of the Shadows*, pp. 80–1.

80 Richard Kaczynski, *Perdurabo: The Life of Aleister Crowley*, Berkeley, CA: North Atlantic Books, 2010, pp. 56–80.

81 Margaret Alice Murray, *The Witch-Cult in Western Europe: A Study in Anthropology*, Oxford: Clarendon Press, 1921.

82 Amy Hale, 'Ithell Colquhoun's Occulted Feminine', forthcoming.

83 Amy Hale, *Ithell Colquhoun: Genius of the Fern Loved Gully*, London: Strange Attractor Press, 2020, pp. 122–30.

84 My thanks to Amy Hale for this interpretation and for her advice on this section of the text.

85 The *Book of Shadows* is a guide to rituals for Wicca, but is an evolving rather than a fixed text with no definitive version. Some Wiccans are known to keep their own versions of the book in which they record spells and rituals. Since its original compilation, the *Book of Shadows* has been shared by members of the Wicca community and has taken many forms, evolving and being adapted to record the beliefs and ritual practices of different groups and individuals.

86 Tanice G. Foltz, 'Women's Spirituality Research: Doing Feminism', *Sociology of Religion*, 61 (2000), pp. 409–18, at p. 410.

87 Ruickbie, *Witchcraft Out of the Shadows*, pp. 163–4.

88 Merlyn Hern, one of the founders of the Children of Artemis, private communication, 2021.

89 Ruickbie, *Witchcraft Out of the Shadows*, pp. 178–87.

90 Jenny Cartledge, a member of the Children of Artemis, private communication, 2021.

91 Lizzie Dearden, 'Thousands of Children Abused over Witchcraft Beliefs as Number of Known Victims Rockets by a Third', *The Independent*, 14 November 2019, available at www.independent.co.uk/news/uk/home-news/witchcraft-exorcism-uk-deaths-child-abuse-beating-burning-police-a9201981.html (accessed 16 September 2021).

92 Witchcraft and Human Rights Information Network, *21st Century Witchcraft Accusations and Persecutions* (2013) [report presented at the United Nations Human Rights Council, Session 25, 10 March 2014], available at www.oursplatform.org/wp-content/uploads/WHRIN-21st-Century-Witchcraft-Accusations-and-Persecution-UN-report.pdf, p. 3 (accessed 16 September 2021).

93 United Nations Human Rights Council, *Report of the Special Rapporteur on Violence Against Women, its Causes and Consequences, Rashida Manjoo* (23 May 2012), UN Doc. A/HRC/20/16, pp. 10–11, available at https://undocs.org/a/hrc/20/16 (accessed 17 September 2021).

94 Sara Dehm and Jenni Millbank, 'Witchcraft Accusations as Gendered Persecution in Refugee Law', *Social and Legal Studies*, 28 (2018), pp. 202–26, at pp. 202, 204; United Nations Office on Drugs and Crime, *Global Study on Homicide: Gender-Related Killing of Women and Girls* (2019), p. 34, available at www.unodc.org/documents/data-and-analysis/gsh/Booklet_5.pdf (accessed 17 September 2021); Seema Yasmin, 'Witch Hunts Today: Abuse of Women, Superstition and Murder Collide in India', *Scientific American*, 11 January 2018, available at www.scientificamerican.com/article/witch-hunts-today-abuse-of-women-superstition-and-murder-collide-in-india (accessed 17 September 2021). See also Ruth Mace, 'Why are Women Accused of Witchcraft? Study in Rural China Gives Clue', *The Conversation*, 8 January 2018, available at https://theconversation.com/why-are-women-accused-of-witchcraft-study-in-rural-china-gives-clue-89730 (accessed 18 September 2021).

95 'Papua New Guinea Students Share Video appearing to Show Women Tortured for "Witchcraft"', *The Guardian*, 23 October 2015, available at www.theguardian.com/world/2015/oct/23/witchcraft-papua-new-guinea-students-share-video-appearing-show-torture (accessed 18 September 2021); 'PNG Repeals Sorcery Law and Expands Death Penalty', *BBC News*, 29 May 2013, available at www.bbc.co.uk/news/world-asia-22698668 (accessed 18 September 2021); United Nations Human Rights Council, *Report of the Special Rapporteur on Violence Against Women*, p. 11.

96 ActionAid, *Condemned without Trial: Women and Witchcraft in Ghana*, September 2012, available at www.actionaid.org.uk/sites/default/files/publications/condemned_without_trial_women_and_witchcraft_in_ghana_report_september_2012.pdf (accessed 18 September 2021).

97 United Nations Human Rights Council, *Report of the Independent Expert on the Enjoyment of Human Rights by Persons with Albinism on the Expert Workshop on Witchcraft and Human Rights*, 23 January 2018, UN Doc. A/HRC/37/57/Add.2, available at https://undocs.org/A/HRC/37/57/Add.2 (accessed 18 September 2021).

98 Broedel, *The Malleus maleficarum*, p. 6.

99 Institoris and Sprenger, *The Malleus maleficarum*, ed. and trans. Maxwell-Stuart, p. 74.

4 JUSTICE & DEFENCE

1 *Devi Mahatmya*, 4.12, trans. Thomas B. Coburn, *Encountering the Goddess: A Translation of the Devī-Māhātmya and a Study of its Interpretation*, Albany, NY: State University of New York Press, 1991, p. 49.

2 Robin Law, 'The "Amazons" of Dahomey', *Paideuma: Mitteilungen zur Kulturkunde*, 39 (1993), pp. 245–60, at p. 251.

3 Ibid., pp. 257–8.

4 Mary Nooter Roberts, 'The King is a Woman: Shaping Power in Luba Royal Arts', *African Arts*, 46 (2013), pp. 68–81, at p. 71.

5 Ibid.

6 Mary Nooter Roberts and Allen F. Roberts, *Luba*, New York: Rosen Publishing Group, 1997, pp. 9–11.

7 Molefi Kete Asante and Ama Mazama (eds), *Encyclopedia of African Religion*, 2 vols, Los Angeles and London: Sage, 2009, vol. I, p. 97.

8 Roberts, 'The King is a Woman', p. 68.

9 Quoted in ibid., p. 69.

10 Mary Nooter Roberts, catalogue entry in *Africa: The Art of a Continent*, ed. Tom Phillips, London: Royal Academy of Arts, 1995, p. 286; Roberts, 'The King is a Woman', p. 69.

11 Roberts, catalogue entry in *Africa: The Art of a Continent*, p. 287.

12 Asante and Mazama (eds), *Encyclopedia of African Religion*, vol. I, pp. 97–8.

13 Roberts, 'The King is a Woman', p. 80.

14 Quoted in ibid., p. 68.

15 Roberts, catalogue entry in *Africa: The Art of a Continent*, p. 286.

16 Ibid., p. 290.

17 Ibid., p. 289.

18 Roberts, 'The King is a Woman', p. 73.

19 Asante and Mazama (eds), *Encyclopedia of African Religion*, vol. I, pp. 514–16.

20 Herodotus, *The Histories*, book II, ch. 37, ed. and trans. Aubrey de Sélincourt, Harmondsworth: Penguin, 1996, p. 99.

21 Richard H. Wilkinson, *The Complete Gods and Goddesses of Ancient Egypt*, London: Thames & Hudson, 2017, p. 181.

22 Ibid., pp. 181–2.

23 For summaries of these deities, see ibid., pp. 153–6, 173–83, 226–8.

24 N. Guilhou, 'Myth of the Heavenly Cow', in *UCLA Encyclopedia of Egyptology*, ed. Jacco Dieleman and Willeke Wendrich, Los Angeles: UCLA, 2010, pp. 1–7, at pp 2–3.

25 Wilkinson, *The Complete Gods and Goddesses*, p. 144.

26 Jenifer Neils, *Women in the Ancient World*, London: British Museum Press, 2011, p. 166.

27 Guilhou, 'Myth of the Heavenly Cow', p. 4.

28 Ibid.

29 More than 280 new statues of Sekhmet have been uncovered through excavations since 1998. James Rogers, 'Archaeologists Unearth 27 Lioness Goddess Statues in Egypt', *New York Post*, 6 December 2017, available at www.nypost.com/2017/12/06/archaeologists-unearth-27-lioness-goddess-statues-in-egypt (accessed 29 September 2021).

30 Betsy M. Bryan, 'A Statue Program for the Mortuary Temple of Amenhotep III', in *The Temple in Ancient Egypt: New Discoveries and Recent Research*, ed. Stephen Quirke, London: British Museum Press, 1997, pp. 57–81.

31 Wilkinson, *The Complete Gods and Goddesses*, pp. 153–6.

32 Paul Harrison, *Profane Egyptologists: The Modern Revival of Ancient Egyptian Religion*, London: Routledge, 2018, p. 3.

33 For more information, see www.sekhmettemple.org/goddess-temple-herstory/84-2 (accessed 29 September 2021). My thanks to Olivia Ciaccia, PhD candidate at the University of Bristol, for the fascinating information about the revival of Sekhmet worship. For more on the subject, see her lecture 'Sekhmet: An Ancient Goddess for Modern Times', available at www.youtube.com/watch?v=J8QilW40Evg (accessed 29 September 2021).

34 The full inscription and a bibliography of sources on the relief is available at www.globalegyptianmuseum.org/detail.aspx?id=12565 (accessed 29 September 2021).

35 Wilkinson, *The Complete Gods and Goddesses*, pp. 150–2.

36 The literal meaning is 'Fighter in Front'; Susan Deacy, *Athena*, London: Routledge, 2008, p. 5.

37 The Varvakeion Athena, a third-century Roman statue in the National Archaeological Museum of Athens, is believed to be closely based on the original Athena Parthenos; those wishing to gain an impression of the splendour of the original may visit the full-scale reconstruction of the Parthenon and its cult statue in Centennial Park, Nashville, Tennessee (see fig. 1).

38 Susan Deacy and Alexandra Villing (eds), *Athena in the Classical World*, Leiden: Brill, 2001, pp. 12–15; Deacy, *Athena*, pp. 41–3.

39 For a translation of texts relating to Anat and Baal, see Nicolas Wyatt, *Religious Texts from Ugarit*, London: Sheffield Academic Press, 2002, pp. 148–69.

40 Wilkinson, *The Complete Gods and Goddesses*, p. 137.

41 Anonymous, 'To Aphrodite', Homeric
 Hymn 5, l. 9, in *Homeric Hymns*, ed. and
 trans. Hugh G. Evelyn-White, Cambridge,
 MA: Harvard University Press, 1914.

42 Aeschylus, *The Eumenides*, in *The Oresteia*,
 ed. and trans. Robert Fagles,
 Harmondsworth: Penguin, 1979, ll. 751–3.

43 Deacy, *Athena*, pp. 30–1, 154–6.

44 Jane Ellen Harrison, *Prolegomena to the Study
 of Greek Religion*, Cambridge: Cambridge
 University Press, 1903, pp. 303–4; Deacy and
 Villing (eds.), *Athena in the Classical World*,
 pp. 9–10.

45 Sarah B. Pomeroy, *Goddesses, Whores, Wives
 and Slaves: Women in Classical Antiquity*, new
 edn, London: Pimlico, 1994, pp. 4.

46 Anonymous, 'To Aphrodite', ll. 12–14, in
 Homeric Hymns, ed. and trans. Evelyn-White.

47 Neils, *Women in the Ancient World*, pp. 170–1.

48 Joan Breton Connelly, *Portrait of a Priestess:
 Women and Ritual in Ancient Greece*, Princeton, NJ:
 Princeton University Press, 2007, pp. 59–61.

49 Ibid., p. 59.

50 'New Medals from BAMS', *The Medal*, no. 10
 (1989), p. 91.

51 Fritz Graf, 'Athena and Minerva: Two Faces
 of One Goddess', in *Athena in the Classical
 World*, ed. Deacy and Villing, pp. 127–39,
 at pp. 133–4.

52 The name appears epigraphically from
 the 6th century BCE; Graf, 'Athena and
 Minerva', p. 130.

53 Barry Cunliffe (ed.), *The Temple of Sulis
 Minerva at Bath*, vol. II: *The Finds from the
 Sacred Spring*, Oxford: Oxford University
 Committee for Archaeology, 1988.

54 Roger Tomlin, 'The Curse Tablets', in ibid.,
 pp. 59–280.

55 Ibid., p. 59.

56 Deacy, *Athena*, p. 148.

57 Ibid., p. 155.

58 T. Richard Blurton, *Hindu Art*, London: British
 Museum Press, 1992, pp. 20–3, 157–60.

59 David R. Kinsley, *Hindu Goddesses: Visions
 of the Divine Feminine in the Hindu Religious
 Tradition*, Berkeley, CA: University of
 California Press, 1988, pp. 6–7.

60 Ibid., p. 18; Jackie Menzies, 'Concepts of the
 Goddess', in *Goddess: Divine Energy*, ed. Jackie
 Menzies, exh. cat., Sydney: Art Gallery
 of New South Wales, 2007, pp. 13–17, at
 pp. 13–15.

61 Kinsley, *Hindu Goddesses*, p. 18.

62 Swami Vijñanananda (trans.), *The Srīmad Devī
 Bhāgavatam*, Allahabad: Panini Office, 1921,
 7.33.21–56, available at https://www.wisdomlib.org/
 hinduism/book/devi-bhagavata-purana/d/
 doc57424.html (accessed 29 September 2021).

63 Sunbir Sanyal and Anjali Sanyal, general
 secretaries of the London Durgotsav
 Committee, private communication,
 September 2021.

64 *Devi Mahatmya*, 2.9–11, trans. Coburn, p. 40.

65 Ibid., 2.36–8, trans. Coburn, p. 42.

66 Ibid., 2.38–68, trans. Coburn, p. 42–4.

67 Blurton, *Hindu Art*, p. 169.

68 *Devi Mahatmya*, 5.37–41, trans. Coburn, p. 55.

69 John Guy, 'The Divine Androgyne: Shiva,
 Parvati and Sexual Syncretism in Indian

Art', in *Goddess: Divine Energy*, ed. Menzies,
 pp. 69–74.

70 Trans. in Alan Croker, 'The Presence of
 Shakti', in *Goddess: Divine Energy*, ed. Menzies,
 pp. 66–7, at p. 67.

71 Jackie Menzies, 'Kali and the Wisdom
 Goddesses', in *Goddess: Divine Energy*,
 ed. Menzies, pp. 131–45, at p. 131.

72 *Devi Mahatmya*, 7.5–8, trans. Coburn, p. 61.

73 Ibid., 5.42–7.25, trans Coburn, pp. 55–62.

74 Menzies, 'Kali and the Wisdom Goddesses',
 p. 131.

75 I am grateful to Dr Ananda Gupta, Anjali
 Sanyal and Sunbir Sanyal of the London
 Durgotsav Committee for providing this
 information.

76 Many thanks to Anjali Sanyal from the
 London Durgotsav Committee for providing
 this interpretation.

77 Imma Ramos, *Tantra: Enlightenment to
 Revolution*, London: British Museum Press
 and Thames & Hudson, 2020, p. 181.

78 *Devi Mahatmya*, 7.8–25, trans. Coburn,
 pp. 61–2.

79 Ramos, *Tantra*, pp. 10, 19.

80 For a detailed discussion of medieval
 representations of Chamunda and her
 relationship with Kali and Tantra, see ibid.,
 p. 50.

81 Ibid., pp. 47, 274.

82 Ibid., p. 193.

83 Ibid., pp. 188–9.

84 Many thanks to the members of the London
 Durgotsav Committee for providing this
 information.

85 Dianne Jenett, 'A Million "Shaktis" Rising:
 Pongala, a Women's Festival in Kerala',
 Journal of Feminist Studies in Religion, 21 (2005),
 pp. 35–55.

86 Ibid., p. 50.

87 *Devi Mahatmya*, 11.4–5, trans. Coburn, p. 74.

88 For a summary of these debates, see
 Rajeswari Sunder Rajan, 'Is the Hindu
 Goddess a Feminist?', *Economic and Political
 Weekly*, 33, no. 4 (1998), pp. WS34–WS38.

89 Many thanks to Gairika Mathur from the
 London Durgotsav Committee for providing
 this perspective.

90 For a detailed discussion of how
 contemporary artists and feminists have
 been inspired by historical images of Tantric
 goddesses such as Kali, including Sutapa
 Biswas and Bharti Kher, see Ramos, *Tantra*,
 pp. 266–71.

91 Joanna Cresswell, 'Sutapa Biswas: "Kali
 is the Goddess of War. But Also Peace.
 I Find her Liberating"', *Elephant*, 16 July
 2021, available at https://elephant.art/
 sutapa-biswas-kali-is-the-goddess-of-war-
 but-also-peace-i-find-her-liberating-16072021
 (accessed 29 September 2021).

92 Sunder Rajan, 'Is the Hindu Goddess a
 Feminist?', p. WS34.

5 COMPASSION & SALVATION

1 'The Universal Gateway of Guanyin
 Bodhisattva', *The Lotus Sutra*, trans. Chung

Tai Translation Committee, 2011, available
 at https://sunnyvale.ctzen.org/wp-content/
 uploads/2019/07/universal-gateway-of-
 guanyin-Bodhisattva-sutra-v2.7-20131216.pdf
 (accessed 23 December 2021).

2 Sabrina Higgins, 'Divine Mothers: The
 Influence of Isis on the Virgin Mary in
 Egyptian *Lactans*-Iconography', *Journal of the
 Canadian Society for Coptic Studies*, 3–4 (2012),
 pp. 71–90, at p. 72; C.H. Roehrig, 'Women's
 Work: Some Occupations of Non-Royal
 Women as Depicted in Ancient Egyptian
 Art', in *Mistress of the House, Mistress of
 Heaven: Women in Ancient Egypt*, ed. Anne K.
 Capel and Glenn Markoe, exh. cat., New
 York: Brooklyn Museum of Art, 1996,
 pp. 16–19.

3 Richard H. Wilkinson, *The Complete Gods
 and Goddesses of Ancient Egypt*, London:
 Thames & Hudson, 2017, pp. 146–7.

4 Ibid., p. 140.

5 Ibid., p. 62.

6 Ibid., pp. 50–1, 147.

7 Eugene Cruz-Uribe, *The Demotic Graffiti from
 the Temple of Isis at Philae Island*, Atlanta, GA:
 Lockwood Press, 2016: for characteristic
 examples, see GPH 32, pp. 63–4; GPH 218,
 pp. 213–14; GPH 872, p. 215; GPH 363,
 p. 255; GPH 368, p. 257.

8 Graffiti associating Isis with Hathor are most
 common in the Mammisi ('Birth House'), a
 room of the temple complex; ibid., pp. 21–8,
 pp. 117–230 for translations. See also
 Wilkinson, *The Complete Gods and Goddesses*,
 pp. 147–9.

9 Glenn Markoe, 'Amulets', in *Mistress of
 the House, Mistress of Heaven*, ed. Capel
 and Markoe, p. 70.

10 The connection between the frog and fertility
 is suggested by the hieroglyph for 100,000,
 which was a tadpole, while the goddess
 Heket, associated with birth, was depicted
 with the head of a frog; ibid., pp. 71–2.

11 Plutarch, *Moralia*, vol. V: *Isis and Osiris*,
 ed. and trans. Frank Cole Babbitt,
 Cambridge, MA: Harvard University Press,
 2014, passage 18, p. 47.

12 Ibid., passage 19, p. 49.

13 Anthony Leahy, 'The Adoption of
 Ankhnesneferibre at Karnak', *Journal
 of Egyptian Archaeology*, 82 (1996), pp. 145–65,
 at p. 148.

14 Object entry for 1895,0511.51 on the British
 Museum Collection Online website, available
 at www.britishmuseum.org/collection/
 object/Y_EA1162 (accessed 5 January 2022).

15 Hugh Bowden, *Mystery Cults in the Ancient
 World*, London: Thames & Hudson, 2010,
 pp. 160–1.

16 Ibid., pp. 156, 159.

17 Vincent Arieh Tobin, 'Isis and Demeter:
 Symbols of Divine Motherhood', *Journal
 of the American Research Centre in Egypt*, 28
 (1991), pp. 187–200; Birgitte Bøgh, 'The
 Graeco-Roman Cult of Isis', in *The Handbook
 of Religions in Ancient Europe*, ed. Lisbeth
 Bredholt Christensen, Olav Hammer and
 David Warburton, Durham: Acumen, 2013,
 pp. 228–41, at p. 229.

18 Object entry for 1772,0703.1 on the British Museum Collection Online website, available at www.britishmuseum.org/collection/object/G_1772-0703-1 (accessed 5 January 2022).

19 Bowden, *Mystery Cults in the Ancient World*, p. 161.

20 Bøgh, 'The Graeco-Roman Cult of Isis', pp. 228–41.

21 Apuleius, *Metamorphoses (The Golden Ass)*, ed. and trans. J. Arthur Hanson, Cambridge, MA: Harvard University Press, 1989, book XI, ch. 5.

22 Ibid.

23 Bowden, *Mystery Cults in the Ancient World*, pp. 165, 180.

24 Bøgh, 'The Graeco-Roman Cult of Isis', pp. 232–3.

25 Eric M. Orlin, 'Foreign Cults in Republican Rome: Rethinking the Pomerial Rule', *Memoirs of the American Academy in Rome*, 47 (2002), pp. 1–18; Horst R. Moehring, 'The Persecution of the Jews and the Adherents of the Isis Cult at Rome, A.D. 19', *Novum Testamentum*, 3, no. 4 (1959), pp. 293–304.

26 For a discussion of *Maria lactans* imagery, see Higgins, 'Divine Mothers', pp. 71–90.

27 Jarl Fossum, 'The Myth of the Eternal Rebirth: Critical Notes on G.W. Bowersock, *Hellenism in Late Antiquity*', *Vigiliae Christianae*, 53 (1999), pp. 306–15; Marina Warner, *Alone of all her Sex: The Myth and the Cult of the Virgin Mary*, 2nd edn, Oxford: Oxford University Press, 2016, pp. 36–7.

28 Warner, *Alone of all her Sex*, p. 90.

29 Higgins, 'Divine Mothers', pp. 73–6.

30 Miri Rubin, *Mother of God: A History of the Virgin Mary*, London: Allen Lane, 2009, p. 83.

31 Gabriel Said Reynolds, 'Mary', *Encyclopaedia of Islam*, vol. III, ed. Kate Fleet et al., available at https://referenceworks.brillonline.com/entries/encyclopaedia-of-islam-3/*-COM_36256 (accessed 23 December 2021).

32 Qur'an 19. My thanks to Patricia Anyasodor, Robina Afzal and Nusrat Ahmed for their comments on Maryam in the context of the exhibition, private communication, 18 November 2021.

33 Anyasodor, Afzal and Ahmed, private communication, 18 November 2021.

34 Qur'an 3:35–7.

35 Qur'an 3:42–4, 19: 27–33. Morteza Rezazadeh, 'Mary in Early Christianity and Islam', *Religious Inquiries*, 6, no. 11 (2017), pp. 37–49, pp. 49–50.

36 Nusrat Ahmed, private communication, 18 November 2021.

37 My thanks to Venetia Porter for her guidance on Maryam in Islamic belief.

38 Dries Raeymaekers and Sebastiaan Derks (eds), *The Key to Power? The Culture of Access in Princely Courts, 1400–1750*, Leiden: Brill, 2016, p. 83.

39 Rubin, *Mother of God*, p. 332.

40 Robin Cormack, *Icons*, London: British Museum Press, 2007, pp. 7–8.

41 Ibid, pp. 14–17.

42 Ibid., p. 17, fig. 10; p. 136, no. 94.

43 Warner, *Alone of all her Sex*, p. 67.

44 Eleanor Heartney, 'Thinking through the Body: Women Artists and the Catholic Imagination', *Hypatia*, 18, no. 4 (2003), pp. 2–33.

45 For a summary of the developing asceticism of early Christianity and the attitudes of Jerome, Tertullian and Origen, see Rosemary R. Ruether, *Goddesses and the Divine Feminine: A Western Religious History*, Berkeley, CA, and London: University of California Press, 2005, pp. 150–2. While Mary's maidenhood when conceiving Jesus is explicitly mentioned in the gospels of Luke and Matthew, and is generally accepted as part of the miracle of Jesus' birth by Christians, the Early Christian affirmation of the perpetual virginity of Mary is not founded on scripture. The gospel of Matthew implies that Mary and her mortal husband Joseph had sexual relations after Jesus' birth (Matthew 1:24–5) and the gospel of Mark mentions brothers and sisters of Jesus (Mark 6:3) through the Greek word *adelphoi*, meaning literally 'of the same womb'. Mary's perpetual virginity was not universally held: both Tertullian and Origen argued that, over the course of her life, Mary represented female states of virgin and faithful wife.

46 Ibid., p. 166. For example, the term was used in 1894 by Pope Leo XIII, available at www.vatican.va/content/leo-xiii/en/encyclicals/documents/hf_l-xiii_enc_08091894_iucunda-semper-expectatione.html (accessed 8 October 2021). More recently, it was used by Pope John Paul II: 'Allocution at the Sanctuary of Our Lady of Guayaquil', 31 January 1985, available at www.vatican.va/content/john-paul-ii/it/homilies/1985/documents/hf_jp-ii_hom_19850131_santuario-alborada.html, p. 6 (accessed 8 October 2021).

47 My thanks to Naomi Speakman for providing this information.

48 Ruether, *Goddesses and the Divine Feminine*, pp. 160–3; Rubin, *Mother of God*, pp. 121–43.

49 Warner, *Alone of all her Sex*, p. 83.

50 Rubin, *Mother of God*, pp. 256–68, 413–34.

51 Warner, *Alone of all her Sex*, p. 116.

52 Barbara Newman, *Sister of Wisdom: St. Hildegard's Theology of the Feminine*, rev. 2nd edn, Berkeley, CA: University of California Press, 1997, pp. 160–1.

53 Ibid., p. 162.

54 Hildegard of Bingen, quoted in Newman, *Sister of Wisdom*, p. 162.

55 María de Jesús de Ágreda, *The Mystical City of God: The Divine History and Life of the Virgin Mother of God* (1670), book III, ch. XXII, passage 692, trans. Fiscar Marison, Mount Vernon, OH: Louis W. Bernicken, 1902, p. 569; Warner, *Alone of all her Sex*, p. 337.

56 Ágreda, *The Mystical City of God*, book III, ch. XXII, passage 630, trans. Marison.

57 Richard Zimler, 'Interview with Paula Rego', available at www.mmll.cam.ac.uk/sites/www.mmll.cam.ac.uk/files/rego_interview_with_zimler.pdf (accessed 8 October 2021).

58 Phoebe Natanson, 'Pope Benedict XVI and the "Third Secret" of Fatima', *ABC News*, 14 May 2010, available at https://abcnews.go.com/Travel/pope-benedict-xvi-visits-lady-fatima-famed-shrine/story?id=10642089 (accessed 8 October 2021).

59 '500 years of Virgin Mary Sightings in One Map', *National Geographic*, 13 November 2015, available at www.nationalgeographic.com/science/article/151113-virgin-mary-sightings-map (accessed 8 October 2021).

60 Among these are her reported appearances in 1858 at Lourdes in France, and in 1917 at Fatima, Portugal. Other manifestations include one in 1973 at Akita, Japan, when a wooden statue of Mary was said to have begun to weep, and multiple occasions between 1968 and 1971 at Zeitoun, an area of Cairo, Egypt, when crowds of onlookers reported seeing Mary appear on the roof of a church.

61 Rubin, *Mother of God*, pp. 385–99.

62 The story of Juan Diego's visitation was not recorded in writing until the mid-seventeenth century, and its veracity, along with the miraculous origins of the painting have naturally been contested; D.A. Brading, *Mexican Phoenix. Our Lady of Guadalupe: Image and Tradition across Five Centuries*, Cambridge: Cambridge University Press, 2001, pp. 54–8. For the historical transition of Marian worship from Spain to Mexico, see ibid., pp. 33–53; Ruether, *Goddesses and the Divine Feminine*, pp. 206–18.

63 Ibid., pp. 207–9; Bernardino de Sahagún, *Florentine Codex: General History of the Things of New Spain* [c. 1540–75], vol. I: *Intro*, ed. and trans. Arthur J.O. Anderson and Charles E. Dibble, Santa Fe, NM: 1969, p. 90.

64 Brading, *Mexican Phoenix*, p. 119.

65 Chloe Sayer, *Crafts of Mexico*, London: Martensson Books, 1977, pp. 126–7.

66 Brading, *Mexican Phoenix*, p. 228.

67 Krista White, 'Espousing Ezili: Images of a Lwa, Reflections of the Haitian Woman', *Journal of Haitian Studies*, 5–6 (1999–2000), pp. 62–79.

68 Ibid., pp. 66–7.

69 Warner, *Alone of all her Sex*, p. 311.

70 Revelation 12:1 (New International Version).

71 Simone de Beauvoir, *The Second Sex*, trans. and ed. H.M. Parshley, new edn, London: Vintage, 1997, p. 203.

72 Warner, *Alone of all her Sex*, p. 345.

73 Luce Irigaray, 'The Redemption of Women', in *Key Writings*, London: Continuum, 2004, pp. 150–64, at p. 152.

74 Translation by Carol Rumens: 'Pussy Riot's Punk Prayer is Pure Protest Poetry', *The Guardian*, 20 August 2012, available at www.theguardian.com/books/2012/aug/20/pussy-riot-punk-prayer-lyrics (accessed 8 October 2021).

75 Johanna Marie Buisson, 'Subversive Maryam, or A Qur'anic View on Women's Empowerment', *CrossCurrents*, 66, no. 4 (2016), pp. 450–9.

76 See Aaron Rosen, *Art & Religion in the 21st Century*, London: Thames and Hudson, 2017.

77 Michael Ellison, 'New York Seeks to Ban Britart Sensation', *The Guardian*,

24 September 1999, available at www.theguardian.com/uk/1999/sep/24/michaelellison (accessed 8 October 2021).

78 Chris Ofili interviewed by Marcelo Spinelli, 23 March 1995, London, quoted in *Brilliant! New art from London*, exhibition brochure, Walker Art Center and Contemporary Arts Museum, Houston, 1995–6, p. 67.

79 Linda B. Hall, *Mary, Mother and Warrior: The Virgin in Spain and the Americas*, Austin, TX: University of Texas Press, 2004, pp. 2–13.

80 Imma Ramos, *Tantra: Enlightenment to Revolution*, London: British Museum Press and Thames & Hudson, 2020, p. 20; Naomi Appleton, 'In the Footsteps of the Buddha? Women and the Bodhisattva Path in Theravāda Buddhism', *Journal of Feminist Studies in Religion*, 27, no. 1 (2011), pp. 36–9; Karen Derris, 'When the Buddha was a Woman: Reimagining Tradition in the Theravāda', *Journal of Feminist Studies in Religion*, 24, no. 2 (2008), pp. 29–44.

81 Charles Hallisey (trans.), *Therigatha: Poems of the First Buddhist Women*, Cambridge, MA: Harvard University Press, 2015.

82 Ibid., p. 45, ll. 61–3.

83 Miranda Shaw, 'Prajnaparamita, Goddess of Wisdom', in *Goddess: Divine Energy*, ed. Jackie Menzies, exh. cat., Sydney: Art Gallery of New South Wales, 2007, p. 188.

84 Chün-fang Yü, *Kuan-yin: The Chinese Transformation of Avalokiteśvara*, New York: Columbia University Press, 2001, pp. 1; pp. 37–9.

85 Ruben L. F. Habito, 'The Trikāya Doctrine in Buddhism', *Buddhist–Christian Studies*, 6 (1986), pp. 52–62.

86 Chaya Chandrasekhar, 'Heruka Buddha Couples', in *Goddess: Divine Energy*, ed. Menzies, pp. 243–55, at p. 243.

87 Chün-fang Yü, *Kuan-yin*, pp. 15–21, 294–5; David Kinsley, *The Goddesses' Mirror: Visions of the Divine from East and West*, Albany, NY: State University of New York Press, 1989, pp. 26–34.

88 Chün-fang Yü, *Kuan-yin*, pp. 353–88; Kinsley, *The Goddesses' Mirror*, pp. 37–40.

89 Maria Reis-Habito, 'The Bodhisattva Guanyin and the Virgin Mary', *Buddhist–Christian Studies*, 13 (1993), pp. 61–69, at p. 61.

90 Kinsley, *The Goddesses' Mirror*, pp. 49–51.

91 His Holiness Tenzin Gyatso, the Fourteenth Dalai Lama of Tibet, 'On the Meaning of: OM MANI PADME HUM', transcr. Ngawang Tashi, available at http://enlight.lib.ntu.edu.tw/FULLTEXT/JR-AN/an141056.pdf (accessed 8 October 2021).

92 Chün-fang Yü, *Kuan-yin*, p. 45.

93 Cathryn Bailey, 'Embracing the Icon: The Feminist Potential of the Trans Bodhisattva, Kuan Yin', *Hypatia*, 24 (2009), pp. 178–96.

94 This information is from the online entry for the Nyoirin Kannon, Metropolitan Museum of Art, New York, acc. no. 56.39, available at www.metmuseum.org/art/collection/search/49109 (accessed 8 October 2021).

95 Reis-Habito, 'The Bodhisattva Guanyin', pp. 65–6; Kinsley, *The Goddesses' Mirror*, p. 38.

96 For the 1857 records, see Maria Reis-Habito, 'Maria-Kannon: Mary, Mother of God, in Buddhist Guise', *Marian Studies*, 47 (1996), pp. 50–64, at p. 59. For Kakure Kirishitan communities today, see Christal Whelan, 'Religion Concealed: The Kakure Kirishitan on Narushima', *Monumenta Nipponica*, 47 (1992), pp. 369–87.

97 Chün-fang Yü, *Kuan-yin*, pp. 151–3.

98 Ibid., pp. 419–20.

99 For an overview of the spread of Tantric Buddhism (Vajrayana) across Asia, and the visual culture it inspired, see Ramos, *Tantra*, pp. 114–71.

100 Chaya Chandrasekhar, 'Vajrayana', in *Goddess: Divine Energy*, ed. Menzies, p. 226.

101 Vessantara, *Female Deities in Buddhism: A Concise Guide*, Birmingham: Windhorse Publications, 2003, pp. 24–5.

102 Miranda Shaw, 'Tara, the Saviouress', in *Goddess: Divine Energy*, ed. Menzies, pp. 211–25, at pp. 222–4.

103 Ibid., p. 211.

104 Sanjoy Barua Chowdhury, 'The Legacy of Atiśa: A Reflection on Textual, Historical and Doctrinal Developments to Enrich Buddha Dhamma from the Azimuth of Vikramśīla to Modern Era', PhD dissertation, International Buddhist Studies College (IBSC), Mahachulalongkornrajavidyalaya University (MCU), Thailand, pp. 87–97, available at http://research.thanhsiang.org/sites/default/files/attachment/th2018v5.pdf#page=90 (accessed 8 October 2021).

105 Miranda Shaw, 'Tara: Savior, Buddha, Holy Mother', in *Goddesses in World Culture*, vol. I: *Asia and Africa*, ed. Patricia Monaghan, Santa Barbara, CA: Praeger, 2010, pp. 117–27, at p. 119.

106 Shaw, 'Tara, the Saviouress', p. 211.

107 Rachael Wooten, *Tara: The Liberating Power of the Female Buddha*, Boulder, CO: Sounds True, 2020, p. 14.

108 Translated in Susan A. Landesman, *The Tārā Tantra: Tārā's Fundamental Ritual Text (Tārā-mūla-kalpa)*, New York: American Institute of Buddhist Studies/Wisdom Publications, 2020, p. 4.

109 Shaw, 'Tara, the Saviouress', p. 211.

110 *Praises to the Twenty-One Taras*, ed. Sylvia Wetzel, trans. Lama Thubten Yeshe, 1979, pp. 5–11, available at https://fpmt.org/wp-content/uploads/prayers/21tarasltrrdr.pdf (accessed 8 October 2021).

111 Shaw, 'Tara, the Saviouress', p. 222.

112 Miranda Shaw, 'Dharani Goddesses and Female Buddhas', in *Goddess: Divine Energy*, ed. Menzies, pp. 193–209, p. 195.

113 Shaw, 'Tara, the Saviouress', p. 222.

114 Rita M. Gross, *Buddhism after Patriarchy: A Feminist History, Analysis and Reconstruction of Buddhism*, Albany, NY: State University of New York Press, 2000, p. 99. A biography of Her Eminence Jetsun Chimey Luding Rinpoche can be found on the website of the school she founded in Vancouver, Canada, available at www.sakyatsechenthubtenling.org (accessed 6 October 2021).

115 Chün-fang Yü, *Kuan-yin*, pp. 414–15.

Select bibliography

This is a general reading list. Further, in-depth, studies of particular figures and time periods are cited in the notes to the chapters (pp. 256–65).

GENERAL

Adegbola, E.A. Ade., *Traditional Religion in West Africa*, Ibadan: Daystar Press, 1983

Amadiume, Ifi, *Male Daughters, Female Husbands: Gender and Sex in an African Society*, London: Zed Books, 2015

Asante, Molefi Kete, and Ama Mazama (eds), *Encyclopedia of African Religion*, 2 vols, London and Los Angeles: Sage, 2009

Beard, Mary, *Women & Power: A Manifesto*, London: Profile Books, 2018

Black, Jeremy, and Anthony Green, *Gods, Demons and Symbols of Ancient Mesopotamia: An Illustrated Dictionary*, London: British Museum Press, 1992

Capel, Anne K., and Glenn Markoe (eds), *Mistress of the House, Mistress of Heaven: Women in Ancient Egypt*, exh. cat., New York: Brooklyn Museum of Art, 1996

Connelly, Joan Breton, *Portrait of a Priestess: Women and Ritual in Ancient Greece*, Princeton, NJ: Princeton University Press, 2007

Eller, Cynthia, *The Myth of Matriarchal Prehistory: Why an Invented Past won't give Women a Future*, Boston, MA: Beacon Press, 2000

Kinsley, David, R., *Hindu Goddesses: Visions of the Divine Feminine in the Hindu Religious Tradition*, Berkeley, CA: University of California Press, 1986

Menzies, Jackie (ed.), *Goddess: Divine Energy*, exh. cat., Sydney: Art Gallery of New South Wales, 2007

Phillips, Tom (ed.), *Africa: The Art of a Continent*, exh. cat., London: Royal Academy of Arts, 1995

Pollock, Griselda, *Vision and Difference: Femininity, Feminism and Histories of Art*, London: Routledge, 2003

Pomeroy, Sarah B., *Goddesses, Whores, Wives and Slaves: Women in Classical Antiquity*, new edn, London: Pimlico, 1994

Quiñones Keber, Eloise (ed.), *Codex Telleriano-Remensis: Ritual, Divination, and History in a Pictorial Aztec Manuscript*, Austin, TX: University of Texas Press, 1995

Ruether, Rosemary R., *Goddesses and the Divine Feminine: A Western Religious History*, Berkeley, CA, and London: University of California Press, 2005

Sahagún, Fray Bernardino de, *Florentine Codex: General History of the Things of New Spain* [c. 1540–75], trans. Arthur J.O. Anderson and Charles E. Dibble, rev. 2nd edn, 13 vols, Santa Fe, NM: School of American Research, 1950–82

Sharma, Arvind (ed.), *Women in World Religions*, Albany, NY: State University of New York Press, 1987

Wilkinson, Richard H., *The Complete Gods and Goddesses of Ancient Egypt*, London: Thames & Hudson, 2017

CREATION & NATURE

Asantewa, Michelle Yaa (ed.), *In Search of Mami Wata: Narratives and Images of African Water Spirits*, London: Way Wive Wordz, 2020

Canals, Roger, *A Goddess in Motion: Visual Creativity in the Cult of María Lionza*, New Directions in Anthropology, vol. XLII, New York: Berghahn Books, 2017

Dexter, Miriam Robbins, and Victor H. Mair, *Sacred Display: Divine and Magical Female Figures of Eurasia*, Amherst, NY: Cambria Press, 2010

Drewal, H.J. (ed.), *Sacred Waters: Arts for Mami Wata and other Divinities in Africa and the Diaspora*, Bloomington, IN: Indiana University Press, 2008

Fischer, Steven Roger, *Island at the End of the World: The Turbulent History of Easter Island*, London: Reaktion Books, 2005

Freitag, Barbara, *Sheela-na-gigs: Unravelling an Enigma*, London: Routledge, 2004

Heldt, Gustav (trans.), *The Kojiki: An Account of Ancient Matters / O no Yasumaro*, New York: Columbia University Press, 2014.

Murphy, Joseph M., and Mei-Mei Sanford (eds), *Òsun Across the Waters: A Yoruba Goddess in Africa and the Americas*, Bloomington, IN: Indiana University Press, 2001

Soskice, Janet, *The Kindness of God: Metaphor, Gender, and Religious Language*, Oxford: Oxford University Press, 2007

Spiro, Melford E., *Burmese Supernaturalism*, enlarged edn, Abingdon: Routledge, 2017

Starzecka, D.C. (ed.), *Maori: Art and Culture*, London: British Museum Press, 1996

PASSION & DESIRE

Collon, Dominique, *The Queen of the Night*, British Museum Objects in Focus, London: British Museum Press, 2005

George, A.R. (ed. and trans.), *The Epic of Gilgamesh*, London: Penguin Books, 1999

Jayadeva, *Love Song of the Dark Lord: Jayadeva's Gitagovinda*, ed. and trans. Barbara Stoler Miller, New York: Columbia University Press, 1977

Kondoleon, Christine, and Phoebe C. Segal (eds), *Aphrodite and the Gods of Love*, exh. cat., Boston, MA: Museum of Fine Arts, 2011

Leick, Gwendolyn, *Sex and Eroticism in Mesopotamian Literature*, London: Routledge, 1994

Ramos, Imma, *Tantra: Enlightenment to Revolution*, exh. cat., London: British Museum Press and Thames & Hudson, 2020

Sappho, *The Poetry of Sappho*, trans. Jim Powell, Oxford: Oxford University Press, 2007

MAGIC & MALICE

Ariati, N.W.P., 'The Journey of a Goddess: Durga in India, Java and Bali', PhD dissertation, Charles Darwin University, Darwin, 2009

Broedel, Hans Peter, *The Malleus maleficarum and the Construction of Witchcraft: Theology and Popular Belief*, Manchester: Manchester University Press, 2003

Farber, Walter (ed.), *Lamaštu: An Edition of the Canonical Series of Lamashtu Incantations and Rituals and Related Texts from the Second and First Millennia B.C.*, Winona Lake, IN: Eisenbrauns, 2014

Garber, Marjorie, and Nancy J. Vickers (eds), *The Medusa Reader*, New York: Routledge, 2003

Hurwitz, Siegmund, *Lilith, the First Eve: Historical and Psychological Aspects of the Dark Feminine*, trans. Gela Jacobson, Einsiedeln: Daimon Verlag, 2009

Lawrie, Margaret (comp. and trans.), *Myths and Legends of Torres Strait*, St Lucia, Queensland: University of Queensland Press, 1970

Petherbridge, Deanna, *Witches & Wicked Bodies*, exh. cat., Edinburgh: National Galleries of Scotland in association with the British Museum, 2013

Ruickbie, Leo, *Witchcraft Out of the Shadows: A Complete History*, London: Robert Hale, 2004

Watson, Lindsay C., *Magic in Ancient Greece and Rome*, London: Bloomsbury Academic, 2019

JUSTICE & DEFENCE

Blurton, T. Richard, *Hindu Art*, London: British Museum Press, 1992

Coburn, Thomas B. (trans.), *Encountering the Goddess: A Translation of the Devī-Māhātmya and a Study of its Interpretation*, Albany, NY: State University of New York Press, 1991

Deacy, Susan, and Alexandra Villing (eds), *Athena in the Classical World*, Leiden: Brill, 2001

Deacy, Susan, *Athena*, London: Routledge, 2008

Harrison, Paul, *Profane Egyptologists: The Modern Revival of Ancient Egyptian Religion*, Abingdon: Routledge, 2018

Roberts, Mary Nooter, and Allen F. Roberts, *Luba*, New York: Rosen Publishing Group, 1997

Wyatt, Nicolas, *Religious Texts from Ugarit*, rev. 2nd edn, London: Sheffield Academic Press, 2002

COMPASSION & SALVATION

Brading, D.A., *Mexican Phoenix. Our Lady of Guadalupe: Image and Tradition across Five Centuries*, Cambridge: Cambridge University Press, 2001

Gross, Rita M., *Buddhism after Patriarchy: A Feminist History, Analysis, and Reconstruction of Buddhism*, Albany: State University of New York Press, 1993

Hall, Linda B., *Mary, Mother and Warrior: The Virgin in Spain and the Americas*, Austin, TX: University of Texas Press, 2004

Hallisey, Charles (trans.), *Therigatha: Poems of the First Buddhist Women*, Cambridge, MA: Harvard University Press, 2015

Landesman, Susan A., *The Tārā Tantra: Tārā's Fundamental Ritual Text (Tārā-mūla-kalpa)*, ed. Paul G. Hackett, New York: American Institute of Buddhist Studies and Wisdom Publications in association with the Columbia University Center for Buddhist Studies and Tibet House US, 2020

Newman, Barbara, *Sister of Wisdom: St. Hildegard's Theology of the Feminine*, rev. 2nd edn, Berkeley, CA: University of California Press, 1997

Rubin, Miri, *Mother of God: A History of the Virgin Mary*, London: Allen Lane, 2009

Warner, Marina, *Alone of all her Sex: The Myth and the Cult of the Virgin Mary*, 2nd edn, Oxford: Oxford University Press, 2016

Yü, Chün-fang, *Kuan-yin: The Chinese Transformation of Avalokiteśvara*, New York: Columbia University Press, 2001

Acknowledgements

From its initial proposal back in 2013, this exhibition has developed steadily over many years thanks to the guidance and specialist advice of many talented people. Sincere thanks are due to everyone who has dedicated their time and effort to the project, all of whom have significantly enhanced the quality of this book and the exhibition on which it is based. The book was partly researched and written during a series of national lockdowns caused by the coronavirus pandemic, when access to important reference material was limited; I am immensely grateful to everyone who diligently and patiently answered endless questions on their specialist field, pointed me in the direction of source literature, and in many cases supplied scans of articles and book chapters when I needed them most. For the many relevant studies I have no doubt missed, I beg the reader's forgiveness.

I would like to express my appreciation and thanks to our supporter, Citi, for their generosity and enthusiasm; without them this project would not have been possible. Thanks to the institutions who generously agreed to lend works to the exhibition. These are named in the Director's foreword, but I offer my sincere gratitude to all those individuals who worked with the British Museum in a spirit of enthusiastic collaboration: Brooke Ainscow, Sean Baggaley, Lottie Barnden, Simone Battisti, Ashley Cooke, Caitlin Corrigan, Hillarey Dees, Emily Dourish, Susan Fox, Jonathan Fraser, Haim Gilter, Gladstone Gallery, Emma Hammond-Thomas, Rebecca Hill, Marci King, Erin Manns, Zofia Matyjaszkiewicz, Astrid Meek, Victoria Miro, Hannah Murray, Ahiad Ovadia, Alice Panton, Chrissy Partheni, Glenn Scott Wright, Claire Sedgwick, Emma Thomas, Lauren Thompson, Shaun Thompson, Vincent Tiley, Rachel Whitworth and Vincent Wilcke. I'd especially like to thank Judy Chicago, Chitra Ganesh, Kaushik Ghosh, Wangechi Mutu, Chris Ofili, Tom Pico, Project Sheela, Paula Rego, Alison Saar, Mona Saudi, Kiki Smith, the Hannah Wilke Collection & Archive and Owen Yalandja, whose artworks appear in this publication. Thanks also to Julia Belham-Payne, Bea Bradley, Lisa Jann, Domniki Papadimitriou and Marsie Scharlatt.

Many external advisers have contributed their first-hand perspectives and shared matters of personal faith to inform the content of this project. My endless gratitude goes to all those who openly and generously gave their time to interviews and consultation workshops: the London Durgotsav Committee, led by Dr Ananda Gupta, Sunbir Sanyal and Anjali Sanyal, for sharing their worship of the Hindu goddesses Durga and Kali, and for their invaluable support in the acquisition of a specially commissioned icon of the goddess Kali; Nusrat Ahmed, Patricia Anyasodor, Robina Afzal and Abira Hussein for their reflections on Maryam in Islam; and Jenny Cartledge, Olivia Ciaccia, Laura Daligan, Merlyn Hern, Raegan Shanti and Lucya Starza for their insights into Modern Pagan and Wiccan spirituality. I am indebted to Kayte McSweeney for facilitating all aspects of this engagement. My sincere gratitude goes to Mary Beard for writing the Preface to this book, and to her and the other guest speakers for their enthusiasm for the project throughout multiple conversations, and for their reflections on the five core themes to formulate inspiring personal commentaries shown in the exhibition.

I would also like to acknowledge the invaluable assistance of my colleagues at the British Museum, from many different departments and fields of expertise. Many thanks to Hartwig Fischer, Jonathan Williams, Roderick Buchanan and Nadja Race for believing in the exhibition and for championing the project, and particular thanks to Rosalind Winton and Jill Maggs for ceaseless practical support and enthusiasm at its inception and throughout its development. Thanks also to Lissant Bolton, Daniel Antoine, Philip Atwood, Hugo Chapman, Jill Cook, Peter Higgs, Jane Portal and Jonathan Tubb for advising on the text and supporting the inclusion of the objects displayed.

Many specialists and academics generously contributed their time to consult on and review draft sections and chapters of this book. My boundless thanks go to: Richard Abdy, Julie Adams, Ladan Akbarnia, Helen Anderson, Gareth Brereton, Sue Brunning, Rosina Buckland, Yi Chen, Alice Christophe, Tim Clark, Barrie Cook, Jago Cooper, Stephen Coppel, Imogen Coulson, Vesta Curtis, Catherine Daunt, Lloyd de Beer, Amelia Dowler, James Fraser, Stuart Frost, Alexandra Green, Alfred Haft, Amy Hale, Emily Hannam, Jessica Harrison-Hall, Nancy Highcock, J.D. Hill, Richard Hobbs, Tom Hockenhull, Olenka Horbatsch, Julie Hudson, Sushma Jansari, Thomas Kiely, Sang-ah Kim, Rachel King, Amber Lincoln, Yu-Ping Luk, Maria Mercedes Martínez Milantchi, Beverley Nenk, Sam Nixon, Elisabeth O'Connell, Thorsten Opper, Venetia Porter, Jennifer Ramkalawon, Imma Ramos, Sebastien Rey, Judy Rudoe, Jill Salmons, Gaye Sculthorpe, Isabel Seligman, St John Simpson, Naomi Speakman, Chris Spring, Judith Swaddling, John Taylor, Jonathan Taylor, Ross Thomas, Marie Vandenbeusch, Alexandra Villing, Sarah Vowles and Akiko Yano.

Thank you to the exhibition's core team, who contributed to making the exhibition a reality: Dave Agar, Maxwell Blowfield, Clark Henry Brown, Josh Cannon, Emily Castles, Mark Finch, Anna Holden, Hannah James, Deklan Kilfeather, Eirini Koutsouroupa, Ann Lumley, Amanda Mayne, Harriet McColm, Sean McParland, Isolde Nicolaysen, Alex Owen, Sophia Patel, Fabiana Portoni, Olivia Rickman, Hannah Scully, John Stokes, Sophie Tregent, Myriam Upton, Ben Watts, Keeley Wilson and Suzie Yarroll. The catalogue could not have been made without the help of the Publishing team – especially Toni Allum, Claudia Bloch and Beata Kibil – or without Rosemary Roberts's sharp editing and Daniela Rocha's beautiful design. I must also thank the exhibition design team – Victoria Ward, Peter Macdermid and Paul Goodhead – for their creativity, patience and collaborative spirit, as well as Sian Toogood and her team for overseeing and creating all digital aspects of the display.

Above all, special thanks must go to project curator Lucy Dahlsen, whose tireless dedication has benefited all aspects of this publication, and whose specialist knowledge of modern and contemporary art has contributed much to its final form; project managers Helen Richardson and Amy Dillmann for their diligence and attention to detail, and for navigating ever changing schedules; interpretation manager Julie Carr for her wealth of advice and experience; and project editor Lydia Cooper, without whose guidance and ceaseless commitment this book would not have been possible. Finally, I would like to thank my family and friends, in particular Jeremy Lock, for their unwavering support.

Picture credits

The publisher would like to thank the copyright holders for granting permission to reproduce the images illustrated. Every attempt has been made to trace accurate ownership of copyrighted images in this book. Any errors or omissions will be corrected in subsequent editions provided notification is sent to the publisher.

Further information about the Museum and its collection can be found at britishmuseum.org. Registration numbers for British Museum objects are included in the image captions. Unless otherwise stated, copyright in photographs belongs to the institution mentioned in the caption.

All images of British Museum objects are © 2022 The Trustees of the British Museum, courtesy the Department of Photography and Imaging.

Chapter openers:

Page 25 (see also p. 64): Detail of a dish with a mythical being (possibly Mami Wata), late 19th to early 20th century. Nigeria. Brass. Diam. 47.3 cm. British Museum, London, Af1952,20.1. Donated by the Menendez family.
Page 71 (see also p. 78): Detail of the 'Queen of the Night' relief, c. 1750 BCE. Iraq. Painted clay. 49.5 × 37 × 4.8 cm. British Museum, London, 2003,0718.1.
Page 119 (see also p. 138): Detail of dance mask showing the face of Taraka, 1994. West Bengal, India. Papier mâché, clay and fibre, painted. 53 × 48 × 17 cm. British Museum, London, As1995,17.2.
Page 163 (see also p. 193): Detail of Durga slaying the buffalo demon Mahisha, 15th century. India. Schist. 58 × 38 × 15.5 cm. British Museum, London, 1872,0701.77. Donated by Mrs John Bridge, Miss Fanny Bridge and Mrs Edgar Baker.
Page 207 (see also p. 241): Detail of figure of Guanyin with 18 arms seated on a lotus, c. 1700–22. China. Porcelain and wood. 41 × 20 × 11.5 cm. British Museum, London, 1980,0728.93. Bequeathed by Patrick J. Donnelly.

Page 9: FAL / Photograph by Dean Dixon, sculpture by Alan LeQuire; page 12: Photo © Musée du Louvre, Dist. RMN-Grand Palais / Philippe Fuzeau; page 19: Photo © The Israel Museum, Jerusalem by Meidad Suchowolski; page 29: Public domain: Marubatsu / WikiCommons; page 33: © 2022 The Trustees of the British Museum, reproduced by permission of the artist; page 35: Reproduced by kind permission of Project Sheela. Photo: Eoin Carley 2021; page 36: Bjanka Kadic / Alamy Stock Photo; page 41: Chico Sanchez / Alamy Stock Photo; page 43: AP Photo / Caleb Jones; page 44: pocholo / Alamy Stock Photo; page 50: imageBROKER / Alamy Stock Photo; page 60: jbdodane / Alamy Stock Photo; page 62: Photo © Sebastião Barbosa; page 63: Copyright Alison Saar. Courtesy of L.A. Louver, Venice, CA. Photo by Don Cole; page 65: Public domain: Amcaja / WikiCommons; page 68: Joacy Souza / Alamy Stock Photo; page 94: Photo: Sergey Sosnovskiy

(CC BY-SA 4.0); page 109: Bibliothèque nationale de France; page 110: REUTERS / David Mercado / Alamy Stock Photo; page 114: © National Portrait Gallery, London; page 115: © ARS, NY and DACS, London 2022, Digital image, The Museum of Modern Art, New York / Scala, Florence; page 116: © Marsie, Emanuelle, Damon and Andrew Scharlatt, Hannah Wilke Collection & Archive, Los Angeles / VAGA at ARS, NY and DACS, London 2022; page 117: © Wangechi Mutu. Courtesy the artist and Victoria Miro. Digital image, The Museum of Modern Art, New York / Scala, Florence; page 128: The Metropolitan Museum of Art, New York, 08.162.1; page 130: The Metropolitan Museum of Art, New York. Photo © Kiki Smith. Photography by Ellen Page Wilson, courtesy Pace Gallery; page 141: R.M. Nunes / Alamy Stock Photo; page 150: Photo credit: Gallery Oldham; page 153: Reproduced by kind permission of the Syndics of Cambridge University Library; page 158: *Dance of the Nine Maidens*, 1940. Ithell Colquhoun. © Tate; page 159: Reproduced by kind permission of the Doreen Valiente Foundation; page 178: Reproduced by kind permission of the Allard Pierson, University of Amsterdam; page 180: Courtesy National Museums Liverpool, World Museum; page 187: The Roman Baths, Bath & North East Somerset Council (top right: Photo © Pete Stone); page 190: DE ROCKER / Alamy Stock Photo (left), Photo 16320092 © Jorisvo | Dreamstime.com (right); page 201: Tuul and Bruno Morandi / Alamy Stock Photo; page 202: Image courtesy of Kaushik Ghosh; page 203: Lal Nallath / Alamy Stock Photo; page 204: © Chitra Ganesh; page 227: © Paula Rego. Courtesy the artist and Victoria Miro; page 228: © age fotostock; page 235: © Chris Ofili. Courtesy the artist and Victoria Miro. Digital image, The Museum of Modern Art, New York / Scala, Florence; page 242: Prisma by Dukas Presseagentur GmbH / Alamy Stock Photo; pages 252 and 255: © Wangechi Mutu. Courtesy the artist and Victoria Miro.

Index

Page numbers in *italic* refer to the illustrations.

Acropolis, Athens 8, 84, 179
Adam and Eve 9, 12, 105–7, *105*, 113, *113*, 123, 127
Adelaide of Montserrat 225
Adonis 113
Aegean Sea 18
Aeschylus, *The Eumenides* 181–2
Agastya 138
Agot 66
Ágreda, Maria de Jesús de, *Mística ciudad de Dios* 225–6
agriculture 46–55
Akan people 36
Akkadians 73, 76
Alexander the Great 188, 212
Allen, Virginia 128–31
The Alphabet of ben Sira 127
Amaterasu 28
Amazons 11, 164
Ambubachi Mela 103
Amenhotep III, Pharaoh *172*, 173–4, *175*
Amida 241, *242*
Ammit 177
amulets 122–3, 169, *170*–2, 210–11, *211*–12, 228, 250
An (Anu) 75, 79–80, 121
Anat 179–81
Anawrahta, King 44
Ancestral Beings 58
Anchin 143
Andes 36, 69, 110–11
Andromeda 135
Anikulapo-Kuti, Funmilayo 116
Annang Ibibio 65
Anne, Queen of England 188
Anthony, Susan B. 160
Anu *see* An
Aphrodite 10–11, 72, 83–9, *85*, 91, 94, 171, 214
see also Venus
Aphrodite of Knidos 11, 91, 94, 112
Apuleius, *Metamorphoses* 214–16
Arctic 56
Ardhanarishvara 196
Aristophanes 54
Artemis (Diana) 147–8, 216
Arugba 59–60
Asase Yaa 36
Assam 101
Assumption of Mary 222
Assyrians 73, 77–80
Astarte 80–3, *82*, 179–81
*asura*s (forces of chaos) 191, 192
Athena 8, *9*, 11, 14, 135–6, 179–85, *181*, *184*–5, 190, *190*, 194, 205
see also Minerva
Athens 8, 54–5, 83, 84, 179, 182–5
Atisha 246–7
Augustine, St 104

Augustus, Emperor 216
Aurelius, Marcus 92, *93*
Australia 58, *58*
automatism 156
Avalokiteshvara 238, 239, 241, *241*, 247
Aztecs *see* Mexica

Baal 181
Baartman, Saartjie 18
Babylonians 73, 77–80
Bacon, Francis 136
Bakor-Ejagham people 66
Baldung, Hans 'Grien', *The Witches' Sabbath* 152–3, *154*
Bali 133, 140–2, *141*
Barong 140
Bashniray 125–7
Bastet 169, *170*
Bath 186–8
Beardsley, Aubrey 128
Beauvoir, Simone de 233–4
Beggar's Benison 113, *113*
Bengal 101, 191
Benin 30–1, 63, 65
Benzaiten (Benten) 29
Bernadette, St *229*
Beyoncé 11
Bhadrakali 201–3
Bhrikuti-devi 250
Bhutan 238
Bible 32, 105, 218
Bihari, *Satsai* 97–8
birth 17, 27, 32–3, 121, 131–3
Biswas, Sutapa 204
Black Panther (film) 164
Blanche of Castile 225
Bob-Eghaghe, Anthony Omorefe ('Uncle Bob') 69
Bodhisattva of Compassion 238–46
Bodhisattvabhumi 237
Bodhisattvas 236–46
Bolivia 69, *110*–11
Bona Dea 55
Book of the Dead 40–1, *40*
Book of Shadows 157
Boshin civil war (1868–9) 164
Botticelli, Sandro, *The Birth of Venus* 112
Boudica 164
Brahma 138
Brahmins 46
brass work *64*, 65
Brazil 61–2, *68*
Britain 113, 164, 186–8, 214
British Empire 39
Brooklyn Museum, New York 204, 236
Budapest, Zsuzsanna 158
Buddha (Siddhartha Gautama) 236–7
Buddhism 15, 26, 44, 46, 140, 155, 208

compassion and wisdom 236–51
Guanyin 238–46
kijo 142–4
and sexuality 96, 101, 107
Tara 246–51
Bull of Heaven 79–80, *81*
Bustamante, Fray Francisco de 230
Byatta 44
Byzantine Empire 220

Caedmon 106
Caesar, Julius 92, *92*
Calon Arang 141–2
Candomblé 61–2, 66, *68*
'Capitoline Venus' *90*
Caribbean 66
The Carters, *APESHIT 12*
Castiglione, Giovanni Benedetto, *Circe Changing Ulysses' Men into Beasts* 148–9, *148*
Catherine the Great, Empress of Russia 188
Catholic Church 36, 41, 108, 152
and Candomblé 61–2
Catechism 31
and China Supay 111
heretics 151
Mary 220, 222, 225, 226–32, 244
and Santeria 61
and sexuality 104
Cellini, Benvenuto 136
ceramics: amphoras 51, *53*, *87*, 181, *183*–4, 185
divination bowls 166–8, *168*
incantation bowls 123–7, *124*–5
Chamunda 198–9, *199*
Chanda 197, 198
Chandamaharoshana Tantra 103
chaos and order 73–94
The Charge of the Goddess 157
chastity 104, 107
Chaucer, Geoffrey 120
Chhau dances 138
Chicago, Judy: *The Birth Project* 32–3, *33*, 34
The Dinner Party 204
childbirth 17, 27, 32–3, 121, 131–3
Children of Artemis 158, *159*
China 17, 99, 238, 239–44, *240*–1, 245
China Supay 111, *111*
Choirine 54, *54*
Christ (Jesus) 66, 68, 69, 106, 217–18, 220, *221*, 222, *223*, 233–4
Christianity 208, 216
God 31–3
Eve 104–7
Holy Trinity 192
and Minerva 188
missionaries 108
and sexuality 73, 104–7, 108, 117, 244–6
Virgin Mary 217–36

witch hunts 151
see also Catholic Church
Cihuateteo 131–3, *132*
Circe 147, 148–51, *148*, *150*
Cixous, Hélène, 'The Laugh of Medusa' 137
Clinton, Hillary 12, 136, 160
cloaks, Maori *38*, 39
Coatlicue 36, *36*
Codex Telleriano-Remensis 109–10, *109*
codices, Mexican 108–10
coins 92, *92*–3
Colina, Alejandro 41, *41*
Colquhoun, Ithell 156
Dance of the Nine Maidens 156, *157*
Three Growing Forms 156, *158*
Commodus, Emperor 92, *93*
Confucianism 142
Congo, Democratic Republic of the (DRC) 11, 68, 165–6, *167*–8
Constantine, Emperor 104
Constantinople 220, 232
Cornforth, Fanny 128
Covenant of the Goddess 158–9
Cox, Renée 236
Cranach, Lucas the Elder, *The Fall of Man* 106, *107*
creation myths 26
creator couples 27–9
single creators 29–34
Crispina 92, *93*
Cross River region, Nigeria 65, 66
Crowley, Aleister 156, 157
Cuba 61, 62, 232
Culpepper, Emily 137
Cupid 84, *86*, 92
see also Eros
curse tablets 186–8, *187*
Cycladic culture 17, 18, *20*–1
cylinder seals *81*
Cyprus 80, 83

'Dahomey Amazons' 164–5
Dalai Lama 251
Daly, Mary 32
Danaë 134–5
Dangkorlo clan 58
Datta, Sri Kajal 138
Demeter 51–4, *52*, 214, 216
demons 120–61
Dendera 171
The Destruction of Mankind 171
Devi-bhagavata purana 191–2
Devi Mahatmya 13, 164, 192, 194–6, 198, 203
Dewi Premoni *see* Durga
Diablada (dance of the devils) 110–11, *110*
Diana (Artemis) 147–8, 216
Dianic Wicca 158
Diego, Juan 229–30
Dike 178

Diodorus Siculus 135–6
Dionysos 86
divine, unification of sex and 94–104
Diwali 23, *50*, 51
Djang 58 *see also* 'the Dreaming'
Dogai people 120
Dōjōji 143–4
'the Dreaming' 58 *see also* Djang
Dumuzi 77, 79
Dürer, Albrecht 152, 153
Durga 141–2, *142*, 191, 192–4, *193*, 196–200, *201*, 203
Durga Puja 200, *201*
Dykewomon, Elana, *They will Know me by my Teeth* 137

Earth, as female entity 26, 36–41
Easter Island 37, *37*
Ecuador 69
Eden, Garden of 9, 12, 127
Efik people 65
Egypt 23, 40–1, *40*, 147, 155, 168, 169–78, *170–8*, 209–12, *210–14*, 217, 227
Eleanor of Aquitaine 225
Eleusinian Mysteries 54, 216
Eleusis 214
Elizabeth I, Queen 188, *188*
Enheduanna 74
Enki 77
Enkidu 80, *81*
Enlightenment 73, 113, 155
Ephesus 217
Epic of Gilgamesh 77–80
Erechtheion, Athens 8
Ereshkigal 77
Erichtho 147
Eros 84–6, 95
see also Cupid
Eve 9, 23, 73, 104–7, *105*, 110, 113–16, *113*, 127, 220–2
The Exorcist (film) 123
'Exultation of Inanna' 74
Ezili Dantò 232
Ezili Freda 232

Fall of Man 105–7, *107*
Farr, Florence 156
Faustina II 92, *93*
feminism 15
and Athena 182, 190
Dianic Wicca 158
ecofeminism 69, 177
and Eve 106–7
feminist theology 31–2
Hindu goddesses 203–5
and Lilith 128, 131
and Medusa 137
second-wave feminism 20, 32, 137
and Venus 113–14
and the Virgin Mary 220, 233–4
Fernández y Félix, José Miguel 232
fertility 15–16, 26–7, 28, 34, 37, 46–7, 51, 54–5, 69
Fini, Leonor 131
Florentine Codex 109
France 164, 222, *223–4*, 227–8
Franciscans 230

Freemasonry 156
French Revolution 136, 190
Freud, Sigmund 136, 137
Fulgentius 136

Gaia 40, 83, 84
Gaja-Lakshmi 47–8, *47*
Galembo, Phyllis 66
Ganesh, Chitra, *Eyes of Time* 204
Gantois, Mother Menininha do 62, *62*
Garbati, Luciano 137–8
Garden of Eden 106, 113, *113*
Gardner, Gerald 157
Geb 40–1, 211
gender-equality movements 20, 117, 161, 205
gender fluidity 11, 13, 241–2
Genesis 31, 105–6, 113
Genmei, Empress 27
Germany 136, *137*, 152, 232, *233*
Ghana 30–1, 36, 68, 160
Ghosh, Kaushik, *Kali* 200–1, *202*
Gilgamesh 77–80, *81*
Gimbutas, Marija 20
Gitagovinda 97, 99
Giuliani, Rudy 236
Glaucus 150
Gnosticism 151
God (Abrahamic) 22, 31–3, 105–6, 127, 218, 220–2, 225
Goddess Theory 20
Goethe, Johann Wolfgang von, *Faust* 128
Golden Dawn, Hermetic Order of the 155–6
Goto Islands 244
Great Ennead 40
Great Mother 174–7, 197, 251 *see also* Guanyin, Kali, Kamakhya, Mary, Mut, Tara
Greece *53–5*, 87–9, 151, *151*, 155, 178, *183–4*
Aphrodite 83–9, 94
Athena 179–85
Circe 148–9
Cycladic culture 17, 18, *20–1*
Demeter and Persephone 51–5, *52*
Gaia 40
Hekate 146–7
Isis 212–14
Medusa 133, 134–5
sculpture 8, 9–11, *10*, 18, 94, 112
Green Tara 249
Greenfield Papyrus 40–1, *40*
Gross, Rita M. 14
Guanyin 23, 238, 239–46, *240–1*, *245*, 249, 251
Guwahati, Assam 101–3

Habito, Maria Reis 239
Hackett, Jo Ann 16
Hades 51, 54
Hadrian, Emperor 92
Haiti 66–8, 232
hannya masks 143
Harvey, P.J. 34
Hathor 171, 196, 209–10

Hawai'i 41–3, *42–3*
heavenly queens 209–51
Hekate (Hecate) 146–7, *147*, 150, 151, 216
Helen of Troy 217
Heliopolis 40–1
Helios 148
'Hellfire clubs' 113
Hephaestus 181
Hera (Juno) 186, 188, *189*
Heracles (Herakles) 84, 181, 217
Hermes 135
Herodotus 169
Hesiod, *Theogony* 83, 84, 146–7
hetairai (courtesans) 86
Hildegard of Bingen 15, 225
Symphonia armonie celestium revelationum 225
Hinduism 155, 208
Durga 192–4, *193*
Kali and Chamunda 196–205, *197*, *199*
Mahadevi 191–2
Parvati 194–6, *195*
Radha 94, 97–9, 107
Ramayana 133, 138
Rangda 140–2
and sexuality 73, 94, 95–104, *95–6*
Shri-Lakshmi 46–51, *47*, *49–50*
Tantra 101–4, 198, 246
Taraka 138–40
Hine-nui-a-Rangi 39
Hiroshige, Utagawa, *Illustrated Chronology of this Realm* 27–8, *28*
Hodegetria 220, *221*, 222
Homer, *Odyssey* 148–50
Horace 149–50
Horus 209, *210*, 211, 216–17
'Hottentot Venus' 18
Huaxtec culture 108
Hundred Years War (1337–1453) 164
Hymn 5 to Aphrodite 182
Hymn to Demeter 51, 147

Iceni 164
icons 220, *221*, 232
Ifa 58–61
Inanna 11, 51, 72, 73–6, 77, 80, 84, 94
see also Ishtar
incantation bowls 123–7, *124–5*
Ince Athena 179, *180*, 194
incubus 123
India 17, 237, 239
see also Buddhism; Hinduism
Indonesia 140–2
Indra 48
Indus Valley Civilisation 17, 191
infant mortality 123, 127
intaglios *126*, 127, 135, *135*
Inuit 56, *57*
Iraq 121–5, *124–5*
Ireland 33–4
Irigaray, Luce 234
'Isa 218, 219
Isaeus 55
Ishme-Dagan, King 76
Ishtar 22, 72, 73, 77–83, *78–9*, *81*,

84, 91, 94, 97, 99, 123, 179–81
see also Inanna
Isias 214, *215*
Isis 181, 209–17, *210*, *213–15*, 217
Isis-Urania 155–6
Islam 140, 151, 208, 217–19, 234
Israel 17–18, *19*
Iustitia 178
Ivory Coast 36
Izanami-no-mikoto and Izanagi-no-mikito 27–8, *28–9*

Jahangir, Emperor 219
Jainism 26, 96
Japan 27–9, 142–5, 164, 227, 238, 242, *242*, *243*, 244
Java 141–2, *142*
Jayadeva 97
Jesus *see* Christ
Jetsun Kushok Rinpoche 251
Joan of Arc 164
John, St 232
John Paul II, Pope 226–7, *228*
Jordan Valley 17–18
Judaism 31–2, 123, 125, 131, 151, 208
Juno (Hera) 186, 188, *189*
Jupiter 186
see also Zeus
Justin Martyr 217
Juvenal 216

Kabbalah 127, 155
Kaibara Ekiken, *Onna daigaku* 142
Kakure Kirishitan communities 244
Kali 9, 23, 191, 192, 196–205, *197*, *200*, *202*
Kali Puja 200–1
Kalighat Temple, Kolkata 198–9
Kama 95, *95*
kama (desire) 95, 99, 103
Kama Sutra 99
Kamakhya 101–3
kami 27–9
Kannon 238, 242, *242*, *243*, 244
Karnak 174–7, 211–12
Kato Nobukiyo 242, *243*
Keen, Henry Weston, *Lilith* 128, *129*
Kenuajuak, Lucassie, Sedna figure 56, *57*
Kerala 201–3
Kijo 142–5
Kiyohime (Princess Kiyo) 143–4
Knidos 11, 91, 94
Koberger, Anton 153
Kojiki 27
Kore 54, 217
see also Persephone
Korea 238
Kramer, Heinrich, *Malleus maleficarum* 151–3, *153*
Krishna 97–9, *100*, 107
Kronos 83
Kundmann, Karl, Pallas Athena fountain *190*
Kuti, Fela 116

Labouré, Catherine 228
Lakshmi *see* Shri-Lakshmi

Lamashtu 121–3, *122–3*
Lateran Council 220
Latin America 66
Lavinium 185–6
lebetes gamikoi (high-handled vessels) 89, *89*
LeQuire, Alan, *Athena Parthenos* 9
leyaks 140–1
LGBTQ+ movements 15, 242
Lilith 12, 123–31, *124–6, 128–9*
Limoges 222, *224*
Lisa 30–1
The Lotus Sutra 208, 242–4
Louis XVI, King of France 136
Lourdes 227–8, *229*
Luba Empire 11, 165–8, 205
Lucan, *Pharsalia* 147
Lucas, Sarah 34
Lucifer 110–11
Luke, St 220
Lysippus 84

Ma'at 177, *178*
Mahabharata 138, 191
Mahadevi 22, 191–2, 194–6, 201–3, 214
Mahayana Buddhism 237–9, 242, 246
Mahisha 192, *193*, 194, 200
Maladamatjaute 65, *65*
Malleus maleficarum 151–3, *153*
Mami Wata 63–9, *64–5*, 67
Mandaeism 125–7
Maori 37–9, *37–8*
Mara 237
Marcia Furnilla *94*
Maria lactans 217
María Lionza 41, *41*
Maria Theresa, Queen 188, *189*
Marie Antoinette, Queen 136, *137*
Mariology 225
marriage 86, 104
Marx, Karl 136
Mary, Virgin 14, 23, 41, 61, 66–8, 217–36, *221, 223–4, 227–31, 233*, 244, 251 see also Maryam
Maryam 218–19, 233
 see also Mary, Virgin
Masakado, Taira no 145
Mascherini, Marcello, *Minerva 190*
masks 65–6, 111, *111*, 138, *139*, 140, *141, 143, 144*
masquerades 65–6, *67*
Maurice, Emperor 222
Mawu 30–1
medals *113*, 136, *137*, 185, *185*, 188–90, *188–9*, 228, *229–30*
Medea 147, *148*
Mediterranean 17, 72–3, 80–4, 94, 127
Medusa 9–10, 11, 133, 134–8, *134–5*, 140, 179
Memphis (Egypt) 169, 177
Mên-an-Tol, Cornwall 156
menstruation 103
Meoto Iwa 28, *29*
mermaids 58, 63–5
Mesopotamia 11, 22, 51, 73–80, *75–9*, 91, 121–3, *122–3*

Messiah 127, 217
#MeToo movement 137–8
Metropolitan Museum of Art, New York 131
Mexica (Aztecs) 29, 36, *36*, 108–11, *109*, 131–3, *132*, 230
Mexico 108, *231*
Mexico City 229–32
Michael, St 110–11
Michelangelo: *Creation of Adam* 31, 33
Middle East 17, 72–3, 80, 94, 127
Mijibu wa Kalenga 166–8
Miller, Madeline, *Circe* 149
Milton, John, *Paradise Lost* 106
Minerva 135–6, 185–90, *188–90*, 216
 see also Athena
missionaries, Christian 108
Mithras 216
Modern Pagans 23, 158, 177
Mongolia 238
monsters 120–61
Mother Earth 20, 22, 26–7, 36–41, 69
motherhood 208–10
 inverted mothers 121–33
Mount Kilauea, Hawai'i Island 43
Mount Popa, Myanmar 44–5, *44*
mountains 41–6
Muddupalani, *Radhika-santvanam* 98
Mukangala, Banze 165–6
Munda 197, 198
Munhata 18
Murray, Margaret 157
 The Witch-Cult in Western Europe 156
Mut 169, 174–7, *177*
Mutu, Wangechi, *Yo Mama* 116, *117*
Myanmar 44–6, *44–5*
Mysteries of Isis 216
mystery religions 216
Myth of the Heavenly Cow 171, 196

Nagarathnamma, Bangalore 98
Nakano Takeko 164
Nana Buluku 30–1
Napoleon Buonaparte 188, *189*, 232
Nashville, Tennessee 8
nat spirits 44–6
National Gallery, London 113–14, *114*, 234
Naukratis 214
Nemesis 84
Neoplatonism 104
Nepal 101, 200, *200*, 238, 239
Nephthys 211
Neptune (Poseidon) 135, 137, 188, *189*
New Testament 232
'New Woman' 128–31
New Zealand 37–9
Nidanakatha 237
Nigeria 63–6, *64*, 67, 116
Nike 179
Nile, River 171, 174
Nkulu-N'Sengha, Mutombo 166
Noh theatre 143–4, *144*
Nut 40–1, 211

occult revival 155–9
Odysseus (Ulysses) 148–9, 181
Ofili, Chris, *The Holy Virgin Mary* 234–6, *235*
Ogun 59, 61
Old Calabar 65
Olorun (Oludumare) 59
Ometeotl 29
order and chaos 73–94
Origen 217
orisha 58–62, 64, 168
Orthodox Church 220
Oshun (Ochun, Oxum) 23, 26, 58–63, *60*, 232
Osiris 209, 211–12, *213*
Osogbo festival 23, 59–61, *60*
Our Lady of Częstochowa 232
Our Lady of Fátima, Portugal 226, *228*
Ouranos 40, 83
Ovid 149, 216
 Metamorphoses 135
Oya 168

Pachamama 36, 69
Pakarati, Leonardo 37
Pakhet 169
Pakistan 17, 191
Palaephatus 135
Panathenaia festival 182–5
Papatuanuku 37–9, *37*
Parliament of the World's Religions 159
Parthenon, Athens 8, *10*, 179, 185
Parvati 191, 192, 194–6, *195*, 197
passion 72, 80, 84, 94, 97, 116
Pazuzu 123, *123*
Pele 41–3, *43*
Persephone 51–4, 147, 216
Perseus 134–7, 181, 217
Peter Comestor 106
Pheidias 8, 11, 179
Philae 209–10
Phoenicians 80–3
Pico, Tom, *Tiare Wahine 42*, 43
Pizan, Christine de, *The Book of the City of Ladies* 136
Platonism 104
Plotinus 104
Plutarch 84, 211, 216
Polydectes 134–5
Pompeius, Sextus 147
Pongala festival 201–3, *203*
Popa Medaw 44–5, *45*
Porphyry, St 104
Poseidon see Neptune
Prajnaparamita 238
prakriti 97, 101, 104
Praxiteles 11, 91, 112
pregnancy 17, 34, 37, 121, 131
Prithvi 46
Project Sheela 34, *35*
Projecta casket 89, *89*
Proserpina 216
protection and strength 165–90
Protestantism 151, 153, 220
Ptah 177, *178*
Ptolemy II Philadelphus, Pharaoh 177, *178*

puppets 141, *142*
Puranas 191
Pure Land Buddhism 242
purusha 97, 104
Pussy Riot 234
Pyramid Texts 209

'Queen of the Night' 77, *78*, 91
queens, heavenly 209–36
Qur'an 105, 218–19, *219*

Ra 40, 169, 171, 181
Radha 94, 97–9, *100*, 107, 191
Rainbow Serpent 58
Rajan, Rajeswari Sunder 204–5
Rama 138
Ramayana 133, 138, 142, 191
Rameses II, Pharaoh 171
Rangda 133, 140–2, *141*
Ranginui 37–9, *37*
Rapa Nui (Easter Island) 37, *37*
Ravana 138
Reformation 153
Rego, Paula: *Lamentation* 226
 Nativity 226, *227*
Renaissance art 106, 112–13
Richardson, Mary 113–14, *114*
Rig Veda 46
rivers 46–7, 56, 59–60
Romans 55, 155, 164
 Christianity 73, 104
 Circe 149–51
 curse tablets 186–8, *187*
 Hekate 146–7
 Isis 214–17
 Iustitia 178
 Medusa 133, *134–5*, 135
 Minerva 185–90
 sculpture 18, *85–6*, 94, *94*, 179, *180*
 Venus (Aphrodite) 83–4, *85*, 89, *89*, 91–4, *92–3*
Romanticism 127–8
Rome 92, 186, 216
rosaries 220, *220, 230*
Rosicrucianism 155
Rossetti, Dante Gabriel, *Lady Lilith* 127–31, *128*
Rowlandson, Thomas, *Connoisseurs* 112, 113
Rudrayamala Tantra 103
Ruether, Rosemary Radford 32
rusalki 120
Russia 220, 234

Saar, Alison, *La Pitonisa* 63, *63*
'sacred marriage' 76
Sahagún, Bernardino de 133, 230
 Historia general de las cosas de la Nueva España 108–9
Sakya Trizin 251
Samudra Manthana 48
Sango 59
Santería 61, 66, 232
Saraswati 47
Sardinia 169–71
Sati 101
Sappho 15, 88, *88*
Satan 105–6, 123, 127, 151, 159

Saudi, Mona, *Mother Earth* 20, 22
Scheuberin, Helena 152
Schneemann, Carolee 114–16
 Eye Body #5 115, *115*
sculpture: 20th century 116, *116*, 131
 Australian 58, *58*
 early figures 16–20, *19–21*
 Easter Island 37, *37*
 Greek 8, 9–11, *10*, 18, 94, 112
 Hindu 9, 194, *195*, 196, 198, *199*
 Oshun 59, *60*
 Roman 18, 94, *94*, 179, *180*
 Sheela-na-gigs 33–4, *35*
Scylla 150, *151*
Sedna 56, *57*
Sekhmet 23, 169–78, *170*, *174*,
 176–7, 181, 188, 196, 204, *205*
Selene 147
Sendai 242, *242*
Sensation exhibition, London (1997)
 234–6
Seti I, Pharaoh 171
sexuality 71–117
 Christianity and 104–8, 117
 evolution of Venus and Eve
 112–16
 order and chaos 73–94
 Tlazolteotl 108–11
 unification of sex and the divine
 94–104
 virginity and chastity 104
Sha'ar HaGolan 18
Shaivism 191
Shakti 96, 99
shakti (power) 103, 191–205
Shaktism 191–2, 198, 214
Shango 168
Shankara, Adi, *Saundarya Lahari* 196
Sheela-na-gigs 33–4, *35*
Sheshonq 211–12
Shintoism 27–9, 142–3
Shiva 9, 96, 99, 101, 191, 196,
 197–8, *197*
Shiva Gajan festival 138
Shiva linga 96, *96*
Shri-Lakshmi 23, 46–51, *47*, *49–50*,
 69
Shu 40, 41
Shulgi, King 76
La Sirène 66–8
Sisyphus 54
Sita 138, 191
Skanda 196
Smith, Kiki, *Lilith* 12, *130*, 131
Sol Invictus 216
Solomon, King *126*, 127
Songtsen Gampo 250
Sophia (Wisdom) 225
Sophocles 72
South America 61, 69, 108, 110–11
South Asia 17, 46, 73, 94–104,
 238, 246
South-East Asia 237
Spain 108, 155, 214
stone circles 156
strength and protection 165–90
succubus 123, 125
suffering and transformation
 133–45

Sulis-Minerva 186–8
Sulla 92, *92*
Sumbha 196–7
Sumerians 73–6, 80
Supay 111
Surrealism 156
Suzuki Nohzin, *namanari* mask for
 Noh theatre *144*
symposia 86
Syria 80, 179–81

Takiyasha-hime 145
Talmud 125
Tane-nui-a-Rangi *37*, 39
Tantra 101–4, 198, 246
Taoism 26, 99
Tara 246–51, *248–50*
Taraka 133, 138–40, *139*, 142
Taranatha 247
Tefnut 40
Temple of Goddess Spirituality,
 Cactus Springs, Nevada 177
Tenochtitlan 36
Tepeyac, Mexico City 229–32
Tertullian 105–6
Thebes 169, 211–12
Themis 178
Theravada Buddhism 237–8
Therigatha 237
Thesmophoria 54–5
Thirty Years War (1618–48) 153
Tiberius, Emperor 216
Tibet 101, *102*, 103, 238, 239, 241,
 241, 246–51, *248–50*
Titian, *Fall of Man* 106
Tlazolteotl 108–11, *109*
Togo 30–1, 63
Torres Strait Islanders 120
transformation and suffering
 133–45
Tree of Knowledge 105
Tripurarnava Tantra 103
tsa tsas (clay plaques) 250, *250*
Turkey 17, 214
Tutankhamun, Pharaoh 171
tyet amulets 211, *211*

Ugajin 28–9, *30*
Ugarit 179–81
Ulysses *see* Odysseus
United States of America 11, 23,
 136, 158–9, 188–90
Ur-Nammu, King 75
Uruk 74–5, 79
Utagawa Kuniyoshi, *Takiyasha
 the Witch and the Skeleton Spectre*
 144–5, *145*

Vaishnavism 49, 97, 191
Vajrabhairava *102*
Vajravetali *102*
Vajrayana Buddhism 237–9, 246
Vajrayogini 103
Valiente, Doreen 157, *159*
Vatsyayana 99
Vaughan, Avril, *Athena and Me*
 185, *185*
Vedas 46–7, 191
Velázquez, Diego, *The Toilet of*

Venus 113–14, *114*
Venus 10–11, 18, 23, 72, 83, *90*,
 91–4, *92*, *94*, 97, 99, 104, 112–16,
 114, 188, *189*, 216
 see also Aphrodite
Virgen de la Candelaria 110
Virgin of Guadalupe 230–2, *231*
Virgin Mary *see* Mary, Virgin
virginity 104, 220
Vishnu 48–9, *49*, 97, 191
Vitry, Jacques de 106
Vodou 66–8, 232
Vodun 63
volcanoes 41–3, *43*
vulva 32–4, 37, 96, 101, 103

Wadjet 169
Walker, Dr Mary Edwards 190
Waqialla, Osman, *Kaf ha ya 'ayn sad*
 219, *219*
Warner, Marina 106
 Alone of All her Sex 234
warriors and warfare 84, 164–5,
 168, 179–81, 191, 192–4, 197
water 56–69
Waterhouse, John William, *Circe
 Offering the Cup to Ulysses* 149, *150*
Wellington, Duke of 188, *189*
Wen-cheng 250
West Bengal 138–40, *139*, 200
White Tara 249, *249*
Wicca 157–9
Wilke, Hannah 114–15
 Venus Pareve 116, *116*
Witchcraft and Human Rights
 Information Network 160
witches 23, 145–61
 witch hunts 151–5, 160–1
Woman of Hohle Fels 19

yab-yum ('father-mother') imagery
 101, *102*
Yalandja, Owen, *Yawkyawk* 58, *58*
Yarmukian culture 17–18, *19*
Yaroslavl 220
Yawkyawk 58, *58*
Yeats, W.B. 156
Yemanja 66–8, *68*
Yemoja 64, 66
Yeshe Dawa 247–9
Yoni Tantra 103
Yoruba 26, 58–62, *60*, 64, 66,
 168, 232
Young British Artists 234–6

Zeus 11, 134, 146–7, 179, 181
 see also Jupiter
Zoroastrianism 125